# DIGITAL ART MASTERS

## : VOLUME 3

# DIGITAL ART MASTERS

## : VOLUME 3

3DTOTAL.COM LTD

ELSEVIER

AMSTERDAM • BOSTON • HEIDELBERG • LONDON • NEW YORK • OXFORD
PARIS • SAN DIEGO • SAN FRANCISCO • SINGAPORE • SYDNEY • TOKYO

Focal Press is an imprint of Elsevier

Focal Press

Focal Press is an imprint of Elsevier
The Boulevard, Langford Lane, Kidlington, Oxford, OX5 1GB, UK
30 Corporate Drive, Suite 400, Burlington, MA 01803, USA

First edition 2008
Reprinted 2008

Notice
No responsibility is assumed by the publisher for any injury and/or damage to persons
or property as a matter of products liability, negligence or otherwise, or from any use
or operation of any methods, products, instructions or ideas contained in the material
herein. Because of rapid advances in the medical sciences, in particular, independent
verification of diagnoses and drug dosages should be made

**British Library Cataloguing in Publication Data**
A catalogue record for this book is available from the British Library

**Library of Congress Cataloging-in-Publication Data**
A catalog record for this book is available from the Library of Congress

ISBN: 978-0-240-52119-0

For information on all Focal Press publications
visit our website at www.elsevierdirect.com

Printed and bound in *China*

08 09 10  10 9 8 7 6 5 4 3 2

Working together to grow
libraries in developing countries

www.elsevier.com | www.bookaid.org | www.sabre.org

ELSEVIER    BOOK AID
            International    Sabre Foundation

DEDICATED TO
# GLEN ANGUS
1970 – 2007

 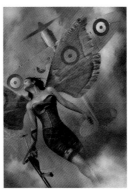

"He was an artist driven by the greats, motivated by his
peers and passionate about his two little children.  And
although he was not long on this planet he will hopefully
for many years remain an inspiration to other artists and
his children."

-- CAROLYN HARNADEK-ANGUS

# CONTENTS

ANDRÉ CANTAREL 10

GERHARD MOZSI 16

HAO AI QIANG 20

JONATHAN THIRY 24

JURE ZAGORICNIK 28

LEVENTE PETERFFY 32

MARCELO EDER CUNHA 36

MAREK DENKO 40

MORGAN YON 46

PAWEŁ HYNEK 50

RODRIGO LLORET CRESPO 56

TEY CHENGCHAN 60

TONI BRATINCEVIC 64

WEI-CHE (JASON) JUAN 70

YIDONG LI 74

80 ZOLTÁN KORCSOK

84 ALON CHOU

88 DAMIEN CANDERLÉ

92 DRAZENKA KIMPEL

96 ELI EFFENBERGER

100 GREGORY CALLAHAN

104 GUILLAUME MENUEL

108 HENNA UOTI

112 LAUREN K. CANNON

116 LOÏC E338 ZIMMERMANN

122 MATHIEU AERNI

126 NYKOLAI ALEKSANDER

132 SANJAY CHAND

138 CHEN WEI

144 DAVID EDWARDS

# CONTENTS

FREDERIC ST-ARNAUD 148   218 NEIL BLEVINS

JAMES PAICK 152   222 NEIL MACCORMACK

MARC BRUNET 156 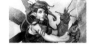 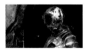 226 RICHARD ANDERSON

MARCO EDEL ROLANDI 160  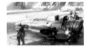 230 ROBERTO F · CASTRO

MATT DIXON 166   236 ROBIN OLAUSSON

NATHANIEL WEST 170   240 TAEHOON OH

SANDARA TANG SIN YUN 176   244 ERIC PROVAN

STEVE JUBINVILLE & YANICK GAUDREAU 180   248 FRAN FERRIZ

TIBERIUS VIRIS 184 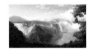 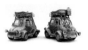 252 HAMED YOUSEF

TOMASZ MARONSKI 190 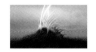  256 JONATHAN SIMARD

DENIS TOLKISHEVSKY 194   260 KRZYSZTOF NOWAK

DR CHEE MING WONG 198   264 LAURENT PIERLOT

EDUARDO PEÑA 204   270 PATRICK BEAULIEU

GORO FUJITA 208 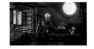  274 VINCENT GUIBERT

JOHN WU 214   278 Y. SONER YURTSEVEN

# DIGITAL ART MASTERS
## : VOLUME 3

### COMPILED BY THE 3DTOTAL TEAM

TOM GREENWAY

WARIN GREENWAY

CHRIS PERRINS

LYNETTE CLEE

RICHARD TILBURY

© VECTOR EA – ARTES ELECTRONICAS

## INTRODUCTION

The third volume of *Digital Art Masters* celebrates another year of incredible artistic talent that has been channeled through the digital medium.

The well-known phrase 'The computer is just a tool' becomes more apparent than ever within the pages of this book, as the processes behind the final images are revealed, and the natural artistic abilities of each of the sixty art masters are displayed as they approach their final render.

By showing the building blocks that form the final images, we aim to provide a book that is suitable for artists of all levels. Newcomers to the digital art world will undoubtedly be overwhelmed by their first glances of the pages, but even in these early stages, the basic processes and starting points of image creations become clear, forming a guide that a less experienced artist can follow when tackling new projects. These lead on to fine tuning the details with tips and tricks that even the most accomplished of artists will find invaluable and inspiring.

As computers become more powerful and affordable, 3D artists benefit in ways such as experimenting with a greater number of lighting solutions and juggling thousands more polygons around their screens. 2D artists can work at higher resolutions, become more mobile and paint and sketch directly onto their tablet monitors. The software is by no means being left behind either and amongst many improvements we are seeing huge advances in a crossover application sometimes referred to as 2.5D, where modeling packages are allowing artists to work with "digital clay" almost brushing in 3D to sculpt some of the most imaginative and detailed characters ever seen.

Along with the release of this third volume, we bring you the exciting news that *Digital Artist Masters Volume 2* will be reprinted in a further edition, confirming the strength of this series and proving what a great job our partners Focal Press are doing, in terms of both worldwide promotions and distribution, in turn bringing more much deserved exposure to the artists within these pages.

And with that mention of the contributing artists I want to round off my introduction by offering our sincerest thanks to each and every one of them from all of us here at 3DTotal. Your talents are unquestionable and your willingness to share your work and knowledge is, as ever, invaluable to our community.

TOM GREENWAY
FOUNDER/DIRECTOR, 3DTOTAL

© 2007 HYBRIDE, STEVE JUBINVILLE, YANICK GAUDREAU

## FOREWORD

We have come a long way since the dreaded "lens flare" Photoshop filter. Like an awful teenage horror flick, we were confronted by "The Flare" on every turn of page featuring a digitally generated image. As though one flare filter tool wasn't enough punishment, Adobe decided in their wisdom to offer us other flare variants. And so came the cheesy teenage horror movie sequels, pulling in big numbers; the 50–300mm zoom, the 35mm prime, the 105mm prime and the movie prime. Then there were four different ways to do the cheesy flare! Some artists actually used all four flare filters in a single picture! Like those disco jump suits everyone swears they never wore, we all don't love "The Flare" anymore. We are suddenly getting rather better at this digitally generated art thingy.

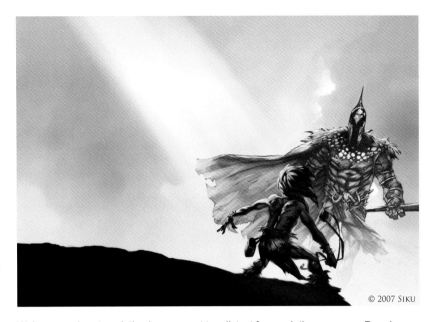

© 2007 Siku

We've moved on to painting in a way not too distant from painting on paper. Dare I say that some of us are actually better at this digital thing than with paint and paper? Hey, try pressing the undo button after you've just done something you shouldn't have done with the oils over that canvas! With advances in software and hardware technology we can now manipulate and integrate other media with our paintings, and make multiple hue alterations faster than you can say "Obamarama". We can even choose to paint with either a dirty or clean brush in software… Nuts, huh?

There is now a proliferation of technically sound digital artists. This proliferation has found its way into the 3D sphere with people who would have been great with clay or stone opting for the virtual domain. Some of these scary "freaks-of-nature" are right here on the pages of *Digital Art Masters 3*. I was privileged to have been invited by the 3DTotal team as guest judge for the now culled collection of outstanding art. We had all the art for the final stage selection categorized into five genres, thinking it would aid us in our attempt at sifting the art down to the very best to go into the book. It didn't work! The entire team argued till late in the evening. In essence, what you have in this presentation is some of the very best digital art on the planet: period.

We are beginning to realize that we can pretty much create anything our minds can concoct through the means of computer technology. The easy access to reference material on the web means we understand the behavior of elements, surfaces and materials better than we ever did. Sharing with the worldwide community of digital artists across the web also means that our development has become exponential. Some of that exponential development is right here within the pages of this third volume from 3DTotal's team. My congratulations go to Tom and Warin Greenway, Chris Perrins, Lynette Clee, and my old mate Richard Tilbury. This is your best collection yet!

Settle down and enjoy some of the best digital art in the universe.
Enjoy!

## SIKU

www.theartofsiku.com
www.themangabible.com
siku@theartofsiku.com

© SIKU

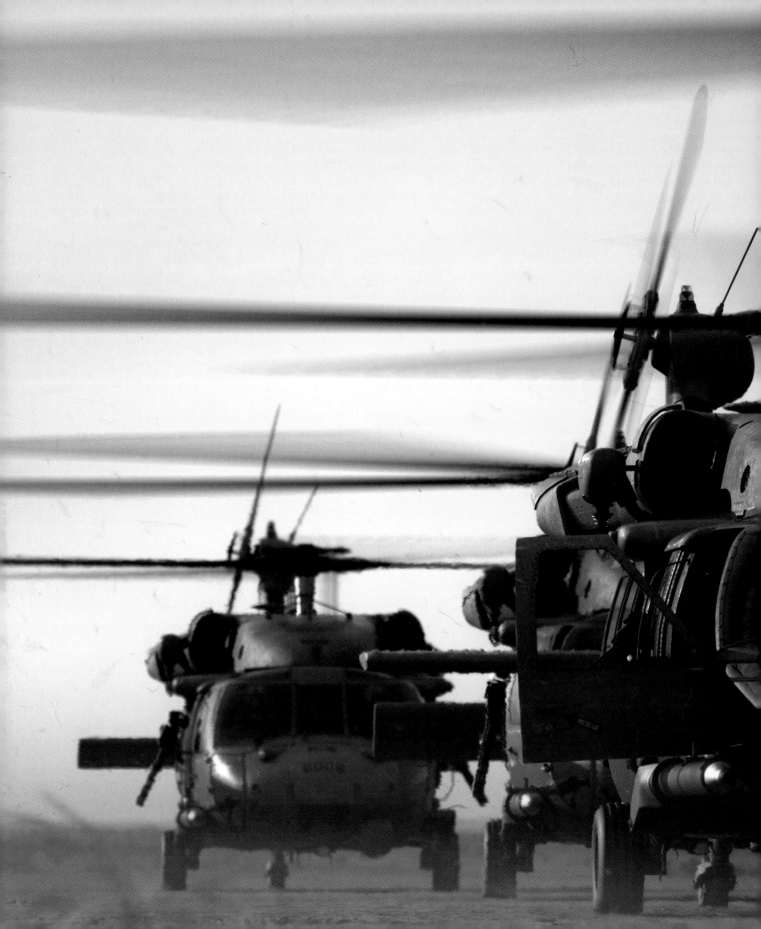

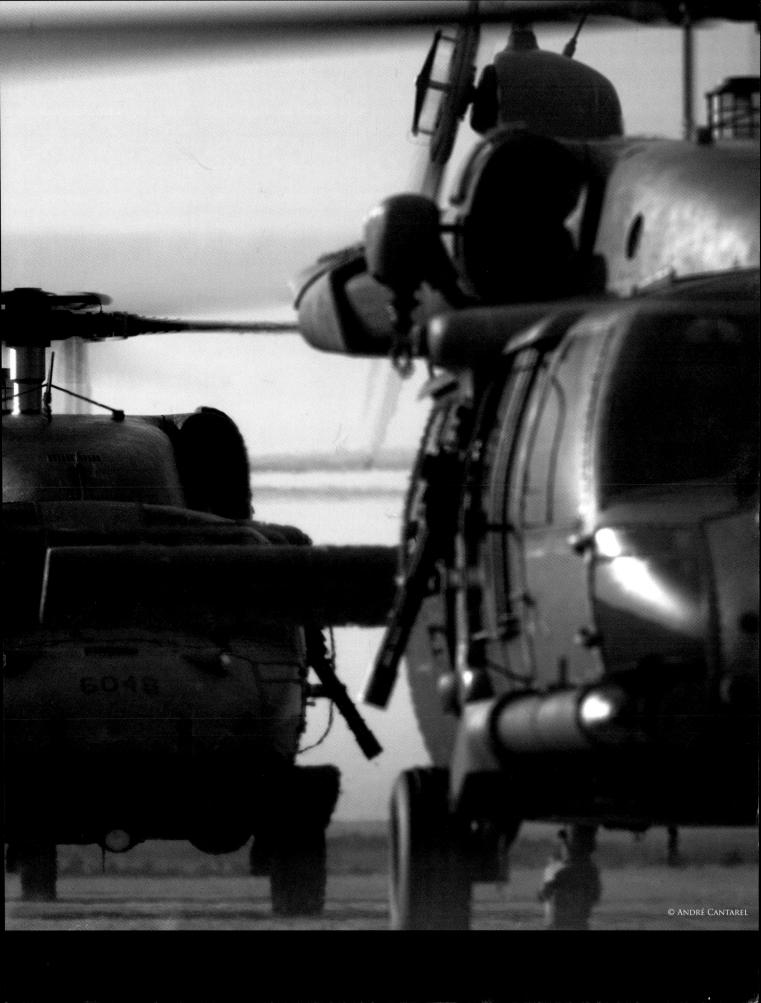

# ENGINE WARMUP

## BY ANDRÉ CANTAREL

### INTRODUCTION

Being interested in flying machines since my childhood, caused by a local US airbase in Heidelberg, Germany, it was just a matter of time before I created one of those noisy, cool-looking gizmos which flew over our garden several times a day. The starting point was set after watching *Black Hawk Down*, which also decided on the type of the helicopter I was going to model. The lighting, color grading, sound design and movement of the helicopters matched my personal taste exactly, so I started with the research immediately after watching the movie. Making a complete helicopter from scratch was also intended to be a personal exercise; a test of myself and my capabilities of solving problems and doing something where I'm the one who decides how something must look.

### MODELING

Before I started creating even the first polygon, I did about two days of research to get into all the details of the helicopter. I collected a lot of photographs and videos and studied them closely to get the complete helicopter into my mind, and to be clear about all the forms and shapes. It was also a bit confusing at the beginning of the research stage as it seems that almost every single helicopter has its own different-looking gadgets!

The first thing I did in 3ds Max was setting up the units to centimeters to ensure everything was modeled in the right scale, and this also made it more easy to imagine the size of all the parts. The second step was setting up the blueprints which I got from a plastic model kit. Always be careful with those blueprints as very often they're not based on construction data! They should just be used as

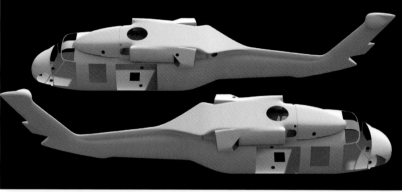

Fig.01

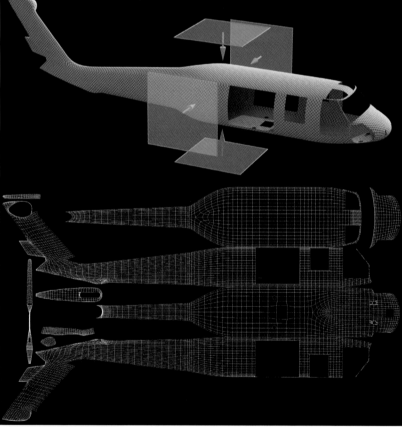

Fig.02

Fig.03

an overall guide of the rough shape. The way I found the "almost correct" sizes and shapes of all the parts was by comparing the parts between each other on the reference photos over and over again, sometimes with the help of drawing lines onto the photos.

The part I started with was the hull, as everything else is based on this part (**Fig.01**). This was also the trickiest challenge of the helicopter as its shape really has to fit.

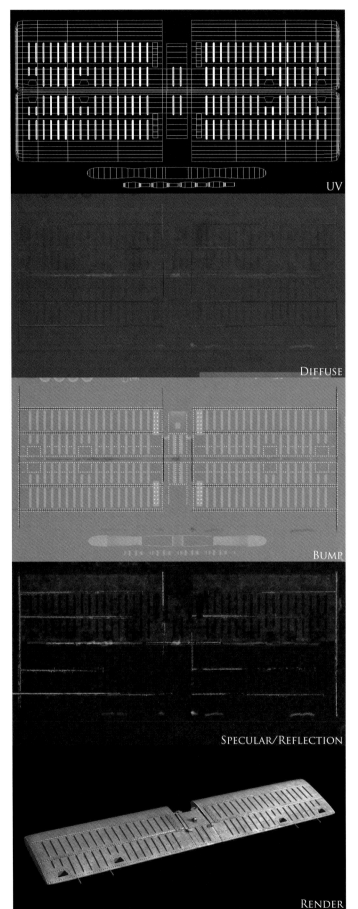

UV

DIFFUSE

BUMP

SPECULAR/REFLECTION

RENDER

Fig.04

If it doesn't, it's almost impossible to get the correct shapes of the doors and windows later on. All the rest of the helicopter was really all about research and standard modeling.

## UNWRAPPING

Many people have asked me questions regarding my methods of unwrapping, and whether there's a special tool I use. Well, everything was done in the 3ds Max unwrap editor, and about 95% of the UV coordinates were generated by planar mapping. I like it very much as, in my eyes, it gives me the most understandable control about how the UV chunks will look later. As you can see on the hull, the clean UVs were generated pretty simply, and if you line them up exactly it's very comfortable to paint the textures later on. A high density checker map is also useful to see possible distortions and to check the alignment of the UV chunks. Sometimes the checker map may trick you when two of the darker squares meet each other at a seam, which looks like a wrong distortion, but isn't (**Fig.02**)!

Several dozens of planar mappings later, the helicopter's UVs looked pretty usable! I used different colors because it made it easier to visualize the different textures (**Fig.03**).

## TEXTURING

After generating all the UVs, I rendered a UV template using the Unwrap editor, at 4K by 4K, to use it as a guide in Photoshop. I started with the color map and, after it was done, I duplicated the folder with all the layers to generate the specular/reflection and bump maps from it. The following image showing the tail wing provides a small example of how the textures look (**Fig.04**). All of the texture details are on top of one basic color, which can be easily changed so the whole helicopter appears gray, black and olive, and so on. This is how the final textured Pave Hawk looks in the viewport (**Fig.05**) and rendered (**Fig.06**).

For the helicopter's interior, I wanted to use a 4K map too, but during this time I was still on my old computer which ran out of RAM. The solution for saving some memory was using a 4K grayscale mix map, which is a lot smaller than a 24 bit color map. I used the grayscale map to mix two tileable textures, "et viola" – it was renderable again (**Fig.07**)!

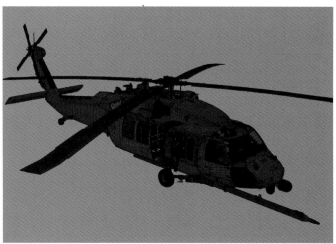

Fig.05

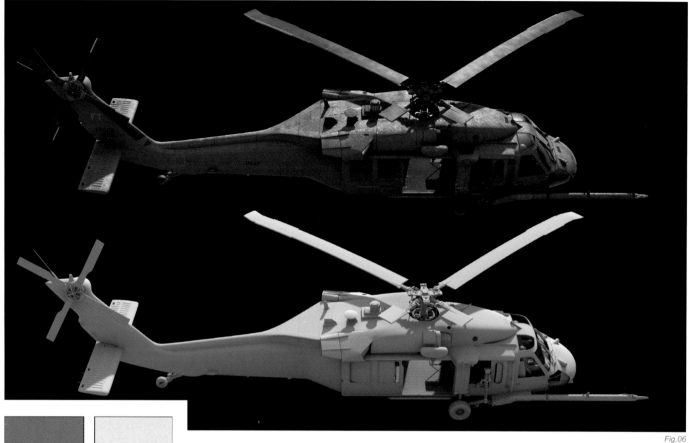

Fig.06

PAINT    ALUMINUM

4K 8 BIT MIX MASK (CUTOUT)

Fig.07

## RENDERING

For rendering I used finalRender Stage-1, as it has been my preferred renderer for years now. For my personal taste, it gives me the amount of control I want to have, especially the fR-Advanced material where everything can be manipulated, especially if it's not so-called "physically correct". The environment for the raytracer, for example, is a mix of an HDRI image, a tinted physical sky system and a gradient to match the look I wanted to have. I used 3D motion blur for the rotors and some depth field in combination with a very long focal length, which is nice to "sell" the weight of the helicopters (**Fig.08**).

## POST PRODUCTION

During private projects, I'm not a big fan of dozens of rendered elements, so I try to reach the final image directly from Max. I did some color grading in Photoshop, like desaturating the colors and increasing the contrast. Also, the heat distortion was done in Photoshop by displacement. This was a small kind of R&D for finding the right size of the waves in future animations, where it will be done with particles. There was actually one additional layer rendered out: the flying pieces of grass. For achieving a grass-like look, I used 3D motion blur with a longer duration rate to "stretch" the particles a little.

## CONCLUSION

After finishing Pave Hawk I can really recommend doing a private project from scratch. You will learn a lot, especially on the side of your own workflow! You start to think about how to save time, and how to prevent yourself from doing something twice, and so on. I was able to build my second detailed helicopter (for a commercial) in almost half of the time, and the model itself became cleaner and better!

The "Engine Warmup" image is my favorite one as I'm (almost) happy with it. As the artist who created the image, I still see many parts which would need improvements, like higher texture resolutions, some additional details on the model, and the pilots for sure! Further ideas are waiting to be created!

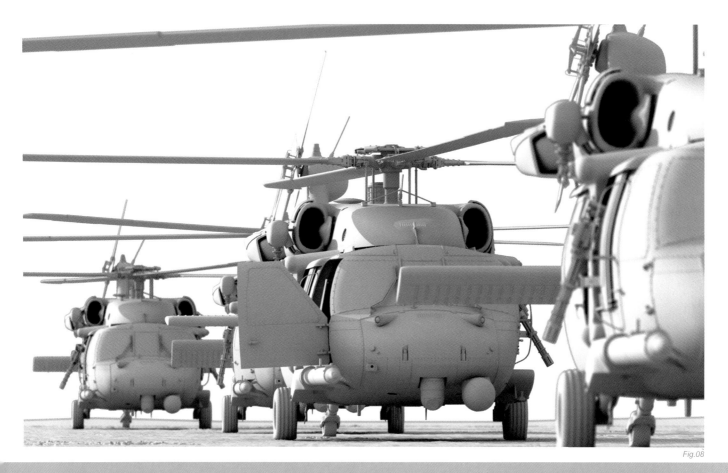

Fig.08

# ARTIST PORTFOLIO

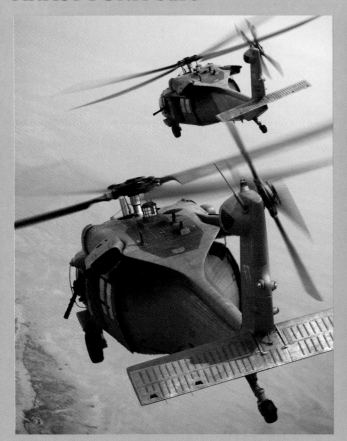

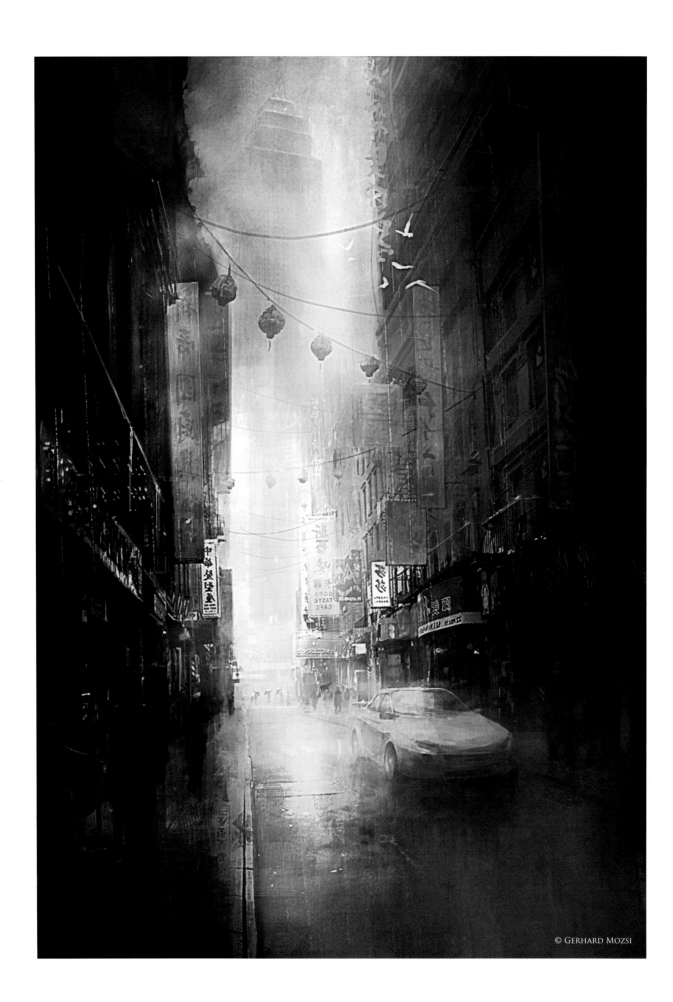

© GERHARD MOZSI

# CHINATOWN
## BY GERHARD MOZSI

### THE CONCEPT

This image began, as all my work does, with vague ideas and scattered images floating around in my head. The intention was to paint a realistic environment with plenty of atmosphere and detail. A city setting was chosen, specifically a "Chinatown" in a big city. This had plenty of scope for interesting detail, colors and shapes, and allowed for a great rainy, almost "noir" atmosphere.

The process to create the image was challenging from the beginning. I wanted to do something realistic, yet quite painterly and loose. I was unsure as to whether I would go down the more "Photoshoppy" path (i.e. lots of photos and integrated 3D elements) or employ a solely painterly method.  In the end I went with a hybrid approach. This meant the use of photos, and painting in Photoshop CS2.

### THE PROCESS

The first step was to find a suitable photo and frame it in Photoshop. This really was just a pretty lazy way of putting something down on the canvas that would give me an instant palette and a starting point. Furthermore, it created, or at least indicated, the perspective (**Fig.01**).

Fig.02

Fig.01

This starting technique allowed my mind to start working and plotting out all the possibilities and permutations that the painting could take. So once a photo was selected I cropped it to a portrait orientation; this framing was a little more dramatic than landscape, and I then started to paint on top of it. This was done until I had essentially rebuilt or painted the image to what I had envisioned.

The initial composition was a simple street scene, with clear perspective and single point lighting. Also, from the beginning the painting had to be clearly blocked out into simple shapes, so things did not become too confusing, or the composition did not become too "messy". Once I was happy with the general composition, I worked to harmonize the values and colors, as well as to define the lighting (**Fig.02**).

On a quick note, generally speaking, I don't do quick thumbnails or preliminary sketches as separate little images. I tend to do it all on the actual file that I am working on. That is one of the joys of the digital medium – so much flexibility.  So I play with and manipulate the image in Photoshop to a great extent, until I am happy with the core components. This way I can crop, change the orientation of the image, and so on, all on the actual file. This is complicated when working traditionally, as you have to be pretty

clear with what you want. For example, it's difficult to change the image orientation from portrait to landscape half way through your watercolor or oil painting. In Photoshop you can do this very easily, so when you have an idea you can test it almost immediately. Plus you always have saved files of all your experiments! This allows me to work quite quickly and a lets me be really open and free with my work, rather than being precious and hesitant.

So when I was happy with the general composition, I started on the color and tonal values. The process began with a new layer set to 30% opacity. I filled it all with black, darkening the image. I created another new layer, with the layer mode set to "Color". This allowed me to set the general color for the image. The color layer is great as it allows you to change the color without changing the tonal values (**Fig.03**). This was followed by a quick adjustment to the Curve and Color Balance tools to complete my first pass. The Curves and Color Balance help to further unify the tones and define a clear lighting structure. Once I am happy with composition, colors, values and lighting, I can start to introduce detail.

When I work I prefer to use global or universal tools, like layer modes and Adjustment Layers, to help unify the image. I believe this is especially important when using photos.

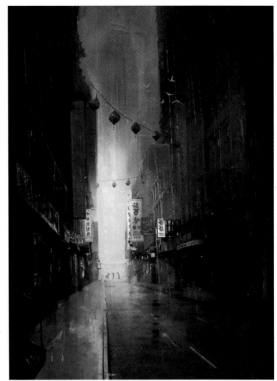

Fig.03

Fig.04

This "global" approach helps in allowing the image to have a greater sense of integration or wholeness. That way it's easier to refine the values and colors with brushwork when detailing, as the general global values have already been set and you can color pick straight from the image.

On a technical note, when I create Adjustment Layers they always sit to the top of my layer "heap". This way I can always change things later. But the trick is that, when I am painting, it has to be on a layer underneath the adjustment layer. Furthermore, the Adjustment Layers have to be turned off (I generally put them all in a set) when painting, otherwise, when color picking from the picture, the color selected is always out and does not match the canvas color. So I paint with the Adjustment Layer(s) off, flicking them on and off regularly to make sure that all is going the way I intended. If you choose to paint above your adjustment layers, and then decide to change the settings, all the layers above will have different values and colors, which is pretty annoying. It's probably an overly complicated way to structure layers... but it seems to work for me!

Fig.05

SCENES

Once I was happy with the level of detail, I started to paint in "noise" which helped to further unify the image. I simply created a new layer, set a low opacity and the layer mode to Soft Light, and then painted over the whole image with my "noise" brushes. Generally this can be a pretty hit and miss affair. The trick here is to control the opacity with the layer and not the brush, as this gives you greater control when adjusting the final amount of noise you want in the image (**Fig.04**).

## ALMOST DONE

Once I am happy with the way the image is looking, I like to leave the image for a day or so and come back to it when I have the luxury of time (which is rare for production work). This way I come back with fresh eyes and can re-evaluate the image (**Fig.05**)!

With this image I realized it was a bit empty and more interest was needed. So I introduced a car and more people to the foreground. This was actually the first car I have ever painted (except when I was eight!) so it was a real challenge for me; the process was just a real grind. I found a reference picture and started to paint – no tricks, just me, and the Wacom (**Fig.06**).

Finally, when all the elements were in place and I was certain that I wasn't going to introduce anything new, I did a final pass of noise, followed by another Adjustment Layer pass (Color Balance, Curves, and Hue and Saturation), and finally a gradient map Adjustment Layer. A final note on gradient maps; I find this to be a very powerful Adjustment Layer. I use it the following way: create a final Adjustment Layer, select a shadow, a mid tone and a highlight color for the gradient map; then,

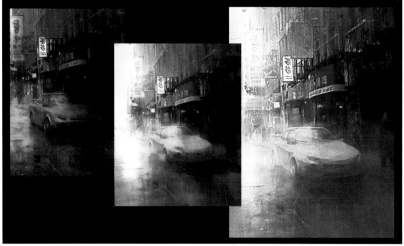

*Fig.06*

once that is set, I play with the Adjustment Layer modes – generally Overlay, Soft light and Screen work successfully. It's quite amazing what a gradient map can do. I use it to add subtle color to my image, especially in the shadows. This is a great tool to experiment with!

## THE END

Finishing a picture is always the hardest thing for me; "Chinatown" was no exception. Simply leaving the image alone, or more to the point knowing when to leave it alone, is a skill in itself. I suppose it comes with greater confidence in one's own art making. But it is essential simply to walk away and start a new picture.

An image can only be "tweaked" so much. It gets tricky with the digital medium as you can never totally destroy the image. It's easy to overwork a watercolor or even a pencil drawing, but digitally you can always hit Control Z. Plus it's awfully addictive to play endlessly with Adjustment Layers, textures and all of the tricks that come with Photoshop.

But it's always best to start a new image and carry over what you have learnt into a fresh painting.

# ARTIST PORTFOLIO

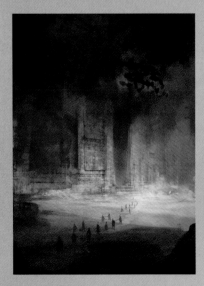

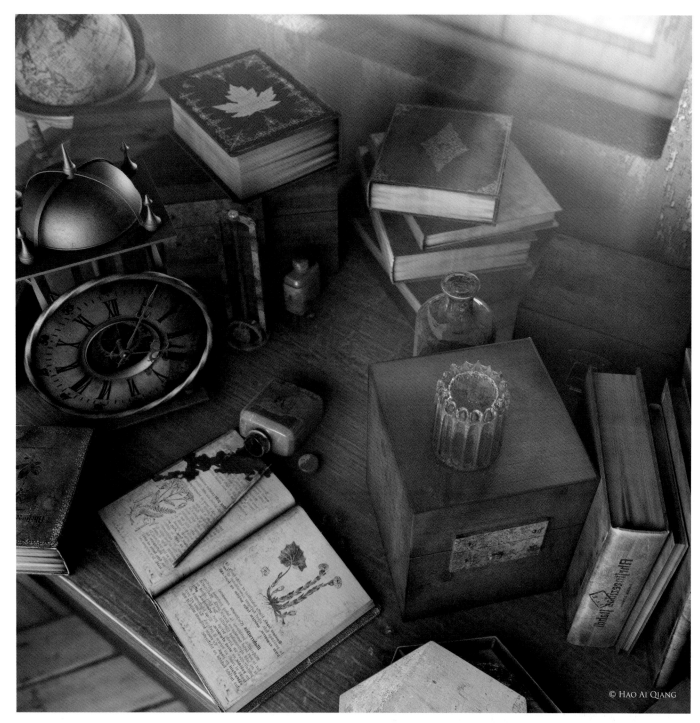

# FALL INTO OBLIVION

## BY HAO AI QIANG

### CONCEPT

This image is the newest creation of my series. Just like the name of this work, "Fall into Oblivion", what I wanted to express was a kind of emotion: the sorrowful sadness and helplessness that we feel when we see time rolling around; the glaring loss of lustre and the dying out of existence.

I chose a shortcut to create my initial draft. As this is the way of making a matte painting, the first thing I did was to use some basic geometric shapes to construct the simple scene in a 3D program, with some rough lighting effects which helped me to establish a direction quickly. Then I made many different copies employing different lighting and tones, according to different camera angles which provided references for the final composition (**Fig.01**).

Of course, an integral aspect is a concept sketch which needed more content in order to help the artistic direction, so I drew additional details on each object on the draft and adjusted the scene. I added some symbolic objects into the picture, such as the clock and the ink bottle, so as to get the draft that I wanted (**Fig.02**).

## MODELING

For almost all of the modeling work, I used polygons to create it, and used the method of subdivision to get the smooth-looking result. Only for the model of the clock did I use a modeling plug-in; "AF Loft", whose function is like Max's Loft, but it's a modifier, so tweaking models is very easy! The AF Loft model's texture UVs can also be adjusted much more easily. In the more recent versions of Max, add a new modifier set – the function is close to "AF Loft", but can be supplemented by "Twist and Cap" after the Loft, whereby the result will resemble a NURBS model (**Fig.03**).

## LIGHTING

It was necessary to use relevant lighting effects to embody the emotion I wanted to express in this work, so I worked a lot on the light settings and rendering tests. To complete my work as quickly as possible, as well as reducing unnecessary amendments and avoiding taking too much time to render (I believe that we all are frustrated with long rendering times!), I rendered each element separately and composited them, then polished them carefully. This seemed troublesome in a sense; however, it saved much time, especially because I didn't have to wait endlessly for the rendering!

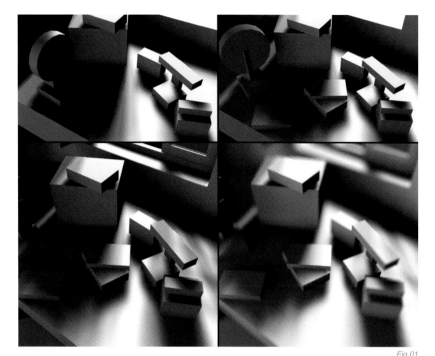

Fig.01

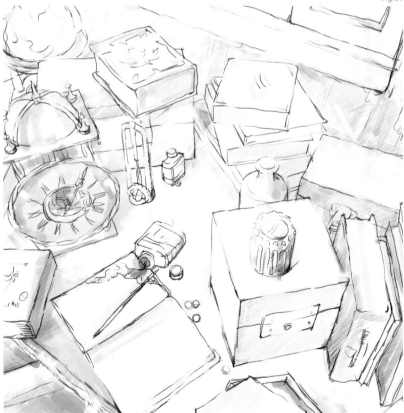

Fig.02

Fig.03

Fig.04

Making the models and the textures is not a problem. I keep the PSD files and all layers when making the textures to adjust the effect conveniently (**Fig.04**). I then used 3ds Max's flat render mode to check whether the grains were harmonious (**Fig.05**). After adjusting and amending, I began the light setting.

The rendering system used was V-Ray; the main light source was V-RayLight, and I also used some Omnis to vary the lighting. The main light shines in from the outside of the window, and the other light comes from the side of the camera. In the adjustment

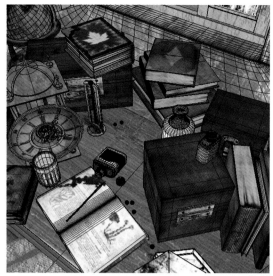

Fig.05

of this light, I used V-Ray to render a lower rate IR map
(turn on the "don't render final image" option) to observe
the lighting effects. Then I compared numerous color
swatches from which I found the best light settings in
order to continue (**Fig.06**).

## COMPOSITION

After fixing the light settings, I first of all I rendered the
scene without any other effects, and then I rendered
the Volume light pass, Ambient Occlusion pass, render
ID pass, and any other elements (**Fig.07**). Because the
V-Ray 1.5 version is fully supported by Max's render
element function, I obtained all of the render passes very
quickly and easily.

In the compositing software, I composed and adjusted
them to make the final effect, using the Ambient
Occlusion to adjust dark areas and the render ID to
quickly get a selection to adjust local parts. Any other
rendered element, for example V-Ray raw lighting, V-Ray
raw reflection, V-Ray raw GI and so on, could always
enhance lighting detail in the composited version.

I then made the depth of field effect using the Z-depth
channel in the adjust image tab. I always turn the image
to gray to check the composite's B&W result. After I got
a good B&W result, I started adjusting the color. I always
make the dark area and bright areas tonally different;
for example, if the bright area has a cold tone, then the
dark area is given a warm tone, and vice versa. This is
because the adjustment will enhance the depth of the
image. After this work, the picture was almost complete
(**Fig.08a–b**). The image only then needed a few tweaks
for print, or if displayed on another monitor.

Fig.06

Fig.07

SCENES

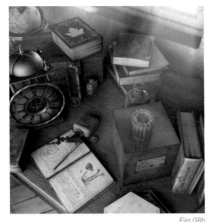

Fig.08a                    Fig.08b

## CONCLUSION

The complete work can help you to "touch" the passing of time – rolling around – and the cold color brings us something blue. Both of these feelings were what I hoped to achieve. Because of the more reasonable process, I only used one third of my normal working time to finish this piece. I also gained much experience, which I think has been very helpful for me in order to create more work, more quickly!

# ARTIST PORTFOLIO

**SCENES**

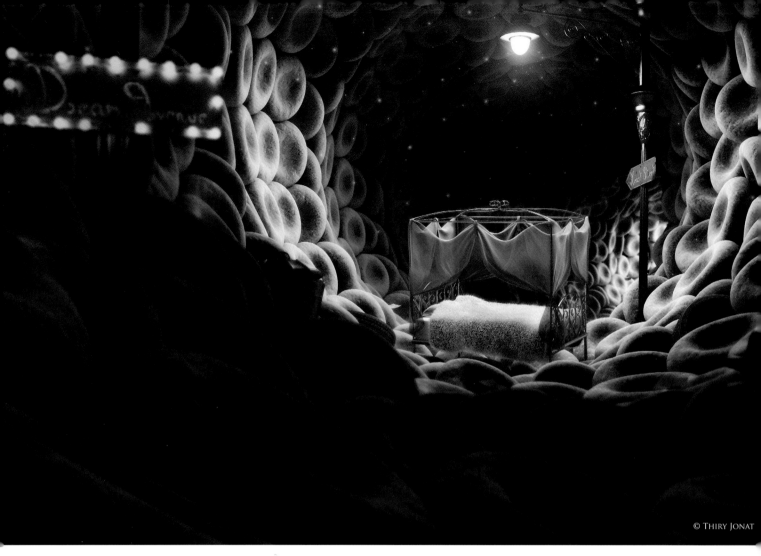

# DREAM AVENUE

## BY JONATHAN THIRY

### INTRODUCTION

At the end of 2006, I wanted to create some kind of V-Ray test scene, but it was one of those moments when inspiration was not too forthcoming. So, I started modeling a few elements of my scene in the same way that a child builds something with plastic bricks! Although, from a technical point of view, the result was rather elementary, I really loved the atmosphere that emerged from it (**Fig.01**). What bothered me the most was answering questions like, "What does it represent?", "Why did you put that bed in?" and so on.

As someone taught me, there are pictures that tell a story and pictures that have no other purpose than being pleasing to the eye: the aestheticism. The idea is very naive, but I am a big supporter of it! So I decided, one year later, to use this scene to "tell" this idea. Generally, I don't draw any sketches before creating a scene, and

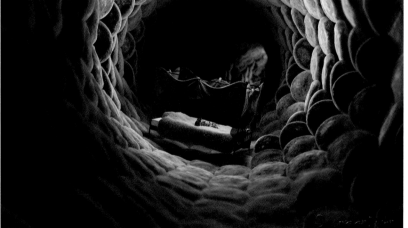

*Fig.01*

*Fig.02*

Fig.03

especially here since I already had a good base to start. But I wanted a larger environment and a less closed-in-on-itself feel. For that, I had to include other smaller elements to mark the contrast.

I have no plausible explanation about this concept; I just found it in a corner of my mind. It is said that even the most far-fetched dreams have a meaning, and I found mine quite interesting.

And what could be more normal than to name this street, "Dream Avenue"?

## MODELING

Modeling was rather simple. Most of the objects have been created from splines, spheres and boxes. For blood cells, I started with a simple sphere, moved a few vertices, added a noise modifier (to remove symmetry and regularity) and finished with a turbosmooth (**Fig.02**). The tunnel was made up of more than 1000 identical cells so it was essential to find a way of avoiding a too repetitive background. So I made a dozen copies of these

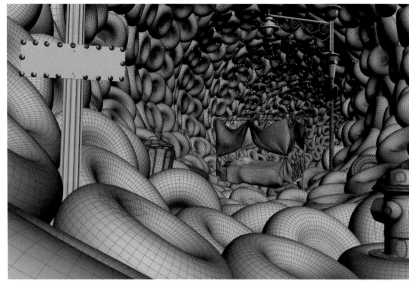

Fig.04

Fig.05

cells, with different settings on the noise modifier for each one. Then, for positioning, I used the Spacing tool from Max, with a Helix as a Path. I finally grouped everything to apply a Bend modifier (**Fig.03**). The frame of the bed and the lamppost were made with Editable Splines. The rest of the objects were made using the box modeling technique. Here is a "wire render" of the scene (**Fig.04**). As you can see, the modeling of this scene was really easy and very relaxed…

## TEXTURING

Once again, this was very simple. All materials used in the scene were V-Ray Materials. It was easily configurable and very intuitive. I focused on the interplay of colors (red tones) and reflections (**Fig.05**). For the cells (**Fig.06**), I used procedural textures, a falloff color (red-pink) with a mix between a smoke map and a cellular map in the diffuse slot (**Fig.07**) and the same texture in the bump slot, but this time grayscale (**Fig.08**).

Fig.06

The only painted textures were those on the "Dream Avenue" and "Heart Street" panels. As it was my dream, it had to be my own writing on these panels. So I created my own font on a sheet of paper, scanned it, and then reworked it a bit in Photoshop. Finally, I used V-Ray Fur to make the hairs on the bedcover. I find this tool very powerful and useful!

## LIGHTING AND RENDERING

For lighting, I used global illumination with a very dark red as the environment color. The principal light source was a V-Ray light (plane light) located just below the lamppost. There was also one light on each bulb located on the front panel. Of course, it would have been easier to use V-RayLight Materials for bulbs because, ultimately, the nuances of the reflection are not rendered because of the depth of field.

Fig.07

The image was rendered to a 4000 pixel width resolution. I therefore had to optimize some settings because my poor computer crashed every time after calculating the light cache. The problem was the large number of vertices: on each cell there was a turbosmooth with two iterations. So, I decreased the more distant cells of the camera (a big part) and increased about 20 of them by one (especially those closest to the camera) to resolve this trouble. Finally, the render took about six hours – it could have been faster, but time was not running against me and I didn't want any bad surprises!

## POST PRODUCTION

I used Photoshop as my compositing software. In **Fig.09** you can see the final render without any corrections, the occlusion pass (**Fig.10**) and finally the depth of field pass (**Fig.11**). I then made some Levels and color corrections and added other effects and fantasies… And that's more or less everything I did in the post production stage!

Fig.08

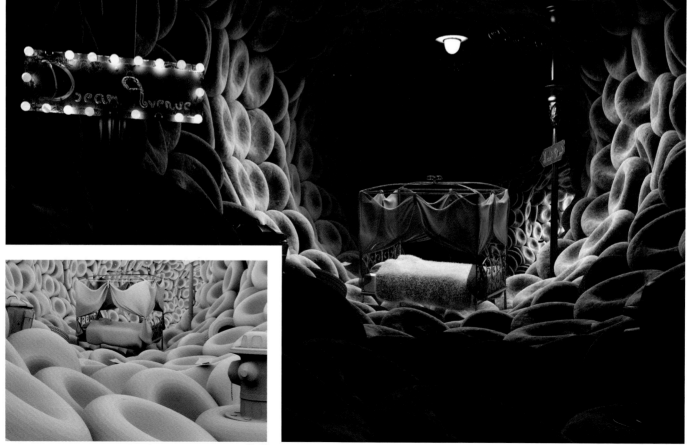

Fig.10

Fig.09

## CONCLUSION

Until now, I've had fewer than three years of experience with 3D, and the large part of my learning has been done independently. So I will not pretend to be able to give advice! However, I would like to mention what another 3D artist wrote to me after I asked for some advice:

*"Everyone faces breaking points in 3D; the difference between those who will make it and those who won't is mainly the patience and time they are willing to give to it." – Ziv Qual*

Every time I learn new things, every time I finish a picture or a song, I get closer to my dreams. And now, it is with the greatest pleasure that I can say, "Welcome to my Dream Avenue."

*Fig.11*

# ARTIST PORTFOLIO

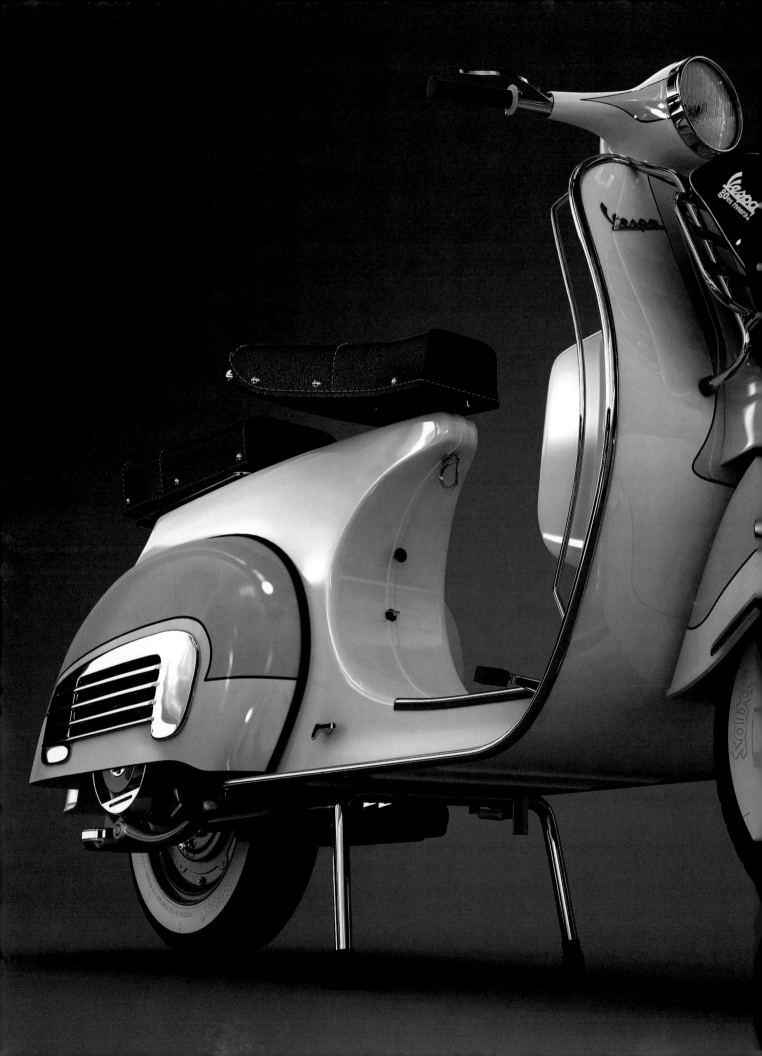

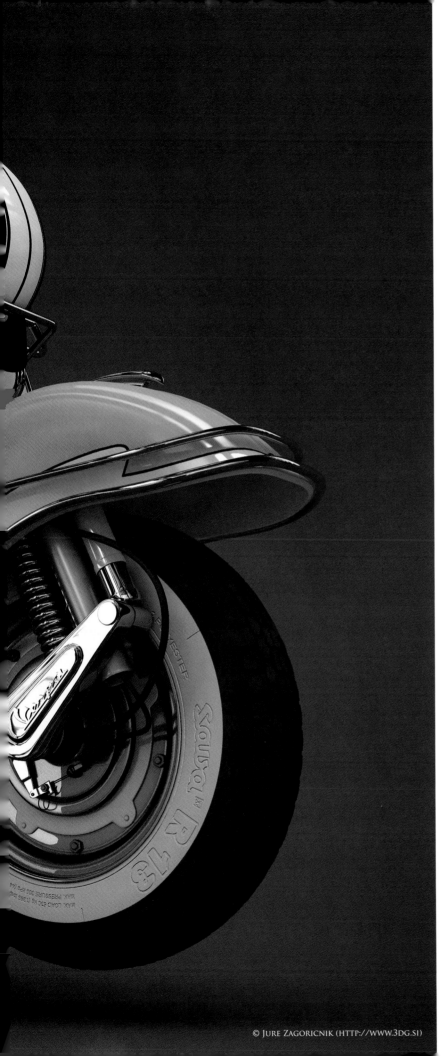

# VESPA 150GL
## BY JURE ZAGORICNIK

### INTRODUCTION
In the past I've modeled a few cars, but never a bike. So, when a Slovenian 3D website posted a challenge called "Motomania" I thought it was a perfect opportunity to test my skills! I am a big fan of the MotoGP series, but for some reason I didn't want to model a high-tech modern bike. I Google-searched for some older bikes, and when the Vespa popped up I knew right away I wanted to model this baby! I did my research and checked out quite a few models and decided on a 1962 Vespa 150GL. Usually, when I start doing a personal project, I only have a rough idea on what I want the final image to look like. But, what I did know was that I wanted to model a very detailed bike. "Will I be making a studio render or creating a whole scene?" was not something I was thinking at the time!

The programs that I used during this project were 3ds Max for modeling, V-Ray for rendering, Macromedia Flash for texturing and Photoshop for post production.

### GETTING READY!
The first thing on my list was to find some decent blueprints. I searched but didn't find anything, so there was nothing I could do but look for some decent side, front and back photos. In the end, I settled for a side view and collected as many photos as possible from all possible angles. Luckily, old Vespas are still popular and many people dedicate their lives to restoring them. With plenty of reference material, I went through all the pictures, checking different parts so I could make a work plan. Apart from the engine and some small bits here and there, I didn't see anything particularly difficult. With a rough plan in my head, I proceeded to the modeling.

### MODELING
I am most comfortable with poly modeling, so I used this technique to model 95% of the parts. I usually start with a basic shape, like a plane, cube or a cylinder. The Symmetry modifier is a must for me, so every object is only modeled as one half – not only is it faster but also easier to change things later on! As I didn't have any blueprints, I used a photo for reference and proportions. Lately, we are just so used to having blueprints for everything that we don't really appreciate them anymore. But not having them makes everything twice as hard!

I started with the handlebars, roughing the shapes with as few polygons as possible. When I was happy with the shape I started to do the details, or as I call it, the fun stuff (cutting, connecting, moving vertices, and so on). Many people just model an object so that it looks right, but I personally like to stick to quads – triangles are evil! They look cooler and are more friendly when it comes to subdivision. You can also ring and loop them without having to manually select the edges (**Fig.01**)!

With the details on the handlebars, I continued with the body. Here I had to use splines for the chrome piece that runs all around it. I selected the outer edge of the object and converted it to a spline. The rest just involved checking the box so that it rendered, and then setting the thickness.

With the body mostly finished, I decided to do the seat – well two of them. Creating the basic shape wasn't that difficult; instead of using a texture for stitches I decided to model them. With this in mind, I selected the edges where the stitches would go and converted them to splines which acted as my guides. Then I modeled a single stitch (bent cylinder) and used the spacing tool to evenly distribute the stitches along my spline guides. I ended up with a decent layout that didn't require a lot of tweaking, mainly just rotating a few stitches and moving a few of them around the corners of the seat (**Fig.02**)

Tires were next! I usually model the tube and the thread as one piece, but this time I decided to do each piece separately. This cut down the poly count quite a bit. The tube was just a basic cylinder and the thread was made using splines that were later extruded. To fit the thread to the shape of the tire, I used the Bend modifier with some manual tweaking. Once they were aligned I arrayed the thread, merged all the pieces into one and used another

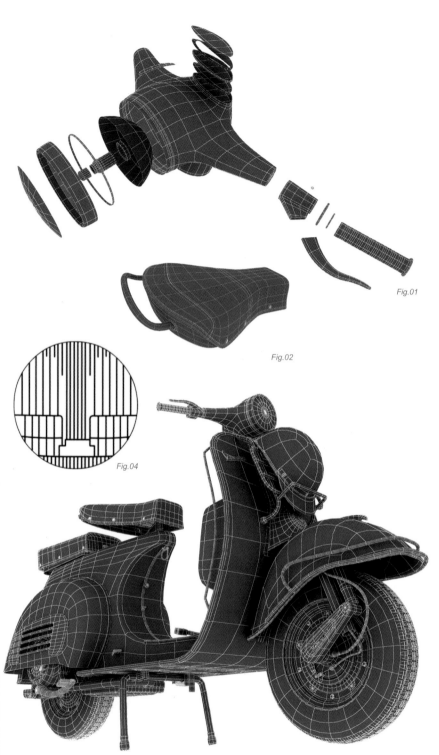

*Fig.01*

*Fig.02*

*Fig.04*

*Fig.03*

Bend modifier to fit it all around the tire – just remember to set the pivot point of the thread to the center of the tire! Logos and signs were made by importing vector versions and then extruding them. To get rid of the 90 degree perfect edge, I beveled the top polygon inwards and extruded it just slightly (**Fig.03**).

## TEXTURING, SHADING AND LIGHTING

With all the pieces modeled, I quickly unwrapped a few parts that were screaming for a paint job. I simply used planar mapping, exported the maps and took them into Macromedia Flash. Flash you ask? Yep! I do a lot of Flash work in my full-time job, so

*Fig.05*

SCENES

I guess I'm just used to it now. Plus vectors are scalable without losing the quality, which is another plus if you want to increase the resolution. The paint scheme was pretty straightforward: I outlined the patterns and filled them with color (**Fig.04**).

For the leather, I used a texture I found on the Internet. Most of the shaders are basic V-Ray Materials with different reflection and glossiness values – I am far from being a materials guru! I mostly go for a trial and error method, which takes a while but you learn a lot (**Fig.05**).

With studio lighting in mind, I had a few concerns as this bike has a lot of reflective materials, not to mention chrome parts. You know what they say, "reflections bring materials to life!" I never use HDRI for lighting so my collection of HDRI maps was very limited. Luckily, I managed to find a few free ones and modified them so they worked for me. In the end, I had three HDRI maps (color, grayscale and color blurred). With the color HDRI in the environment reflections map, I started to tweak materials. Parts that I wanted to control the highlights got their own HDRI map in the environment slot. To get them just the way I wanted meant a lot of test renders while rotating the HDRI but it was well worth it in the end!

For lighting, I used one big V-Ray light above and two omni lights below the motor. The latter ones were to brighten up the bottom part that didn't receive a lot of light (**Fig.06**).

I used the default Max camera to render the scene. For the background, I created a simple plane that rose up behind the bike to create a soft transition.

## RENDERING AND POST PRODUCTION
I hate waiting for renders, so I try to lower the render times as much as possible. A scene at 800 x 600 with

Fig.06                                                                 Fig.07

Global Illumination took around 15 minutes on an AMD 4200 Dual Core. To render masks for different parts, I switched to the Default Scanline Renderer and just applied a self-illuminated white material to the parts I wanted to be masked, and 100% black material to the rest.

I opened Photoshop and loaded up the render. First, I did some color corrections and other adjustments using Levels and Saturation. Parts that were too dark were brightened up using the masks (tires). I also used a lighting filter on the background to get some darker and lighter spots. I could have spent ages tinkering with different adjustment layers, but one has to say "stop!" sooner or later. What I like about Photoshop is that you don't have to wait another 15 minutes to render a scene if you want to change the color of the background; possibilities are endless and your imagination is the limit, so think what can be done inside a paint program before you waist another two hours re-rendering stuff (**Fig.07**)!

## CONCLUSION
What have I learnt from this project? In the past, I have always wanted my renders to be perfect, right from the rendering engine. What I learned here is that you can fix/change/improve a lot of things in the post production phase using masks and different layer blending techniques. I was really surprised at how the bike turned out in the end, and what means the most to me is that people like it as well!

## ARTIST PORTFOLIO

# BEFORE THEY ARE HANGED

## BY LEVENTE PETERFFY

### IDEA

Usually I just start scribbling on a single colored canvas before a theme is set, but this one had a different story to how it got started. I simply asked a friend of mine to name a theme for a speed painting. He replied "Before they are hanged". I thought about the theme and tried to make a sketch of it in my head. I think it's a

Fig.01

BACKGROUND SHAPES

FOREGROUND SHAPES

Fig.02a

SCENES

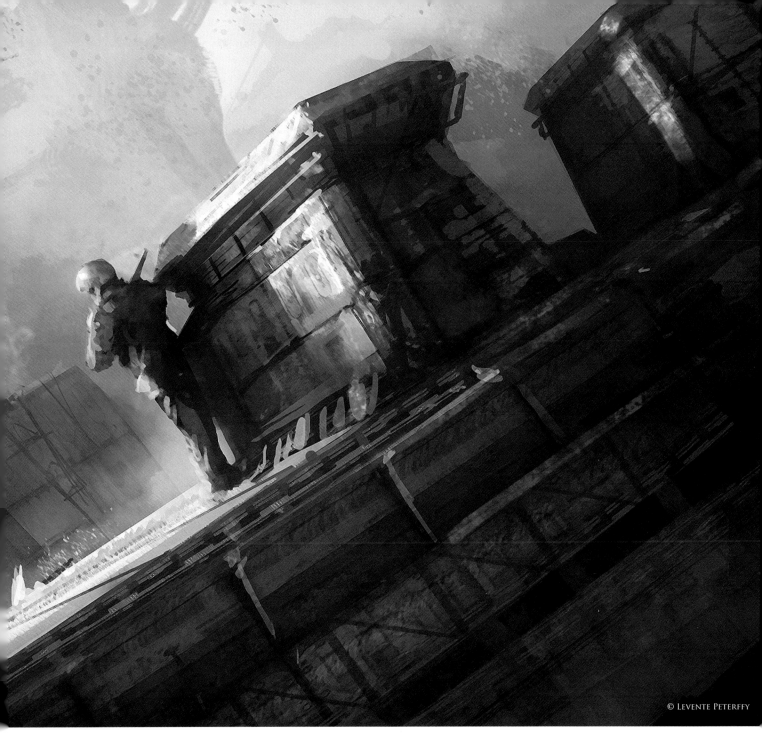

good idea sometimes to approach an image this way, especially in practice for production work where you sit with a client and they give you guidelines about the image they want you to create. So, this image got started by a friend naming the theme.

## BLOCKING IT OUT

Since the theme was pretty violent, I wanted to approach the perspective differently, avoiding the dull front and side angles. Instead, I wanted to introduce a low-angle shot, slightly skewed. To begin, I picked two colors. These two colors represented the background and the foreground, and they were on separate layers. The background color

*Fig.02b*

*Fig.03*

was on the background layer and foreground color was on the layer on top of it (**Fig.01**). The next step was to start erasing on the top layer. When doing this, I used a low opacity brush. While I erased, I tried to block out shapes of the environment in this angled perspective (**Fig.02a–b**). When I saw that the shapes were becoming more and more defined, I just kept working on them, adding more texture and solid outlines (**Fig.03**).

At this point, I'd only been using a very small number of colors. But, when you are blocking out shapes and setting up the image, it's enough. First, when you have the whole image set up in shapes, you can start experimenting with colors and lighting. I have a rule: always use a low opacity – around 10–20% – when it comes to painting light and introducing new colors. This way I can spot a good color without overpainting the image. This process could be pretty long, but with practice one can recognize what colors and combinations work. I think it is good to try to experiment in this stage, too. That way, one can stumble upon new color combinations (**Fig.04**). There are artists reusing the same color palettes from previous paintings – a tip to remember!

## CUSTOM BRUSHING

The general idea for a speed painting is to paint down all the important parts of an image as quickly as possible: perspective, shape, color, light, textures and so on. One way to help in this respect is the creation of custom brushes. The effectiveness of a custom brush is evident when it comes to patterns and texture. For instance, it is possible to create a brush that simulates a certain repetitive pattern. It is also possible to create brushes

that make texture painting easier. For instance, it is possible to create a brush that can simulate an oil brush. So with that said, I tried to paint parts of this image with the help of custom brushes. **Fig.05** shows an example of a custom brush used. This particular brush was effective because it has sharp edges which helped in painting clear shapes, and it has a textured fill. I use this brush almost all the time when I do these speed paintings! Another example of a custom brush is the "chain-brush", which paints a linked chain in a single stroke!

## COLOR SETTINGS

During the painting session I tried to experiment with colors as much as possible. I did this because it was a great way to learn how to use new colors. I stopped experimenting with a certain color palette when I felt that the colors were convincing to me. This could take some time to do, but it's definitely worth it because the learning process is so great! The procedure for this consists of creating different kinds of gradient maps and then applying a blending mode (Overlay, Multiply and so on) to the maps. So, when the layer with a blending mode interacts with the underlying layer, the result might be a good one. The challenge here is to find combinations of colors that work with a blending mode on a layer. There are of course lots of ways (Adjustment Layers, Curves, Photoshop filter, Hue/Sat) to play around with colors, but this is my favorite way of doing it. The colors in **Fig.06** were created in this way.

*Fig.04*

SCENES

## CONSISTENT PAINTING

When the blocking in of the shapes was done, colors and lighting set, it was just a straightforward task to paint in the details. This meant building on the painting on a smaller level and not really introducing anything new. Let me clarify this with an example: the soldier holding a rifle watching the hanging has the same type of colors as we set earlier and the same type of light interaction as with the other objects. So what I did was to just paint in the same way, only on a smaller scale. The important thing here was to think logically, and the answers were clear. That's really everything there was to it! If we paint the helmet and we know that the helmet is made of metal, it would mean that the light that comes bouncing on it will look slightly brighter than on a non-metal helmet.

With every object that is painted, it is important to think of exactly what kind of an object it is. Because you will probably remember what properties it has and how it interacts with light!

## CONCLUSION

When I work with speed paintings I try to approach them with the intention of achieving a painting with the right colors, perspectives, "light play" and story as imagined in my mind. And with each speed painting I do, it's a lesson learnt, because they are mainly just quick painting sessions, and with each session a certain aspect of the painting comes through. In one speed painting you can have a great texture, and in another painting you can have convincing colors, and so on. For this particular painting I think the colors could have been more convincing than what they really are. And for the story, some more objects could have been depicted. But that's the content of the result which is carried on to the next speed painting session!

Fig.05

Fig.06

## ARTIST PORTFOLIO

© MARCELO

# HOMAGE TO SIDONIO PORTO

## BY MARCELO EDER CUNHA

### INTRODUCTION

The idea of realizing this project has been following me since the day I started my studies in architectural visualization. It came along with my admiration for the architect who projected it, the Brazilian architect Sidonio Porto, and, more specifically, for this building in general. The opportunity to realize it came to me when I decided to move from the city where I was living and working, to the city where I grew up and where I was going to start my solo career. I had one week, so instead of spending my spare time resting, I spent it, of course, in front of the computer doing... 3D!

The whole process took me 11 days in total, from the beginning of the modeling process through to the final image, a few hours a day. Since I had a short deadline for this, I decided that I should end the job on the last day of that week off, having finished it or not, because I knew

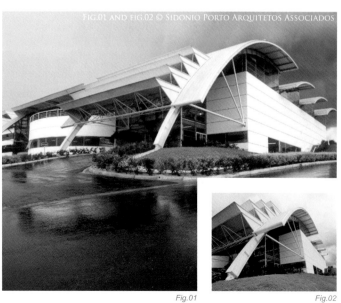

FIG.01 AND FIG.02 © SIDONIO PORTO ARQUITETOS ASSOCIADOS

Fig.01                                    Fig.02

I wouldn't have the time to develop it with the same passion and dedication after this week.

## REFERENCES

This was maybe the most difficult part of this job. When I started this project, I had only two images from a magazine (not featured here; the two images in this "making of", **Fig.01–02**, were kindly supplied by the architect Sidonio Porto). Although they helped in guiding the modeling process, they didn't show the right angles necessary in order to understand the entire structure, or how the different parts corresponded with each other. So, before starting the job in 3D, I made a lot of drawings to get a feel for the project; the proportions, angles and so on. This part was very important because it helped me to avoid lots of mistakes and misunderstandings that would have happened if I had chosen to start the modeling following the pictures only. Perhaps, due to my architectural education, I just couldn't start something without these preliminary drawings. It is time consuming, indeed, but it keeps the work organized and much more fluid.

## MODELING

Despite the complex appearance of the image, the modeling was quite simple to do. The process I used was a mix of spline modeling, whereby the shapes were

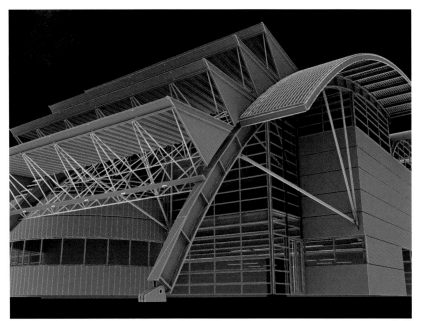
Fig.03

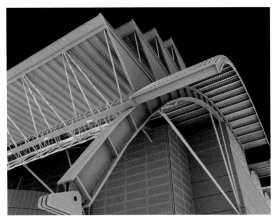
Fig.05

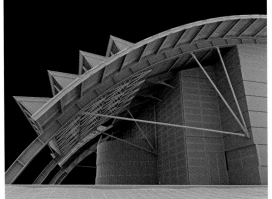
Fig.06

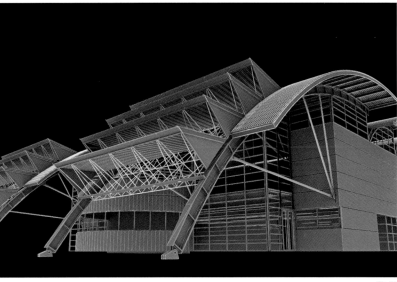
Fig.04

drawn with splines and extruded using another spline as a path, and traditional box modelling, modifying primitive shapes by way of polygon subdivision (**Fig.03–06**). I started the modeling in AutoCAD, since I was looking for absolute precision in order to locate the different pieces – just one mistake and the whole process would have been ruined!

In **Fig.07**, we can see some pieces indicated with letters, showing how each one was modeled, as described below:

A. The spline was drawn in the left view and extruded; additional details were attached later to the main geometry

B. The poly line was extruded using an arch as a path, then transformed into an Editable Poly to model the irregular and squashed parts;

C. A primitive tube was transformed into an Editable Poly;

D. A primitive tube was transformed into an Editable Poly;

E. The roof is a plane transformed into an Editable Poly for further modeling;

F. The grass was modeled using a particle-flow system;

G. Vegetation was from an Evermotion "Archmodel" collection;

H. Lamps were cylinders with light material;

I. The plane was transformed into an Editable Poly for further modeling;

J. The poly line was extruded using an arch as a path;

K. Renderable spline.

## TEXTURING

Texturing irregular objects is, in my opinion, the most annoying part of 3D. Due to the need for finishing the piece, I decided to use simple UV maps for the whole building, such as Planar, Box, and so on. Leaving the unwrap for the really necessary parts, like the round pillar and the triangular part of the roof. I used two generic metal shaders with a mix in the Diffuse slot, and a dirt mask in the Mask slot for almost all metal pieces (**Fig.08**). Nothing complex here; basic materials with some fresnel glossy reflections to achieve a better and believable result. On the round pillar and the triangular part of the roof, I painted dirt maps in Photoshop using a tablet and some photos of rust, scratches and dust. The original building doesn't have this weathering, as you can see from the photos, but I thought it would make the render more interesting!

## LIGHTING AND RENDERING

I decided to use Mental Ray as the render engine, because its sun/sky system is amazing. We can achieve very believable results with it, and most importantly we can do so in a short period of time! The sun/sky was done inside a daylight system, and then the sun position was adjusted to achieve an afternoon lighting situation. The overall lighting was adjusted through the exposure control, where I used the logarithmic exposure control for

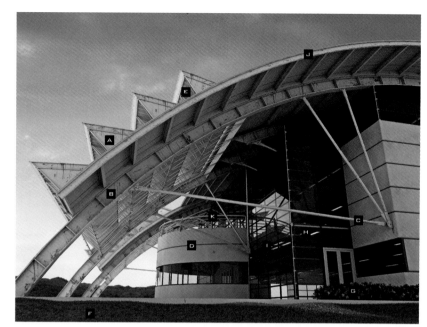

*Fig.07*

*Fig.08*

this. Inside the Mental Ray rendering parameters, I used only Final Gathering, with 500 rays per FG point. The final result can be seen in **Fig.09**. As you can see, the result is very, very different from the final piece.

## POST PRODUCTION

This part was responsible for creating the mood I was looking for. The original render pleased me a lot, but it had some very dark shadow areas that didn't fit the mood I was trying to achieve. The colors were a bit washed out and it lacked contrast, so I started applying a violet photo filter in Photoshop to prepare the image for corrections, such as a shadow/highlight modifier to reveal the dark areas. Some exposure changes and color balance adjustments were made to achieve the violet lighting as well. The layer was then duplicated and set as an Overlay copy with 40% opacity. With this, I got more vivid colors and a better contrast.

*Fig.09*

SCENES

The next step was to add an Occlusion pass to strengthen the soft shadows (**Fig.10**). The final image was almost complete now; the next step was the sky. I used a photo set to Overlay above a gradient, from violet to soft yellow, and that was it!

## CONCLUSION

This was a very pleasant work which opened up a lot of doors in the architectural visualization industry for me, and the most important thing was that it made it possible for to me to meet the architect who designed it: Sidonio Porto, who, pleasingly, enjoyed this image a lot! I hope that with this work I can spread the name of this already renowned architect, putting more people outside the architectural field in contact with his amazing work. For new people in the 3D world who have followed this "making of", I hope that I have shown them that, with simplicity and organization, we can achieve great results!

*Fig.10*

# ARTIST PORTFOLIO

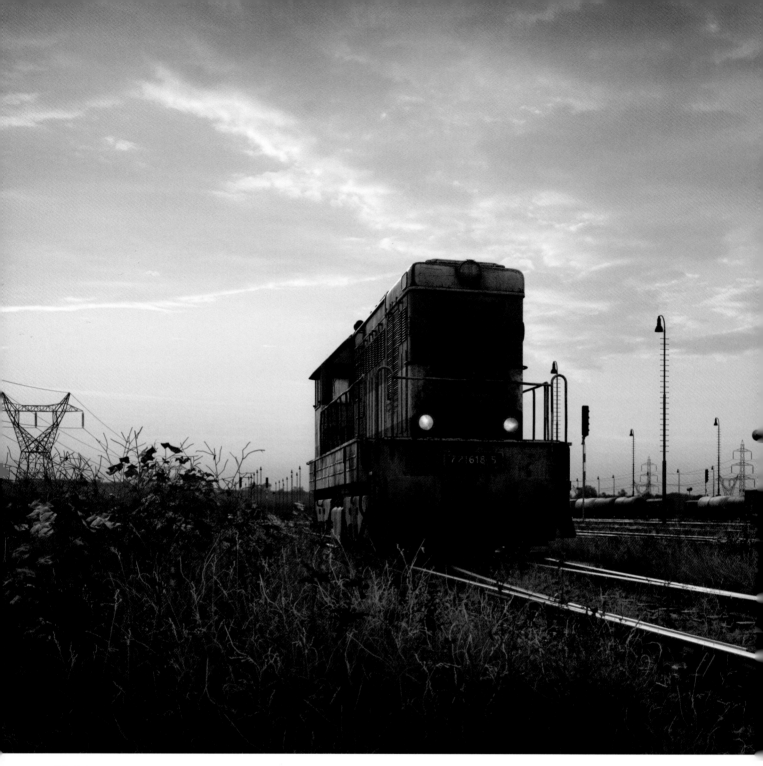

# HEKTOR

## BY MAREK DENKO

### INTRODUCTION

There was an image of diesel locomotive in an old train station – still alive and still strong enough to carry out its everyday duties. So let me write down a little about the "making of" that image – an image named: "Hektor".

In the beginning there was an idea, and since I'm a man who likes to

work on personal projects, even if my day job is consuming almost all of my time, I started working on that idea. I studied railway construction at a university of technology, so this image is really a small tribute to all of my old friends and teachers, which is something that had to happen one day. And that day was one at the end of summer 2007. I started painting with my tablet; I painted a simple sketch, and after few days I decided to remake it in 3D. I spent more or less two months of my free time on

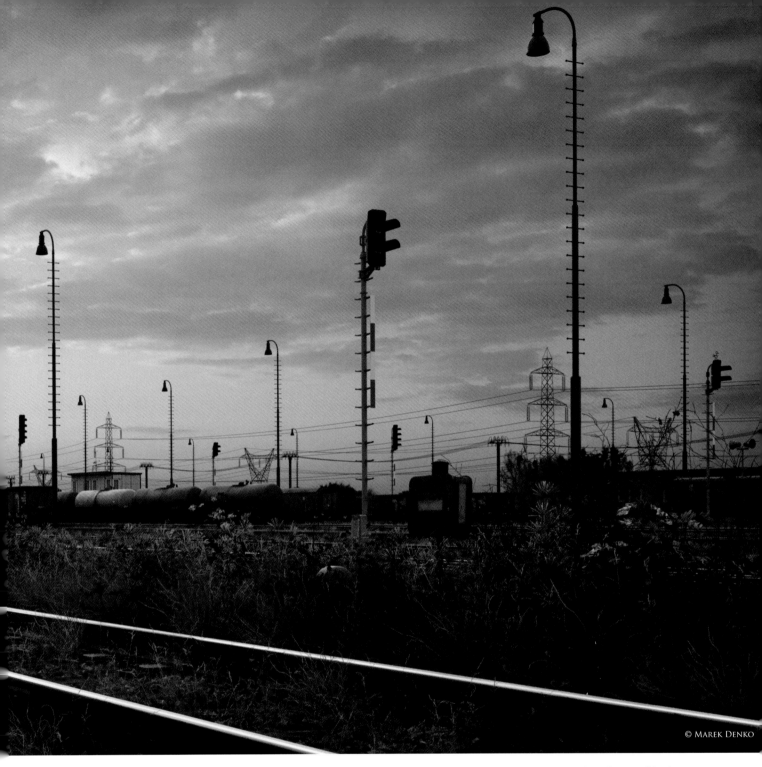

© Marek Denko

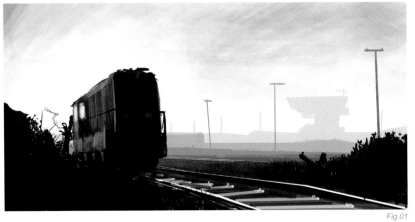

*Fig.01*

this piece. I really enjoyed doing all parts of the image – step by step, bit by bit – during the autumn nights. So, here is how I created this image, from both technical and artistic aspects; step by step, starting from the sketch, to searching for references, through the modeling, texturing, shading, lighting and rendering, to the final post production work.

## CONCEPT AND REFERENCES

The sketch was done in just a few minutes (**Fig.01**). I started with the railway and the locomotive's position, building up the main perspective and then adding details

*Fig.02a*

to it as I felt necessary. After a few days, when I decided to remake it in 3D, I started to search for references. I spent several hours searching the Internet and my photographic library to find nice pictures of elements which I could possibly use. I also went to the train station of my hometown, Hlinik nad Hronom, to take pictures of railways and objects connected to them, like signal lights, wagons and so on.

I always find references as an essential part of my work. When you look at your references you can find lots of interesting things and details which are very hard to understand if you don't see them directly. They are very helpful for the modeling, texturing and shading stages (**Fig.02a–e**).

## MODELING

All modeling work was done inside 3ds Max, except for a few bushes and trees which I'll describe later. For modeling objects, like the locomotive, the rail track, stones and signal lights (**Fig.03a–b**), I used an Editable Poly, which is one of the most frequently used modeling techniques in the industry. Anyone who wants to start with computer graphics should know this modeling technique thoroughly. It is one of the most common methods of modeling! For me, modeling is just a routine part of the work, but I still enjoy doing it. When I'm modeling, in most cases I begin with the standard primitive objects, such as a plane, box, cylinder, sphere, or even shapes such as a circle or rectangle. After deforming them somewhat, I usually convert them to an Editable Poly or an Editable Spline. Then it's a case of applying modifications

*Fig.02b*

*Fig.02c*  *Fig.02d*  *Fig.02e*

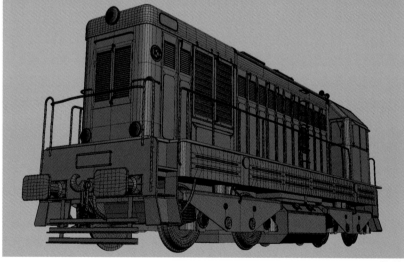

*Fig.03a*

*Fig.03b*

to certain selection groups: extruding, beveling, chamfering, cutting, and all those modeling tools which are available in your 3D package (which in this case is 3ds Max). Very often, I use several types of modifiers to deform or change the geometry. For example, Symmetry, Bend, Twist, Taper, Free Form Deformer, Noise, Displace, Turbosmooth, Wave, Ripple, Path Follow and so on. If you are beginner to 3D modeling, you should read the manual that came with your 3D package to try to discover how it works. You can trust me that modeling static objects is one of the easier parts of 3D! If you want to be a fast, good and precise modeler, you need to know your modeling tools as well as possible. So take the time to read about them and try them!

Fig.04

After I finished this picture, the most frequently asked questions I received were about how I created the vegetation. My answer is always that I didn't use anything special! I've simply just tried to reproduce real vegetation as well as possible, taking hardware limits into consideration.

## GRASS

I modeled a few types of grass strands with very few polygons, and then I scattered them with the script called "Advanced Painter", by Herman Saksono, upgraded by my friend Federico Ghirardini. Script is free and you can find it on Scriptspot.com. I created several different grass groups and then randomly placed them into the scene. I was quite satisfied with that, but it still missed some variation and irregularity (**Fig.04**).

## PLANTS AND BUSHES

For the plants, I used base geometry from X-frog and OnyxTree libraries imported into 3ds Max. I optimized them and then scattered a few, simple, polygonal boxes across them to create a more "realistic" look. To finish them, I used the Noise modifier to make them look older, after which I followed the same approach for the bushes (**Fig.05a–e**).

## DISTANT GRASS

For the grass in the distance I used cards with pre-rendered grass.

Fig.05a

Fig.05b

Fig.05c

Fig.05d

Fig.05e

## STONES

I created several levels of detail for the stones on the railway. I then used Particle flow to scatter a few types of stones across the base geometry. High resolution stones were used for the foreground, medium for the more distant stones, and low polygonal ones for the background.

## TEXTURING AND SHADING

When it comes to texturing, I mainly exploit the use of photographs and sometimes, if necessary, I paint in some details by hand. There are a few very nice texture sites on the web, such as www.environment-textures.com and www.cgtextures.com. I also used a lot of dirt textures from 3DTotal Textures: Volume 5: R2 DVD. I consider the dirt collection from 3DTotal to be one of the best texture collections available! For texturing, I used Photoshop (**Fig.06a–c**).

Since I used V-Ray for this image, I used V-RayMtl as a base shader for all geometry. Very often I used a low intensity of fresnel glossy reflections. In general, raytraced reflections also increase render times, but they help to achieve a more natural and believable image (**Fig.07**).

## LIGHTING AND RENDERING

For rendering, I used V-Ray from Chaosgroup, which is a very good renderer used mainly in architectural visualization, but it is also more frequently used for movies and commercials. Basically, there are two lights in the scene: one is a directional light coming from the background of the image, simulating the sun. I used very soft shadows since the sun is behind the horizon in the scene. The second light is a skydome with constant color. I also used Global Illumination bounces to produce a more realistic result.

## POST PRODUCTION

For post production I used only Photoshop. I added the background sky using an alpha channel. I did lot of color correction to the render and I also painted over a few details. All was done in a 16-bit/channel with color depth to protect color information as much as possible.

## CONCLUSION

So that's it – the making of Hektor. I believe that if you've read all of this then you may have understood some of my techniques and how I work. I'm not saying that my way is the only way and the right way, of course. I'd be happy if you could take this "making of" as a piece of my heritage that I'm sharing with you.

Fig.06a

Fig.6b

Fig.06c

Fig.07

Sunrise of the 80's | Marek Denko 2007 | www.marekdenko.net

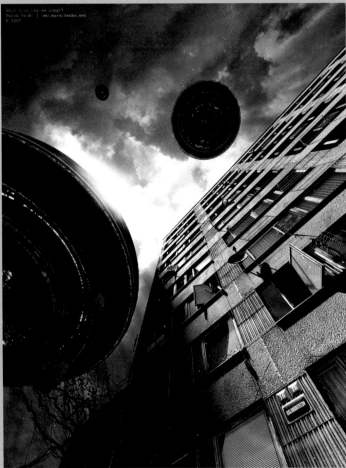

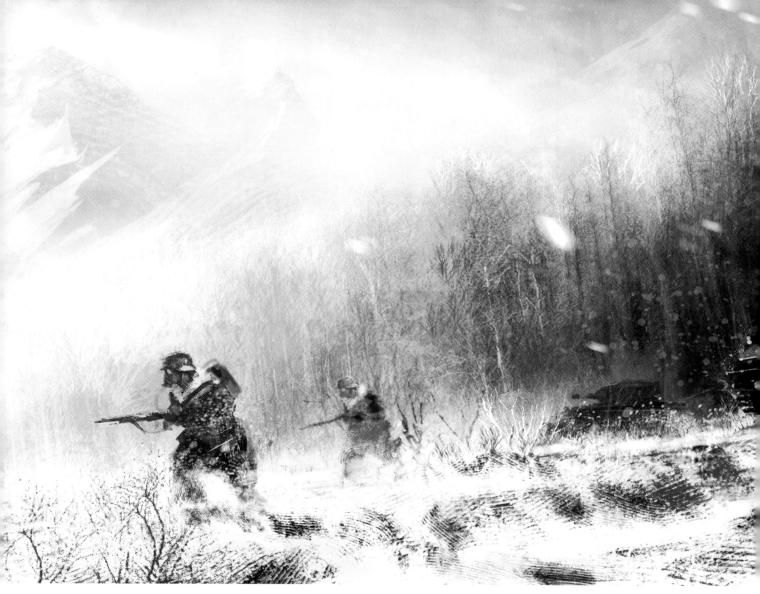

# DEVIL'S BEAUTY

## BY MORGAN YON

### INTRODUCTION

I have always been interested in history and the big landmarks which have built our world. It was therefore obvious for me to create an illustration dealing with the subject matter of WW2.

In "Devil's Beauty", my main idea was to paint a disturbing image with a strong atmosphere, and to show the strength, beauty and power of a subject which, at first glance, seems cold and inhospitable. While tackling this image I told myself that it would be preferable, to better convey my ideas, not to be too focused on the realism but rather to suggest elements to render them more alive by fully using custom brushes. The challenge thus was to create a "beautiful" war scene by using, as raw material,

*Fig.01*

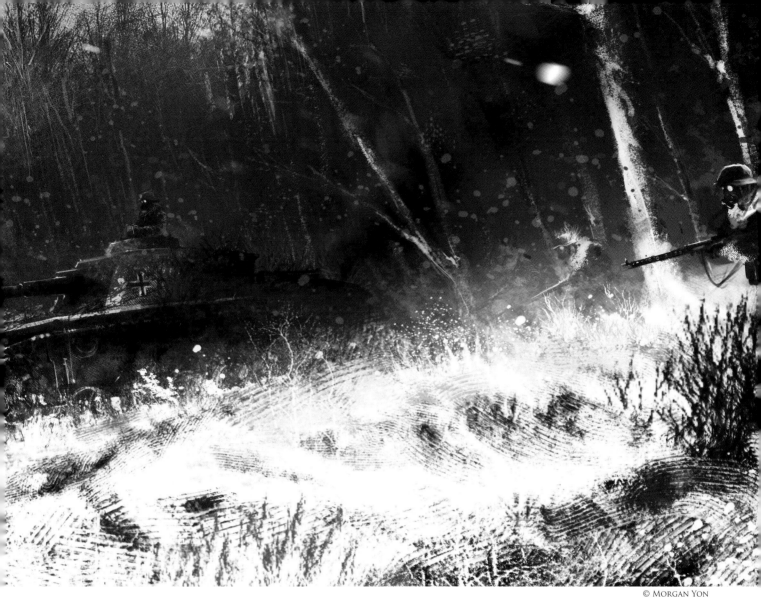

cold and hostile elements. The title of this illustration stems directly from this idea of a paradox between the devil (war) and its "beauty".

## "IN BETWEEN"

I began by making a first quick sketch in Photoshop using its basic brushes (**Fig.01**). The idea was to quickly set the masses and the tones. I had no precise idea of the framing before beginning, but I wanted a choking, rather dark image, where the white of the paper would occupy a very thin space. Nevertheless, I realized rather quickly that this framing did not serve my subject and I decided to widen the latter to allow a better understanding of where the action took place (**Fig.02**).

According to the process, I defined the masses more accurately and added more precision to the row of trees, which in the end fully participated in the dynamics of the image. Indeed, my intention was to use these elements as a natural path for the eyes of the viewer. I wanted the reading of the image to go from left to right and for the contrasts to follow the same principle (**Fig.03**).

*Fig.02*

*Fig.03*

Fig.04

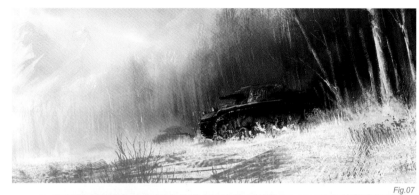

Fig.07

Fig.05

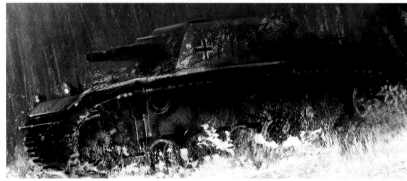

Fig.08

Fig.06

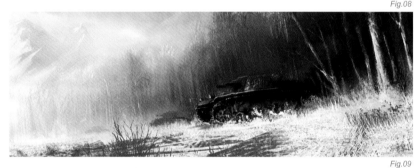

Fig.09

These masses, which become more and more impressive, are similar to a wave which breaks out, and in its heart: the tank. The devil comes down! For the work of the vegetation, I opted for the creation of custom brushes (**Fig.04–05**). I would have been able to use reference photos which I could have painted over, but this time I wanted to keep total control over their rhythms (**Fig.06**). By trying to keep this dynamic, I continued to emphasize details more precisely by working on the "heart" of this garrison: the tank, the paradoxical symbol of protection and violence (**Fig.07–08**). For example, to create the tank I applied a Sharpen filter several times on the brush strokes which I had just put on, quickly giving the idea of a rigorous and cold material.

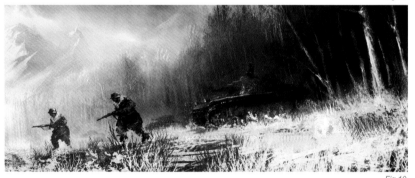

Fig.10

The following step consisted of making initial research for the color range. I duplicated my image and began color tests by applying layers with suitable blending modes. I used a layer painted in Color Burn mode for the sky, and for the right part I used a layer painted in Vivid Light (**Fig.09**). Once satisfied with the tests, I resumed the painting of details by trying to keep a certain depth, acting on the contrasts of the foreground and background.

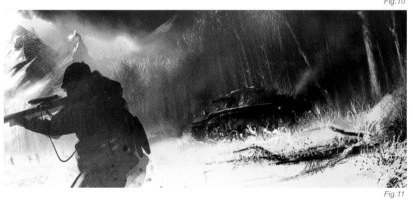

Fig.11

SCENES

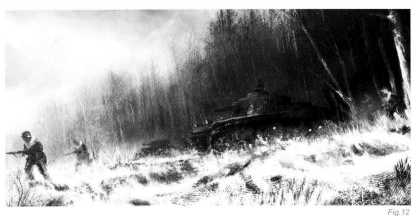
Fig.12

Fig.13

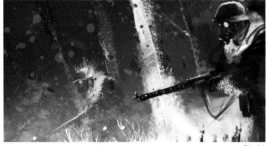
Fig.14

I added, step by step, some elements and enjoyed painting the soldiers in the foreground and the one on the tank (**Fig.10**). I then arrived at a stage which has become more and more recurring in my works. Being more familiar with character design, each time I work on a set I always want to put a character extremely detailed in the foreground, to work deeper on facial expressions and movements… I told myself that it would be great to see a soldier in the foreground making a crazy face with his rifle, so I quickly sketched it on a duplicate of my image and did some more color tests (**Fig.11**). The result did not really help: it added little and the composition was weaker; I lost the depth and the image filled up again. I went back to the previous version and continued to work on details and focused on an interesting foreground, without adding a character (**Fig.12**).

I wanted to create an interesting snowy ground; muddy and hard to tread, even though this troop has no difficulty crossing it. For these purposes, custom brushes also helped a great deal. I used a rake brush which is supplied with Photoshop (**Fig.13**), and allowed me to configure the marks in accordance with the direction of the stroke to create the illusion of an injured ground. The succession of the brushstrokes gave an interesting effect that I decided to keep till the end.

I then arrived at the end of the illustration, where I made the last color corrections, level adjustments, and added the last details to the soldiers to bring them out of the forest (**Fig.14**). Finally, I made a layer of snowflakes created from white points affected by motion blur. And that was it: done!

## CONCLUSION

In the end, I reached my goal. The atmosphere is heavy, the monochrome image indeed serves well, and the subject and I did not get lost in details. I tried to keep a general vision of the image, its composition and its dynamics throughout the process, and I believe that has paid. Having a deep interest in this kind of subject matter, I think that it allowed me to put a little more passion into this work, which certainly has more impact than the other images that I was able to make. I also discovered, through the process of creation, that the use of custom brushes allows an important amount of extra time, but especially a huge freedom for creation. As I like often saying, "Technique does not matter much; if the message is strong, the result will be even better!"

# ARTIST PORTFOLIO

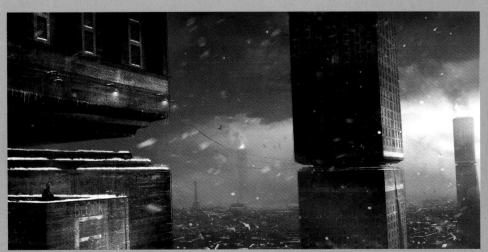

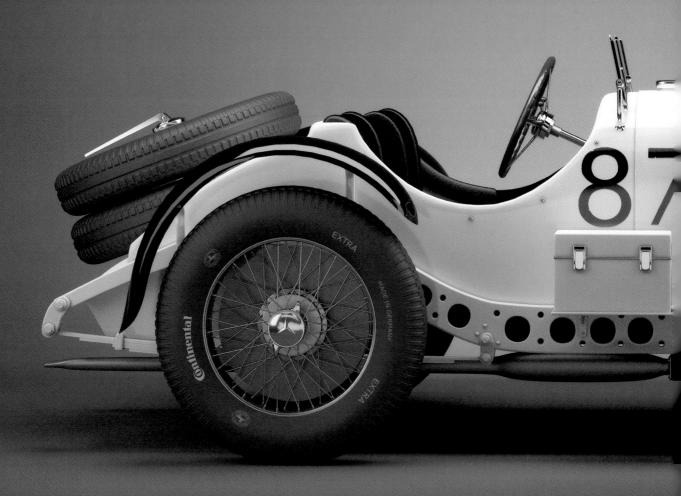

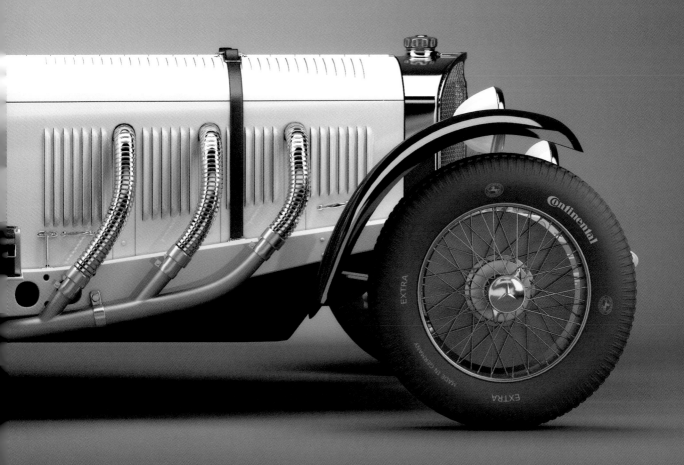

# MERCEDES-BENZ 720 SSKL

## BY PAWEŁ HYNEK

### INTRODUCTION

For as long as I can remember, I have always been fascinated by old cars, motorcycles and planes. You can find an unusual combination of beauty and strength in them. This combination is hard to find in current constructions, which have become common as you can see them on every corner of the street.

Because of this, when I decided to create a car model for a personal project, I chose a 1931 Mercedes-Benz 720 SSKL, which, in my opinion, is one of the most beautiful constructions man has ever made! I wanted to create a particular model: one owned by Rudolf Caracciola – one of the greatest grand prix drivers! I decided to use 3D Studio Max 9.0 for modeling and rendering the final image.

### PREPARATIONS

Before I started modeling, I spent many hours watching pictures of remaining copies and replicas of the Mercedes-Benz SSKL. Exact knowledge of body shape and how particular elements were joined allowed me to quickly build the mesh without having to correct it too extremely later on. An additional obstacle was the differences in the photos of the cars that I was able to obtain. But there is nothing strange in that, because every Mercedes-Benz 720 SSKL model was different – it was a customized car, not in serial production. In addition, there were many changes done during the exploitation process (such as holes in the frame which were drilled to make the car lighter or the removal of the start number pin kit). After many hours of comparing photos, I chose a few which allowed me to pinpoint exactly the car shape, and to start the modeling process.

### MODELING

I used traditional poly modeling to build the mesh, starting with the biggest elements and adding smaller ones during the work's progression. I assumed that I would make the final renderings with a camera set in the front hemisphere of the car, so I could save some time on modeling parts which would be invisible in such views. I started work by creating the body, hood, frame, mudguards and radiator from standard primitives (such as box, low segment cylinder and so on). I had to use very low quality blueprints of the Mercedes-Benz 720 SSKL, but in spite of that I managed to correctly set the position of all elements. The car wasn't symmetrical, but nevertheless, at this point it didn't matter. I modeled only the left half of the car (**Fig.01**).

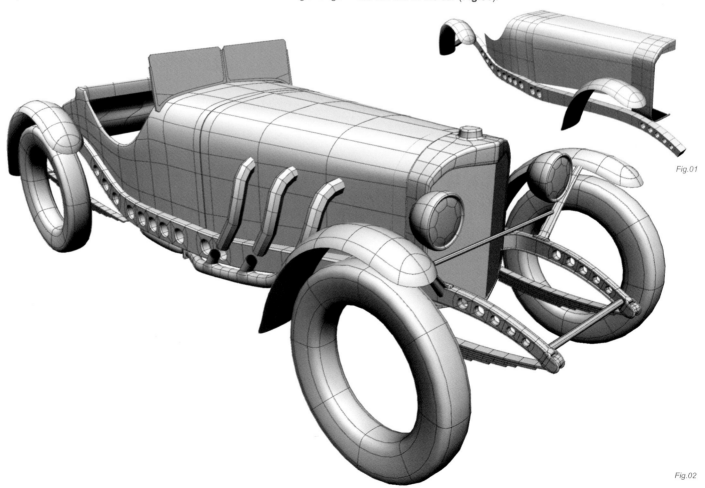

*Fig.01*

*Fig.02*

The next step was to give a correct shape to the frame and radiator, and I was able to do that using the Tapper and Bend modifiers. Also, the body and hood were modeled in a state comparable to the final result. I started to add smaller elements, some of which, such as the tires, were used only as "helper" objects at this stage, helping the positioning and modeling of other elements. The hood and body were copied, mirrored and welded (**Fig.02**).

With the mesh at the current stage, I could then start the modeling of the asymmetrical body and hood elements, and add most of the details that defined the form of the car. At this point I decided to raise the base density somewhat. I did this mostly to preserve memory, but also to continue modeling on the mesh with a higher intersection level (body, hood). I opted for displacement and chose the elements to be treated as such (tires, hood, break drums, wheel caps, frame and so on). I decided to use displacement mapping to save time, not because it was the only possible solution. Every element that was displaced could be modeled in the traditional way, but in some cases it would have become time consuming and would have made differences in quality which would be hardly visible. The car was now given its "serious" looks (**Fig.03**) and needed only a few smaller details and displacement maps.

The last stage of modeling work gave me the most pleasure – all the small details brought the model to life. So, I decided to add every single screw and lug nut I could find from my references photos. I also modeled the radiator shielding in 3D (originally I planned to use a plane and a material with an opacity and bump map). **Fig.04** shows the results of my work at this stage; I placed visible displacement maps (in red to make them more visible), which marked the final stage of the modeling process.

As you can see (**Fig.05**), the front of the model was detailed enough to create high resolution images. So I succeeded in bringing home the bacon!

## MATERIALS

After finishing the modeling, I started to create shaders for particular parts of the car. As you can see (**Fig.06**) there were not many materials used; two kinds of car paint (white and black – a standard color scheme for Mercedes-Benz sport cars), chrome, copper, two kinds of brushed metals, glass, leather and rubber. To be honest, it was

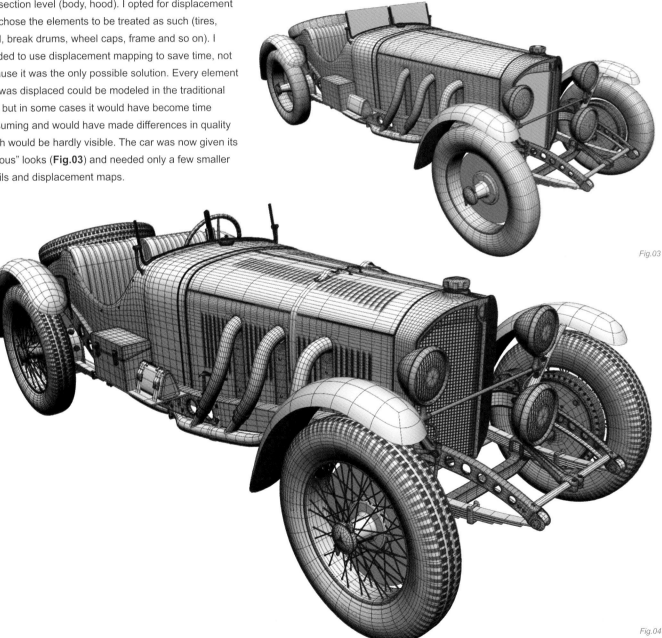

*Fig.03*

*Fig.04*

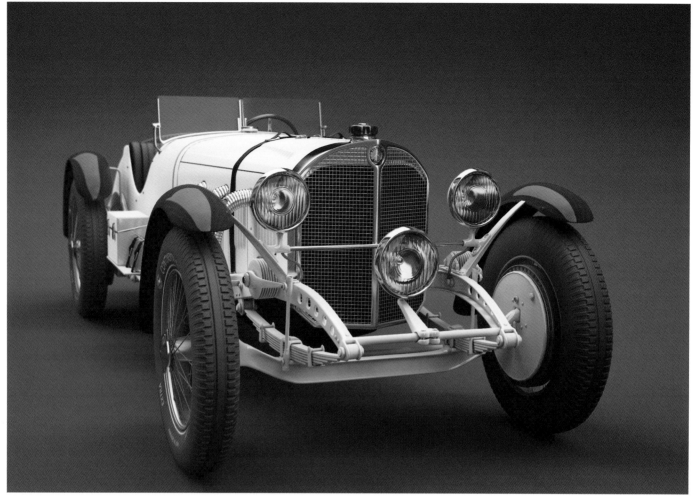

Fig.05

more difficult to create the white paint material, as it's hard to keep the whiteness of a surface and achieve nice reflections at the same time. It also needed a lot of correction, depending on the light intensity and environment settings. I also prepared some textures – mainly masks for blending materials. Diffuse textures were used only for the Mercedes-Benz sign. A bump map of leather was fully procedural – it looked good and maintained the correct world scale, and this negated the need for mapping elements.

## Lighting

The last step was to set up a scene with lights. For me, this is the most important stage of creating a 3D image. You can make a perfect model, give it great textures and shaders, but without proper lighting the image will be uninteresting. There are two general ways to light up a scene: HDRI-based lighting and environment or system light sources. Sometimes it's better to combine both techniques. I decided to use system light sources only, without an environment. I used four planar lights for lighting the car, and one additional light to light up the background geometry (**Fig.07**). Lights were set to

Fig.06

SCENES

generate light and reflections, but I turned off direct visibility to the camera. The rendered image was very similar to the final and didn't need much post production work. I only made a few changes in Levels, Gamma curve, and Color Balance.

## CONCLUSION

Well, you can see the end result of my work, and I can assure you that it was fun! Sometimes, even with personal projects, you can encounter phases which are boring, unpleasant or hard to get through. This time I couldn't actually recall such a stage! Perhaps I would change my modeling aproach with some of the elements, but only to make the process faster. I'm very pleased with my final images (I've made few renders with different environments and camera angles) and I must say, it's a great feeling when you can look at your image and feel no need to make any changes!

*Fig.07*

# ARTIST PORTFOLIO

ALL IMAGES © PAWEŁ HYNEK

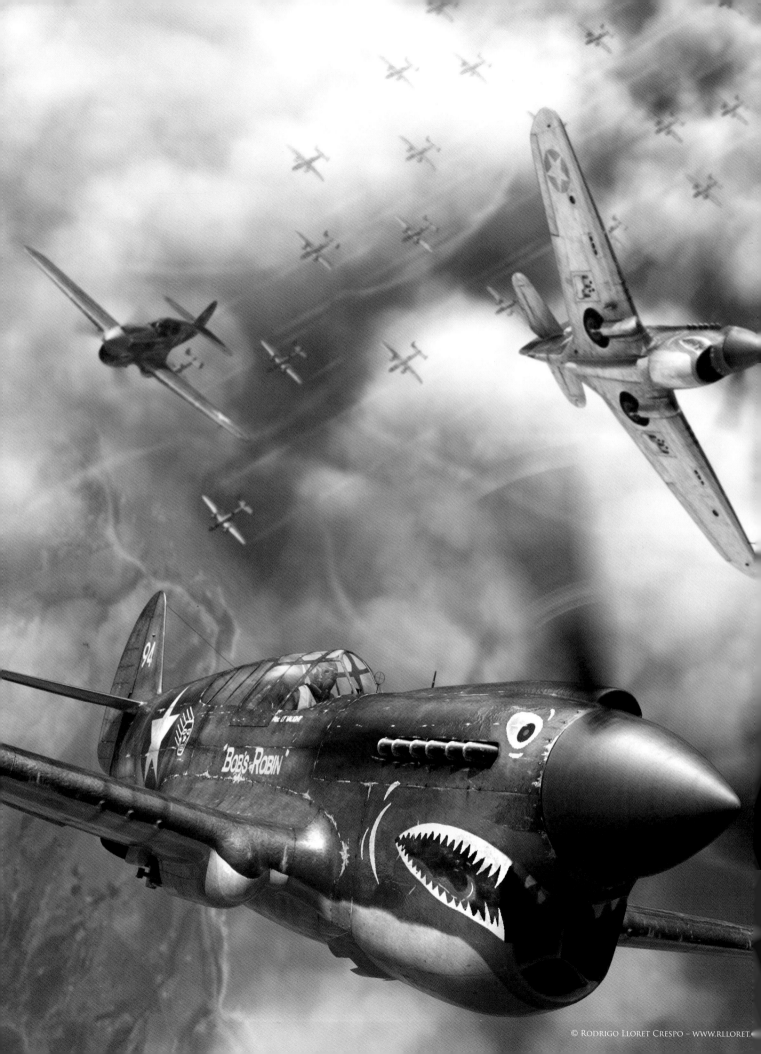

# IN THE SKY
## BY RODRIGO LLORET CRESPO

### INTRODUCTION

I have always been very interested in WW2 aircrafts. For me, they have more romanticism than the actual war vehicles. When I was a child, I enjoyed looking at the covers of WW2 scale model machine boxes... their colors, their aggressive perspectives, and so on... I decided it was time I made my very own cover!

For this image I wanted to use the mythical fighter P-40 Warkawk, in the most well-known version. This version had a shark's mouth on the nose and flew through the skies of the Pacific Ocean when Japan joined WW2. To complement this fighter I used my old B-25 model in the scene, because it was an inseparable companion in those days.

I didn't want a normal 3D image; I wanted to make something more artistic. I wanted the composition, the light and the colors to express emotion and to give a feeling to the whole image. I wanted to give up using pure 3D for this image and instead used it simply as a tool.

Fig.01

Fig.02

Fig.04

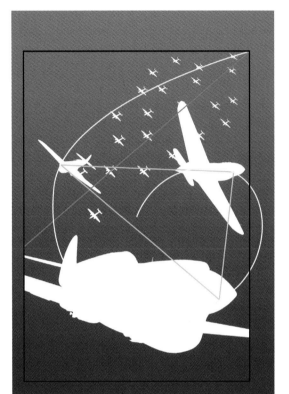

Fig.03

Fig.05

Fig.06

Fig.07

Fig.08

### COLOR

When I was thinking about this image, I saw it like a gradient between the first shot and the background colors. This color palette is like the one used in the works of art of the best artists that have expressed war, destruction or the postwar period: earth colors, ocher colors, gray colors... they make us feel the time go by, the loneliness... (**Fig.01–02**).

As I wanted the image to have a lot of depth, I played with the forms that composed the image and played with the colors. I used darker colors in the first shot and lighter colors in the background.

### COMPOSITION

For the composition I performed a lot of tests and used the alpha channels of the objects because they allowed me a better understanding of the positive and negative spaces in the picture, as well as allowing me the freedom to work very quickly.

I based my image on three compositional shapes; the first one is a general composition in the shape of a spiral (a group of all the objects), the second one is in a triangular form (the propellers of the P-40) and the last one in diagonal line across the background (B-25). This way, all the things have an attractive composition. To create the perspective, I played around with the size of the objects to give depth and drama to the image, and used a 28mm camera to emphasize the effect. For the sensation of motion, the propellers and the trace of the fighters helped (**Fig.03**).

DIFFUSE

Fig.09

GLOBAL ILLUMINATION

Fig.10

CLOUD REFLECTIONS

Fig.11

SUN REFLECTIONS

Fig.12

OCCLUSION

Fig.13

## SKY

The clouds needed to have a lot of detail because they were a main part of the image, even though they form part of the background, because they filled the empty spaces. I thought about using photos, but after a lot of failed attempts I focused on the Fluids system in Maya. I've used the Fluids system in other projects, and so obtained a high quality result based upon previous experience (**Fig.04**).

I used a 3D Container, and combined with the texture properties and opacity of the shading it helped me to model the clouds and achieve the best effect. I carried out a lot of tests with the different types of textures (Perlin Noise, Bilow, Volume Wave, Wispy, Space Time). The best ones for this kind of effect are the Bilow and the Perlin Noise

Fig.15

Fig.14

Fig.16

textures, but I prefer the latter one because it calculates faster and the final effect is more artistic in my opinion. The most important values are the Opacity in the Shading group, and the Threshold, Amplitude, Ratio and Depth Max in the Texture group.

For the colors, I used the normal blue gamma because I was thinking about changing it later in the post production stage. To change it later was far faster than changing the values continuously and making renders (**Fig.05–08**).

When the sky was finished, it was very realistic and it filled the empty spaces of the image, but also gave a glimpse of the background.

## POST PRODUCTION

I divided the image into several layers: background, clouds, B-25 and one layer for every P-40. In that way, I could work the different shots separately. Besides these layers, the P-40 was divided into the main structure, pilot, propellers and glass. In addition to this I rendered the Occlusion pass to provide more volume to the fighter, two different layers of Reflection (the whole sky and the sunshine only), and the Global Illumination of the P-40 and B-25. As a result, I worked with 21 layers in total (**Fig.09–16**)!

The first step was to work the image in Combustion, because it creates some effects better than in Photoshop. I imported the background, the clouds and the different render layers of the P-40 and blended these until I was happy (I added the layers of the B-25, pilots, propellers

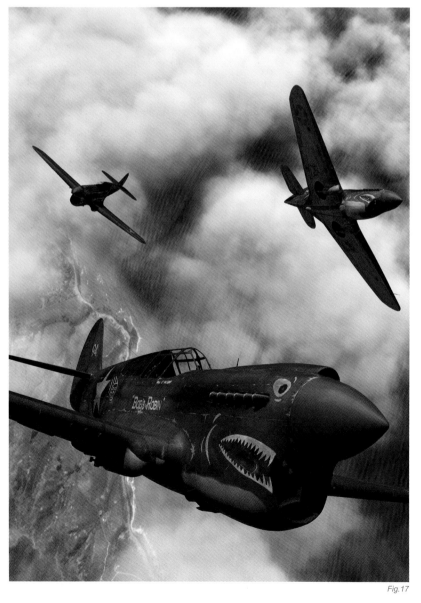

Fig.17

SCENES

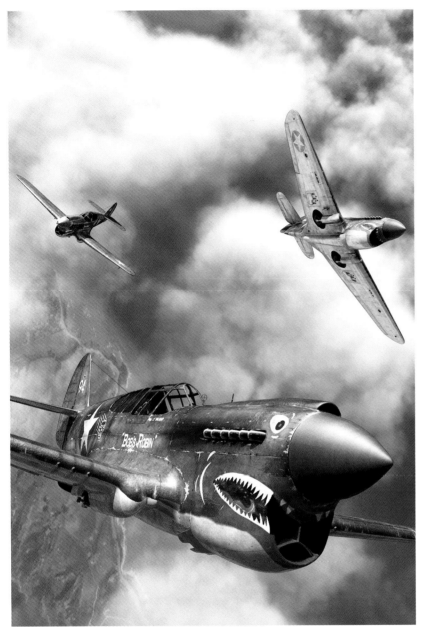

and the glasses later in Photoshop). Then, with the color retouch in Combustion, I obtained the pallete of colors that I wanted and I played a little with the plugin "Sappire" (Glint, Distorsion RGB) to add some effects to the image. Finally, when I'd finished working in Combustion, I saved everything in different layers with alpha channels to modify the image in Photoshop. A lot of work was still necessary (**Fig.17–18**).

## PHOTOSHOP

The first thing I did in Photoshop was to add the pilots and the B-25. I left the glasses and the propellers to the end, because at the time it just disturbed me when I tried to integrate the elements in the image. Little by little I integrated the colors of the P-40 and B-25 in the background to obtain the same pallete of colors across the whole image. Then I integrated the B-25 into the background with the light and blurring. Once the background was finished, I started working on the main shots. I made the brightness and the tone equal and I blurred the fighters as they moved further away, to achieve more depth and credibility. With the whole image integrated, I drew the traces of the P-40 and B-25 to add the sense of motion and depth. Then I added the propellers and the glass, and retouched the dimensions of the second P-40 because it was a little small for the composition. Finally, I included the brightness of the sun on the glass of the main P-40. The image was finished.

## CONCLUSION

I gained a lot of knowledge of both color and compositional techniques during this process. Perhaps people think that the colors are rather desaturated, but… I like them!

*Fig.18*

# ARTIST PORTFOLIO

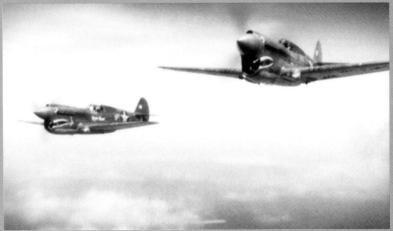

# PHILOSOPHER
## BY TEY CHENGCHAN

### INTRODUCTION

Philosopher is my favorite piece to date. At first, I wanted to create a high-tech world, but after repeated contemplation I decided not to dwell too much on technology as there are other great pieces talking about that. I am always attracted to styles that are both classic and antique; I enjoy the nostalgic feel that such works exhibit. One day, an idea of blending the new and the old popped into my mind. I thought it would be nice to have a good mix of the new and exciting, with the old and enduring. Philosopher was my conquest to create just that!

So the idea was set and it was time to start doing some research. I started visiting antique stores and took pictures of the vintage merchandise within. The Internet was also a very good source of information for my research.

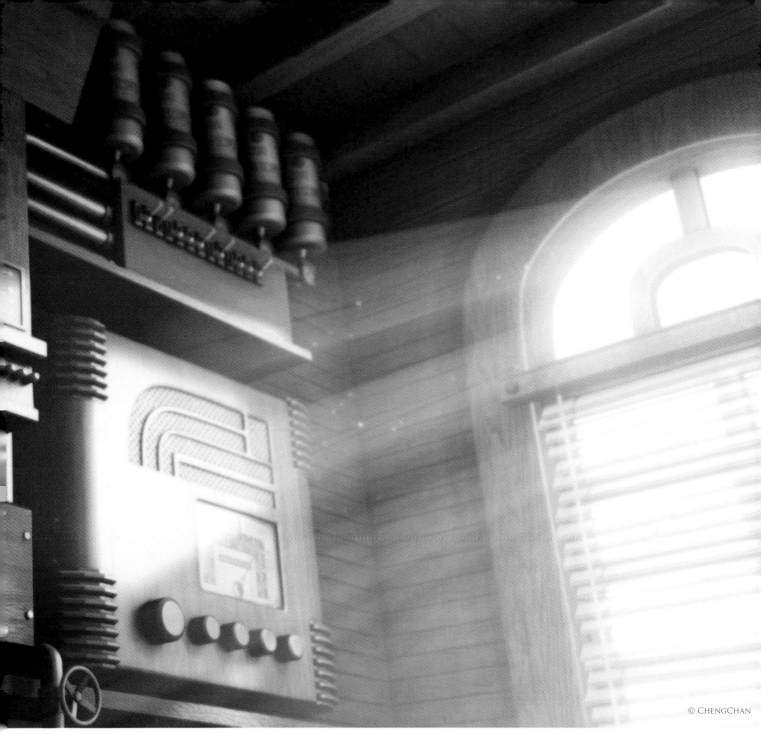

© ChengChan

Fig.01

There was a common element that I discovered in the course of my research; most of the antiques were made from earthy elements, like wood, copper or metal. I also wanted to bring a feel of nature into Philosopher. So I decided to base my designs on wood, copper, metal and other natural ingredients. The robot (**Fig.01**) is an example.

I spent around one month doing research, gathering all my resources, and then I started designing the background and the lead character. I would now like to share with you the processes of modeling, texturing, shading, lighting and rendering that went into the making of Philosopher…

## MODELING

I had an easy time during the modeling stage, mainly because many of the assets were already created. I only had to make simple modifications to them; some of the assets were reused without any changes! All geometry was modeled in Maya (**Fig.02**).

There were some props that did not require detailed modeling, for example the time clock and the button hanging on the wall; these were achieved using painted textures assigned to them. This saved time and optimized the scene in that it kept the file as small as possible – such measures are necessary, especially when there are huge amounts of geometry expected in the scene!

## UV MAPPING AND TEXTURING

For the background and the robot, I used basic planar and cylindrical UV mapping. The pictures that were taken from the antique stores and the Internet were very useful when it came to texturing the models that were created. They added realism to the final imagery.

## LIGHTING AND COMPOSITING

After all the required assets were modeled and the proper textures applied, the next step was to light the scene. All lighting was done in Maya; there were no complicated steps involved. I used directional lights and spot lights most of the time – they are easy to deploy and manipulate due to the way that their light rays

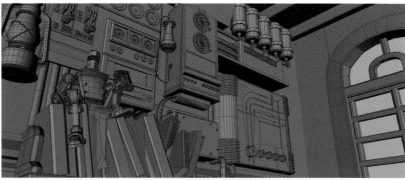
Fig.02

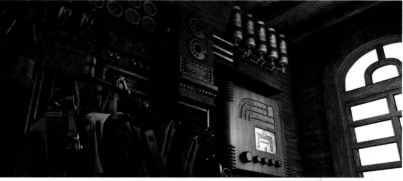
Fig.03

are computed. Maya Software Render was used for the entire rendering process. All passes, except for the Ambient Occlusion pass, were done in Maya Mental Ray.

In the initial lighting stage, I used a dome light for the background; this created a very soft ambience for Philosopher. The background was treated as a separate beauty pass (**Fig.03**) from the main lighting (**Fig.04**). It allowed more convenience when it came to color correcting on the main lighting and background; separating the main lighting and the background into different passes gave me the flexibility to process them individually. This method was also useful when it came to compositing, where I wanted to add glow effects and control their respective intensities.

Apart from the two passes mentioned, a Z-depth pass, an RGB pass, a Specular pass, a Reflection pass and an Ambient Occlusion pass were also created. I used the Z-depth pass to calculate the depth of field (**Fig.05**), which was used to make the robot more noticeable in the foreground while the background was blurred to convey distance.  The RGB pass was extremely useful in the compositing process (**Fig.06**). For example, if I needed to select a portion of the background for color correction, or to add effects to it, I could do it through the RGB pass. Basically, RGB passes are used to distinguish or separate a portion of an image so that more treatment can be done to it. The Specular pass (**Fig.07**) and the Reflection pass were just for pile-up. They were used to tweak and fake, or to add details to the rendered images. Lastly, the Ambient Occlusion pass added solidity to the objects in the scene (**Fig.08**). The Ambient Occlusion pass contains information of soft shadows caused by objects coming close to each other. These soft shadows, caused by object occlusion, gave an illusion of weight to the objects so that they didn't look "CG".

Light rays shining through windows are known as god rays, due to the "God-like" quality that such rays possess. Adding god rays gave Philosopher a "sacred instance" look and feel. This was essential in emphasizing the decisive moment that the robot was going through – a holy and eye-opening point in his life. This was done wholly in the

Fig.04

Fig.05

Fig.06

SCENES

compositing stage, as it was not possible to achieve through lighting. A part of the glow light was also done via the compositing.

When I started the lighting, there was a huge difference in the color, mood, look and feel of Philosopher to the final result which was achieved during the compositing phase. I was constantly trying to outdo the previous benchmark that was attained at every stage. It was also my quest to make Philosopher look as good as possible using the best of my skills – the "perfect" look that I was aiming for.

## Conclusion

It has been a great pleasure to share with you my experiences in producing Philosopher. It took me four to five months to complete Philosopher. The only times at which I was permitted to work on it were after office hours on weekdays and during the weekends.

I have also posted Philosopher online. You are welcome to view Philosopher on www.youtube.com or any other 3D and CG websites.

Great efforts have gone into the production of Philosopher; my wish is to be able to develop the story further and hopefully make a short film out of it in the future. Until then, please stay tuned to Philosopher! Thank you so much.

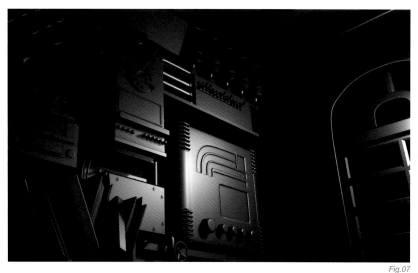

*Fig.07*

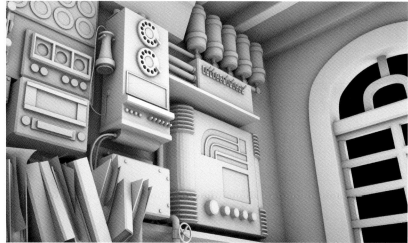

*Fig.08*

# Artist Portfolio

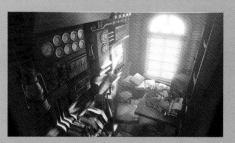
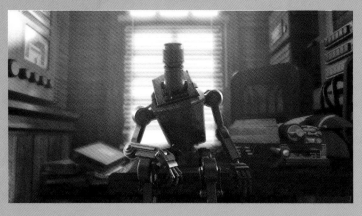

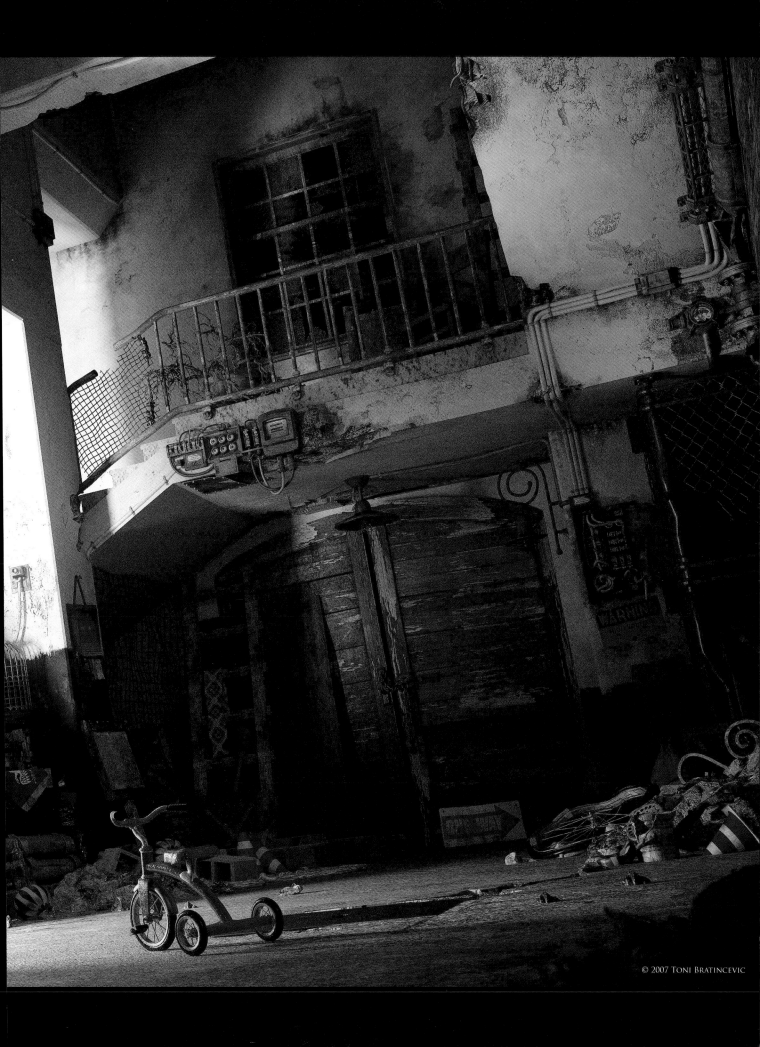

# IT WAS YOU
## BY TONI BRATINCEVIC

### INTRODUCTION

The idea for this image came from a hallway in an old building near where I used to live (**Fig.01**). The hallway was dirty and full of junk, but people were living there; everything was unclean, but there was still life in the environment. I loved the kind of ambience – created by people and abandoned over time. To begin, I photographed the environment and created some textures for the collection, but after some time I had the idea of creating a picture based on that actual interior. To start with, the idea was just to do the architectural reconstruction of the hallway and make some tests with Global Illumination, but in the end I formed a little story which gave it some life and meaning. Later on, it became a gift for my wife, Martina, since the story was about her, me and the vision I had when I was young.

"It Was You" was my first project created in 3D Studio Max, created in an unbiased render engine called

Fig.01

Fig.02

Fig.03a

Fig.03b

Fig.03c

"Maxwell". This meant that every material and light created was constructed as it was in nature. The great thing about Maxwell is that there's no need to adjust tens of parameters to get decent render results; Global Illumination, Depth of Field, Caustics, Glossy Reflections – everything is calculated by default in the renderer! The downside, however, is that it is slower than unbiased render engines, like Mental Ray. The creators of Maxwell call it a "light simulator", the reason being that with Maxwell you'll get images of the highest quality output available!

### PREPARATION

Once I had an initial idea for the image, I searched the Internet for as much reference material as possible. This is standard practice for all of my images, since it's impossible to think about every detail you want to put into the image, and you can always get new and fresh ideas when searching through photos! Reference images are also great because, sometimes, you can grab base textures for your objects and do additional painting on them to get high quality textures to apply to your objects! Of course, some texture libraries are a must-have, and, as usual, my base to start with was the 3DTotal Textures collections.

One important step in my image creation process is sketching. Sometimes I'll do rough sketch paintings before I start in 3D, but for this one I blocked in the initial objects in 3D Studio Max, where I also defined the camera view. Once I established a nice camera shot, I rendered the scene with a flat material and no lighting, then overpainted it in Photoshop to get a better idea of the environment, the kind of objects I needed to create, their placement and the overall composition (**Fig.02**). For this, I used an A3 Wacom Intuos tablet. In the past I've tried working with the mouse, but it's just pointless! After I was done overpainting, I started modeling and created most of the sketched objects. Then I made another render and overpainted again.

## MODELING

The modeling for this image was an easy ride, but a little time consuming. The scene had simple geometry which could be easily created starting from simple objects, like a box or cylinder, and tweaked using

Fig.04a

Fig.04b

the EditPoly modifier to get the desirable shapes. The usual tools that I use with an Editable Poly are Extrude, Chamfer, Cut, Inset and Bridge. Combining these tools and several others are enough to get every shape I need! One important thing was to get geometry that resembled the real objects as closely as possible, which was done by modeling scratches, holes, and rounded edges and so on. All this was needed to get a final realistic image that wouldn't have a computer-generated look. Of course, there is no need to add all the details since you can get small details with bump or normal mapping; finding a good balance between real models and faked scratches using bump is essential, and no one can teach you this without a great deal of practice! To add little imperfections to the overall geometry of the objects, I used a noise modifier combined with some kind of selection modifier (when needed on part of the object). For the selection modifiers, you can use polyselect to directly select the group of vertices, but most of the time it's better to use volume select because polyselect is dependent on the geometry below it, and volume select isn't. This means that, if you change the number of vertices of the object below the polyselect modifier, your selection will be messed up, which won't happen with the volume selection modifier. Of course the Noise modifier is only used to effect imperfections to the vertices of the object, so if you need to create scratches and little breaks the EditPoly and Cut tools are the only real solution. If you plan to smooth your object, you need to watch out for the topology of the mesh – the model should be modeled properly to achieve the correct smoothing in the end result (**Fig.03a–c**).

## TEXTURING AND MATERIALS

Usually, I don't want to spend too much time doing UV mapping, so, whenever I can, I use the UVW Map modifier with box/planar/cylindrical mapping. Of course, this cannot be used in all cases, so if you need to put some signs or some textures that need manual UV mapping, you need to dig in and edit the UV map with the Unwrap UVW modifier. Good practice is to use box/planar/cylindrical UV map in the first mapping channel, and if you need a special UV map you can edit it in the second map channel. So, by having two different UV maps in separate channels, you can do some really

Fig.04c

Fig.04d

*Fig.05a*      *Fig.05b*

*Fig.05c*

complex texturing, but it is crucial that, in the material editor, once Bitmap or any other 2D textures are chosen, you set the mapping channel to the one you wish to use. Most of the textures in this image were heavily painted in Photoshop. For example, for the walls I used the basic texture pass grabbed from a reference photo then added several more layers to get nice details and a look of an old, dirty wall (**Fig.04a–b**). After I made a color map, I copied the image, converted it to grayscale and made some more modifications to get a nice bump map. The texture resolution for the walls was 4096 by 4096; I used a high resolution because I knew the final image resolution would be around 4k, and the walls would be visible over the whole image. For the other objects that took small areas of the image, I went for 1024 by 1024 images and resized them down if needed (but kept the original files in higher resolution just in case I needed them). Because I wanted the environment to look old and dirty, most of the textures, once the base color passes were made, were combined with several new layers of dirt. For example, for the crate texture, I found a wood base texture on the Autodesk Area website and transformed and reshaped it to the shape of crate, and then painted dirt directly onto the crate to age it (**Fig.04c–d**). In general, my own textures and photos were used and then built upon with several painted dirt layers to create the necessary effects.

As for the materials, in Maxwell they were really easy to set up because of the approach to it. There was no separate option for specular highlights and reflections, and each option was connected to the other. You don't have to fake specular as in other rendering engines; specular in Maxwell comes from the real reflection of the light source. Usually I have only two bitmaps, for color and bump, but sometimes, to get more realistic materials, it's necessary to create textures for other channels (like specular, reflection and so on). Since in Maxwell specular

and reflection are combined in one channel, it was only necessary to create that one. The final solution to achieving more realistic materials is layering two or more different materials – this can sometimes lead to very realistic results. This is what I used for the floor, although it's not so visible in the final image. For the floor I had two materials: a more reflective one which was used for the areas where I had a wet floor and the other which was much less reflective for the standard floor. The mixture of these two was controlled with a separate grayscale image, used as a mask.

## LIGHTING

Lights in Maxwell are not the usual lights that you'll find in Max (Omni, Spot, Direct). To define a light in Maxwell, you need to assign a Maxwell material to the object, which in turn will be used as the light, and in the material section you set the option to use it as a Light Emitter. In this scene, I used two area lights. The main light, which gives most of the light to the scene, was hidden on the left side behind the wall (**Fig.05a–b**). This gave a warm light with the shape of a vertically stretched sphere. The other light was a simple plane placed outside the scene which gave an additional cold blue light (**Fig.05c–d**). The combination of these two lights gave an attractive color gradient from one to another, providing really nice results. The good thing about Maxwell is a render option called "Multilight", which can be used whilst rendering an image. It sets almost in "real time" (with a separate slider for each light) – the amount of light coming from each source. With this, you can start playing immediately with the lighting composition of your image whilst it is rendering. If I'm not satisfied with the lighting from the second light, I can just lower its intensity to zero and exclude it from the image.

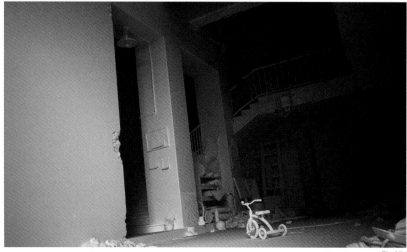

*Fig.05d*

     SCENES

## POST PRODUCTION

"It Was You" was one of the first images that I post processed in Photoshop. Usually I do the compositing in Fusion because, compared to Photoshop, you have a lot more flexibility and everything is non-destructible so you can easily make changes later. But, since this was an experiment (3ds Max, Maxwell and so on), I decided to take a different road with post production and chose Photoshop as the main tool. For the post production, I used several color corrections, like gamma/color/saturation tweaks, and added a few vignettes so I could get more attention to the part of the image that mattered the most (as well as a little signature) (**Fig.06a**). There was also a glow created by copying the image, blurring it heavily and adding some gamma correction to achieve more contrast, then adding it as a Screen layer. Comparing the final image to the one I got from Maxwell (**Fig.06b**), the post-processed image looks much more interesting and not so flat. Post processing is as important as a high quality 3D output from a program. Don't try to get a brilliant image directly from your 3D package – if you can do it in post production you'll save a lot of time, since most of the stuff you do in post production happens in real time! Since this image had only one layer, I didn't have to construct the composition with several passes.

## CONCLUSION

As much as a good image is important, the promotion of that image can be as important as the image itself. What's the use of art if you don't share it with the world? After finalizing the image, I spent a few weeks sending it to the most popular sites on the Internet, like 3DTotal, CGSociety, CGChannel. In many cases, the images that I think are not so good make a good impression on the public; people send me emails saying "This is great but I don't like this, and this bit could use some more work!" Don't take it wrong: be open for critiques and see what can be done better next time! In the end, you can't grow on your own; you need people around you to help you improve. What's true about art is: it's not about me, it's about us!

*Fig.06a*

*Fig.06b*

# ARTIST PORTFOLIO

© 2006 TONI BRATINCEVIC

© 2004 TONI BRATINCEVIC

# TEMPLE FESTIVAL
## BY WEI-CHE (JASON) JUAN

### CONCEPT

People paint for various reasons. Some people seek the joy they experience during the process, whilst others are eager to reveal their feelings through their painting. There are people who tell stories through brushes, sometimes even with the ambition that their paintings might make the whole world a better place! It is a media and a universal language that people have been using for an extensive length of time.

Last year, I was looking at some old slides that I took in 1998. One of the pictures was taken in my hometown, Houli, in Taiwan. It was just a snapshot of the street with no human beings in it, but it aroused my desire to paint. Since worship in temples is one of the major social

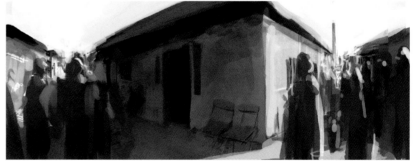

Fig.01

events that take place in Taiwanese culture, this subject became the focal point of my exercise.

### PROCESS

There were three brush settings that I used for this painting. These were sufficient to block in the major shapes and to paint details, and I also combined some overlay techniques in Photoshop. For some of the rough surfaces, like the wall and the ground,

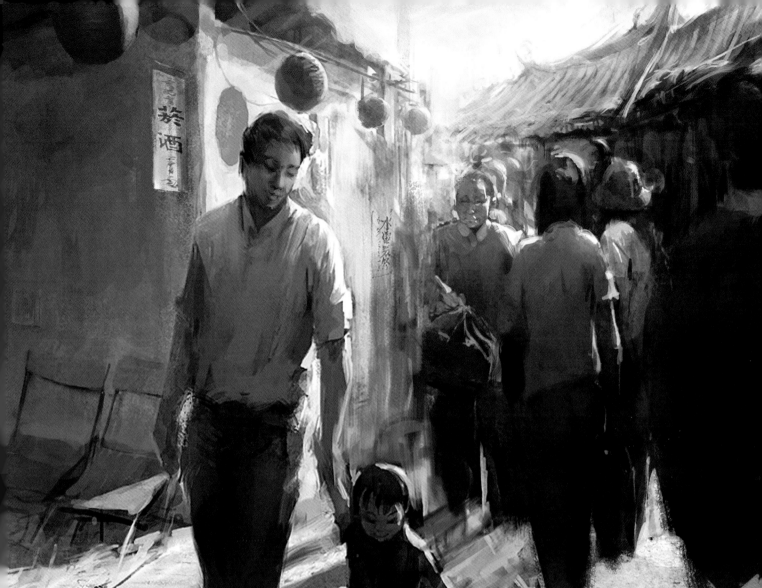

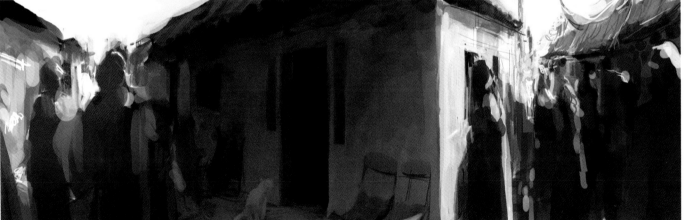

Fig.02

I applied a High-Pass filter to photos to achieve the texture details, which I then applied directly over the painting and combined with the brushes.

For the first 30 minutes, I started from a very rough sketch and focused on the composition and color. This step was very short but it locked 50%–70% of the content of the whole painting. Once the initial sketch was done, I just needed to fill the blanks. If the initial sketch is successful, it means the final result will be successful. From **Fig.01** to **Fig.03**, I was still changing some

elements, but no major changes were made and a few other details were also added to it. During this stage, it was still good for changing major shapes and playing with colors and composition. Once I felt everything looked good, in a thumbnail size, I started working on the details. The composition and the values usually change after I start to add more detail, and it always then needs to be rebalanced. Sometimes, the adjustments don't work well, but other times accidents can bring unexpected surprises, so I usually work on two or three

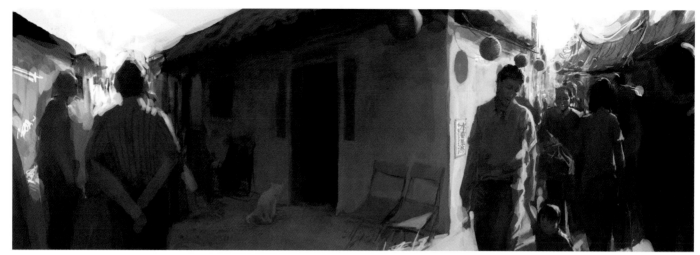

Fig.03

layers that I can constantly turn on and off to check the current layer and the layer I did few minutes ago. If the results turn out unpleasant, I simply delete the current layer and redo it! One issue is that, the more I paint, the more problems I need to solve. It is like solving a mathematical problem and one has to try to figure out a way to balance it! Solutions are not always there, but there is always a workaround to make the painting better. Whenever I feel stuck, I will show my work to my peers. They may not be able to provide the perfect answers, but, usually, I can be inspired and, based on their input, I can think it through differently. Take the major problem in **Fig.04**, for example: I did not know what had gone wrong, but I knew there was something unsuitable in the painting. The strong line on father's right side created by the corner of the wall cuts the painting in half. I did not see it until my friend pointed it out to me!  In the final image, I fixed the problem, and I also added the cloud on the left of the sky to balance the bright part of the right side.

## Conclusion

There were also some ideas which formed during the painting process. One fun experiment is that, by using a loose sketch, we can make people see things differently even though they're looking at exactly the same shapes. In this painting, I mingled some elements that are contradictory to each other, such as silent and noisy, young and elderly, busy and relaxing, light and shade, and so on. The actions of adding

elements in and taking them out from the painting is a constant and necessary effort when painting. The whole process is like finding a perfect point on a single line. If it is not enough, then I need to push it more, but if it is too much I need to pull it back until it is on the "right" spot of the line. For example, I created the cat and the elderly man sitting in front of the door for two reasons. First, because it was empty over there it was good to have something for the composition. Second, I wanted to have an elderly man to reflect the busy street that has a child running in front of his father.

For me, there are many stages that I have to go through before I can actually make a painting. The initial one is to construct a solid drawing foundation; then I will select pleasing colors and structure the composition. The former is to search for interesting ideas, the latter is to gather references efficiently. Missing one part may fail the painting. Each skill or idea may take years to master, but the most important part is a strong desire for painting. It is the origin and source of power for making art!

A genuine painting will draw us back to it from time to time, and may even make us want to study it or go beyond its visual aspect – this is also the spirit of painting and the physical presence of the source of human beings.

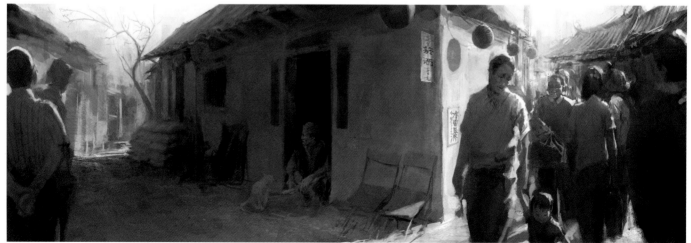

Fig.04

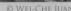

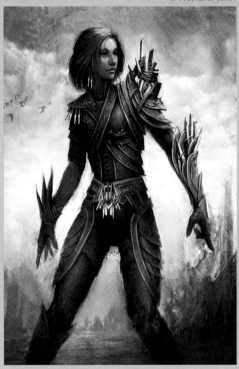

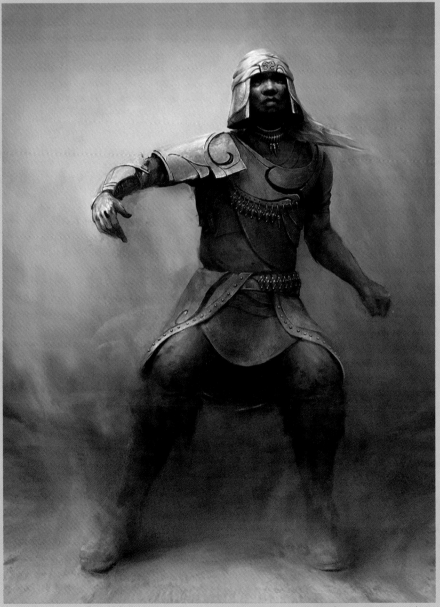

# RELIC
## BY YIDONG LI

### INTRODUCTION

The original intention for creating this work was to co-operate with friends on a short series about "Metal Slug" (a famous multiplatform video game). At the time, a lot of work was done to prepare for it, but it had to be put aside for a while due to other work demands. Lately, however, I got some free time, so I'm now going to share with you the making of my "Relic".

The artistic conception of this piece was to show a brief instance, with the entire truck as the visual focus. In the short series, this image is just one small shot, so the scene itself is not dramatic. Generally speaking, this piece was created just to show my technical skill. But now I will share with you what I learnt throughout the whole creation process.

### REFERENCES

Reference collecting is a very important step; our experiences and imaginations are all somewhat limited, and so references may help our work to become more ample and vivid. Though this was not a complicated scene, I still collected pictures in abundance as reference for this project. For example, I found pictures of truck models and military model scenes; I referred to in-game scenes from Metal Slug and game snapshots, as well as movie scenes and other good CG-related work which all provided great inspiration. They won't always help the work directly, but they will often inspire you to be creative (**Fig.01a–c**).

### CREATING/DESTROYING THE TRUCK

First of all, I designed an integrated truck by comparing different pictures of models. The technique itself for

© ISTOCKPHOTO.COM/PETER VIISIMAA
*Fig.01a*

*Fig.01b*

*Fig.01c*

*Fig.02*

this part was fairly simply, mostly dealing with polygons (**Fig.02**). Using my reference pictures, I then came up with a design for the destruction of my truck (**Fig.03**).

I went through the following process during the fabrication/destruction of the truck:

• The front and back of the truck were disconnected and the front part was pushed downwards. The most important part was to show the massive changes that had been made to the original shape of the truck through destruction.
• The damaged door, broken rubber bar and the opened door portray the scene of a fleeing driver when the truck was seriously damaged.
• The engine cover was obviously damaged by the explosion, the truck wheel was shriveled, and the shape of the front dynamo had been affected, as well as some distortion and damage made to the track from the outer force.
• Many detailed damages were made to the truck; glass pieces were scattered from the vehicle's doors; some of the truck's parts, such as the wiper, were dropped to the ground, and so on.

### SHADING THE TRUCK

Reference collecting remains important throughout the image creation process, and at this stage I started analyzing the work of Alessandro Baldasseroni (**Fig.04**): "US Ambulance". I could see from his work that he had displayed an almost consistent color, but with some exquisite diversity. He achieved spray-painted letters and design on the vehicle, wear and tear in all the relevant places, as well as bullet holes in the truck body

and through the glass windows. Regarding my own work, I decided also to add other elements, such as rust marks in some places, soot marks, dirty rain… and my name.

After analyzing Alessandro's work, I used an effective way to assist my own work production. I gave the model a consistent color in Maya, and then rendered one frame. Next, using Photoshop, I used layers to bring the whole effect together. The layers used were: rust layer, dust layer, dilapidation layer, rain dust layer, sootiness layer, spray-painted layer, and so on.  Then, based on the planned effect, I continued using 3D tools. The advantage of this was that, before I knew exactly what the final effect would be, I could see what I had achieved and could therefore adjust and control it freely. Using this method, the final effect was exactly the same as if using Photoshop.

The original rendered truck can be seen in **Fig.05a**. Effects were added to the truck in Photoshop (**Fig.05b**). The final effect was then added in Maya, using my Photoshop image as a reference (**Fig.05c**). It's not too technical organizing shading in Maya; I mainly

Fig.03

use the layer texture and layer shader to combine spray-paint, rust marks, bullet holes, wear and tear, "sootiness" and so on (**Fig.06**). Another couple of points about shading are the bullet holes on the front windshield of the truck which were achieved by shading and not modeling. Also, the bump map contributed a lot when expressing the blocky cover of the truck, and made it more detailed. Here is the final picture of the truck (**Fig.07**).

## CREATING THE SCENE

Using reference pictures, I drew a design to set the scene and atmosphere (**Fig.08a**). Because this image was only going to be used as a static frame, the placement of the scene was not very precise and was instead arranged based on the position and perspective of the camera lens. To give prominence to the sense of space in the scene, I added some wire netting, a brick wall, a few weeds, a gas can, and so on, in the foreground. On the other hand, some unreachable angles and ground were left neglected, as it would not be seen by the camera. In view of the upcoming short series, the precision of the scene model was managed intentionally; otherwise problems would naturally occur in a macro scene render and alternating speeds (**Fig.08b**).

Shading maps were mainly used on the spot shot pictures. I got them mostly from www.cgtextures.com – a brilliant website! When dealing with scene shading, the main

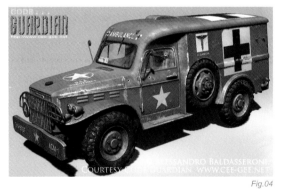

Fig.04

Fig.05a

Fig.05b

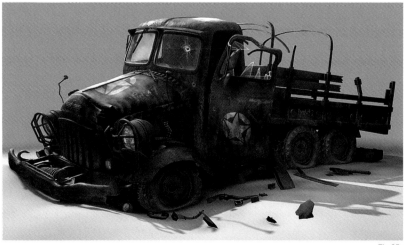

Fig.05c

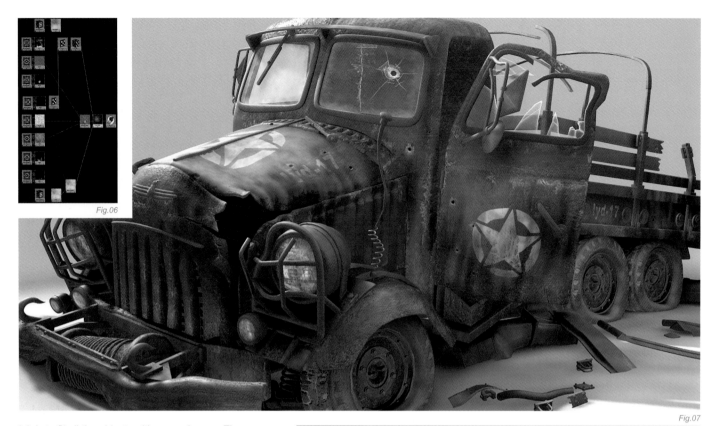

Fig.06

Fig.07

job is to fit all the objects with general maps. These maps should possess abundant diversity. The scene is very big and has many objects in it. I cannot make everything perfectly, because it would cost so much time. With some buildings being far from the camera, I didn't have to make the shading brilliantly, because it would look so small in the camera view. So I decided that I needed to focus my energy on certain points in my scene where the work would be more easily seen. I made those parts better, and consequently the whole scene looked better! For example, for the building on the left-hand side of the scene, I drew a fallen wall and added a soot effect to it. On the bottom of the building I also added some dust. On the main body of the building, I gave it a dusty rain effect. The ruins and the sky in the distance were both composited pictures.

## LIGHTING

To light the scene, I basically used the GI_joe light Matrix, a main light, other supplementary lights and Occlusion, which were later combined. The main function of the GI_joe was to simulate the light from the sky and to support the whole scene with well-proportioned basic illumination.  In addition, GI_joe also helped to form the shadows between objects, and to make the structure more solid and vivid. The main purpose of the key light was to simulate the sunlight; other supplementary lights were used to sculpt the details in the scene. A backlight was also used to partially draw the scene out.

Fig.08a

Fig.08b

SCENES

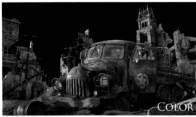

COLOR

Fig.09a

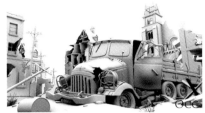

OCC

Fig.09b

WIRE

Fig.09c

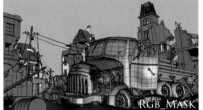

RGB_MASK

Fig.09d

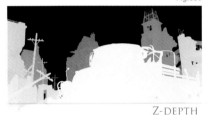

Z-DEPTH

Fig.09e

FR

Fig.09f

## COMPOSITING

The separate rendered layers can be seen in **Fig.09a–f**: Color, RGB-mask, Z-depth, Occlusion and FR. I then adjusted these layers in After Effects. I chose After Effects rather than Photoshop because, in Photoshop, once the filter has been used, it cannot be amended. For example, I want the foreground to be blurred by 10%, but then I may want it to be reduced by a further 5%. If I use Photoshop, I have found that it is not easy to revert back, so I find it better to choose After Effects to adjust the settings of any parameters in the work.

## CONCLUSION

Through the process of making this work, I have learnt many things. The most important thing is that the design is the soul of the work. Without a good design you will not have a good artwork, even if you employ the highest technical quality. In addition, the work looks so quiet with no vital force, so perhaps I could have added some beasties, such as a bird! Maybe, in this way, the work would have been given more of a realistic touch.

## ARTIST PORTFOLIO

through the street

# HELLFIRE WIDOW

## BY ZOLTÁN KORCSOK

### INTRODUCTION

This picture won first prize in the Hellfire Widow Contest, organized by Subdivisonmodeling.com. My idea was to model an anatomically correct spider and to make a photorealistic render of it. Reference materials for the job were provided by Subdivisionmodeling.com: photos, and drawings by Glen Southern. I looked up many other references and anatomical descriptions to be able to make the model more accurate. I also drew several studies for the modeling.

### MODELING AND UV-ING WITH MODO

I used spider references as backdrops to aid modeling and modeled the body of the spider by way of symmetrical box modeling. I created one leg by extruding it from the body, then used it as a base for the other legs. The legs were only modeled on one side, and then mirrored to the other side after creating the UV map. This way, I saved texture space because the pairs of legs would occupy the same co-ordinates on the texture map. I did a little tuning on the topology of the finished model so that the polygon density would be even for sculpting in ZBrush. I also corrected the bodyparts anatomically, using the references (**Fig.01**).

After I'd finished the work on the model, I exported the model in OBJ format to do further work on it in Zbrush. The branch was created using a simple cylinder.

### SCULPTING WITH ZBRUSH

The model was divided into a higher mesh resolution and the sculpting was done with the brushes. Besides the known sculpting tools, I used other textures as stencils. I used Wrap Mode to project stencils onto the sculpted surface, and used LazyMouse for precise and

Fig.01

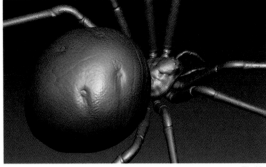
Fig.02a

smooth sculpting, which I needed for creating smooth creases. The skin's pores and the surface of the chitin were formed using DragRect Stroke and several default ZBrush alphas (**Fig.02a–b**). After I'd finished sculpting, I adjusted the subdivision level of the model to the lowest value and hid the parts mirrored onto each other. Finally, I generated a displacement map as well as a cavity map.

## TEXTURING, POSING AND RENDERING WITH MODO

I created an item mask and added a blank 1024 by 1024 pixel texture to the spider's material. Modo's Image Ink was used for painting the diffuse texture. First, I painted the spider's base color on a difftext, then the pattern on another difftext with an alpha channel. On a third difftext, I painted the color of the soft body parts and the joints, and finally, on a fourth difftext, the tenuous texture of the skin and feet (I used this latter difftext as the bump map too). These textures were baked into one, which is a difftext in the spider's material.

To bake the difftext, I set the Layer Blend Mode of the pattern to Normal, and the Layer Blend Mode of the skin to Multiply under Shader Tree/Properties and then set

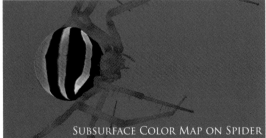
SUBSURFACE COLOR MAP ON SPIDER
Fig.03g

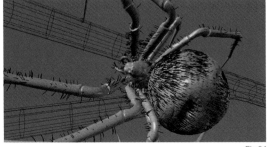
Fig.04

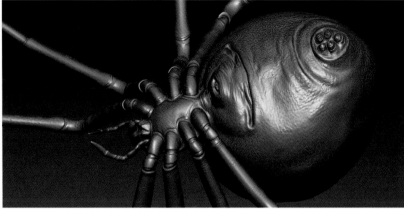
Fig.02b

DISPLACEMENT MAPS
Fig.03a

DIFFUSE COLOR MAPS
Fig.03b

DIFFUSE MAPS
Fig.03c

SPECULAR MAPS
Fig.03d

TRANSPARENT MAP ON SPIDER
Fig.03e

SUBSURFACE MAP ON SPIDER
Fig.03f

Final Color Render Output to Diffuse Coefficient in the Shader Tree, and finally baked the textures to the spider's diffuse color texture. I painted the other textures on the model in a similar fashion.

After the diffuse texture, I created the other image maps. For the bump map I used the skin texture painted for the diffuse image map, and for the Specular Amount image map I used the grayscale version of the diffuse map as a base. Using the paintbrush, appropriate parts were painted lighter or darker according to the greasy-looking surface of the opisthosoma's skin and the chitinous legs. For the Subsurface Amount map I painted the map for the material's subsurface effect, and for the Subsurface Color map I painted the map for the coloring of the subsurface effect. The Transparency Amount map was created for the slightly transparent legs and cephalothorax. The Reflection Color map was created for the blue colored light reflections of the dark shades of the spider's skin. I added the Displacement Map, which I generated in Zbrush, to the material in the Shader Tree panel. I set Effect to Displacement, Low Value to 50 and High Value to 50 under image map properties. The Cavity Map (which I also generated

*Fig.05*

in ZBrush) was then added with a Diffuse Amount Effect. I used this map to give the model more depth (**Fig.03a–g**).

After I had added the image maps to the spider material, I set the values of Specular Amount, Opacity, Subsurface Amount and Subsurface Color. I used Render Preview for getting feedback. When I thought the settings were correct, I rendered a test image to see the details, and then, using that, I made further adjustments. For texturing the branch, I used Image Ink.

## POSING THE SPIDER AND MESHPAINTING FUR

After I created the branch, I moved and rotated the spider onto it and rotated the legs one by one to the branch in Polygon mode. Then I created as many kinds of base meshes of fur as I wanted in order to vary them on the model. The anatomically appropriate fur was painted

*Fig.07*

DIFFUSE SHADING (UNSHADOWED)

*Fig.06a*

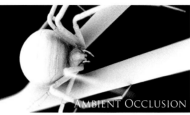

AMBIENT OCCLUSION

*Fig.06b*

ALPHA

*Fig.06c*

SPECULAR SHADING

*Fig.06d*

SUBSURFACE SHADING

*Fig.06e*

SHADOW DENSITY

*Fig.06f*

on the different body parts, for example "combed backwards" on the abdomen, and perpendicular on the legs. I set a material for the fur, too (**Fig.04**).

## CAMERA AND RENDERING SETTINGS IN MODO

I set the camera to the appropriate distance, enabled Autofocus, and then set F-Stop to the value I used for determining the amount of DOF. Two light sources were set: one stronger, from the back of the spider, and a weaker one from the opposite direction (**Fig.05**). I set some render outputs in the Shader Tree: the Alpha, the Final Color Output and the others. Under Render properties, I set the size of the frame, enabled Depth of Field, and finally started the rendering process. I saved the rendered image in PSD format so that the render outputs were stored in separate layers (**Fig.06a–f**).

## COMPOSITING WITH PHOTOSHOP

With the saved Alpha output, I masked out the final composited outputs. A photograph was used as the background and several adjustment layers were used to get the final tones. I then made a render from another view (**Fig.07**).

## CONCLUSION

I succeeded in creating the picture I wanted, and I hope the workflow described above will help other people to create similar images!

## ARTIST PORTFOLIO

# FEARLESS
## BY ALON CHOU

### INTRODUCTION

This is a story based on the era of the Crusades; I was commissioned by a Portuguese company, Vector EA – Artes Electronicas, for the project named "Lisbon Siege – 1147". The original plan was to create some character designs, but I suggested creating some more powerful and completed illustrations. By using dramatic expression, I hope to let viewers have a more direct communication with the drawings. Creating emotions in my drawings is very important for me; luckily, they accepted my suggestion.

This character was one of the Crusader's leaders - a Norman. My client wanted the design of this character to somehow suggest the dark side of the Crusaders, which was brutal and greedy, whilst also presenting him as a powerful leader.

### CONCEPT

The story happened in 1147 and is based on historical truth, therefore a great deal of research was needed. Of course, personal imagination can also be added. I did a really rough drawing of the cloth design. To emphasize the character's facial expression and to capture the viewers' focus, I decided to remove the helmet so we could see his face. I also added a cape to bring out the authoritativeness (**Fig.01**). The colored, rough drawing indicates the possible further color design (**Fig.02**). I think red and white make a good contrast.

*Fig.01*  *Fig.02*

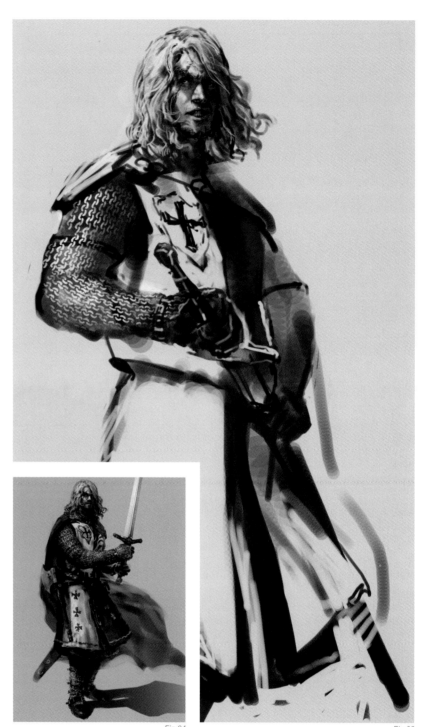

*Fig.04*  *Fig.03*

### COMPOSITION AND MOTION DESIGN

I first started out studying his characteristics. The client provided some descriptions. He was a leader of the Crusaders; a very brave man on the battlefield with the talent of agitating soldiers, and with an element of brutality in his persona. He was very obstinate and rude, and enjoyed pillaging. He was not a decent man and his characteristics implied the negative side of the Crusaders.

On the motion design, the initial idea was for him to draw his sword, but this pose lacked vigor and motion (**Fig.03**). For the second design, I focused on his facial expression. I wanted to present him as ambitious, carrying a disdainful smile on his face (**Fig.04**). In his pose, his two hands grasp the sword harder.

The client liked the facial expression, but corrected two errors on the other parts. First, a two-handed sword had not yet appeared in the 12th century, so his weapon had to be single-handed. The second error was the emblem on his chest; the cross is usually recognized as the emblem of the Templar religious military order. To avoid this kind of historical mistake, I needed to choose other patterns instead. As the kinds of ornaments used by the Normans were animals, like dragons, lions, tigers and geometrical patterns, I redesigned the emblem as a lion (**Fig.05**), and also combined it with an eagle's wings in order to bring out the aggression and tension.

I then went into the third revision of his pose. The previous draft of his pose was too still and I wanted to represent him killing on the battlefield, as this would emphasize his pugnacious personality and the function of the Crusaders.

This time he was given one weapon in each hand, which is perhaps more assertive than before (**Fig.06**). His forehand is defending with a sword, and his backhand is wielding an axe, about to hack, with his foot sliding

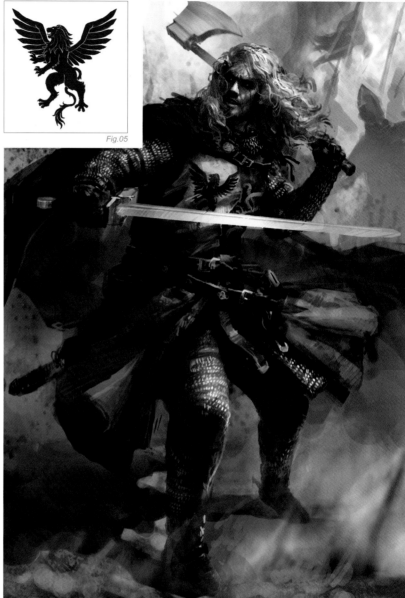

*Fig.05*

*Fig.06*

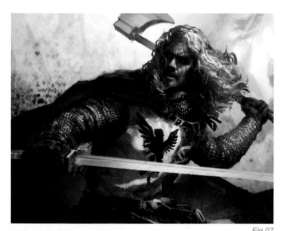

*Fig.07*

*Fig.08*

*Fig.09*

forwards making the dust spread. This time the pose was much more dynamic. More details were also added to the background: soldiers killing, flags fluttering, dust filling the air, grit spreading, and fire burning everywhere. The whole picture now looked more complete.

For the facial expression, I restrained the evilness a little to make the drawing more comfortable to view. While battling, I thought he would just be thinking about defeating his enemies, so I thought, why not emphasize the courageous side of this character as well?

## COLORING AND FINISHING TOUCHES

When I started on the coloring, first of all I switched the brush mode to color and painted directly on the black and white original (**Fig.07**). I then drew a basic pattern of the chain mail on the side (**Fig.08**) and started to redo the chain mail on the character's body. After erasing the originals, I pasted the chain mail pattern that I drew earlier piece by piece onto the main drawing, adjusting the shapes according to the different angles on each part of his body (**Fig.09**).

CHARACTERS

I really enjoyed certain war scenes in movies which I had seen, like the saturated orange-toned battlefield you might see as the sun is going down. Here I made a sketch – really quickly – according to this feeling for viewers to understand (**Fig.10**). I think the atmosphere created works very well. The only issue would be that the background is brighter than the figure, since he is backlit. I wanted the light to spot on the main character, but I also wanted the background to have the kind of tone I mentioned before. When combining these two atmospheres I faced some difficulties. Does the light have to come from the back when the background is very bright? If so, then the foreground should be backlit, but the main figure cannot be too dark or else it loses attention. So, how should I combine the two of them?

In the end (see final image), I assumed the light was coming from the right side. The background could still be very bright without any negative effects. I added highlights on his sword which reinforced the sword in the foreground, and I darkened the axe a little and made its texture more clear, so the axe looks further in the distance. Other than that, I also retouched the stains on everything, including his face, clothes, hair and so on. By adding stains it shows more traces of fighting on the battlefields. I also retouched the background by creating two brush strokes to handle the grit and dust scattered behind (**Fig.11**), and I refined all the details.

Here is a close-up of some of the detail (**Fig.12**); I usually leave many brush strokes on materials for polishing.

## CONCLUSION

Looking back to the original goal of using dramatic expression, placing the character in some sort of situation, combining his pugnacious personality with a brutal battlefield and giving viewers sensations of war – just like watching a scene from a movie – I think I have accomplished my goal.

Other than that, I also wanted to express, with many brush strokes, the pursuit of quality, instead of smooth types of stroke, and I think I have also achieved this. The solution for the figure's expression and the atmosphere of the battlefield also turned out to be satisfying. Finally, I have been very happy to share my thoughts here with you.

*Fig.10*

*Fig.11*

*Fig.12*

# ARTIST PORTFOLIO

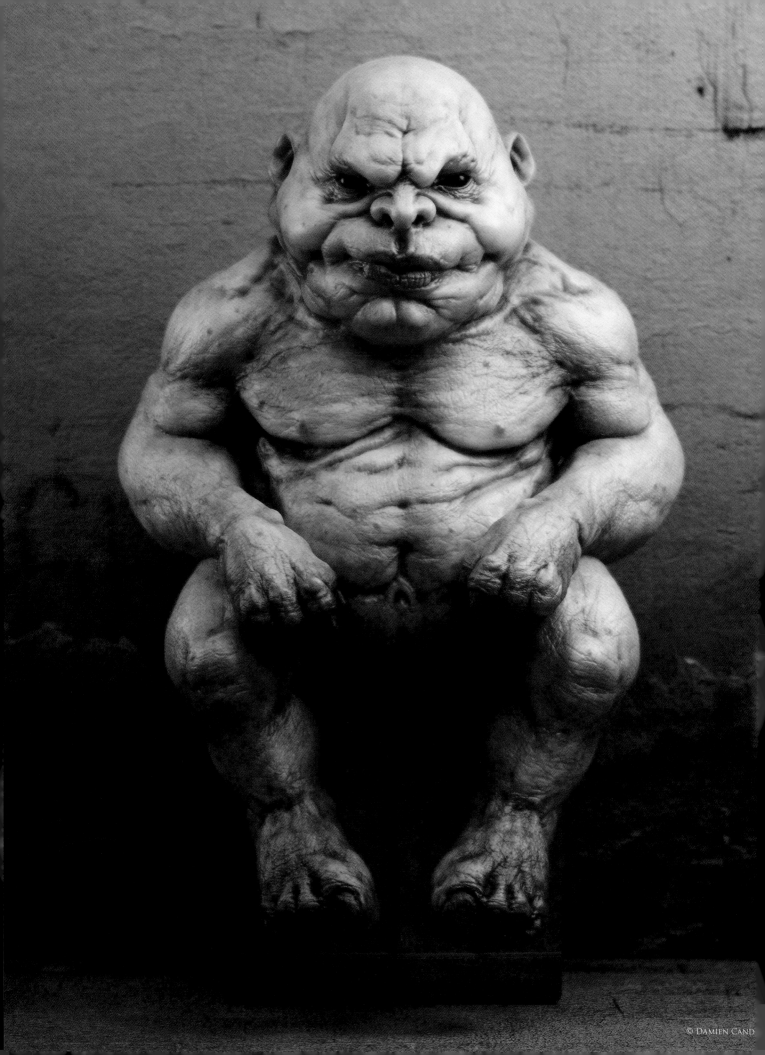

# THE GNOME
## BY DAMIEN CANDERLÉ

### CONCEPT

For this illustration, I didn't start from a concept or an original idea. In fact, this character came to life by chance, rather than from a well-planned project. It was first shaped when I was beta-testing ZBrush 3. In order to test the new possibilities of the software, I started sculpting from a sphere and, after adding more and more details, I ended up with the gnome's face (**Fig.01–02**). My goal was only to test ZBrush but, seeing how the model turned out, I decided not to stop with just a head… I just had to make a complete character with a full body and then bring it to life with a nice lighting set up!

### MODELING

The techniques used to model the head were rather simple and very close to traditional sculpting. The idea was to start with very basic shapes to block out the proportions and shape of the face. I didn't think about details such as wrinkles or skin texture at this stage; I simply concentrated on getting the right shape and position of the eyes, nose and mouth, and so on. Once I was happy with the result, I further detailed the model using the same logic, which consisted of sculpting the most important and visible elements before sculpting more subtle details. The procedure is always the same: start from something simple and gradually add finer details.

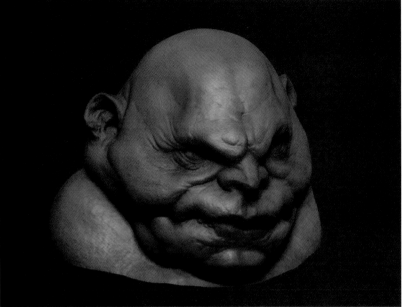

Fig.01

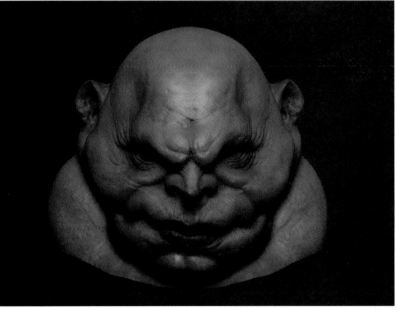

Fig.02

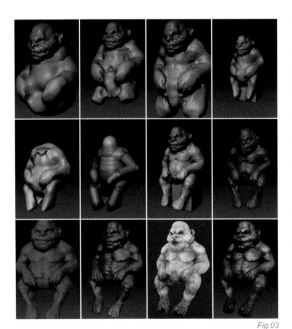

Fig.03

I applied the same principles for the body. I started with a sphere and quickly sculpted it to achieve the basic proportions. After modeling the head I imagined the character with a short and stocky body, so I tried to achieve that. Once I was satisfied with the basic proportions of the body, I recreated it using ZSpheres to make sure I was working with a clean topology. I later added secondary shapes, like muscles, joints and fingers, and then sculpted winkles and finer details, like nails. Finally, I added grain to the skin, and some small veins and spots.

At this stage, the modeling was almost done, but the head was still separated from the body. To achieve a single object, I used ZBrush's topology tool, which allows you to transfer details from one object to another with almost no need to retopologize an

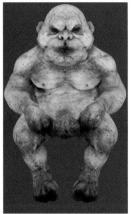

Fig.04    Fig.05

object, whilst keeping the level of detail. I used the latter technique to put the head and body together. A bit more tweaking was necessary to adjust the head/body junction, and the modeling was finally finished (**Fig.03**).

## TEXTURING

Textures are a very important element in the conception of a character. Bad textures can ruin a good model! I usually try to make textures which highlight the shapes and spirit of my models.

With the gnome, I wanted the skin to be almost human-like, to give it more life. I painted the texture directly on the model within ZBrush. The same principle as before also applies here. I first painted general shades and then added more and more details, such as skin blemishes and spots (**Fig.04**). Regarding skin textures, I tend to paint as neutrally as I can, with no shadow or highlight effects. I think this just gives more interesting results when rendering.

## LIGHTING/RENDERING

Then came the time to bring our friend to life! I had a model with textures applied to it, so I just needed a lighting set up at this stage. Since I wanted all the attention to be on the gnome, I created a simple scene (**Fig.05**) and set up the lights. To find the best

Fig.08

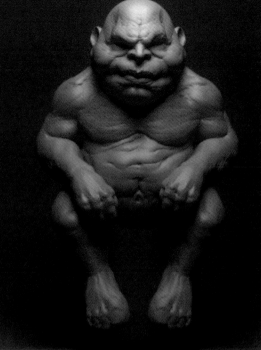

Fig.06

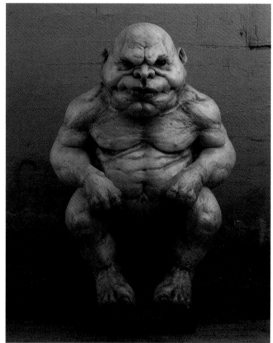

Fig.07

positions for lights, I often test with quick renders with no textures. This allows me to better understand how the lights affect the scene (**Fig.06**).

Once I was done with the lighting set up, I created the shaders. With the gnome model, the only tricky shader was the skin. I decided to render my scene with V-Ray because I like the quality of its renders and the way the shaders work. The most important thing in this case was to get an interesting skin aspect. To find the best

settings for the shaders I rendered each element of the shader separately so I could optimize them better before rendering them altogether. For instance, I started working on the Sub Surface Scattering with no diffuse, no specular and so on. Once each element was set up correctly, I checked how they worked when rendered together. I've found this helps to control the final result when I work in this way. I sometimes render with several passes to have more control, but didn't do it for this particular illustration (**Fig.07**).

## POST PRODUCTION

For the last step of this illustration, I used Combustion to finish the image. Discreet Color Corrector was really helpful for this task as it gave me complete control over the colors. This step allowed me to adjust colors, contrasts, hues and so on. Renders are, in general, a bit cold – very "computerish". Having a last step to adjust colors is usually the final touch which gives more life and power to an illustration (**Fig.08**)!

## CONCLUSION

Working on this character was very interesting and instructive for me. I was quite pleased with the result knowing that I originally only wanted to make some tests. This character came to life all by itself, which may be why it has such a strong feel.

Well, I hope you've learned something from this "making of". As a little extra, here is the gnome from a different angle and another lighting set up (**Fig.09**)!

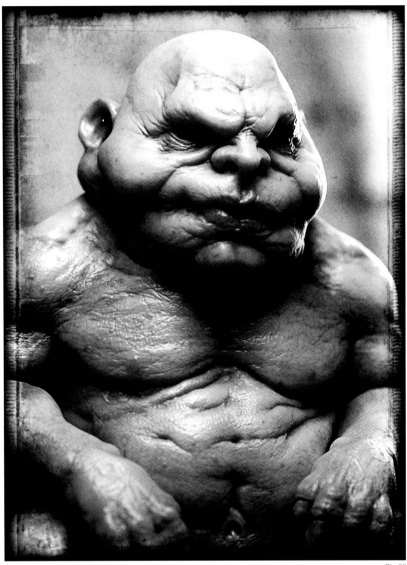

*Fig.09*

## ARTIST PORTFOLIO

ALL IMAGES © DAMIEN CANDERLÉ

# PURPLE ORCHID
## By Drazenka Kimpel

### Concept
Orchids and flowers in general have always been an inspirational force behind many of my creations. The intricate design Mother Nature has provided us with bares endless ways of stimulating my creativity. There are nearly 22 000 known species of orchids in the world. The source of inspiration to create this image flourishes in the depths of the Florida Everglades: the ghost orchid. I became familiar with this very rare species about a year ago.

The path to its natural habitat is somewhat unapproachable and holds a degree of danger; the trip requires a good amount of planning. Until the time comes for me to see the real life specimen, I have to resort to creating an image with one of the most common orchids. However, even the most common orchid is a feast for the eyes! With that in mind, I decided to create an image that would incorporate all of nature's attributes.

### Working Process
I love drawing and painting female figures, and I knew from the beginning there would be one featured in this painting. I wanted to portray a sense of serene beauty and tranquillity, not just of the character but the surroundings as well. In this stress-filled world, we all reach for a secluded, quiet place where we can feel relieved.

Fig.02a  Fig.02b

Fig.03

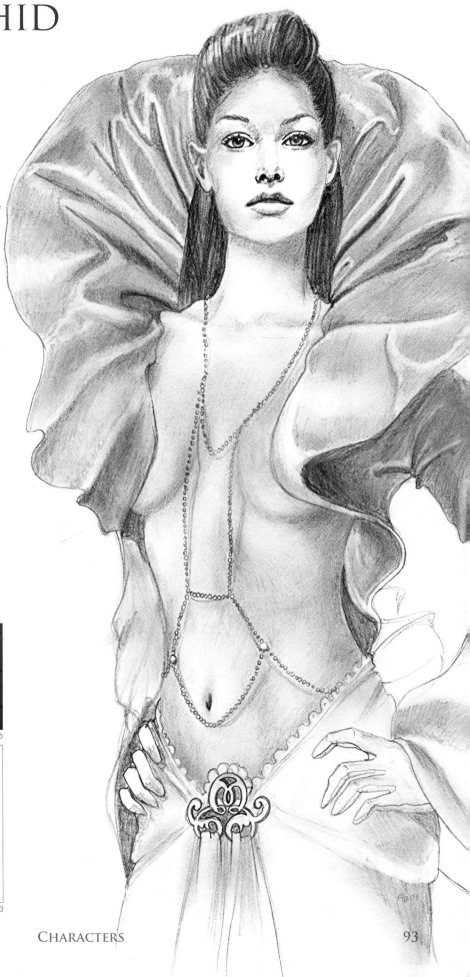

Fig.01

For years now, my workflow has begun with a good, solid concept sketch on paper (**Fig.01**). I like to support my work with as many reference pictures (**Fig.02a–b**) or study sketches (**Fig.03**) as I can find and create, to help me along the process. The concept of a female wrapped in a black cape-like garment with an oversized collar seemed like a great idea! This lifted collar would ultimately resemble the orchid petal, which I thought would look good in the image.

Sticking with the original idea was not as easy as I would have liked it to be. Most of the time, when I look back at the initial sketch and compare the final painting, there are many great differences. The process, however, remains very similar. The pencil sketch was scanned into Photoshop at a high resolution – normally 300 dpi. I don't necessarily convert my sketch into line work as I use the sketch as a guideline and go from there.

Before I start the painting process, I set the canvas size. I usually go with the standard framing size to avoid any unnecessary expense at the framing shop. After the initial canvas size was set, I began with the color selection and rough painting to get the overall feel of the surroundings (**Fig.04**). The color choice was not a problem in this case. I had a pretty good picture in my head of what I wanted and the general color tones I wanted to incorporate into the painting. To contrast the "coolness" of the greens I picked purple hues, just bordering magenta, for the collar and orchid flower to attract the viewers' attention towards the character.

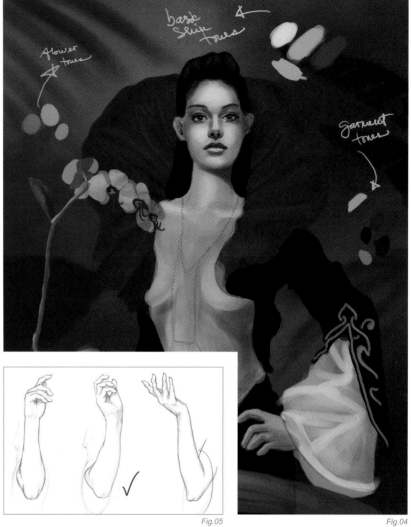
Fig.04

Fig.06

Fig.07

Fig.05

Composition can change many times during the production process. Clearly, the subject needed some major improvements. For one, I didn't like the position of her right arm. I wanted the character to interact in some way with nature. People tend to follow the hand movement, and so a good hand position can be very effective. This is one way to guide viewers' eyes around the painting. I decided here to go back to the drawing board and sketch several hand positions and pick from there (**Fig.05**).

I also decided to redesign the belt buckle. I found a photo of an oriental piece of metal fencing, which I thought would look great as a belt. I sketched it (**Fig.06**) and then worked on it in Photoshop (Edit > Transform > Distort) to make it look like a wrap-around belt that would sit nicely around the character's hips and accentuate the lower portion of the body (**Fig.07**). I found that manipulating a sketch in Photoshop actually saves more time, rather than sketching it time and time again and hoping that it would turn out just right. After incorporating fresh modifications into the image, I proceeded with refining and painting in the shadows and highlights (**Fig.08**).

Now that the hardest part was over, I was able to concentrate on the refinement and detailing. The refinement process was the fun part! I have used the same method and order for years. The following was used for the face, but I applied the same basic steps for the entire image (**Fig.09**):

CHARACTERS

• **Blending the colors** – a hard bristle brush, set to low opacity, switching colors with the Color Picker as I went along)

• **Smoothing the colors** – a hard bristle Smudge tool, set to very low opacity, for the extra smooth edges and color transitions)

• **Highlights and shadows** – a soft airbrush or airbrush pen, set to low opacity)

• **Texturing** – a color 3–4 shades darker than mid-tones, a rough dry brush, layer set to Opacity, brush set to Scattering and 10% angle jitter, applied to whole body)

## CONCLUSION

It's really rare for things to "click" in the way they did whilst painting this image. What helped a great deal was having a solid idea, which was imbedded into my memory, and which, at the same time, allowed me to avoid making many changes in the process. I am very happy with the final result, although thinking back to the starting point of the process I wish I had created a unique look to the orchid flower – perhaps something more "alien", but at the same time breathtakingly beautiful. Overall, the painting process has been a great creative journey!

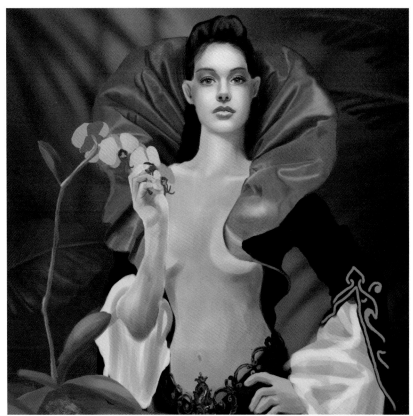

*Fig.08*

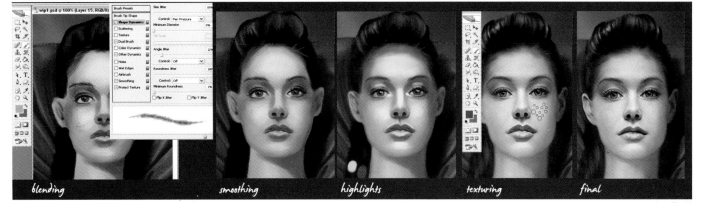

blending    smoothing    highlights    texturing    final

*Fig.09*

# ARTIST PORTFOLIO

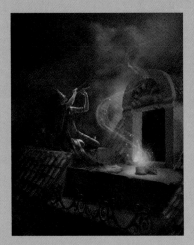
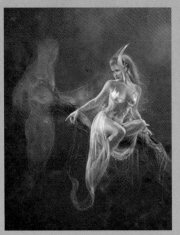
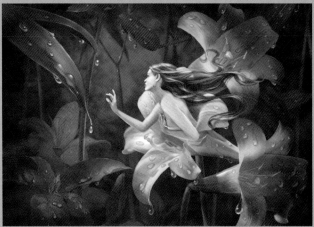

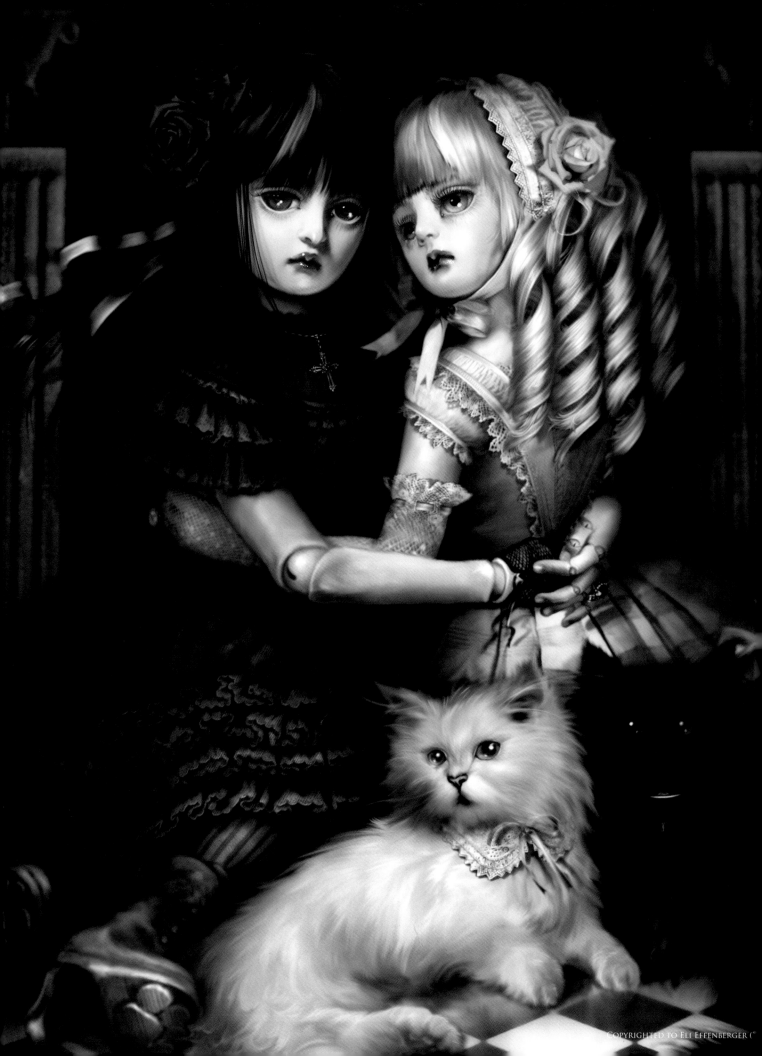

# BLACK CAT WHITE CAT

## By Eli Effenberger

### INTRODUCTION

It was one of those rare, lucky occasions where I could see the image vividly before my eyes, so I could foresee the coming stages and plan the workflow accordingly. As I started working, I knew I was going to take my time. Still very new to digital media, working with a pen tablet and using Photoshop as my only tool, I was planning to use the coming painting to depict realistic characters. My emphasis was on facial expression and tension in both composition and texture. The first thing I decided on was the color scheme. I wanted it to be nearly monochromatic so it would not crowd the composition and leave room for viewers to focus their attention on smaller details – such as subtle expressions – which would create the tension. I wanted this piece to have a "close to life yet not living" feeling, which was what I chose primarily to focus on. This is what makes one person (such as myself) fall in love with dolls, and yet another to get goosebumps from them!

Entirely inspired by French ball joint dolls, and the Asian Gothic culture, I was striving to communicate a "cute yet somewhat disturbing" atmosphere through this piece.

### THE "MAKING OF"

First I came up with a quick doodle for the positioning and composition (**Fig.01**). I scanned it and placed it on my

*Fig.01*

*Fig.02*

canvas on a layer set to Multiply. The doodle was mainly meant as a basic guideline, but not really to be used as the base line work. The positioning was still going to change, and also I wanted a more realistic feeling than my quick stylised sketch could portray.

The first thing I always do when starting on a new drawing is to quickly fill in just basic dabs of color to get the right balance in the foundation (**Fig.02**). I do this at a relatively low resolution: 150 dpi canvas. This is so I can quickly blend in many colors and not have to worry about traveling "long distances" on a huge canvas (my final resolution would be an intensive 600 dpi canvas for extra fine details, but it'll be much later in the painting before I boost up the dpi).

Now, since I was using a very basic scheme here, it didn't take very long and it wasn't very complicated to get the balance right. My basic colors were to be pinkish whites and creams, contrasting with dark, desaturated purples and blacks. I wanted to oppose these with dark, desaturated greenish shadows, and also use some red to enhance the deep rich pinks in the eyes and mouths, to get a slightly demonic look (**Fig.03**).

Once I had the basics done, I decided to get the main focus of the painting resolved as quickly as possible. This way I could be reassured that my painting was heading in the right direction. In my case, it usually means getting started with the faces and hands, as these are the most expressive parts in the painting. Just before doing this, I remembered to boost up the resolution on my canvas (from 150 dpi to 600 dpi). Then I could get into much more detail later on, as the work progressed.

As I started working on the faces, I realized that it would be easier for me to leave the eyeballs to be painted in a later stage. This was due to the fact that I was painting almost expressionless doll faces. Dolls have the most fascinating way of giving the impression of an emotion through their glass eyes, without ever having a defined expression to their faces. Painting the faces without the eyes would let me cognitively separate the porcelain face from the expressive eyes, hopefully resulting in an unusual, and intriguing, dollish expression.

The left hand of my black-haired doll was the most complex to draw. I focused on getting it to show the joints but still looking relatively relaxed and natural. Joints can look a little strained if you are not careful! One other point to focus my attention on was the positioning of both the dolls' and cats' feet in perspective to the viewer. After playing around with angles a little, I managed to position them so they poked out, but still kept aligned one with the other (**Fig.04**).

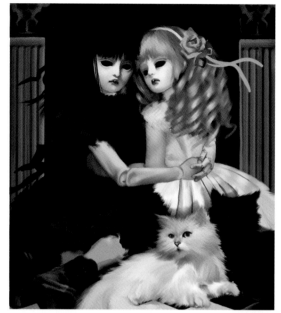
Fig.03

Fig.04

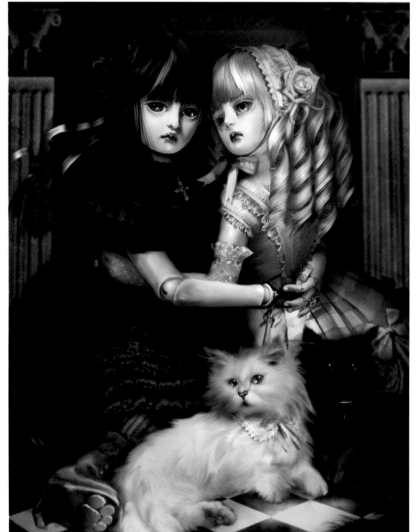
Fig.05

I then turned to the use of a hard, semi-transparent brush with its Shape Dynamics set to Pressure. I lowered the size dramatically and used it to pinpoint smudges in the fabrics and highlight them – not only to further deepen creases, but also to emphasize smaller features, such as lace detail and frill volume.

At this stage I was considering adding blood stains to the cat paws and floor, just for fun, but finally decided to discard them, and left the unsettling feeling to be created solely by the tension between the characters and through their strange expressions – they were actually becoming "creepy" enough already at this stage!

Finally, I got to the eyes. Painting them in on a separate layer, I played around with the shading until I got a nice

CHARACTERS

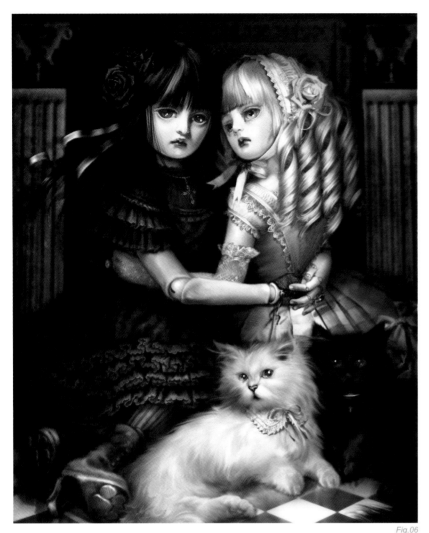

positioning of the eyeball and iris, and left it at that for the time being. Everything was looking pretty good so far, so from this stage onwards it was all about further detailing (**Fig.05**).

Rethinking some elements in the drawing, I added interest to the cats' collars, shoe design and jewelry. When thinking about striking equilibrium between the doll's shoe and the cat's paw, I came up with a shoe having a cat paw imprinted on the bottom of the sole. If she walks around in the mud (or blood) with them, she'll leave cat footprints all over the floor. (I've got to make shoes like that one day!)

Now that I had all the key features drawn in to my satisfaction, I decided to give the piece some additional thought – for color and fine finishing touches. I did a little color correction using a separate layer set to Hue, added a little shimmer to the eyes and lips, drew in a few stray whiskers and… done (**Fig.06**)!

## Conclusion

It was probably the first time I produced such a close match to the original image I had in mind when I first started working. Also, I found that the work process was quite consistent. There were no big mess-ups in the middle, so even though the painting took an awfully long time to complete, it was really fun and I learned a lot about digital painting – and that, after all, was my initial hope!

*Fig.06*

# Artist Portfolio

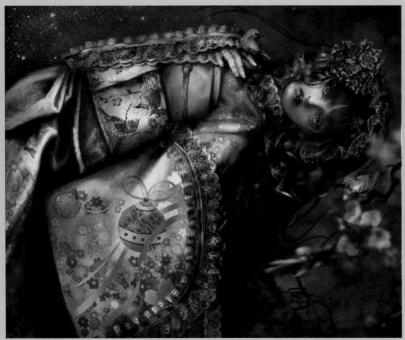

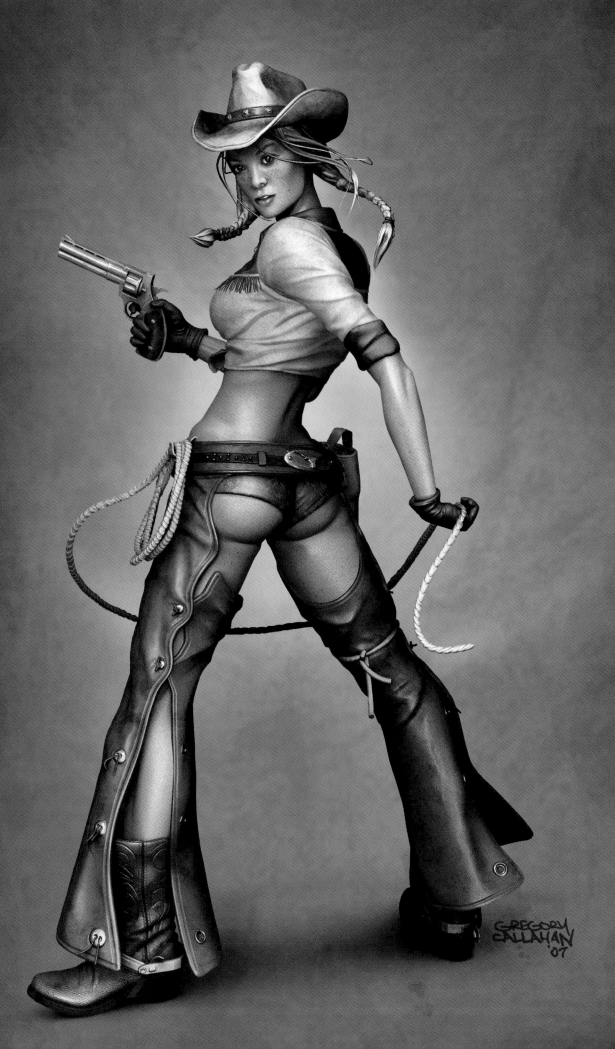

# BUCKLE BUNNY
## BY GREGORY CALLAHAN

### INTRODUCTION

The Buckle Bunny character was based on an original 2D painting I did years back (**Fig.01**), which was inspired by the classic pin-up posters of the 1940s and 1950s. The pin-up style art is now long gone to the ways of photo retouching, but I have always found the light-hearted poses and hand-painted images to have more character and life. Originally, when I completed the Buckle Bunny painting, I had planned to take the character into 3D, but pushing polys around with the software that was available years back was not my idea of fun! Years later, however, I ran across my old 2D painting and felt, with the advancements in sculpting software packages like Mudbox and so on, I could finally bring my concept into 3D. I had originally planned to recreate her to match my 2D painting, but the freedom that the 3D software offered me made it hard to resist changing my original concept.

### WORKFLOW

For this character, I really wanted to focus on the overall pose. My original pose was a little too casual, and I felt an action pose would give the viewer a better sense of how the character might carry herself. I decided to go with more of a Western gunslinger type pose. I very

Fig.01

Fig.02

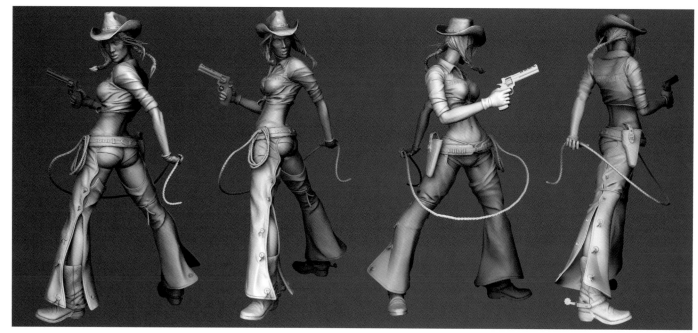

Fig.03

loosely blocked out the figure's pose, as if she was startled from behind and had drawn her gun. From there, I added other elements that would help sell her motion, like the hair and rope swinging around her. I liked the idea of using these props almost like an animator would us them as secondary motion in an animation. The initial costume design included a skirt, but I ended up replacing it with chaps. I felt the chaps added another layer of motion to the pose.

Once I had the overall pose completed, I then proceeded to improve the silhouette of the character. For this, I looked to the works of Scott Campbell, of whom I am a big fan! Campbell is known for doing really stylized female characters for comic books. I often look to his works for inspiration and insight on how to really push the human form. I have always liked the idea of stylized anatomy. Features like elongated limbs and really exaggerated female hour glass forms help enhance silhouettes by making them read faster.

**Fig.02** is the model in its rough form, separated into more manageable pieces so that each element could be defined.

Satisfied with the figure's pose, I then moved on to detailing the figure and her costume. Up to this point I left the cloth detail and most of the muscle definition undefined. For the cloth, I started by adding in what I like to think of as "key folds". "Key folds" are folds and wrinkles that will help define the material moving over the human form. I fine-tuned and detailed the major muscles prior to defining the cloth. From this stage on,

the character really began to come to life as the fine details, like hair, belt buckles, and other accessories were added. A total of 52 different objects were made to fully accessorize the character. These objects were mostly made from primitive shapes and then sculpted into the respective forms.

**Fig.03** shows the finished untextured digital maquette model. After having completed this stage I rendered out several different views to decide on the best angle for the final composition. The action lines on the early render (**Fig.04**) show the direction of the key cloth folds. Final details were accomplished by using a variety of stencils, such as snake skin and stitching, as you can see (**Fig.05**). Most objects were subdivided to a minimum of two million polygons to achieve the final level of polish.

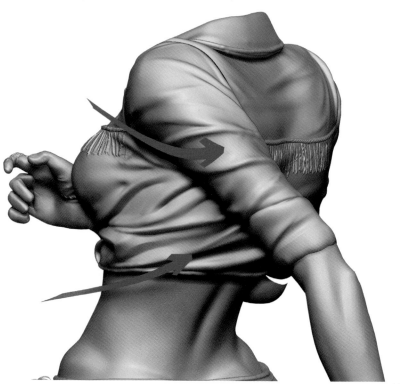

Fig.04

## LIGHTING AND RENDERING

For the final render, I was not looking to do anything photorealistic. I prefer more of a painterly style with a hint of photorealism. The final render was made up of five different render passes. The first pass was a hard light pass to emphasize shadows. Then a high contrast render pass was completed to emphasize the highlights. Afterwards, three different renders were made for each of the materials on the character cloth, leather and skin. Lastly, an alpha render pass was completed to give the figure more depth.

The base shader for the character was made up of depth, flat light, specular light and shadow renders (**Fig.06**). These were then composited using Photoshop to adjust the hue, contrast, and blending between the different render passes. Then a simple background was painted and a few Photoshop filters were added to help pull the image altogether.

## CONCLUSION

All in all, I am pleased with the final image, but, as an artist, I always feel there is still something left to be tweaked or fine-tuned. Having learned many new techniques, I feel I can move on to my next project with a better understanding of the tools available and continue to push the limits of my ability!

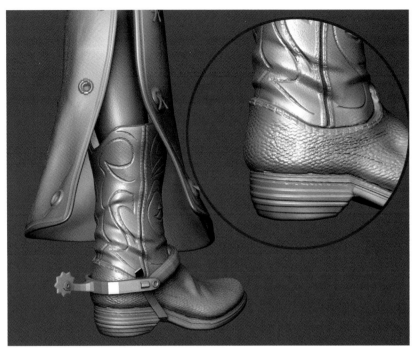

Fig.05

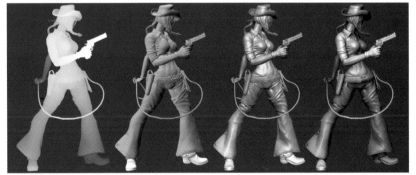

Fig.06

# ARTIST PORTFOLIO

# MIAMI
## BY GUILLAUME MENUEL

### INSPIRATIONS

Ideas for this illustration came from various sources. The first source was illustrations and calendars from the 1950s. I found the representation of the female body along with the colors to be fantastic. I was also inspired by some film characters which I really admire, such as those of the Coen brothers and Tarantino. The characters have a very tragic and dark side, but they are also somehow detached, almost phlegmatic. This illustration is therefore more narrative, than technical.

### STEP BY STEP

I immediately envisioned the composition of the image, the general atmosphere and the posture of the young girl; I wanted to achieve a film-like feeling right from the very beginning. One sketch created with a graphic tablet was enough to set the guidelines (**Fig.01**). I also knew I was not interested in making a pin-up with no personality, and that I wanted her to be in a strong environment without showing too much – almost nothing. Miami sounded like a good choice because of its heavenly surroundings and all the paradoxes that characterize it. This illustration was going to be done quickly!

*Fig.01*

*Fig.02*

*Fig.03*

I added the first shades of colors and started to build the initial volumes without any color harmony, as I didn't know at this stage what atmosphere I was aiming for in terms of colors (**Fig.02**). At this point, the girl was still sitting on a low wall.

As I started adding details I thought about the elements which would give depth to the image and which would allow the viewer to identify the personality of the character, and maybe to imagine her story. That's why I replaced the wall with a car, and changed her haircut to a shorter style (with a fringe plus an Alice band) which would contrast with the relaxed and almost rebellious attitude of this young girl – similar to Uma Thurman in *Pulp Fiction*! The cigarette was there right from the beginning (**Fig.03**).

From this stage of the illustration, I continued working on shapes and accentuating the curves of the young girl. I wanted to keep sharp shadows and a rough aspect. I never smooth my illustrations because I think they would lose some of their dynamic feel. That's why I usually work with sharp brushes in order to have strong angles. I try to find the right combination between round shapes and sharp angles.

Before going any further in the detailing process, I wished to concentrate a bit more on the coloring and lighting of my scene. I still had in mind the illustrations from the 1950s which made a lasting impression on me. I decided to give a vintage feel to the render while keeping the hot and sunny side of Miami. As with many of my other works, I used layers of material textures – usually photos of old walls or rusty metals – which I altered to get a render similar to, but not exactly like, an old photo. I also used a flat color layer and, by varying the tints and fusion modes of all these layers, I finally found the render I was looking for, after a lot of trial and error (**Fig.04**)!

Fig.04

Fig.05

Once the atmosphere was in place, I added further details, fine-tuned the model, and worked on the most important elements of my scene (**Fig.05**). I also added last minute details, such as the pack of cigarettes. At this stage I realized the "atmosphere" layers were too strong and had a bad impact on the overall image. I therefore adjusted the colors and increased the contrast in some areas in order to achieve a more coherent and dynamic overall image.

## CONCLUSION

I hope that the viewers will both feel the narrative aspect that I wanted to give the image, and be touched by the world I have created. Creating this image was a real pleasure as I instantly knew – and this is unusual for me – what I wanted to do, because I had very precise references in mind.

## ARTIST PORTFOLIO

# TORTUREMENT

## BY HENNA UOTI

### INTRODUCTION

The idea came to me in the middle of another painting. From the beginning, it struck to me as something really dark yet at the same time truly enchanting. Inspired, I dropped the painting I was working on and started searching for the right reference pictures...

### PROCESS

I spent some time trying different kinds of compositions and color schemes. I decided I wanted the girl to be almost centered, placed perhaps a little more to the right side, leaving much empty space behind her to cause some tension.

After I had the concept fully thought out in my mind, I started painting it without too much trouble. My first step was to begin vaguely sketching the character and other important elements. I used a tiny brush for really quick and simplified line art. I wanted to make sure I did not make the line art too detailed so it would not limit my creativity. Instead of just filling my line art with color, like one would do when coloring in the lines of a coloring book, I fully painted over my lines, carefully correcting any possible mistakes which I may have made earlier.

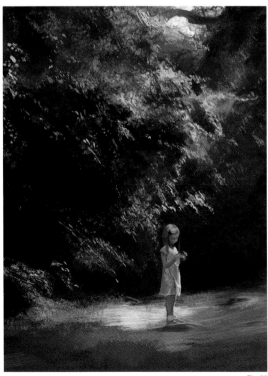

Fig.02

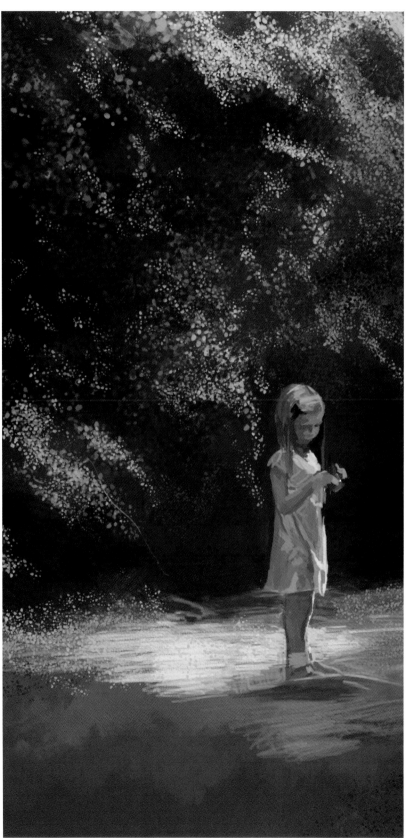

Fig.01

I then created a new layer and started sloppily blotching in some colors and shapes (**Fig.01**). I did this using a relatively big speckled brush (seen later in **Fig.05**), and reduced the size as I progressed with the painting. My method is not to expect the figure to be so many heads high, nor the head so many eyes wide; instead I rely on careful observation. I tried to keep the whole painting at the same stage while I worked so that I wouldn't end up in the situation where I had finished the face, but the background and other elements were still in the line art phase and with the background color showing everywhere. Colors hugely affect each other, so it's crucial to have them placed right from the very beginning!

Once I'd finished this stage, the painting already looked quite right to me; in fact, if I was after a looser, impressionistic style, I could very well have left the painting as it was and called it "finished" (**Fig.02**). To lift the painting to more realistic heights, it's really just a matter of polishing your brushstrokes and adding more details. Whenever I feel stuck with the painting, I simply change the size or settings of my brush and soon I find myself back on track.

A good painting is always a combination of good background and good character, so I try to give the background at least as much attention that I will be giving to the figure (**Fig.03a–b**). The way I paint backgrounds is almost always the same: I start with very small, unnaturally sharp brushstrokes which I later almost fully paint over with different types of airbrushes. Though this method can be very slow and nerve-breaking, to me, a

*Fig.03b*

good detailed base has often proved to be the key for believable realism! I find it much easier to soften or blend too detailed brushstrokes into the painting, whereas, on the contrary, it can be almost impossible to pull sharp edges where there haven't previously been any.

## Reworking

The painting was originally painted in October 2007, but I chose to rework it for the book entry. Aside from adding some tonal variation, I added some butterflies to improve the storytelling (**Fig.04**). Originally, the brush strokes were much rougher, but I decided to heavily smooth some of those out. I consider the smooth finish that you see here one of my latest tricks for creating an illusion of depth. Used in the right places I have learned that it really takes away the flatness of a painting and adds a romantic element. I have also learned that my clients often prefer the softer look.

## Conclusion

Technically, this one was really interesting to paint. In the early steps, when I was starting to sketch the leaves in, I used a variety of brushes with the spacing almost always set up to 100%. Instead of the long sweep, the brush then creates a line of several dots (**Fig.05**). I had almost never done so before, but now believe that it is

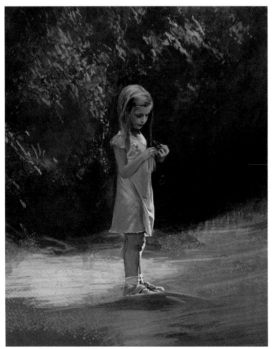

*Fig.03a*

CHARACTERS

an essential time-saver! I'll definitely be using this tool more in future, too. I love it when I feel I have learned something new.

The reworking of the image really changed my attitude towards this piece, and it was when the painting really started to breathe. There is a saying that it's fairly easy to reach 80% realism, but to reach 90% will take as long as it took to reach 80%, and to reach 95% will take three times as long. That's exactly how I felt. I feel embarrassed to think how many hours I must have spent just tweaking the colors and playing with the lighting! The computer makes it so easy to edit things, but one needs to stop at some point.

*Fig.04*

Later, when I posted this to galleries, I received some suggestions about the composition and the cropping. Though I had my reasons for the unbalanced composition, I actually prepared a differently cropped version of this painting to show on the front page of my website. It's crazy how much you can change a painting simply by cropping it differently!

I enjoy the contrast between the rather cheerful surroundings and the dark theme. You can't quite figure out whether she's just unthinkingly curious and destructive, or honestly doesn't care. Someone once commented to me that little girls (or the entire female species in general) can be a truly scary thing…

I couldn't agree more!

*Fig.05*

# ARTIST PORTFOLIO

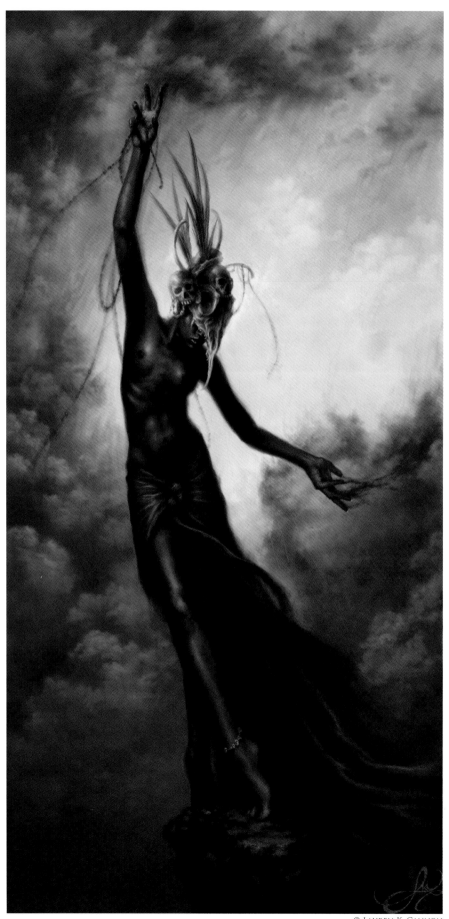

# Heaven Slain
## By Lauren K. Cannon

## Introduction

Much of my work is dominated by strong visual arcs in the composition, and this painting was no exception. When I started this image I had many things in mind: I wanted to create an image that had a tribal, surreal feel, typical of my images. But I also wanted this painting to be a landmark for me, in terms of technique and the challenges it would present. I chose a color scheme I had never attempted before, and to paint a deep skin tone (something I had never done with satisfactory results). The pose was to be the biggest challenge; I wanted the figure to be elongated and unnatural, but fluid and dynamic. The whole thing would be set against a really spectacular sky, with some of the most detailed clouds I'd attempted. I chose to keep the composition fairly simple so I could focus on the detail.

## Process

First things first: reference photos. I try to rely on myself for references as much as possible, and the way I use references is by compiling many different photos rather than directly copying from one source. In this case, I had to do four different sessions of photos in addition to looking at outside references to help with the skin tone and proportion. After taking a few quick references of myself in a trial pose, I opened Photoshop and created an initial sketch (**Fig.01**). When I work digitally, I rarely use line art; instead I plan my images with shapes and blobs of color. Color is very important to me, and it's also something I struggle with, so I try to lay out my palette as soon as I can.

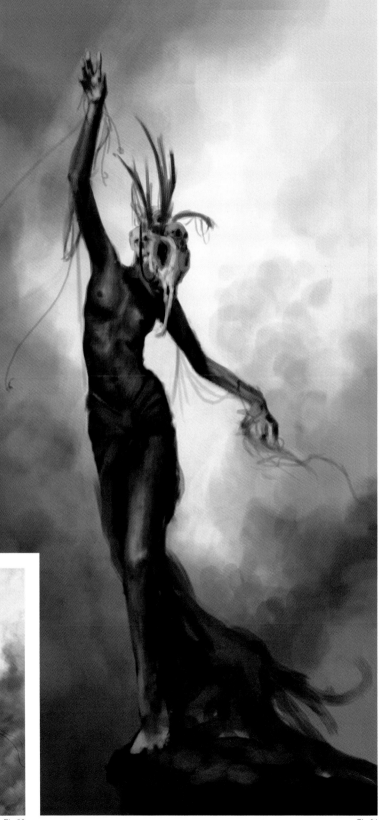

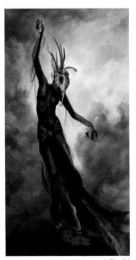

Fig.02          Fig.03          Fig.01

Once my sketch was done, I noticed the pose was too stiff and awkward, not at all fluid like I wanted it to be. The most important thing for me to get correct early on is the composition and general "flow" of the picture, so the first thing I did was to rearrange her legs so that her front leg followed the curve of her spine (**Fig.02**). This also reinforced the directional flow of the cloth, creating a smooth visual arc sweeping down the canvas. I also pushed more vibrancy into the colors, deepening her skin and adding deeper purples and oranges to the sky as I refined the shape of the clouds to complement the movement of her body.

I detailed her face and headdress first, but soon ran into a wall when I got to her torso (**Fig.03**). It was without a doubt the hardest part of the painting, and took me several repaints to get it to look right. Another challenge was the skin tone. I used a deep, dusky purple as the base of her skin, and complemented it with blues and rosy tones. But I discovered that the key to making dark skin look real is the highlights – I pulled in the pale blue of the sky for bold highlights on the skin and got a surprisingly natural look!

After several failed attempts at fixing her torso, I turned my attention to the sky… When painting skies, I use a large, grainy texture brush to build up an interesting base before I paint in clouds (**Fig.04**). This way, even blank portions of sky have subtle textural depth. For the clouds themselves, I use a combination of a textured round brush and a normal hard-edged round brush to give them definition without making them too sharp (**Fig.05**). Exaggerating the saturation of the shadows within the clouds tends to make them more realistic, and it is also important keep lighting in mind: clouds should always be lit the same as the subject.

Fig.04

Fig.05

Fig.06a

Fig.06b

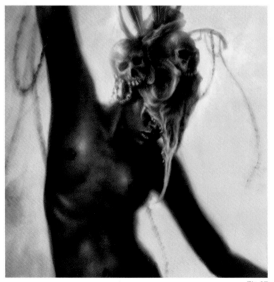
Fig.07

After finishing the clouds, I move back to the figure, this time detailing her hands. Because hands are so complex, I always use a direct reference for them and build the shapes up slowly (**Fig.06a**), and then slowly refine the details. In this image, I wanted her hands to have a sense of motion, so I employed several little tricks I often use to convey motion in an image (**Fig.06b**). One is to duplicate the layer with her hand on it, rotate it slightly, and then paste it behind the original layer at very low opacity. This creates a subtle double image without having to make the hand all blurry. Another trick is to create lines "rushing" across the canvas. This can be done in two ways – one is to erase thin portions of an object, as I did with the strands of beads; the other is to take a very small hard brush and draw thin, sweeping lines down the canvas and then set them to very low opacity. I did this all over the sky in this image. It is barely visible, but creates a subtle rushing sensation that follows the arc of the figure.

Finally, I tried to tackle the torso again, and after many frustrating attempts I finally got it to look right (**Fig.07**). Persistence pays off! But I also had to make the edges of the torso look coherent with the way I had treated the headdress, with a soft and glowing edge.

CHARACTERS

You can see how soft and undefined the edges of the figure body are against the sky. This serves two purposes: one is to make the figure look more cohesive, and not pasted onto the background, and the other is yet another way to suggest movement without being over-the-top blurry. It also adds a nice touch of ambient light to the painting.

The last two things finished in the image were the cloth and rock (**Fig.08**). Cloth is something I have to be careful with – I love making it look very soft and smoky, but I must take care not to sacrifice detail. I painted it the same way I paint clouds: a semi-soft textured round brush, and a hard brush to keep some definition. And finally, the rock, which was done with a hard brush set to "wet edges", which is the best way I've found for creating a rough texture manually.

## CONCLUSION

It is not often I complete an image and still like it months afterwards. This painting, though, is one I still feel satisfied with. I felt I made a huge leap in terms of color and technique, which is precisely what I set out to accomplish. I consider it to be a turning point for my work and it remains one of my strongest pieces.

Fig.08

# ARTIST PORTFOLIO

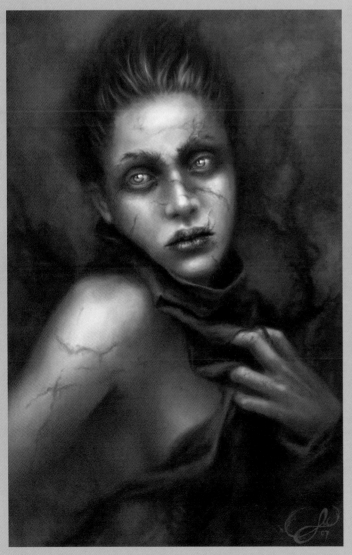

# Longmen's Fall, Revisited

## By Loïc e338 Zimmermann

### Introduction

For a long – very long – time I've been thinking about having a tattoo. Thank God I waited for all these years, as I never felt ready to design it, until now. This year, for some strange reason, I felt it was time; I felt I was ready.

The first step in the process was to meet a good tattoo artist – someone I could trust, someone with experience, and someone who could put his ego in the closet regarding interpretation of the design I'd give him. I was clear about that: the design I'd provide would have to be precisely needled on my skin. No freedom at all!

We spent a while discussing the positioning of the tattoo, skin limitations, time, and the process itself. For me, it was obvious that CG had to be part of the genesis. I create characters for a living, I texture them, and obviously "unfolding" was so close to what the guy was doing by hand to design a tattoo, I had to test this on me the digital way! It is safe to say that the tattoo artist was confused at this stage.

### Preparation

I went back home, with tons of Japanese references, and I started the design and worked on it night after night.

Then I gave a call to the company I work for, Quantic Dream. My fellow supervisor was OK doing a 3D scan of my torso, and so we did it. This is how we were working for their upcoming PS3 project and so, to me, this was the best way to proceed for my new quest. Having a scan as a guideline would provide me with the exact proportions, and it was necessary to be really precise since the design would have to be unfolded and then wrapped onto *my* body.

After the scan session was complete, a lot of work was necessary to combine the different patches together (their scanner is not a body scanner; we use it for faces), and then more work was needed to create a cool, easy to work with, topology on top of it (**Fig.01**).

I made two UV layouts: one for the global texturing and one for the tattoo. This particular layout had to take into consideration real stretching and how the tattoo artist would apply the template on my skin. So I created some

*Fig.01*                    *Fig.02a*

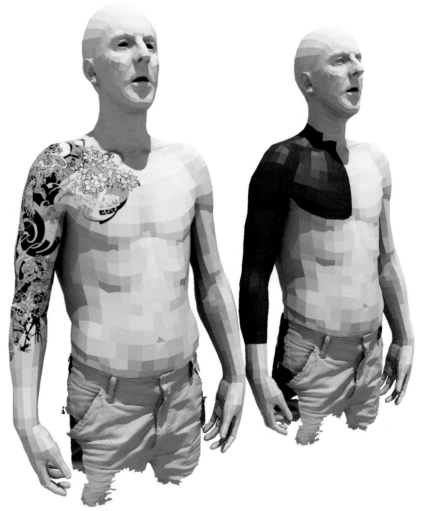

*Fig.02b*

cuts. It would be a lie to say this was 100% correct; we had to do some minor adjustments. But still, the idea was there and the next one should be perfect since I know how to deal with the tricky areas now (**Fig.02a–b**).

The rest of the process was classic, since it was regular character work.

## CLASSIC CHARACTER CREATION

Once the low-res model was finished, and the tattoo was designed and applied, I decided to push this project further, as a demonstration of my skills…

It was about time to create some textures for the body. I did it in the same way as I do for my job, using real photos projected and baked. Then, with Photoshop, I combined all those projections together and post painted on top to improve the result. After that I did a declination for the specular map, SSS and so on (**Fig.03**).

The shader used was the good old MISSSfastSkin for MentalRay. Nothing in particular to say here really, other than the use of layer textures to combine the tattoo with the various elements (diffuse, subdermal) in various opacities. I also used a couple of extra nodes (setRange) in order to reuse some of the many textures, instead of creating plenty more of them (**Fig.04–05a**).

Fig.04

Fig.05a

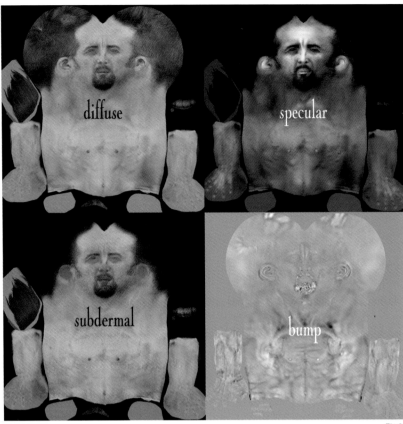

Fig.03

## ZBRUSHING!

The fun stage was next, that is "ZBrushing", creating a low definition mesh and a very detailed, high-res geometry. The cool thing was that references were easy to find. A mirror and this was it! I wanted to be objective and not turn myself into some kind of hero. It was fun to do and I realized that I definitely could spend some time at the gym (**Fig.05b–07**).

## FUR…

One more step, which was the worst for me but necessary, was the Fur! Gosh, I hate this part so much I could just drop CG and work in a fast food chain! Well, I might be exaggerating just a bit… So Fur was necessary for the few hairs that I have: my beard, and on my arms. I also decided to create the 12 hairs on my chest in the same way (**Figs.08–09**).

## CLASSICAL STUFF AGAIN

Then, once again, there was more classical stuff to be done: tuning the shaders, the displacement, the SSS, and so on, and finishing it off – a cool render and a couple of pictures for the sake of CG art!

The posing was quickly done within ZBrush with the Transpose function. It's efficient enough for basic posing which I intended to do for these pictures, although for tricky posing I still prefer using a regular rig within Maya.

## THE TATTOO DESIGN AND CREATION

I'm a huge fan of Japanese culture. For me, the tattoo had to start from the classic Yakuza schemes. I knew very early in the process that I'd go for a black and white design, although, after a while, I decided to add a 50% gray color in some areas. It

had to reflect my 2D work, my taste for graphic design, and have a few symbols for fun. It also had to include halftones, since I use them all the time in my work; I find them very appealing and I guess it comes from my taste for comic books and pop art.

Halftones are sometimes used in classic tattoos, but they are random and noisy. I wanted them to be directly taken from a pattern and be very regular. I remember this session pretty clearly; we printed a full page of them on carbon paper, applied them to my arm, and then Arno, the tattoo artist, outlined the areas to draw. And I started counting the dots, one after the other, for two hours. There are more than 1000 dots!

In my research, the theme was important, and I found in some classic designs a hybrid creature, halfway between a fish and a dragon. I read more and discovered the true origins of dragons in the "Longmen's fall" story; a Koi fish that succeeded in climbing a waterfall and then turned, during the next 1000 years, into a dragon. That was it!

I was jumping from Photoshop to Maya all the time to improve the positioning, fill the empty portions, combine elements, and so on… this is why I say that it's not "only" a 3D render, but also a 3D process in creating the tattoo.

I added clouds and flowers around the dragon to create a full environment that would truly make sense with the next figure to come on my back.

It was not enough though, since the whole thing looked like a regular Japanese tattoo. I wanted some very modern, graphic elements in it and I started to merge and erase the design with portions of my brand new logo. This is a very vector line-based identity and it gave the whole thing a new dimension. That's it (**Fig.10–11**)!

*Fig.08*

*Fig.09*

*Fig.05b*

*Fig.06*          *Fig.07*

The gray color is not a regular black ink dissolved in water, but a true gray pigment that definitely looks different!

## CONCLUSION

This project was a very interesting experience. Technically speaking, I finally had, apart from my work, the opportunity to push a CG character quite far, compared to what I usually do for my illustration works. Don't get me wrong, this is always done on purpose: I simply don't find it interesting to spend weeks on a character when it's "only" for a still image, and since I have no time for animation (although I like it a lot) it just doesn't make sense to me. In this particular case, it was necessary.

The way both CG and tattoo audiences received this project was a great source of motivation, and it also happened that I found a new job because of it, which could lead to an interesting experience within the coming months.

Finally, this crazy idea, which has been hiding in my head for years now, took shape through 3D and is now real. It's strange and I understand that some people may not dig it as much as I do, but for me it's a real joy having this picture under my skin. I guess that this process will become easier and more common in the future, but I'm pretty sure I was one of the first to go for it the way I did. It may sound stupid or lame, but I'm proud! Cheers to you and thanks for reading this.

copyright e338
Fig.10

Fig.11

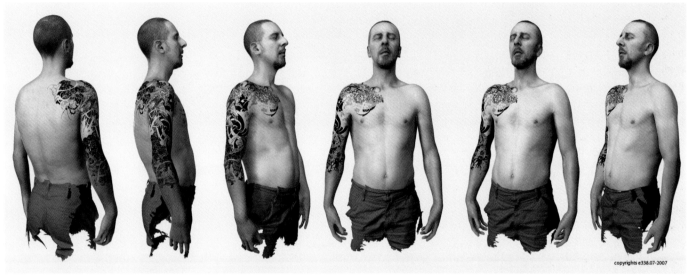
copyrights e338.07-2007

# ARTIST PORTFOLIO

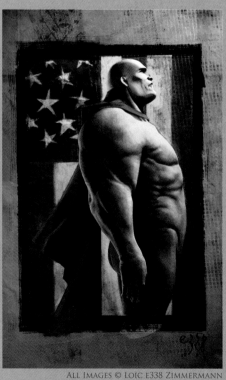

ALL IMAGES © LOÏC E338 ZIMMERMANN

CHARACTERS

121

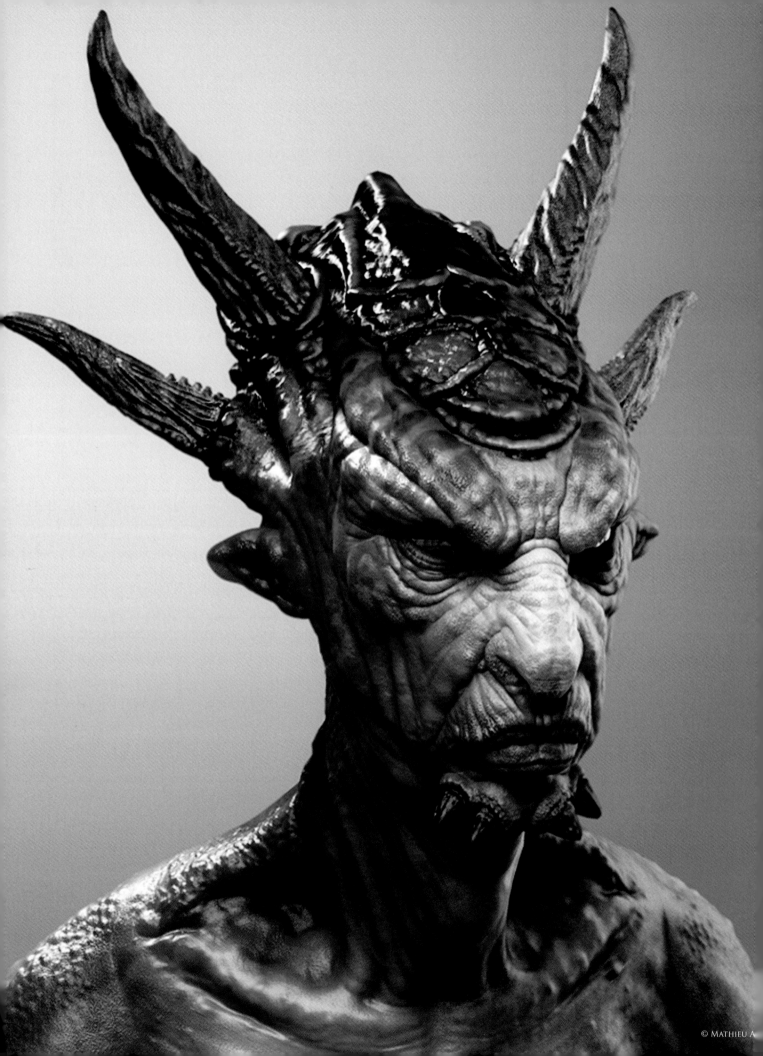

# CREATURE CONCEPT

## BY MATHIEU AERNI

### 3D CONCEPT

The idea for this creature started when I was looking for a way to use horns in an unusual way on a goatish-like creature. I came up with the idea of using four backwards-pointing slim horns. It was very clear in my mind that I didn't want a brute type creature with a bodybuilder's physique; instead I wanted him to be lean and light. Despite its unfriendly looks, I wanted my creature to come across as wise and old. I started to work with those ideas in my mind, and through the entire concept phase I used ZBrush as a "3D sketching tool" rather than as pure production software, as I do at work. To me, this project was more about exploring ideas in 3D than creating a specific illustration. The idea was to develop and design a creature directly in 3D that looked believable, with strong character and personality. As with 2D concepts, I believe presentation and rendering are very important to deliver the right feeling for your artwork, so I gave a lot of attention to rendering and lighting after my modeling was finished. Over the next pages I would

Fig.04

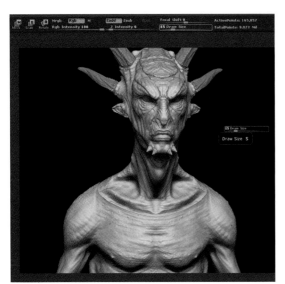

Fig.02

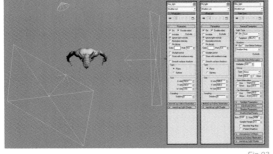

Fig.03

Fig.01

like to go over how I created this creature, starting with the base mesh in 3ds Max, the modeling and texturing stage in ZBrush and the lighting, shading and rendering in 3ds Max.

### MODELING

For the modeling, I started with an old bust model that I had done in the past, using the box modeling technique; starting with a primitive, I deformed and extruded it until I achieved what I was looking for (**Fig.01**). The horns were modeled separately for more flexibility and were made from primitive boxes deformed as an editable poly. Then I imported my bust into ZBrush and started deforming the model using the move tool in Symmetry. At that stage, it was very important for me to keep the mesh at the first level of subdivision until my new shape was pretty much locked. I work with a complete bust even if I plan to do a close-up of the head for a final render, as it helps to get the proportions right. Also, I may use the model in the future in a more completed image that shows more than just the face.

Once I was happy with my new bust I was ready to work on the details (**Fig.02**). Note that I separated the head from the bust, which gave me the option of separating them into two different ZTools, in case it became too heavy to handle. I usually never go to a higher subdivision level before I am sure that I have done everything I can to make the one I am working on look nice. This prevents me from having a model full of details with uninteresting shapes, which is so easy to do in software which gives the opportunity to go into deep details – like ZBrush.

My modeling method is pretty simple, using basically only the standard brush and smooth brush. For this piece I tried to keep the few basic inspirational guidelines, which I mentioned at the start, in my mind – I iterated on the details a few times if I considered that my concept looked too clichéd, or if it went in a direction that was way too far from my starting idea. A few ideas came from animal pictures, for example the protective scales on the top of this head came from a picture of a crab. I tried to do my best to keep in my mind the things that I have learned through modeling realistic humans to make it believable, such as the muscle masses and the direction of the wrinkles.

## LIGHTING

Once I was close to being done with the modeling, I rendered a displacement map in ZBrush, exported the subdivision level 3 and put all those things together in 3ds Max to begin the lighting process.

I used V-Ray as the renderer for this image. My lighting set up was a very basic three point lighting (**Fig.03**). The key light and the fill light were both V-Ray lights. The first one had a slightly yellowish tint, while the second was

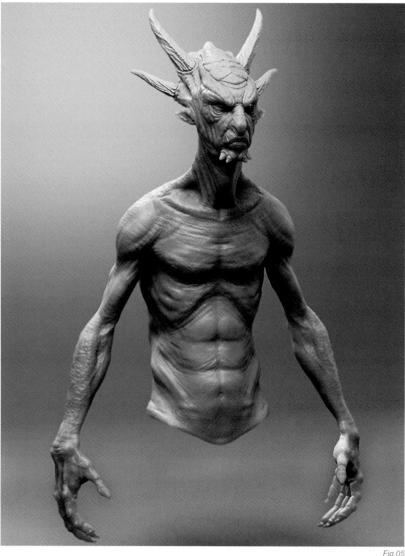
Fig.05

TRANSLUCENT AND REFRACT. MAP
Fig.06b

DISPLACE AND BUMP MAP
Fig.06c

blue. The backlight turned out to be more efficient as a standard 3ds Max spot, instead of a V-Ray light. This light is the one that provides the white rim that gives a little more definition to my model's outline.

I chose not to use much indirect illumination to provide more contrast to my image and to save precious render time. All my render tests were done using a basic neutral gray material so I could set up an interesting lighting very quickly while knowing that the color texture would not change the result significantly (**Fig.04**). In this case, I also tried it with

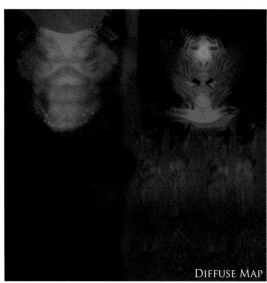
DIFFUSE MAP
Fig.06a

CHARACTERS

a more fleshy material in order to have a more precise idea of how the lighting reacted with colors closer to the direction where I want to go with the textures (**Fig.05**).

## TEXTURING AND MATERIALS

For the texturing process I returned to ZBrush where I did all the texturing, switching from ZBrush to Photoshop using ZAppLink. This process is very intuitive and extremely convenient for painting handmade textures, giving you the ability to paint directly on the model with those good old tools from Photoshop, like the Dodge and Burn tools. I started painting the base colors, then added a shade of lighter ones and then added motifs like stripes and dots. I finished with three textures (**Fig.06a–c**); the diffuse map, the translucence map (which is also used as refraction map) and the displacement map exported from ZBrush (which is the one used as bump map). In **Fig.07** you can see what my material looks like. I made several render tests using different cameras and playing with darker backgrounds and more translucency (**Fig.08**) before definitively choosing the final set up.

## CONCLUSION

I had so much fun working on this project. In the past I have worked on a number of projects where I have to put into 3D a precise idea, but working on personal concepts is an extra challenge for me, and is definitely an area where I can get more satisfaction. To me, this project was about pure creativity and the liberty that a relatively new software like ZBrush gave me the extra freedom I needed, and showed me that these programs can turn out to be a very interesting tool for creativity. Of course, there are many improvements that can be made to this creature, and I intend to work on it in the near future while completing its body, posing him and putting him in an interesting context.

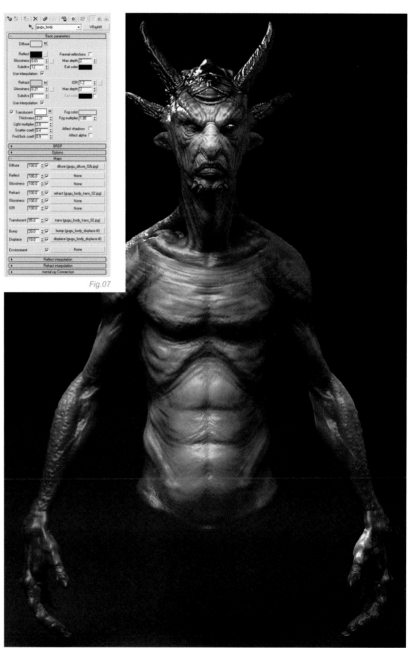

Fig.07

Fig.08

## ARTIST PORTFOLIO

© Nykolai Aleksander

# LUCIFER
## BY NYKOLAI ALEKSANDER

### INTRODUCTION

The idea for this concept of Lucifer first emerged when I started getting involved in the writing of Andrew E. Maugham's novel, *Convivium*, back in 2001. Of course, the character of Lucifer from scripture and myth was nothing new to me; in fact I'd always had a fascination with this elusive creature. However, it never occurred to me to draw or paint him, until *Convivium* came along. One of the earliest sketches I still have was done on a small piece of scrap paper (**Fig.01**), but painting him seemed too daunting a task then. When I finally decided it was time to do it, I wanted to capture the character as he was described in the book, the untouchable yet vulnerable side of him that made him appear real, while still retain the ethereal beauty, power and wisdom that he is known for. I first attempted it two years ago (**Fig.02**). I was satisfied with the result to begin with, but then realized something was missing. The only way to figure out what that something was, in my mind, was to paint him again.

### PROCESS

First, I only had his face in mind. For me, the face of a character, and specifically the eyes, are more important than anything else. Since I wanted to stick to the original concept of his appearance, it was easy for me to sketch (**Fig.03**), but a simple portrait wasn't enough, so I tried a few poses before deciding on an almost statuesque one, draped in heavy fabric akin to the iconic images painted by the great masters (**Fig.04**). It also echoes a scene from the book, one that I have always been very fond of.

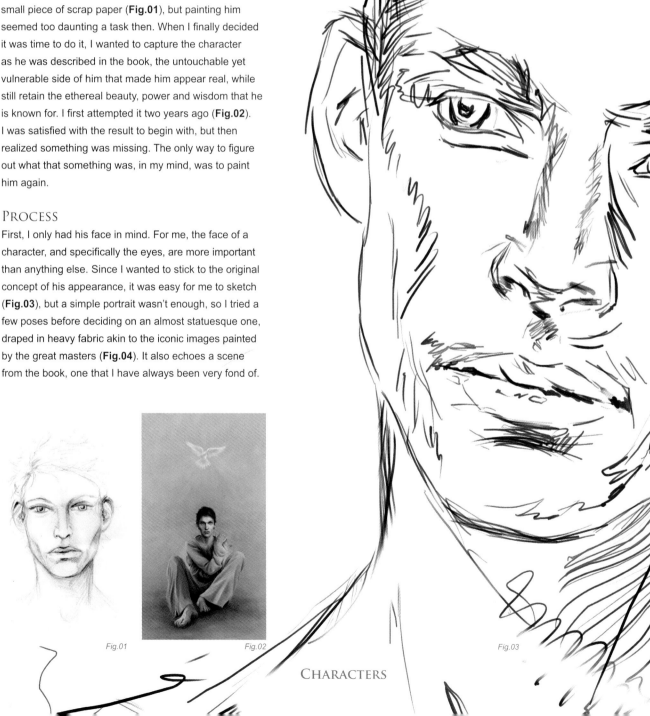

*Fig.01*          *Fig.02*          *Fig.03*

I knew from the beginning the color scheme would be cold, a majority of blues and greens. Not just because it works beautifully with the character's appearance, but it also aided what I wanted to convey. Once I had blocked in the basic colors and refined a few key features (**Fig.05**), I began to think about some details, whether I wanted to add more to the painting or not. At this point, I was very unsure of any kind of background, but knew I wanted to do something with the fabric. There was no way to get away with any shortcuts, since I wanted it to have a certain weight and flow. I had to fully paint the whole thing to keep up the level of realism I was headed towards (**Fig.06**), using default round and custom texture brushes (**Fig.07**). My duvet cover was a great help there, as it is the kind of heavy and shiny cotton brocade that I was after.

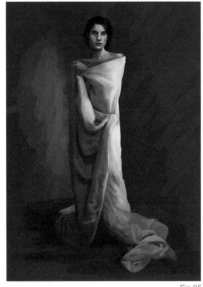

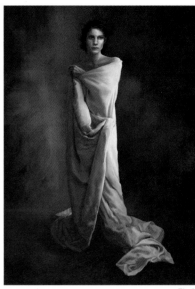

*Fig.05*

*Fig.06*

When the bulk of the fabric was done, I went back to the face to refine it some more, and to work out whether I wanted the short hair from the sketch, or keep the longer hair I'd been painting. I also played around with his eyes, changing the position of the iris until I was happy (**Fig.08**).

Once I was satisfied with the face, I dedicated most of my time to the brocade pattern of the drapery. I felt that it had to be something very light, as otherwise it would drown out everything else in the picture.

*Fig.04*

*Fig.07*

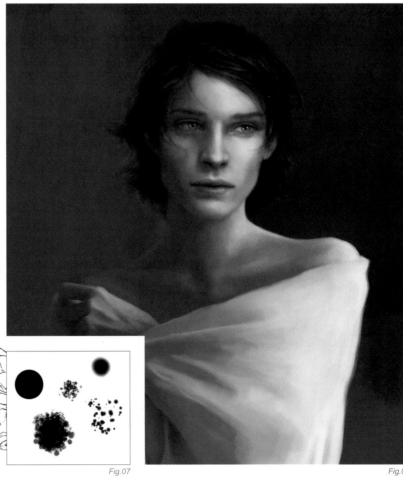

*Fig.08*

CHARACTERS

I opened a new file to paint a part of the pattern, which I wanted to be repetitive, but not so much so that it was painfully obvious (**Fig.09**). I then dragged it across to the painting to carefully piece the sections together. Just dragging and dropping the pieces to make up one big block was no good, as the fabric twists and turns, and certain sections overlap others. Once all the separate pieces were in place on the actual painting, I merged the sections that belonged together, erased the overlapping parts, and finally merged all sections to become one layer (**Fig.10**).

I knew I wanted a white on white brocade, so the first layer was filled with a blue tinged white, and then set to Overlay. I adjusted the layer's opacity so it was only faintly visible, then duplicated and inverted it, and set it

*Fig.09*          *Fig.10*

to Linear Burn. I then erased certain parts within the light areas of the fabric from the first layer to let the darker pattern come through (**Fig.11**).

This was already quite nice to look at, but I wanted to integrate an emblem of some sort, as if the drapery were a banner or flag rather than something to be worn. Again, the reason for this lies in the story. I opened another new file and started designing the emblem, using the Custom Shape tool and then altering the default shape to something that suited my needs (**Fig.12**).

Once I transferred the emblem onto the painting, I altered the shape to go with the folds, cutting and moving parts around, and erasing any overlapping sections. I also blurred it slightly to get rid of the sharp edges. When that was done (**Fig.13a**), I duplicated the layer, inverted it (**Fig.13b**), set both to Overlay, and then erased the brocade pattern beneath it (**Fig.13c**). The lighter layer was only added to give the emblem a light glow.

Pleased with the character, the background almost emerged on its own. To me, some steps were faintly

*Fig.11*

*Fig.12*

visible in the colors, so I just ran with it. It worked in this case, as anything too elaborate again would have taken away from the character. As a last step I faintly textured the background with a couple of custom brushes, and then played with the Color Variations to fine-tune the colors and push the palette that little bit more.

## CONCLUSION

I feel that, with this painting, I have at last managed to capture the essence of the character, as well as the scene from the book, albeit having taken some artistic license regarding the latter. Something I am also rather happy with is the fact that, despite the overall cold atmosphere and color scheme, the character himself still radiates warmth without losing his distanced, majestic appearance, which certainly was helped along by the drapery.

Fig.13a

Fig.13c

Fig.13b

I'm a rather patient person when it comes to painting details, but painting the fabric folds has taught me that patience is not everything. I was ready to drop this piece many times, cursing myself for the drapery. I only kept working on it because I wanted to see this finished, see it in front of me as I'd seen it in my head for over five years. And I'm glad it's done… for now.

© Nykolai Aleksander

© Otherworld

© Otherworld

© Nykolai Aleksander

# LAUGHING OUT LOUD
## BY SANJAY CHAND

### INTRODUCTION

For as long as I can remember, I have always been fascinated with movie monsters and with character design in general. When I was a kid, I would spend many hours of the day drawing my favorite superheroes out of comic books. Fast forward 20 years, I found myself pursuing a career in computer graphics at the Gnomon School of Visual Effects in Hollywood. It was my last term at the school and I was enrolled in a creature creation class that was taught by the founder of the school, Alex Alvarez. Throughout the course, our objective was to find concepts by well-known artists and attempt to replicate them in 3D. Eventually, I became confident enough in my workflow that I decided I would design my own creature, based on what I had learned in the class. My goal was to create a creature that would be expressive, dynamic, yet have believable anatomy. Not only did I plan to manifest these qualities within the model itself, but I also wanted to create the desired mood and effect through lighting and compositing, which is what I naturally gravitate towards. My inspiration and drive to create this creature stemmed from my experience with the creature design class, and also from my childhood obsession with superheroes and movie monsters.

### MODELING

For this piece, I did not start with a concept sketch, but with a polygon cube in Maya. I roughed out the silhouette and began to adjust the overall proportions to create a dynamic feel. As with most standard character workflows, I only modeled half of the polygon mesh and once it was complete I mirrored the model along the X-axis and welded the vertices to form a symmetrical mesh.

Once I was in ZBrush, I began to adjust the overall forms with the move brush. I then switched to the standard brush and again tweaked the overall forms of the model, by each subdivision level. If a very large area of the mesh needed to be tweaked while at a higher subdivision level, I would step down to the lowest subdivision level, adjust the model, then step up to a higher resolution to preview the changes. While I was doing this, I was constantly monitoring the profile and gesture of the creature (**Fig.01** – low-res mesh; **Fig.02** – medium-res mesh; **Fig.03** – high-res mesh).

*Fig.01*

*Fig.02*

*Fig.03*

Once the general forms were to my liking, I subdivided the model and began to cut around the major forms with the slash brush as, in my opinion, this is the most efficient workflow.

Lastly, I created a base mesh for the gums and teeth, and repeated the same process.

## TEXTURING

Once done with the modeling, I created 4k maps and then proceeded to paint directly on the model to establish the base coat. I switched over to Projection Master and painted in various skin hues. I used lighter values on the raised areas of the sculpt and darker values in recessed areas. Once the general hues and values were established, I then painted in the wrinkles, spots and high-resolution skin detail.

When the color map was finished, I then changed the material to the "bumpviewer material", created a gray 4k texture, and went into projection master to paint the bump map. Most of the high frequency detail was painted in the bump map, which included pores, wrinkles and further cuts into the major forms.

In the end, I had only the color map (**Fig.04**), cavity map, and the bump map (**Fig.05**). For the gums and teeth, I had a color and a bump map.

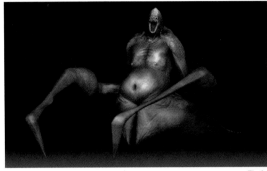
Fig.04

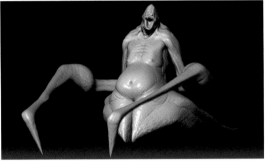
Fig.05

## POSING, SHADING AND LIGHTING

I imported the level one mesh into Maya, and then posed the character using clusters. I then imported the posed mesh into ZBrush, thus propagating the pose throughout the subdivision levels. I exported level 3 and level 6 meshes from ZBrush, the former for test rendering purposes and the latter for the final render. I also set up the gums and teeth, as well as the eyes which were simple polygon spheres with an extrusion out of the center.

Once inside Maya, with the character and background plane set up, a gray Lambert shader was assigned to the objects and I proceeded to set up my lights. I first set up my key light and fill lights using mostly spotlights converted to Mental Ray area lights. For bounce and rim, I used directional lights with no shadows. I then placed a point light behind the creature for environment lighting (also with no shadows). Each light was placed in its own render layer. All of the lights were colored white and with black shadows (with regard to those lights with shadows enabled). (The shaded render can be seen in **Fig.06**.)

Once the lights were set up, I assigned a miss fast skin shader to the creature and adjusted the algorithm control to around 30. This is the most important control on the shader and is a multiplier that decreases the overall scattering effect the higher the value you enter. I then plugged in my color map into the epidermal and diffuse slots, and left the rest of the settings at the default values. (See **Fig.07** for the lighting set up and shader settings.) I also set up an ambient occlusion pass, a cavity pass,

Fig.06

Fig.07

spec passes (black skin shader assigned to the creature with specular colors set at red and green, lights with a white color and shadows turned off), a reflection pass (similar to the specular pass but reflecting an HDR), and a few mattes to control elements within the comp (**Fig.08** – render layers; **Fig.09** – render passes).

Finally, I had around 14 passes or so which gave me complete control over each light, as well as occlusion, and specular/reflective properties.

## POST PRODUCTION

This is where a lot of the "magic" happens. In Fusion, almost every pass was color corrected by shadow, mid-tone, or highlight (sometimes all three). This included the ambient occlusion, as well as the cavity pass, which were corrected by shadow and highlight to match the color range of the other passes. The specular and reflection passes remained untouched as far as hue, and were corrected on the basis of gamma and overall opacity (**Fig.10** – node tree).

## CONCLUSION

Well, that's it! Overall, I am pretty pleased with the image, although not entirely happy. There are many things I would like to go back and improve upon, but I tend to jump from project to project and would rather focus my efforts on something new. Hopefully, I will be able to apply what I learned to whatever it is I do in the future, as that is what learning how to create art is all about! Of course, it's about having fun, too.

Fig.08

Fig.09

Fig.10

CHARACTERS

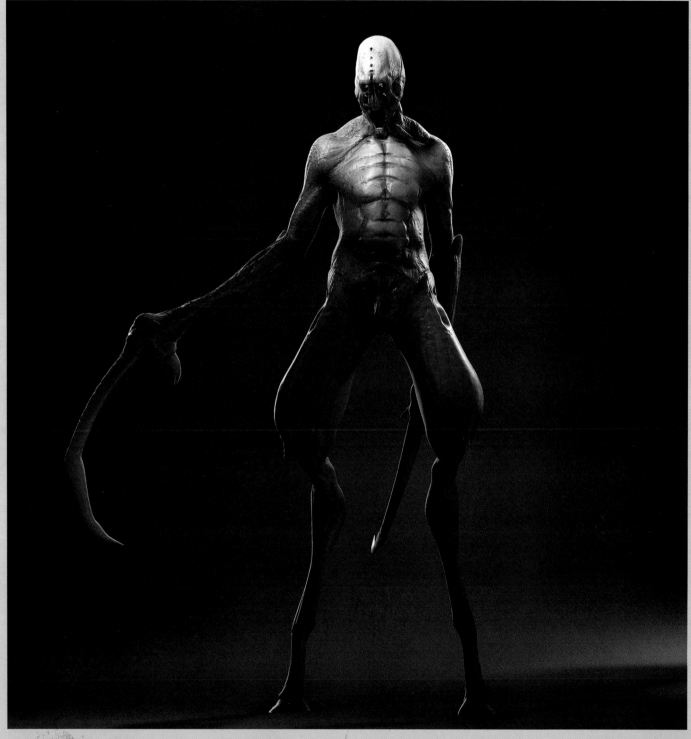

# Queen of Ultima
## By Chen Wei

### Concept

I am infatuated about a certain vision: a lady – maybe a flying goddess – so holy, so glorious, so beautiful… So I decided to make her on paper! This piece not only conveys a holy and beautiful quality, but the fall of a world. As you will see, the roof is raised and the ground has fallen – a rise and fall in the same moment. The time is "Ultima".

Many people may think that CG techniques will eventually replace traditional art. Many artists in fact have even announced that they will throw away their pencils and brushes after discovering CG! It seems to me that the mouse has replaced traditional methods in fantasy art. However, we must pay attention to one essential question: What makes so many complex lines and colors become a wonderful art work? Obviously, it is your artictic capability, not the knowledge of the software. So I recommend that you improve the level of your traditional art if you want to create some nice work!

### Software Preferences

First of all, we should understand how to use the brushes in Photoshop CS3 (**Fig.01**).

As **Fig.02** shows, by changing the Spacing and Angle, we can make a variety of brushmarks, such as different parts of a waterfall.

Using the Define Brush Preset (**Fig.03–04**), we can easily paint specific things, such as hair or the coat.

If we start off with some photographic materials in the first step, we must now clean up the "mosaic". Using Painter X – Real Bristle, Real Oil Smeary – the "mosaic" will disappear very quickly (**Fig.05**).

### Composition

A Wacom tablet can help you to create a rough picture. Some existing images can also help you to complete a rough concept quickly (**Fig.06**). Don't set the brush opacity very high though, just 40% is enough. Then use this brush to paint the most important areas of darkness and light, using a pressure sensitive drawing tablet.

*Fig.01*

*Fig.02*

*Fig.04*

*Fig.03*

*Fig.05*

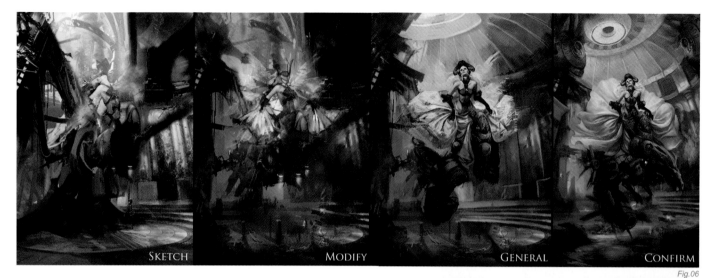

SKETCH       MODIFY       GENERAL       CONFIRM

*Fig.06*

With each new step, you should check the lighting set up in grayscale mode (**Fig.07**). Remember that making a strong contrast is the key at this point!

**Fig.08** shows the painting of the rough character, from gray through to a colorful version.

Regarding the concept, I just want to say that the CG design is not just a copy of animals, humans, and other living forms existing in common, everyday life. The primary task, before starting this kind of work, is to decide its "personality". Think about the personality and discover the body shapes that will reflect this, then choose suitable poses. You need to add personality to the whole character, and forget that just the face is conveying the character's personality (**Fig.09**). First, you should show off your skills by creating a very strong character, with a strong personality, right from an early stage in the process.

## DETAILS

Take one step at a time to bring the image alive with color, details and light (**Fig.10–11**). In **Fig.12**, you can see that I have continued to strengthen the contrast in the face.

With regard to the color, I just want to say that you should take care to differentiate the hue, using different variations of a similar color. You can see many different versions of brown maiking up the armlet, as well as some yellows and reds, and so on. Variation makes different contrasts; different contrasts create the feeling of depth; a feeling of depth creates a nice picture (**Fig.13**).

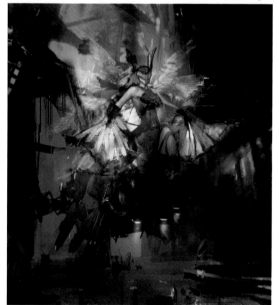

*Fig.07*

*Fig.10*

*Fig.08*

*Fig.09*

Shiny objects should display the best decoration, to show off their beauty (**Fig.14**); for this image I applied some color roughly and then painted the gold-filled flower pattern on top, lighting up the objects one by one then finally dealing with the edges (**Fig.15**).

Edges are important; they are the boundary of different shapes and colors. If you want to make your painting

clear and easy to understand, you should pay close attention to the edges – some will be clearly defined, whilst others will be more blurry (**Fig.16**).

The painting of the accessories began with a rough sketch. First, the shape and style of the shield was created with a big and strong brush. I could then go over the edges with a much thinner brush. It looked as though the big strokes were put together by thousands of smaller strokes!

Fig.11

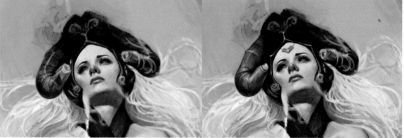

Fig.12

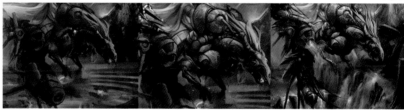

Fig.15

Painting the flower pattern sculpted on the accessories was not as easy as it looks. The accessories had to fit in to the left hand, naturally. But all turned out OK – I was victorious in the end!

The center area of the accessories and the glitter were supposed to be made of gold, decorated with a metallic flower pattern. Gold is not a bold color; it is made up from many different colors, like yellow, red and even green. Your task is to put all of these many colors into the most suitable positions!

Between dark and light, I blended the colors together, which may actually be compared to traditional oil painting techniques!

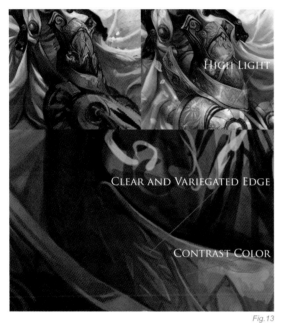

HIGH LIGHT

CLEAR AND VARIEGATED EDGE

CONTRAST COLOR

Fig.13

Fig.14

Fig.16

Using the Define Brush Preset option, I created some colorful leaves. When using brushes, don't forget to change the control panel; you'll want to adjust the Angle and Spacing settings for tasks such as this (**Fig.17**).

In order to adjust the printable size of this piece, I changed the proportion and created a strong effect in doing so (**Fig.18**).

Fig.17

Fig.19

Fig.18

## CONCLUSION

We should really analyze the composition as a whole (**Fig.19–20**). These two images show just how the space was utilized.

How many circles can you see in **Fig.20**? All of these circles interact with one another. After several hours, I completed the final image as seen here. I am pleased with the result; it is so beautiful and is full of the "holy" feeling that I originally wanted to capture in my concept.

And finally, friends, I would like to provide you with some tips:

• By using photos in the concept stage, you can create your work easily and quickly!
• Painting details requires patience; if it's not OK then modify it, but never give up!
• Finally, learn to analyze the composition as part of your daily practice.

Fig.20

FANTASY

# FALLEN BEAUTY

## BY DAVID EDWARDS

### INTRODUCTION

I'm constantly inspired by rusty old buildings and factories, places that once had life, a purpose and a strong place in society; gears of the industrial world that have long since seized and become forgotten, consumed by nature, painted with a new shade of beauty where machines made of steel are bent with vines and plants climb high up walls and through rooftops…

Fallen Beauty was taken from this inspiration and fused together with ancient wonders, such as the lost cities of Cambodia and other parts of the world where civilizations had sunk into the sands of time over

Fig.01

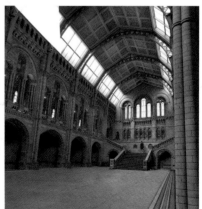

Fig.02a

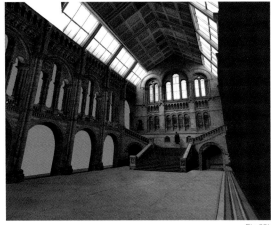
Fig.02b

Fig.03

Fig.04

thousands of years, and the idea that nature has slowly begun to tear down the world built by man in an effort to heal and repair itself from centuries of abuse and neglect.

The original photo was taken while on a business trip in London (**Fig.01**); I was asked by a client to photograph a few financial buildings, and when that was done I used the rest of the time to take in the sites. It was always a childhood dream to see a dinosaur in the "flesh", or bone, as the case may be, so I took a trip over to the Natural History Museum and began shooting lots of pics!

## RESEARCH

Before I begin working a new matte, or even making my first sketches, I'll spend as much time as I possibly can researching the subject and sourcing reference images from the web; this can take anything from a few days to a few weeks, depending on time permitting and the complexity of the job. I try to absorb myself in the subject as much as possible to get a feeling for the environment and the story being told. I mainly use the web to find reference images, using various image stock libraries. When searching for images I try to find those that have interesting compositions and lighting, images that emote the same feeling that I'm trying to express.

## PRE-PRODUCTION THOUGHTS

To begin with, I think about my goals, what I want to achieve and how I'm going to achieve them. With Fallen Beauty, this was more associated with a feeling rather than a direct brief, so for me, in this case, the overall process was a lot more organic with greater room to express; the perfect brief one might guess, but also the most difficult!

I live in a remote part of Yorkshire, on the edge of Leeds, where I'm surrounded by wildlife and the sounds of nature; the kind of sounds that you never hear living in a built-up urban surrounding. Being surrounded by this

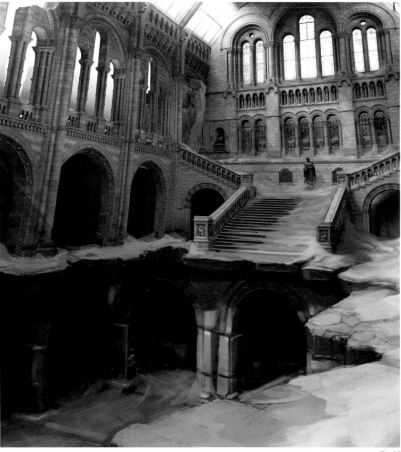
Fig.05

kind of environment adds to the emersion. When I look back on the final image while listening to the sounds through my window, I can see how much this added to the final effect. I can imagine I might hear the same sounds in the painting.

## PREPARATION

I took the original photo of the Natural History Museum interior and began preparing this for the base. My first thought was about what I wanted the final crop to be. Because this wasn't for film output, I wasn't too concerned about the size; however, I did have a square ratio in mind, allowing the opportunity to add a camera move with a final crop into widescreen should I wish. The square ratio allows me the freedom to move around within this area.

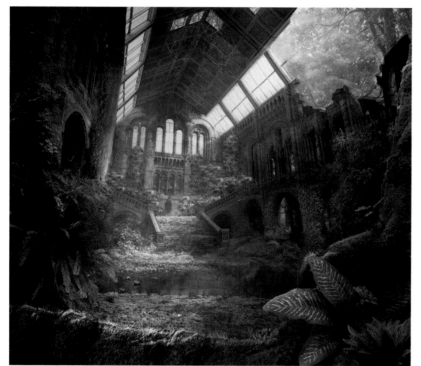

*Fig.07*

*Fig.08*

*Fig.06a*

## CLEANING THE PLATE

I resized the canvas to a 6k square so I could get in detail where needed without loss of quality. I then began the process of cleaning the plate; in this stage I removed all the people and familiar signs of modern day society. The image I had in mind existed thousands of years in the future, so I had to think to myself about what would still exist and what would have decayed over time. For the most part, I decided to keep only the basic structure – the stone walls and glass in this case. I bent the rules a little though, as glass would probably have been destroyed over time, but I thought it was cool and so decided to make an exception with this (**Fig.02a–b**).

The process of removing the people was pretty laborious and time consuming; it involved using a combination of the brush and clone tools to paint them out and overpaint the backgrounds back in. Care should always be taken to match the tones and sample the right areas taking into account the effect of shadows and light. With this being a symmetrical building, I looked for symmetrical elements that could be cut out and flipped over to the other side. Once I'd cleared out all the people and signs, I was left with a pretty empty place. I then started working on the existing light, removing any interior illumination from artificial lighting and generally toning the scene down to a more neutral tone.

## COMPOSITION STAGE

Composition is always very important; I decided early that my focal point was going to be the stairs leading up to the lone statue. Everything had to lead the eyes in this direction; the composition of the plants and the placement of the flowers in the pool are all placed to direct the viewer in one direction.

With the plate finally cleaned up, the next step was to extend it to fill the canvas. In this example, I extended around 30% to the left and around 15% to the bottom and right. This was done by simply copying parts of the existing wall and moving them out, using the distort

FANTASY

*Fig.06b*

tool to correct the perspective. Given the design of this building, it became very easy to extend as most of the walls were repeated in the original design. I then started to add in the leaves, moss, plants and foliage, carefully building up the environment and taking care not to overdo the effect to the point that it became too dense (**Fig.03**). I was aiming for a location that would be completely overrun with plant life, with trees breaking through the stone floor and vines growing across the ceiling – it had to seem like a secret haven of life in the middle of a dense jungle, without becoming so dense that it was unreadable.

As I continued, I saved multiple iterations often branching off in two or three directions working simultaneously on each file, seeing how one might work better than another. With this piece, I ended up with four different versions, each more developed than the last. One version initially took a more sandy approach which wasn't working, while another was very much like the final result with no water and a different tone (**Fig.04–05**).

## Lighting and Atmosphere
Once the elements were all in place, I began the final process of color correcting and lighting – this was key to establishing a sense of realism. The lighting was also used to re-enforce the composition, again directing the eye with different values, creating a corridor of light for the viewer to move through.

Throughout the lighting process, I made heavy use of gradient maps in conjunction with the opacity and various blend modes such as overlay, multiply and screen to achieve different tones, seeing what worked and what didn't (**Fig.06a–b**).

Lighting is the most important stage for me and one that goes through much iteration. Effective lighting can direct the mood of a scene and re-enforce the shot, while equally bad lighting can ruin a great painting. With Fallen Beauty I tried to capture the essence of the environment through subtle variations in the shade and light which breaks through the mist. Another trick that I employed was to pick off highlights/light blooms where the light would fall. I think doing this allows you to avoid using excessive CG-looking shafts of light and yet can still create the illusion of light through suggestion (**Fig.07–08**).

## Conclusion
I was happy with the final results; however, there's always something else that can be done – another brush stroke here and there. One might say a painting's never quite finished, only abandoned. But in the end, I feel I accomplished the original vision of what I set out to create (**Fig.09**).

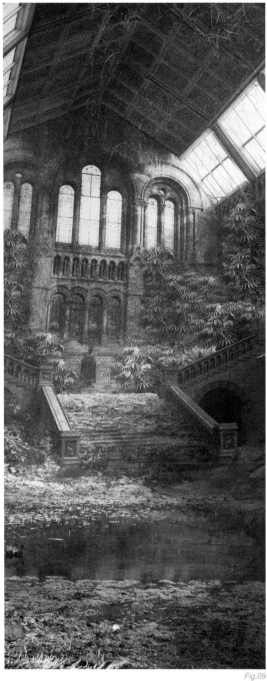

*Fig.09*

# ARTIST PORTFOLIO

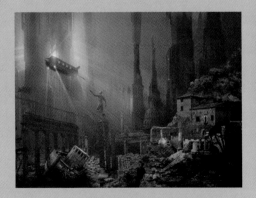
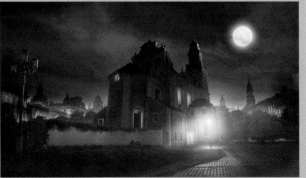

# DESNOYERS-VILLE

## BY FREDERIC ST-ARNAUD & MARTIN DESNOYERS

### INTRODUCTION

Desnoyers-Ville was a special and uncommon project. Back in 2006, I did a four-month contract at a company called "Alpha-Vision" based in Laval, Canada. They specialized in 3D pre-visualization architecture and were looking to improve their skills in matte painting because

© ISTOCKPHOTO.COM
Fig.01

© ISTOCKPHOTO.COM/CHRIS ELWELL
Fig.02

148 FANTASY

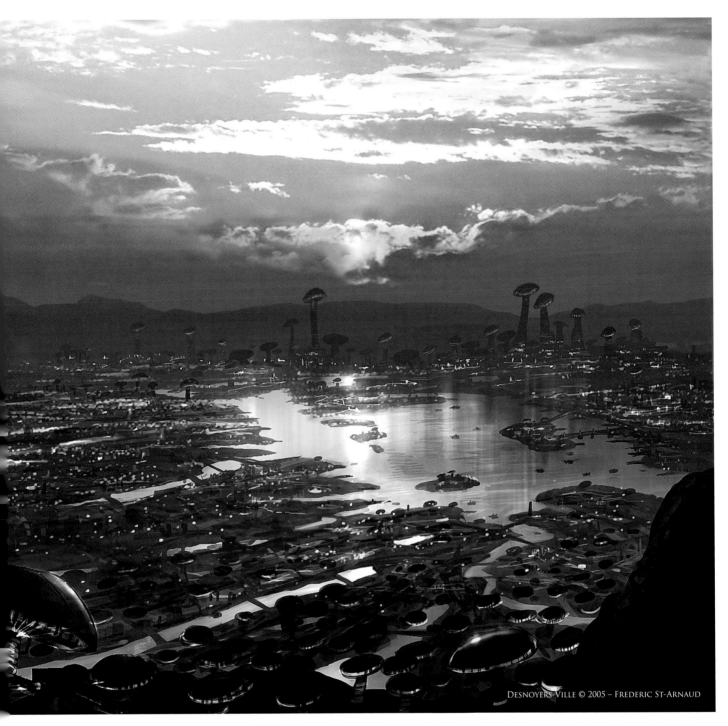

DESNOYERS-VILLE © 2005 – FREDERIC ST-ARNAUD

*Fig.03*

architecture and digital matte painting are two similar fields; they both create digital backgrounds with the same type of software, but they work with different clients.

Martin Desnoyers was one of my students. He had a lot of motivation but he was stocked with what some people call the "blank sheet syndrome", which means that you have problems starting your artwork because nothing comes to mind.

## REFERENCES

The first references for this project were found by Martin (**Fig.01–03**). He was looking for different shapes of mushrooms, usually with very high stipes (the tails) and large caps on top in order to be able to transform them into interesting architectural buildings.

The part that experts call the "ring" (located just under the cap) were to be replaced by large beams to support the top structure.

I used personal photographs that I took myself to inspire me as references to do a great futuristic sunset cityscape (**Fig.04–08**). I ended up with a photo that was shot on top of Whiteface Mountain in the Adirondack Park, located in the state of New York (USA), during a fall hiking trip (**Fig.09**). This photo was the beginning of the artwork. I used the Photoshop filter called "Median" to get rid of the ugly, grainy look of the photo, and also because I knew that I would paint over it using the Eyedropper tool, which is usually more efficient when the pixels are not all mixed up by grain.

Fig.04

Fig.05

Fig.06

Fig.07

## PROCESS

First of all, let me explain that this project was a simple concept art. I achieved it in just two hours, which will explain why there are so many sketchy brush strokes and some weird perspective angles – especially in the background. During the process, I knew how easy it would be to get lost and waste my time on details. In this case, the main purpose was to create a great and interesting moody ambience in order to inspire Martin to create something that he would like!

I started by extending the lake with small rivers all around, which helped lead the viewers' eye to where I

Fig.09

Fig.10

Fig.11

wanted – like straight, bright lines that go to the far city (**Fig.10–12**). It was also a great way of establishing the scale of the scene and adding more elements to evaluate the distance. I added islands, rooftops, streets and other rough details to give a quick illusion of a city near the lake. I created a black silhouette with huge mushrooms, like the references from Martin, to imply the cinematographic and useful rule of foreground, middle ground and background layers. In this case, huge mushroom buildings were in my foreground, the lake and rivers areas were my middle ground layer, and my background was the very high mushroom towers mixed with the far mountains.

I added some dark blue shading, normally due to the reflection of the sky, in the foreground to create volume

Fig.12

FANTASY

on the caps and tails (**Fig.13**). Then, in two steps, I found photos of night cityscapes that I pasted onto my work, using some different Photoshop blending modes such as Screen, Color Dodge and Linear Light (**Fig.14–15**). I also added some handmade lights with the brush tool. I wanted to use bright saturated yellow and orange lights to create a contrast of colors, due to the overall blue atmosphere in the mountains that I was later going to add.

I changed the first sky for a wonderful sunset sky, where the sun was hidden under the clouds (**Fig.16**). That way, I didn't have a too intense sun spot in the image. In terms of the composition, it was easier for the eyes to observe different parts without being disturbed too much by only one single bright spot. Finally, I added many yellowish highlights on the foreground buildings and on the surface of the lake.

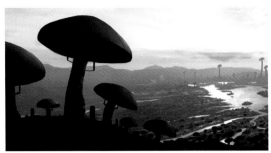

Fig.13

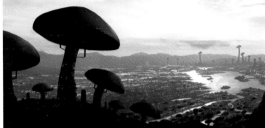

Fig.14

Fig.15

## CONCLUSION

Of course, I did not have time to do a concept art for every student in this class! Some people find inspiration and motivation by themselves, whilst others need help sometimes. Martin had a good idea in his mind with the mushroom city concept; he just didn't know where to start. He's always had the great potential of becoming a matte painter, and I wanted to help him find enough motivation to better develop his idea.

I've always thought that you can improve your own artistic skills faster by doing personal projects. Of course, we can learn as well during the creation of an artwork for a client, but having your own projects on the side keeps your imagination and your real passion for art growing. This is a way never to forget why you chose this very special field of work!

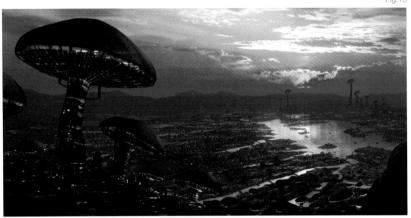

Fig.16

# ARTIST PORTFOLIO

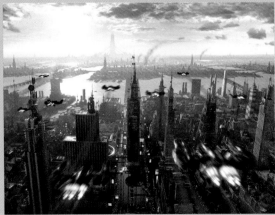

THE DECLINE OF BABEL MYTH © FREDERIC ST-ARNAUD 2006

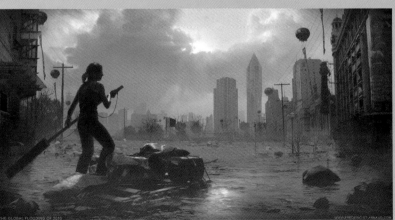

THE GLOBAL FLOODING OF 2010 © FREDERIC ST-ARNAUD 2008

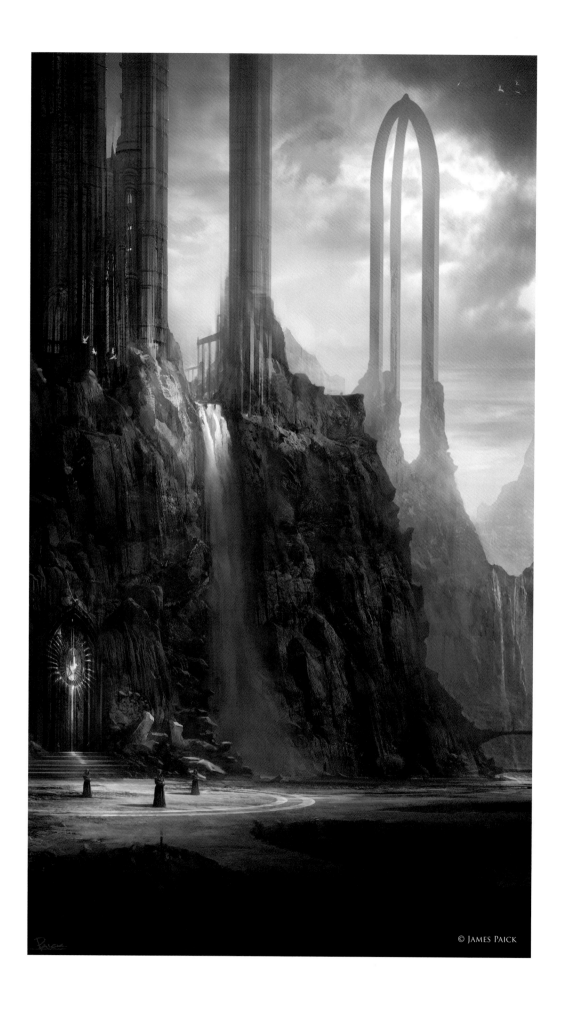

© James Paick

# Palace Entrance

## By James Paick

### Introduction

After a long hiatus from working on personal projects, I finally had an opportunity to take some time to create something solely for myself. The first thought that came to mind was the idea of playing with reality, almost pushing it into the realm of fantasy. My focus was to create a dramatic environment within an epic scale, rooted in a mysterious culture. I definitely wanted a powerful, serious image that could draw in an audience.

### Process

With the general idea in place, I sat down to sketch whatever came to mind. I always like to start in a fast and loose fashion that allows for big gestural strokes to establish the composition. I tend to push around lines and paints until I start to see something interesting and unique.

At first, I started with laying out my hierarchy – small, medium, large areas (**Fig.01**). My sketch started off very – very loose!  After just a few strokes, I could already start to see a very striking composition that captured my attention (**Fig.02**). At this point, I already wanted to address any uncomfortable spacing or tangencies. Also, although it was still rough, the thumbnail already showed me a palette range of warm and cool colors that could be useful in developing my layout further. I continued using textured and round brushes to give me random shapes to help me find "happy accidents". I felt this was a good start and could easy build on top of this.

Fig.01                    Fig.02

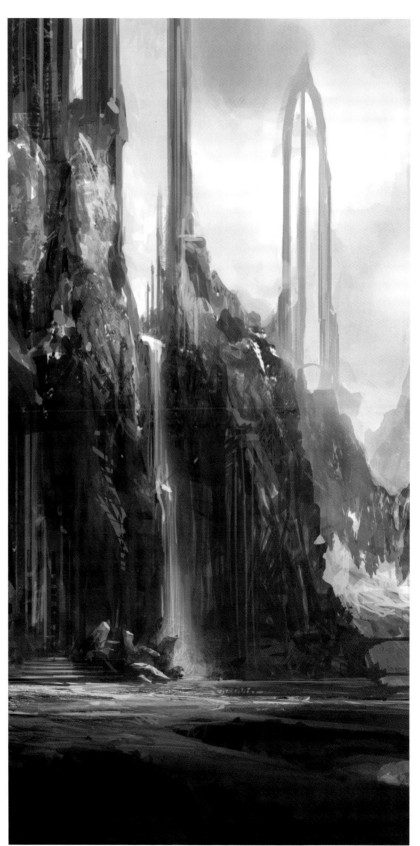

Fig.03

The thought of a monolithic palace tower entered at this point. I decided that this would be the driving force of this culture. With the general composition in place, I started to refine my sketch to figure out what was really going on in the painting. I wanted to pursue the relationship of warm and cool colors, keeping that throughout the piece. I wanted to keep elements in the foreground in a cool and lower value. This helped to create a vignette to keep the focal point centralized. This then helped to establish scale (see **Fig.02**).

Establishing the scale, lighting and composition are all very tricky tasks, but are so rewarding when done right! I had a piercing three-legged tower in the background and I repeated the shape in the foreground to help establish the scale (kind of how a walkway bridge helps with scale when rails are repeated), as well as painted in smaller details. Within each major plain, foreground, middle ground, and background, I started to push the palette and values. In the sky, I established a dominant light source. The mountains in the background got a treatment of subtle values to reinforce the light source in the sky.

*Fig.04*

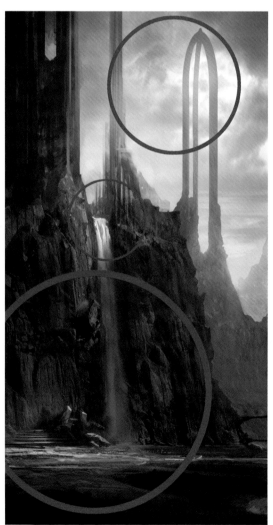

*Fig.06*

I continued to push the warm versus cool relationship in the middle and foreground. Keeping the bottom of the piece in a dark, cool tone created the contrasting mood.

Lighting was a key factor in making this an epic piece. I definitely wanted a backlit effect so the silhouette would be the initial read. To make this a compelling image, I wanted to push the palette range so that the immediate focal areas were in light. Keeping saturation within the lit areas was important to reinforce the lighting. This helped to direct the viewer where I wanted them to look.

About halfway through, I flipped my composition horizontally to check the balance of the piece, and found it more interesting in the new layout; I decided to keep it this way. I started to carve into the piece, creating the staging ground to be the main focal point. This was to be the main entrance to the great palace. To establish this area, I painted with Color Dodge and Overlays to push the palette and values without sacrificing any of the details or drawings (**Fig.03**).

Having a good reference library of images is very important for any artist (**Fig.04**). Generally, when needed, I use images in many different ways, such as for lighting references, textures, color palettes, and so on. In this case, I wanted to use photography to help to give it a matte piece finish of detail and believability.

Bringing in a photo texture can be a tricky thing. I tend to backtrack a little and allow the photography to describe the shape as much as possible. Using what I had already established in the piece in terms of form, shape and lighting, I painted over my initial piece to give it more of a flat, less textured layer (**Fig.05**). Using bits of photos and painting on top, I created a sky that supported the design and used it as a communication tool. I definitely did not want to texture everything – just the parts I wanted to read as focal points (**Fig.06**).

*Fig.05*

FANTASY

At this point, I was ready to give attention to the details of this piece. I only wanted to give details to the parts I wanted the viewer to read. Even so, small details here and there, even in non-focal areas, helped to really tell the story and to sell the concept. I added figures to reinforce the scale and refine color saturations where necessary. I added "hide and go seek" elements throughout the piece to keep the viewer interested, such as a flock of birds and details on the entrance door (**Fig.07**).

## CONCLUSION

I had a lot of fun with this piece! I really feel that I met the criteria I gave myself at the beginning. I feel it tells a story, and it is definitely dramatic and mysterious. Looking back on the piece, I am happy with the hard work and effort that came from this painting. My process of working big to small, loose to detailed, helps to carry me on an unknown journey. I tend to visualize the outcome more towards the middle—end of the process. Of course, there is no set way or working, and everyone has his or her own method, but this way has helped me to grow as an artist.

*Fig.07*

# ARTIST PORTFOLIO

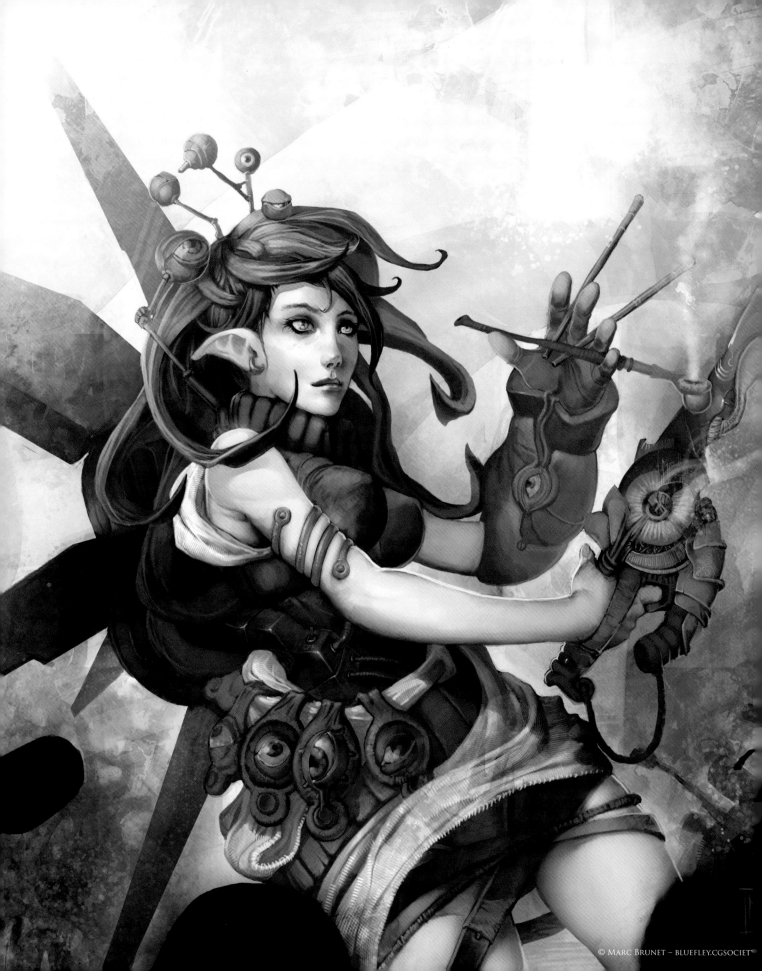

# THE EYEWITNESS

## BY MARC BRUNET

### INTRODUCTION

The Eyewitness was a project that was done a while ago and was actually a test of a new coloring technique. Up to that point, I had never painted in black and white so I told myself I had to give it a shot. My plan was to focus first on shades of dark, then once done, to be able to concentrate on the colors alone. It was, as most of you should think by now, pure genius.

This piece started at school while I was still a student, just about last year. The night before my course, I had a weird dream, and for some reason I had an image that got stuck in my head so I took the time during class, rather than writing down some notes, to put that image down on paper. I didn't really plan to color it or anything at first, which is why I just scribbled it on a cheap sheet of paper, as you can see in **Fig.01**.

### PROCESS

When I start a piece, I normally start with blobs of color to define the basic shapes and mood of the piece, then proceed to adding details until I consider it done. This process differs for every artist; some will prefer to have a clean line art and color the inside of the lines with flat colors and add shading afterwards; some will start with shades of gray and only then add colors later in the process – there are all sorts of ways to do this. It was a little different from my usual technique in this case. After scanning the image, importing it to Photoshop, putting it over the background layer and setting the line art layer's Blending mode to Multiply so I could color underneath

Fig.01

Fig.02

without touching it, I realized soon enough this wasn't going to be the best way to work. Instead I just got rid of the layers and started to paint in shades of gray over the line art.

Starting that way is a load of fun and you seem to progress a lot faster since you don't have to worry about your palette of colors at all. I knew a lot of artists that were using this technique but I had yet to try it myself (**Fig.02**).

I did, however, start as I do for every drawing I work on. For some reason I get really bored if I don't start with the head. In my pieces the heads are, most of the time, the focal point, or at least a very important part, so having them done early in the process helps me stay motivated. If I like my character, I will take the time and enjoy the process so I make sure I fall in love with it as early as possible. It's like a love story every single time! I tend to use this technique often, where I will start from the face then add details from there outwards.

After getting the shading right for this painting, or at least most of it, I then added layers and layers, set to the "Overlay" or" Multiply" Blending modes, of colors, starting once again with chunks and adding more details and color variations along the way until I was happy with the result (**Fig.03–04**).

## SPECULAR ACCURACY

One thing that I find to be incredibly important when it comes to a semi-realistic piece, like this one, is getting the different visual properties of various materials right. Aside from the color that can vary a lot from one material to another, this specular, or the way the light reacts when it hits it, will either make it or break it. The word "specular" is a word commonly used in 3D, and is how light will bounce off a surface. Shiny surfaces will have a very small, yet bright, specular, since it will act almost as a mirror, while a "matte" or furry surface will have a very diffuse and visually darker one. Every single material has a particular and distinct specular, and getting it right will make an image a whole lot more believable (**Fig.05**). To get it right you don't need much really: a good sense

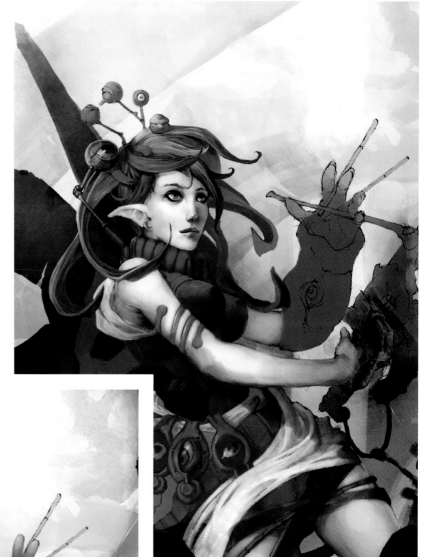

*Fig.03*

of observation and a good memory. Look around at how light reacts on different surfaces and try to picture it in your head when you draw.

This is normally one of the final steps when I paint, and when I'm happy with the lighting and the composition, I'll bring my painting to life with credible and varied speculars for the different surfaces. When I do, I still use the same technique and brushes as all the rest. In that case, I was using a basic round brush with Spacing set to 25 for the most part, and only a few custom brushes for the background.

What I always do – but something I didn't do for this painting, since I was experimenting with this new way of coloring – is to restrict myself to a single layer as if it was a real canvas and try to stop using the infamous Ctrl + Z as much as possible. It gives the image a more traditional

*Fig.04*

FANTASY

look; something I'm always trying to achieve. It also forces me to be more confident in my brush strokes, and in the long run it makes me a lot faster at painting. Give it a shot, you'll see!

## CONCLUSION

While I did learn a lot from trying this way of coloring, it's not something I would recommend as it doesn't really justify the extra time it took me to shade in black and white then color over it. It does, however, give it a particular look – lots of washed out and muddy colors. I know a few artists that can pull some amazing results using this way of coloring, but the palette of colors I normally try to go for is way too much saturated and lively for it. I did have to paint over a lot of parts with pure colors to get the look I wanted and the extra time could've been saved, but this is definitely a technique to remember when I go for a darker palette, as I think it would be a perfect fit. Even then, it was a lot of fun!

Like the old blind wizard once said, "This wasn't the right ingredient you idiot, now we'll have to start the potion all over again!"

Wait... What?

*Fig.05*

# ARTIST PORTFOLIO

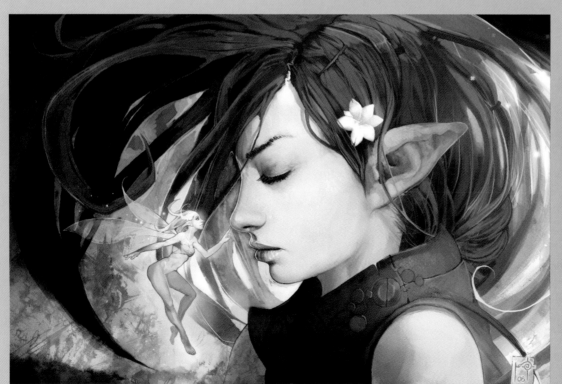

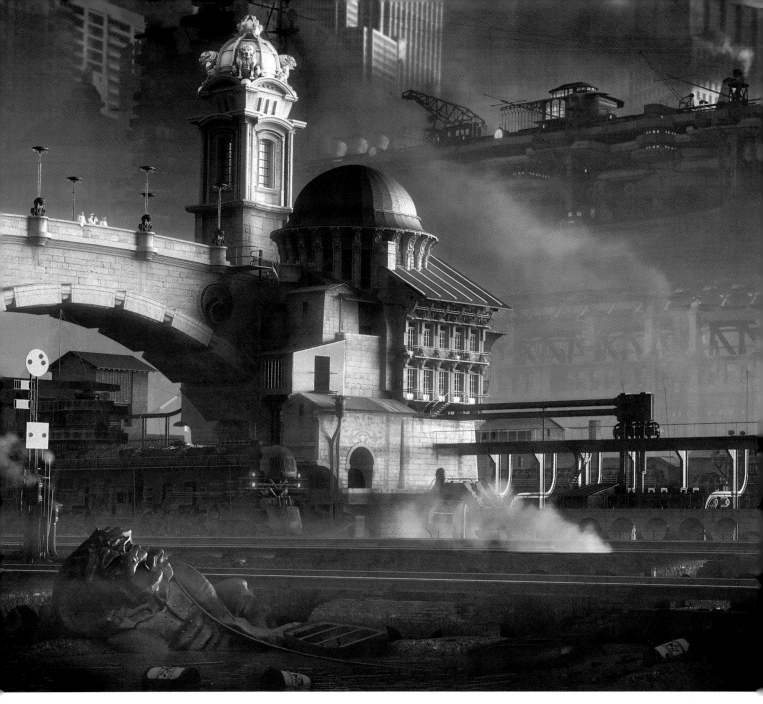

# Rail Haven

## By Marco Edel Rolandi

### Introduction

I usually try to create whole sceneries and stories, rather than single stand-alone images, and this shot is no exception, being not only a frame of an animation (**Fig.01**), but also just a view of a more complete work. My approach obviously carries both advantages and issues: you'll recycle a lot of material from one scene to the other (helping you out in assembling your "frozen" image), but you'll have very different objects with various degrees of resolution ending up in the same scene, usually leaving you with scarce detail on the foreground and possibly exceeding detail in the

background as well (**Fig.02**). Not being an illustrator, I was also worried by the quality of my final product and of being unable to communicate with a single image what I actually had in mind.

I used both my own concept art (**Fig.03**) and pictures to create the scene, while the idea behind it – in which every aspect of the society, including architecture, was influenced by and recalls mechanical parts (**Fig.04**) – was highly inspired by movies like Fritz Lang's *Metropolis*, where the ideals of the futuristic movement degenerated in a world in which man was nothing but a single, small piece of giant majestic machines.

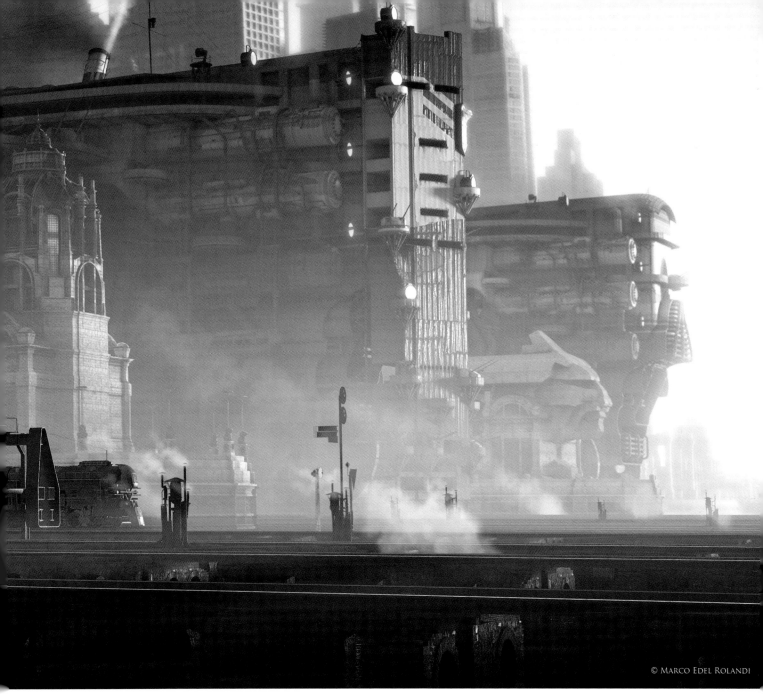

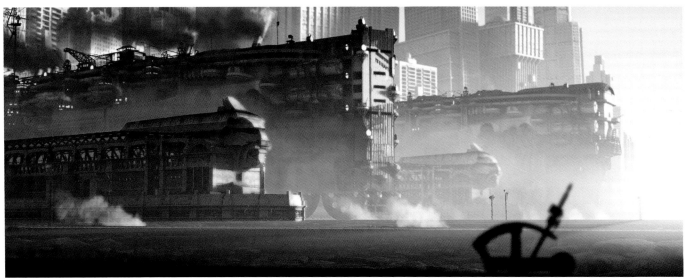

*Fig.01*

FANTASY

## GIANT LOCOMOTIVES

Important elements of the scene were the Daridras (**Fig.05**) – a cross between Japanese WW2 aircraft carriers and giant steam locomotives 290m long and 125m high, conceived as asymmetrical vehicles being able to fire only on one side, and stand defensive on the other. Opposite to any good principle for modeling, instead of building an overall shape and then start detailing when needed, the Daridras grew from the basic relationship between human scale and the overall proportion of the main carriage and then modeled outwards. This is why the steam engine and the main wheels were already modeled and textured, even before an overall shape of the "ship" was even conceived (**Fig.07**).

At this stage I enjoyed translating the normal scale mechanism into a giant scaled counterpart, where even simple objects like connecting rods had to be modeled as planar trusses with a full set of hand rails, huts and revolving stairs in order to remain close to the original concept of having people running back and forth like ants (**Fig.06**).

I later began experimenting (**Fig.08**), adding armor, two main turrets and a horizontal version of the bridge, inspired by *Tron* (1982). As I began to refine the shape even more (**Fig.09**), I quickly realized the need to simplify things due to technical reasons.

Fig.04

Fig.05

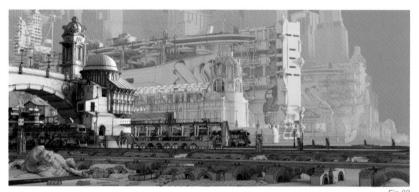

Fig.02

Fig.03

I therefore opted to ignore the "least interesting side" of the machine by modeling only the offensive half for stills, and by moving the camera and the background, instead of the whole 7000-part object, for animation (both techniques are used in a lot of movies!). The huge amount of parts required me to have a clear planning of the texture channels at a very early stage as well; those same channels needed to control the overall color scheme. I eventually animated all the wheels and rods and outlined the final shape of the object (**Fig.10**) by adding a more vertical tower bridge. I also finally defined all the texture channels, using a planar UVW map scaled to cover the whole 3D model for the color scheme, and several smaller cubic channels for bitmap materials. The moving parts required separate channels and the use of

Fig.06

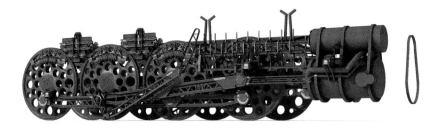

*Fig.07*

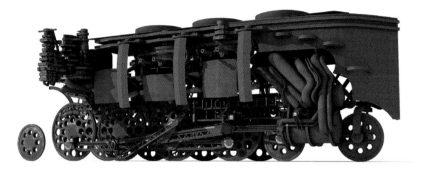

*Fig.08*

handmade dust maps, in order to take into consideration the friction of moving parts when dealing with weathering. I finally began to add finer detail (**Fig.11**) by taking pieces from other 3D objects I've made (houses, airplanes, cars, etc.) and using them as "fillings". I also quickly modeled some ship parts, using old Tamiya kits as reference, as I needed to keep the ship idea but I didn't have any previous 3D model I could scavenge. Once finished, I started painting the large masks (**Fig.12**) and completed the texturing. The last thing I added to the model was indeed one of the most important: the bow. I've always wanted to give some "personality" to the machine, and the new bow reflects this, being partially inspired by African masks, as well as large herbivores.

## THE METAL SHADER

The process of creating the metal shader wasn't linear at all, as the same material had to be used in different scenes with different lighting conditions, and required seven or eight revisions. The shader was almost completely procedural and was composed of three standard materials blended together in four steps. The

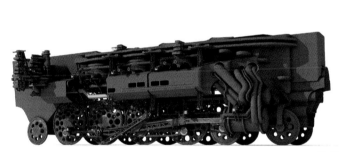

*Fig.09*

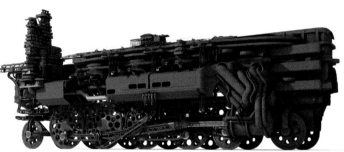

*Fig.10*

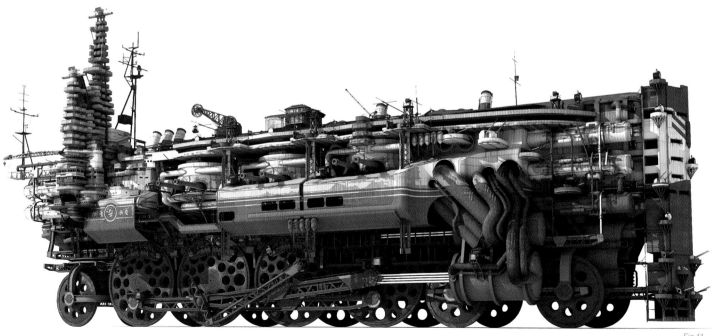

*Fig.11*

base layer (**Fig.13**, on the left) contained the first gray material (procedural) and a simple bitmap rust material, mixed using a fractal noise map with a coarse finish and a gradient ramp; the latter was used to simulate the rust depositing on the lower part of the objects, and to gain direct control over the appearance. The second layer (**Fig.13**, center) added a shiny metal using an inverted dirt map to simulate weathering and to give a better volumetric consistency of the shape as well. The final result (**Fig.13**, on the right) overlays the same rust material with a new dust mask to give a more coherent appearance. In the end, the same material was used in the scene with very different results, and constituted a good procedural base for more complex texturing, where handmade masking was necessary (**Fig.14**).

## COMPOSITION

When compositing all the single elements together (**Fig.15**), I tried to create a "flow" of darkness guiding the observer's eye back and forth diagonally along the image, and setting the center of the image towards the upper left part. I eventually came up with some composition lines (**Fig.16**) subdividing areas of light and dark, of foreground and background. In order to maintain an interesting rhythm, I subdivided the horizontal space by placing vertical frames, aligning the position of every object along vertical lines and circles, and placing key objects on the intersection of the vertical lines and the horizontal. Of course, the process was characterized more by trial and error than it actually sounds!

*Fig.12*

*Fig.14*

*Fig.13*

FANTASY

## CONCLUSION

As with all of my work, I would say that I'm not completely satisfied with the results. There's plenty of room for improvement in almost every aspect, especially on the left foreground, where detail is lacking (**Fig.17**), and the overall composition is still a bit unresolved; at the same time I believe I've reached a balanced point where the concept has been adequately transmitted to the viewer. I've learned a lot creating this shot and I consider it to be a good starting point for hopefully better work!

Fig.17

Fig.15

Fig.16

## ARTIST PORTFOLIO

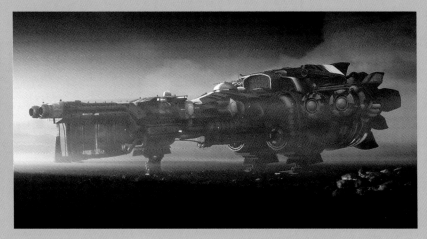

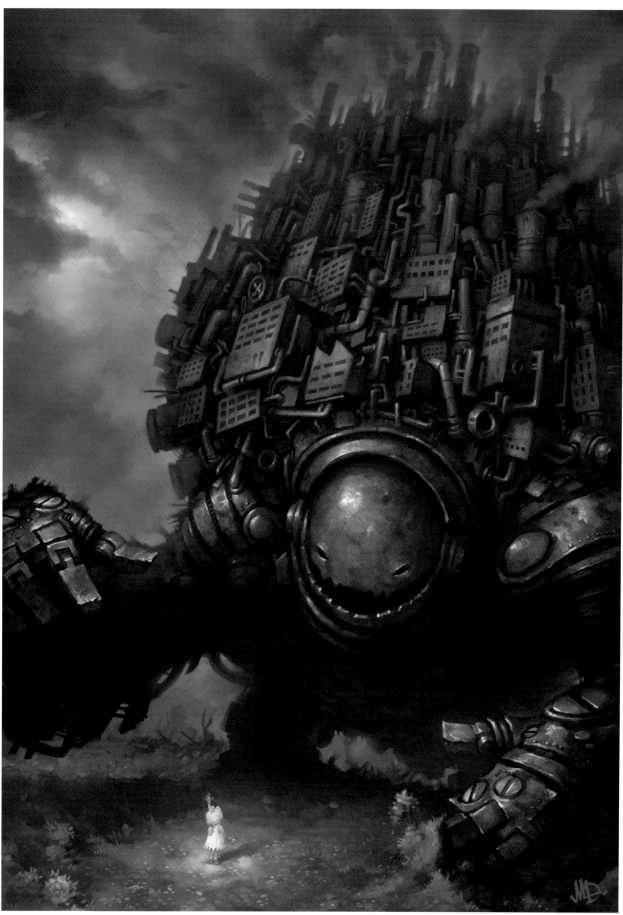

# THE MACHINE
## BY MATT DIXON

### INTRODUCTION

"The Machine" was created for a challenge run by CGSociety.org. The theme was "Master and Servant". Perhaps because I spend most of my life sitting at a computer, the subject immediately suggested the connection many of us have with technology, so I set out to create an image to explore the relationship between man and machine. First ideas often have a clarity and simplicity that makes them hard to improve upon, so I pursued my initial, rather literal, interpretation of machine as a giant robot with humanity represented by a child. A strong contrast in the scale of the characters helps to emphasize

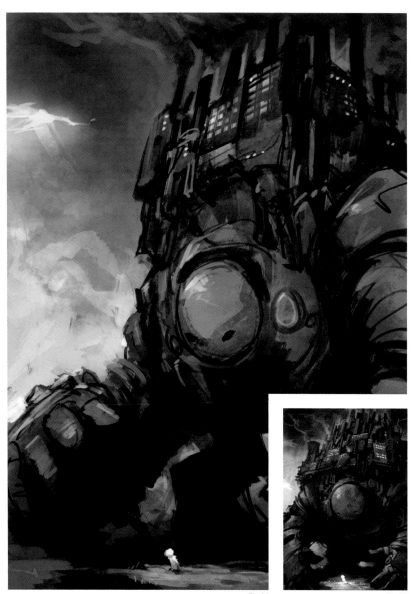

Fig.01                     Fig.02

the potential power of technology against the vulnerability of mankind, so I sought to maximize this juxtaposition in my initial sketches (**Fig.01–03**).

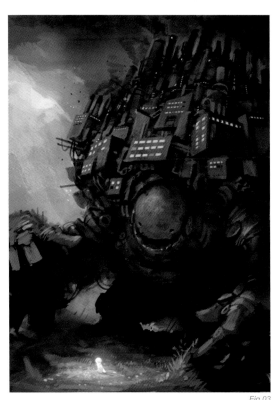

Fig.03

### WORKFLOW

Having settled on a composition, I produced a color rough (**Fig.04**). This allowed me to quickly experiment with color to find a harmonious palette for the final painting. Half an hour's work here also helped me to visualize the finished piece, giving me a clear goal to work towards. I find this very useful to keep me motivated during the painting process – if I have a good idea what I'm aiming for, I have a better feel for where I am along the journey to that point as I work.

Now the painting begins! I started with a simple value study (**Fig.05**). Often, an early sketch will be quite adequate for this purpose, but in this case I wanted to make some subtle changes to the robot's pose and design.

Fig.04                     Fig.05

*Fig.06*

*Fig.07*

When complete, the value study was set to the "multiply" blend mode and I applied a simple wash of color on the background layer (**Fig.06**). I reduced the opacity on the value layer a little to allow more of the color to come through and to reduce the tonal range, so I could work from mid to low base colors towards higher values.

Managing lots of layers distracts me from the business of painting, so at this point I flattened the image. From here all the painting was done on a single layer (**Fig.07**). I then began to paint, refining the shapes that remained from the value sketch. My process is one of gradual refinement, which gives me the impression of the painting "coming into focus" as I work. I think this is an economical process, helping me to manage the amount of detail I need to apply.

I work from dark to light. It feels like I'm pulling the shapes out of the darkness, which gives me a good

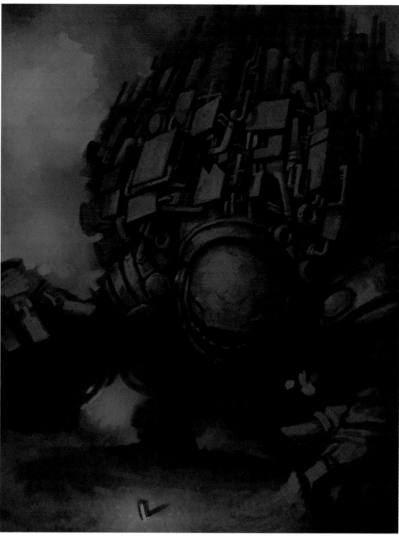
*Fig.08*

impression of the form I'm creating (**Fig.08**). Note how roughly defined the hands of the robot were at this stage.

As I work from dark to light, I'm also working from broad to fine marks (**Fig.09**). Notice how the hands have changed from the previous step, and the city on the robot's back has been refined and detailed. At this point I also scaled the image within the canvas to give me some extra space to expand the city upwards. Isn't working digitally wonderful?

With the basic image defined and tidy, I could then begin to render. This relatively quick process brought a big change to the image (**Fig.10**). Adding highlights, a few fine details and deepening the shadows suddenly made the painting look much more complete.

All the important elements were now in place. All that remained was to refine and improve what's already there (**Fig.11**). At this point, I detailed the sky, put the finishing touches to the little girl, and made the final refinements to the robot. Eventually, I rejected the strong hue of the sky in the color rough, opting instead for more neutral tones that drew less attention from the robot and didn't set such an aggressive mood. I added some subtle purple and blue to the sky to balance with the flowers around the girl. The final task was to make a few adjustments to color and contrast and the piece was finished!

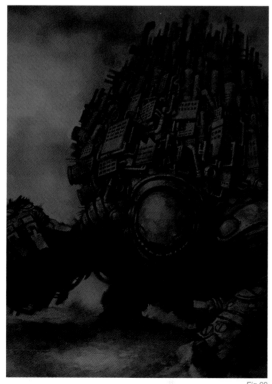
*Fig.09*

FANTASY

*Fig. 10*

## Conclusion

"The Machine" was unusual for me, in that the original concept remained basically unchanged throughout. One of the benefits of digital painting is the infinite opportunity we have to manipulate and change an image as we work, and I often take advantage of the fact, adjusting and adding to a piece as new ideas present themselves. This image is a reminder to me that, as I stated earlier, one's first ideas can often be the best – this has been one of my more popular paintings and I think that's partly due to the simplicity of the concept. I think most people "get it" pretty quickly.

Exactly what they "get" is another matter, however, and my favorite aspect of "The Machine" is the many different ways people interpret the image. Of course, there is no right or wrong way to see it. The painting is intentionally ambiguous, and I would suggest that how it is viewed has as much to do with the individual as the image itself.

Just like our relationship with technology.

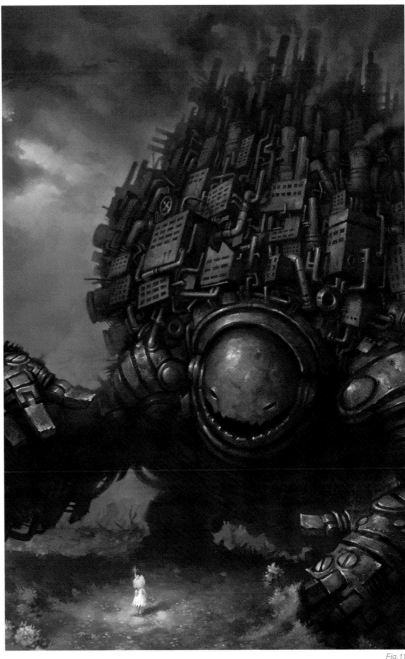

*Fig. 11*

# Artist Portfolio

Fantasy

169

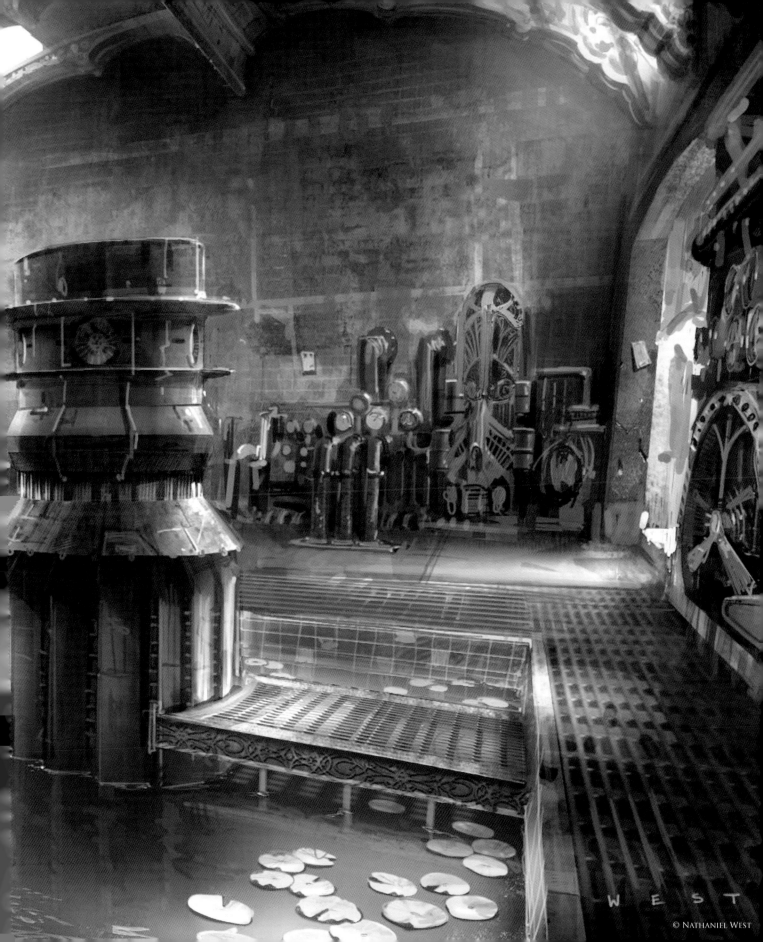

© Nathaniel West

# THE CONTROL ROOM

## BY NATHANIEL WEST

### INTRODUCTION

I was commissioned to do this painting for a video game in order to generate an idea of what a specific location may look like. The parameters that I was given were that it needed to be an old, run down pump station, with an 18th-19th century feel to it. In the center of the room there would be a futuristic machine that the player must use as an energy device at a specific point in the story. At first, I contemplated a dark and hidden space, with twisted machinery peeking out of the darkness, but then decided that I'd play around with the idea of a lot of filtered gray light coming from above, giving it almost a greenhouse feel. I was intrigued by images of old steam technology, specifically those set in Europe, which ultimately led to me deciding to add a Parisian Art Nouveau feel to the architecture and design of the machines.

Fig.01

### PROCESS

When first beginning any new painting, the most important step to think about is the initial lay-in (**Fig.01**). I personally like to start with a grayscale underpainting in order to focus only on value relationships and overall lighting schemes. This step can be overlooked and rushed at times, mostly due to an artist's excitement to progress towards the finished stages as quickly as possible. But to me, this stage is the most critical, as all artistic decisions will be based on the foundation that I've created.

With that being said, I began laying in values with broad brush strokes. I wasn't concerned with details at this

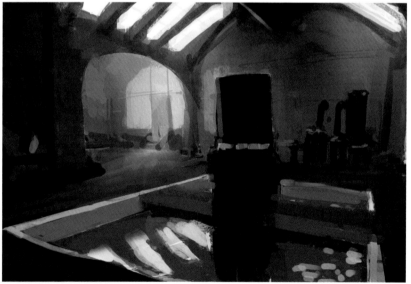

Fig.02

point, but instead wanted to block in large masses of darks and lights in an effort to better understand where my light sources were coming from and how they would filter down to interact with the environment I was creating. One thing that I always keep in mind is a strong graphic quality to the image. So many times an otherwise strong image can appear soft and "flat", due to a lack of strong dark elements set against light ones. Taking this piece as an example, we have a relatively dark room set against the almost white sky above. Within the room, I've once again silhouetted two doorways using dark against light, as well as silhouetting the form of the central cylindrical machine.

Fig.03

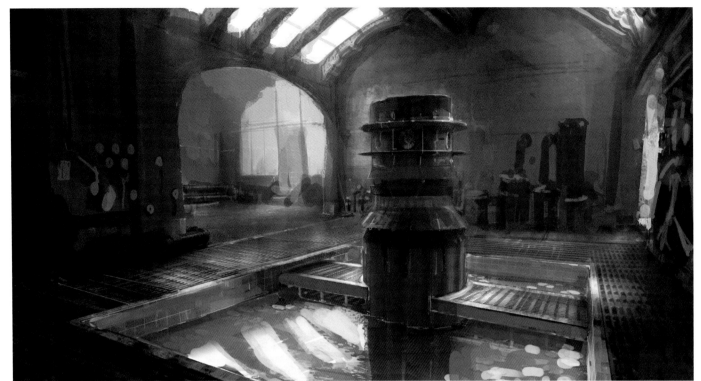

Fig.04

Refining the value sketch further, I began introducing dark forms for the machinery and pipes that would line the walls (**Fig.02**). I also indicated some strong reflections in the water below, which adds realism, as well as acting as a bright focal point amongst the darker portion of the painting. Once again, I was not too concerned with details at this point, but wanted to have most of the forms and "big ideas" massed in before heading to color.

Once all of the basic elements were laid out, I made sure that I was happy with the lighting and stood back to make sure it read from far away. When all was working well, I could then proceed to coloring the image. I recommend anyone to stay in the grayscale stages until they have their lighting worked out, and to take their time, as this really is the most crucial time in the development of a painting. Nine times out of 10, when a painting isn't working, it's because of a weak value structure, and it's easier to do it right the first time than to go back later on to fix value issues.

I next used a soft brush set on Overlay, and glazed the whole painting with a warm yellow-orange hue (**Fig.03**). From there, I added other colors in specific areas, such as the water and the background area beyond the archway on the left. The water was a little dark, so I lightened it up quite a bit to achieve the desired quality. Sometimes the presence of color can drastically change the appearance of a specific value, and you will have to make changes as you go!

After the overall palette was achieved, the next step was to begin defining forms and adding details (**Fig.04**). I first began to work on the central machine, and the ground plane around it. I decided to do a metal grating on the floor, and therefore grabbed a photo texture and put it on a transparent layer over the painting. This was very beneficial in creating a sense of realism, as well as saving many hours of rendering out a floor grate. I commonly use photo textures and collage them into my work for this very reason.

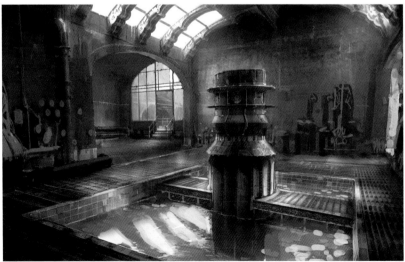

Fig.05

Fig.06

I continued with the detailing, adding in brick textures to the walls and defining the machinery further (**Fig.05**). I also grabbed some random photos to use as textures, just to create some subtle color and value shifts throughout the painting. I also began to make a wrought iron graphic that I could drop into the archway on the left (**Fig.06**).

A trick I commonly use for specific elements, such as grids, fencing, iron work and so on, is to use Illustrator to create flat graphics that I then import into Photoshop and manipulate into the desired perspective (**Fig.06a**). For the archway, I took a number of default ornamental shapes and combined them into a wrought iron shape. I then copied them and flipped them horizontally to get the other half of the archway, which was a perfect mirror image.

I next turned my focus to the water, refining the shape of the reflections and adding ripples as detail (**Fig.07**). I then cleaned up the lily pads and continued to add in highlights and details here and there as I saw fit. After a good amount of time detailing out the pipes and machines, I put in some additional highlights, as well as little bits of trash and paperwork on the walls. Finally, there were some areas that I felt needed to be a touch lighter or darker, and so I used a large soft brush to darken as well as add atmosphere and haze.

*Fig.07*

## CONCLUSION

Looking back on this piece, I believe that I accomplished all of my initial goals when creating it. As with all of my work, this piece helped me to refine my lighting and indication skills. Looking back at it now, there are some areas that I'd darken a bit more to help silhouette specific forms, such as the central machine and the mullions in the ceiling, but I'll keep that in mind and apply that knowledge to the next one!

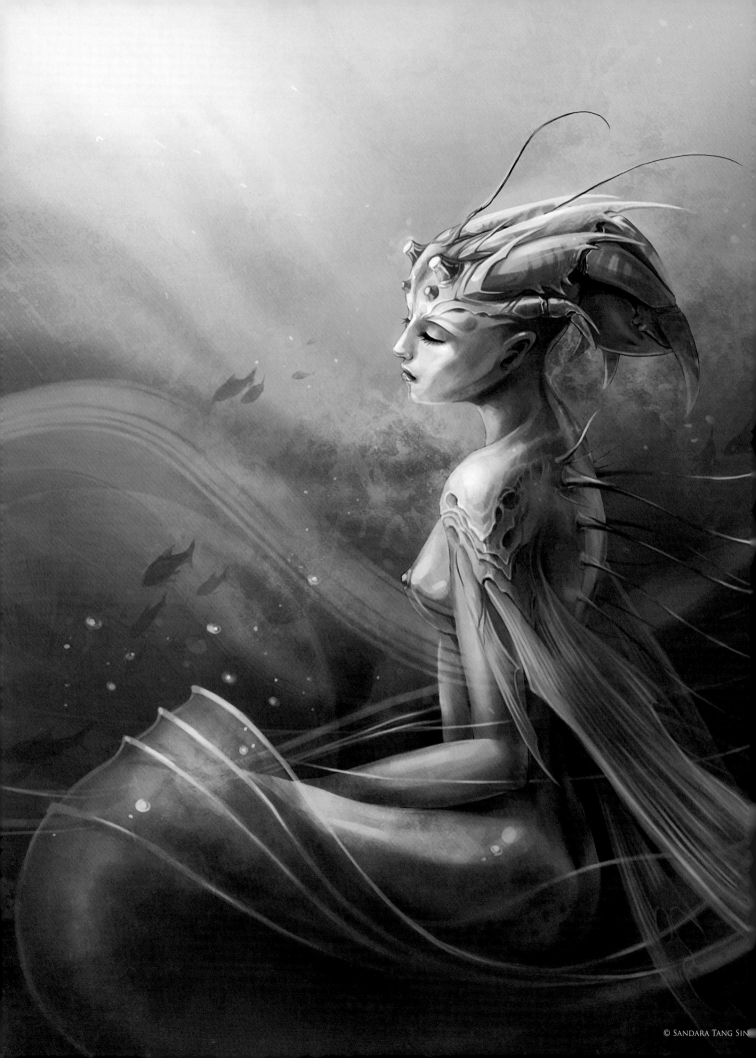

# LADY SYLPHINE
## BY SANDARA TANG SIN YUN

### INTRODUCTION

My initial idea for this picture was something along the lines of an underwater being. I wanted her to be graceful, serene and regal, like a lady of the ocean, but didn't want the standard mermaid look with a fish tail. I tried out some concept sketches of her head, but I ended up not quite liking any of them (**Fig.01**).

At that time, I kept some hermit crabs as pets and I noticed the elegant way in which they positioned their claws. They are held close together and curve out very nicely from their shells, and I decided to incorporate this into my drawing (**Fig.02**). I had some problems with her design as claws would usually mean a rather monstrous creature design. Finally, I decided to put the claws on her head, in place of hair, following the curve of her skull. They aren't functional of course, just decorative, like a crown of sorts. I added some fins flowing from her shoulders as they looked a little bare, and lastly sat her down in a bubble-like shell (**Fig.03**).

### THE MAKING OF

Once the initial sketch was completed in Photoshop, using a standard hard brush, I made a Multiply layer and used that to paint the base colors that would set the light and color theme for the whole piece. It started as a quick gradient down from the top left-hand corner, darkening towards the bottom right corner. Base colors for the creature were then blocked in roughly.

My base sketch and colors will usually differ a bit from the final image; as in this case, the sketch didn't quite catch the expression of the face that I wanted. However, I left it until the detailing stages to refine it (**Fig.04**).

Next, the shadows were painted in using another Multiply layer on top of the first. I always try to use a range of

*Fig.02*

*Fig.01*

colors for the shadows and not just a flat gray. These added some subtle color variation to the creature.

I next used an Overlay layer to add even more color into the image, and also to adjust some of the base colors slightly. For example, you can see in **Fig.03**, around her face and lower body region, I have added a bit of purple so her whole face would not be a monotonous green. The final step for the creature was detailing, where I added a normal layer and zoomed in to 100% and slowly painted over the outlines, smoothing out the roughness and painting in the small details. In this image, the focus is on her face and shoulders, and so that's where I spent most of the time on detailing.

I think the hardest part of painting this creature was doing her face. It took a long time to get her expression just right and I found myself changing the small details on her face over and over again (**Fig.05**).

Once she was almost complete, I went to work on the background. I decided on doing a more abstract looking background rather than painting a life-like ocean so as not to draw attention away from my main subject. Using the Overlay layer again, I made the area around her slightly textured. I then added some faint curves to complement the curve of her skull claws and the bubble she's sitting in. At this point, I decided to add in the filaments on her back that flow with these curves, as it was looking rather bare.

*Fig.03*

FANTASY

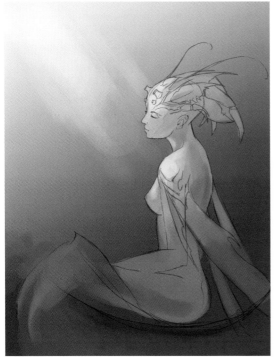

*Fig.04*

The only time a custom brush was used in this painting was for the large, wavy line that runs across the mid-section of the image. The entire image was painted using the number 19 Airbrush Pen Opacity Flow brush in Photoshop. I've found that, for painting skin, especially if I wanted a soft natural looking skin, this was the best brush to use. Finally, I painted in the small fishes and bubbles. As a last touch, I make an Overlay layer again and did final color adjustments.

## CONCLUSION

I had a lot of fun working on this piece, especially on her head. I tried very hard to capture a feeling of peace and serenity in her features, and I think it came out pretty well in the end. I really learnt a lot about painting skin

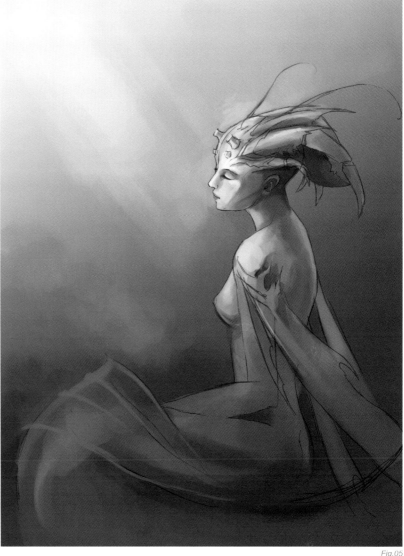

*Fig.05*

texture after finishing this picture. I think that, if I had to change or redo anything about this image, I would make the creature stand out more from the background. As it is now, they are still very similar in color and it is only the lighting on her that makes her stand out.

## ARTIST PORTFOLIO

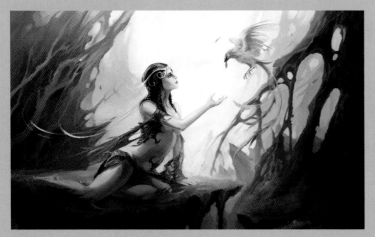

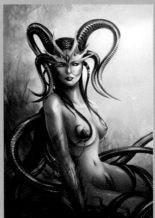

ALL IMAGES © SANDARA TANG SIN YUN

# DARKNESS MONSTER

## BY STEVE JUBINVILLE & YANICK GAUDREAU

### INTRODUCTION

In creating this character, our main goal was to test ours skills by creating a realistic – but fantastic – creature. In order to do this, we drew some inspiration for certain aspects from movies such as *The Lord of the Rings* (which inspired the character's height and the all-over fantasy look and feel of the movie), *King Kong* (which inspired us for the creature battle scenes) and *War Hammer* and *War Craft* (which inspired us when designing accessories and armor used for the film. Our concept is mostly based on the use of lighting; we wanted to create a bright and well-lit atmosphere, which is contrary to more popular "dark and evil"

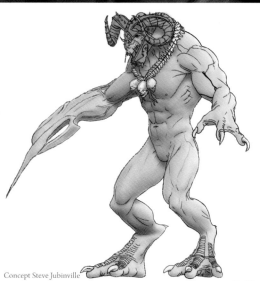

Concept Steve Jubinville

*Fig.01*

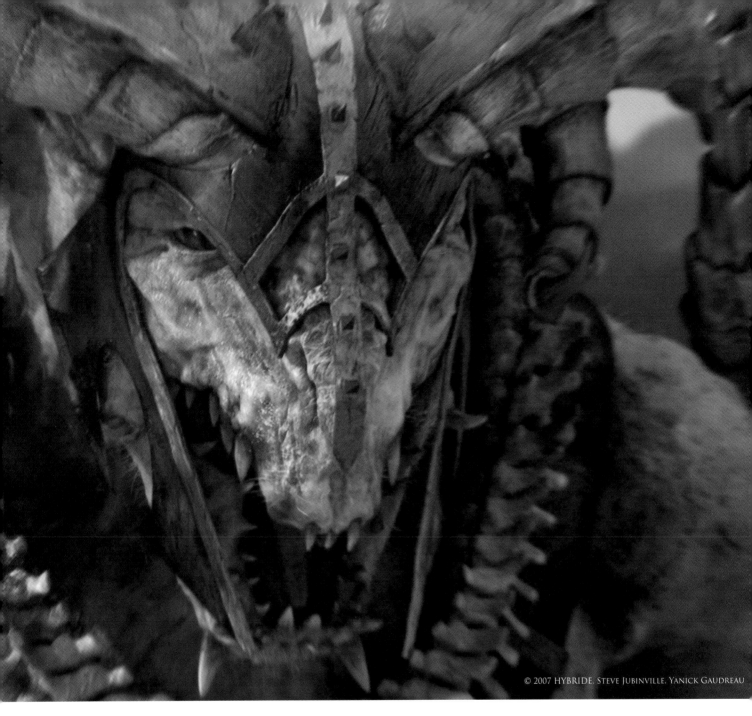

© 2007 HYBRIDE. STEVE JUBINVILLE. YANICK GAUDREAU

creatures we usually see in these types of animations. We also wanted to focus on the character's traits and expressions.

In this particular frame, the character stands out because there's a ray of light streaming from left to right through the clouds of a stormy sky, which helps accentuate the focus on the character and makes it appear to come to life. Also in this setting, we've focused on the character's height and proximity so it dominates its environment and seems like it's about to jump off-screen. We've taken care to not show too much of its body, putting the focus on the creature's face and its cold and cruel stare.

## RESEARCH AND CONCEPT DRAWINGS
The first step before drawing a character is to find a subject. The look is very important, but it is also essential to consider other aspects, such as what kind of character to create, whether it should be big or small,

what kind of environment it lives in, and so on. These aspects directly influence skin texture and color. For this particular character, we wanted to create something fantastic and so we mostly focused our research on Tyrannosaurus Rex dinosaurs, albino crocodiles, large birds' feet and bulls. Since we wanted to create a strong character with a mean and crazy look, the albino crocodiles were the obvious choice as our main guideline. It was, however, a very big challenge to achieve this particular type of skin using Sub Surface Scattering (**Fig.01**).

## MODELING, UV MAPPING AND ZBRUSH
Once the concept was ready, we chose to start the model with a low-resolution mesh, which made it easier to picture the character's main features. We personally don't like to start models with a box; we prefer starting with a simple quad, duplicating the edge, and then looking for the main line. This technique is quite effective in order to create

FANTASY                                                                181

the character's muscular contours. The advantage of making a low-res version first is that it is possible to send it to the rigging department early on to test the modeling deformations (**Fig.02a**). Once the model was done, we chose to unwrap each part of the model before starting with ZBrush, then we unwrapped the pieces with UV Layout, and Unfold 3D. The important thing to remember about the UVs is that you need to make sure every square on the character is equal, which makes the texturing part easier, and avoids any texture scaling later on (**Fig.02b**). When the UV Layout was finished we used ZBrush, which helped improve the model and add very specific details. Details were also made using different kinds of alpha and brush techniques. This also made it possible to extract Displacement Maps, Normal Maps and Cavity Maps (**Fig.02c**).

## TEXTURING AND SHADING

To create custom textures, we started with basic surface textures in Photoshop, then corrected them using the paint, color and mixing tools. The character's morphology was highlighted by making the skin very pale and by giving him very dark eyes. Moreover, the paleness of the skin helps bring out the different tones of color in the armor and in the accessories. As for the Render Tree, it was really simple: we used a phong material for the shader and some maps for the texture (**Fig.03a**). Now, because the modeling was very high in detail, we

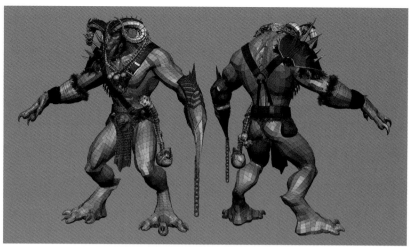

Fig.02a

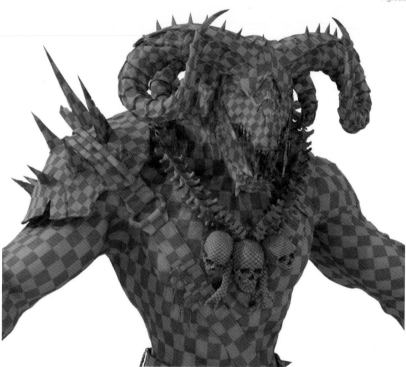

Fig.02b

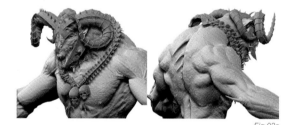

Fig.02c

Fig.03a

used a simple Diffuse Map alongside a Displacement Map and, at this point, the sub-surface scattering (SSS) shader was not connected because we added the (SSS) in a separate pass (**Fig.03b**). For this specific image, we used a very high-resolution mesh, which was faster for rendering. For the final animation shot, we put a lower mesh in the scene and applied displacement using the Render Tree (**Fig.03c**).

## LIGHTING AND RENDERING

For the lighting, it was not necessary to create a complex rig; we simply needed to insert some light to recreate an outdoor atmosphere, and then added a sun to recreate a nice rim of light on the back border of the head. In reality, a reflection is created when light hits an object, and for this reason we needed to add an environment map in order to simulate reality, complete with natural outdoor details and cool variations. With a bit of imagination, this creature really could come to life (**Fig.04a**)! Final Gathering and caustics can help achieve the look, but this increases the render time, so we've recreated the look in our image by diffusing light all around the character, varying its intensity depending on the lit areas. We tried to imagine rays of light falling on one

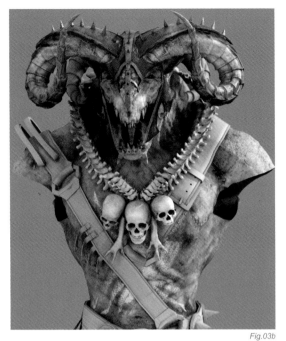

Fig.03b

object and then bouncing off a second, and this was the phenomenon we tried to apply to the character (**Fig.04b–04c**). Rendering was done using Mental Ray in Softimage XSI.

## POST PRODUCTION

Post production for this image was done using Photoshop, which is great for compositing if you're working on a still frame. Shake and Fusion were used for the final animated shot and we incorporated motion blur, inspired by an action shot of a repetitive movement which certainly helps break up the static quality of the image. We then added a Hair pass to make the transition between the background more natural.

## CONCLUSION

In short, all of the discussed aspects are what make up the essence of the image. We carefully proportioned the lighting and textures, and paid special attention to modeling details to ensure an extremely realistic feel to the character and its surroundings.

Fig.04a

Fig.03c

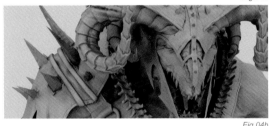

Fig.04b

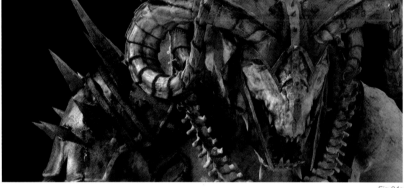

Fig.04c

## ARTIST PORTFOLIO

# LOST WORLD: TEMPLE OF NATURE

## BY TIBERIUS VIRIS

### INTRODUCTION

I've always loved mystery and legends – epic ones in particular. But trying to imagine those great worlds behind the stories is even more rewarding. One such legend is the one of the Temple of Nature, a Native American story coming from the old Maya civilization. Supposedly, a long time ago (as always), in a green,

lush valley, surrounded by a thousand waterfalls, a great temple was built to worship all of nature's deities in the same place: "Bacab" (God of Earth), "Chaac" (God of Rain) and "Pauahtun" (Wind Deity). This valley was so remote and hidden that it could be accessed only through a narrow path in the mountains, at the end of which a godly green paradise opened before your eyes.

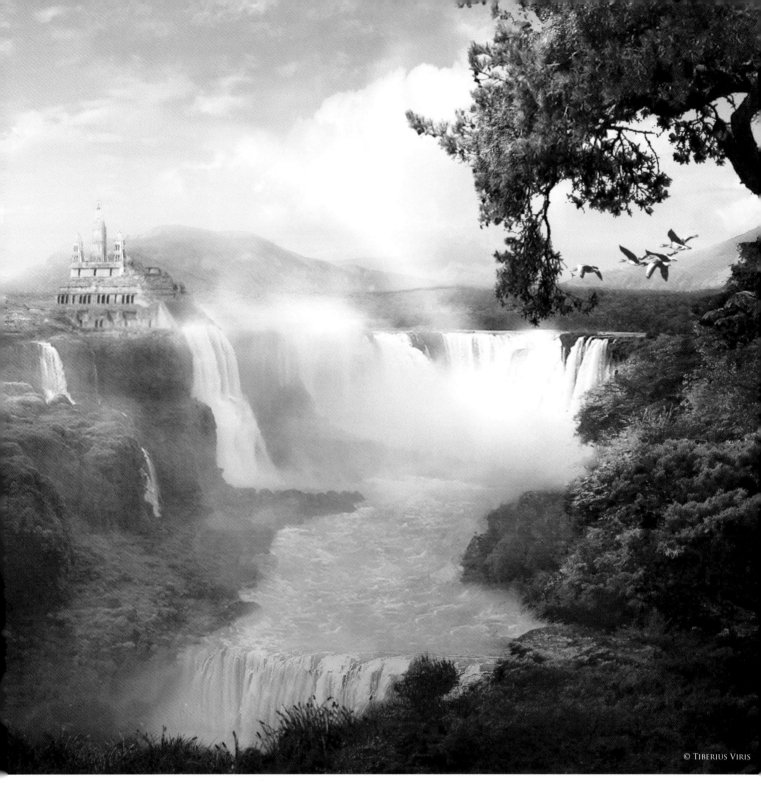

© Tiberius Viris

*Fig.01*

The temple itself was built upon a waterfall and was surrounded by the village of Tzununiha (meaning "house of the water"), inhabited by special jaguar guards who protect the temple day and night.

I chose this legend because I find the environment behind the story to be one of the most astonishing ones that can be found on Earth. So, rather than wait for its discovery, I went on creating a matte painting of it.

## CONCEPT CREATION

When I create a concept sketch, I focus on quickly "transferring" my idea onto screen, and rather than paying attention to values or rules, I'm more

interested in finding the right shapes and composition. This is what is usually called a "rough sketch". When I started my image I already knew what I wanted, so I quickly made 4–5 such rough sketches and studied the best composition. At this point I didn't pay any attention to the details. In the end, this was the concept I chose to start my project with (**Fig.01**).

Although this was a rough sketch, and most of the texture/elements will be replaced and/or refined, you can see – if you look at the final image – that not much has changed in terms of the composition.

## TECHNIQUE: ABOUT MATTE PAINTING...

Before I start writing about the working process, please allow me to point out to you that this image is a digital matte painting; a complex style with dozens of techniques, with the ultimate goal being a realistic result.

For this, digital matte painting combines digital painting, photo manipulation and 3D, in order to create "virtual sets" that are otherwise hard, if not impossible (and nevertheless not cost effective), to find in the real world.

### ...AND THE RULES

All the rules from traditional art are transferred here, and in addition a matte painter has the difficult task of making everything photorealistic. There are several elements that "tell" the eye it's watching something that exists (even if it doesn't!), as follows:

Fig.02

Fig.03a

**Depth:** This is the natural progression of color and focus that you see in nature. In the distance, elements have less saturation and contrast, details are harder to spot, and in the extreme distance you can only see two shades (highlights and shadows), whilst the objects tend to have a bluish tone due to the heavy atmosphere filtering. On the other hand, the foreground – meaning the objects that are close to you – have normal saturation and contrast, full black levels, and you can see all the details in them.

Fig.03b

FANTASY

**Lighting:** While this is obvious in nature, one has to be careful when creating a matte painting so that all the highlights and shadows match the source light and direction.

**Scale:** Again, it's very important to match the scale of every element. You don't want a tree as tall as half of the mountain, even if it might seem cool in a fantasy setting.

## BUILDING UP THE ENVIRONMENT

After deciding upon a concept, it's then time to start the actual matte painting! Usually, I start with the sky first because it affects everything in the scene: it defines the light, casts shadows, and defines the mood, the colors and the interaction of almost everything in your scene.

I began by creating a basic sky in Vue (**Fig.02**). Then I added the big cumulus cloud and refined everything in Photoshop. This became the final sky that you can see in the image, which hasn't changed throughout the creation process.

Then it was time to take the sky into the main file and start working on the land itself. After gathering up all the reference I needed, I started taking them into the scene. At first, I discarded the foreground sketch to reveal more of the waterfall behind, and to be able to build it properly. Later on, I was then able to go back and build the foreground elements up in order to fit the original concept.

Creating the basic mid-ground, and in particular the many waterfalls, was a difficult step because the references had different perspectives and light directions. Whilst the latter can be corrected with enough work, the first can simply make the stock useless, so I ended up painting huge areas. Fortunately, the waterfalls are quite far away, and this, combined with a double painting size of 4k, allowed me to create quite realistic textures (**Fig.03a–b**).

Fig.04

Fig.05

At this point, I deliberately left the right background empty because that was the area where the temple would be and it therefore required micromanagement. I continued working on the mid-ground and defining all the waterfalls, especially the one coming closest to us. This one also proved tricky perspective-wise, and in the end I had to create it using parts of a river and a lot of high-res painting. Then, to further integrate everything and also to add to the realism, I painted a low-level mist, which accurately represents water particles generated by the huge waterfalls.

After a struggle, I finally got the mid-ground I wanted; the waterfalls looked nice and the environment I had in mind started to take shape. So then came the time to mess with the foreground (**Fig.04**)!

For the foreground, I quickly blended 2–3 references, just to get an idea of the overall feeling. I was happy with it so I went back to finishing the right background that would sit behind the temple. I was careful not to create shapes that would not complement the scene or detract from the subject in question, but I also wanted to fill that area and create depth (**Fig.05**).

It was then time to finish the foreground. I added a tree to help with the framing and some birds for the composition. I also used some Vue-rendered vegetation (**Fig.06a–b**).

Fig.06a

*Fig.06b*

I'd like to make a note at this point about how difficult the overall blending up until now has been. In the WIP examples, you'll have seen some nice-flowing textures, with the same colors and proper lighting, but behind them are dozens of adjustment layers for each element which has been used, and there are 20 or so different photos used in this piece! To sum it up: more than an insane number of layers were involved (not to mention the difficulty of managing everything!). And on top of that there was also a group of other adjustment layers used for the overall scene. Just to give you an idea about how the scene would look without those top adjustment layers, please refer to **Fig.07**. The layers themselves (less than 10% of the total amount) can be seen in **Fig.08**.

## FINAL TOUCHES

You might want to ask why I haven't worked a single pixel on the focal element (the ancient building) up until now. Well, this is the power of a strong concept art set in your mind! I knew the building would be there, I knew how it would look, and I knew how it influenced the land, so I concentrated on creating the land first.

In the final step I built the ancient temple complex, refined the atmosphere and corrected individual elements (such as wrong perspectives, colors and blending – for this step I've worked in full resolution which is around 3600px). In the end, I added a rainbow to complete the scene and to add more realism. As you can see, I also shifted the focal point a little to the left of the right-top intersection, for more dynamism (**Fig.09**).

IMAGE WITHOUT TOP ADJUSTMENT LAYERS

*Fig.07*

*Fig.08*

*Fig.09*

## CONCLUSION

Bringing to life this old legend was a great experience, and it was also rewarding to be able to visualize something I've had in mind for so many years. From start to finish it was a lot of hard work, but I'm sure it was all worth it! I think I managed to create an original image that captivates the viewer and brings to his or her eyes the beauty of a godly realm.

© MARONSKI

# BONE HILL
## BY TOMASZ MARONSKI

### INTRODUCTION
Ever since I can remember, I have always been fascinated by surreal views and monumental buildings full of good moods, and I have based my portfolio on this kind of imagery. There are thousands of ideas for creating a good piece like this, but I love to base my work on rather spontaneous ideas that burst into my mind out of nowhere! Bone Hill was created like this.

### THE IDEA
The idea to create my piece came to me during a dinner with my beloved wife, somewhere by the sea. After we'd eaten, all that was left on my plate was a very interesting skeleton of a fish that we just ate. I smuggled the skeleton back home. My wife, of course, tried to convince me that it was a very – and I mean very – bad idea, but I knew back then that it was going to be useful (**Fig.01**)!

After finishing some of my freelance work, I sacrificed a bit of time to work on my landscape. I knew more or less what I wanted to achieve, so I got right to work on it. First of all, I took a picture of the fish bones on a uniform background (**Fig.02**). Using a uniform background helped me when cutting the fish bones out in Corel.

## CREATING THE MOOD AND LIGHTING

After placing the skeleton in the middle of the picture, I settled the proportions and the horizon. The most suitable shape for the workspace was a rectangle (**Fig.03**). These were quite easy steps; the most difficult part was to give the scene proper mood and lighting. I'd like to share with you with this part of the creative process.

The goal was for it to be spectacular yet at the same time very peaceful. I like to show contrasts in my works. As you can see from **Fig.03**, the dominating colors weren't yet established. To create the proper mood you have to choose the right color for the scenery right from the beginning. I made a few trials with the colors from which I chose the version with the warm colors (**Fig.04**). In my work, I use different color palettes and different styles of lighting. Sometimes it has a cold mood, and other times it will be unnaturally saturated. It depends on my own, personal mood when I'm working! Music is very important for me and it is the most important generating factor.

With the kinds of colors chosen for this piece, I decided to add a rising sun. This gave me an idea to create a strong light bloom on the top of the skeleton which boasted the overall look and gave the scenery more contrast and visibility. This was the time to paint

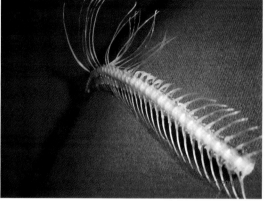

*Fig.01*

*Fig.02*

white, bony scimitars and to settle the skeleton on a hill. I achieved the low sunrise and naked, white bones which I imagined early on (**Fig.05**). Thanks to this, the skeleton is dominating and it is also in the middle of the composition, which makes it more majestic and more visible. This served as the founding principle for this piece, which later became known as "Bone Hill".

## DEVELOPING THE IDEA

The first idea was to show a lonely skeleton lying on the hill, but during the work my idea evolved. I missed the scale in the image. If you look at the image – somewhere in the middle of the work – you will not be able to tell how big the bone hill actually is! I was thinking about a flock of birds to add scale, which is an idea which always works. But this time I needed something stronger… So I decided to paint a city nearby, or I should say the bone hill became a city. It gave this scene more charm and logic. It also added a mood of a kind of mysterious riddle. Who would live in a world such as this? Why was this settlement originally built?

## THE COMPOSITION

I started creating the buildings and all the architectural elements (**Fig.06**). I had to take care of a good composition and detail, and at the same time I had to make it fit in properly. Some buildings were painted and some were cut from photos that I'd taken around my home city. You can see an example in **Fig.07**. Since

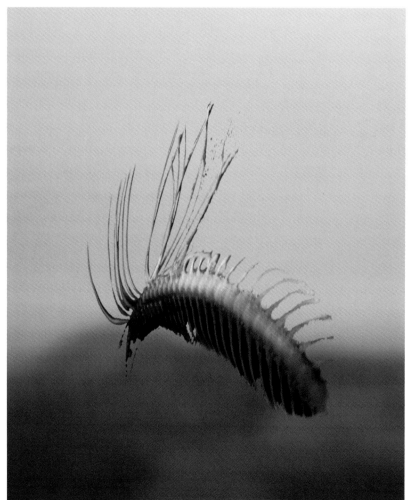

*Fig.03*

the city wasn't in the original idea, I had to correct the overall sense of dread. I made the lower parts of the city a bit darker, which gave more contrast to the hill and the morning sky (**Fig.08**).

## FINE-TUNING

With what I had at that time, I could have considered the piece as being finished. But since I had no time limits at all, I added a few more extra details. When I was looking at the picture I wanted to paint more here and there. While I was painting a detail in one spot, I was automatically noticing another spot where I could add even more. This way of working can be very disturbing! So I divided the image into parts and started working on each part separately (**Fig.09**). Then I simply pasted everything where it belonged.  This was the best part of whole creation process – I knew after this that it could be only better! Thanks to this, I gained more patience to tune everything just right.

Fig.04

Fig.06

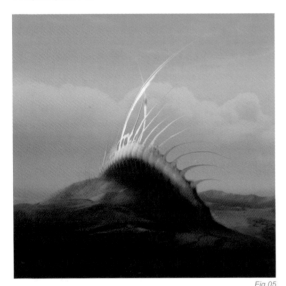

Fig.05

Fig.07

The software I used was Corel Photopaint, which is a program I use to create my pieces. Over many years I have met a lot of people who think that Photopaint is simply worthless, and the almighty Photoshop is the only reasonable software to use when it comes to digital painting. But, from my point of view, it is simply a matter of what software you had at the beginning!

I sacrificed about 15 hours to complete this piece. I always try to work no more than one week on a piece, otherwise I know that I'll never finish what I've begun, and I recommend this way of working!

## CONCLUSION

This work was created in 2006. Since I was doing it just for fun, just for me, I was able to do everything just the way I wanted, without any intrusion into the creative

FANTASY

Fig.08

Fig.09

process. I was really pleased with this image. I've learned so much since then, but still, I like to come back to this piece. Now, having written this article, I know that I could have done it better and I have new ideas! Right now, I figure the skeleton could be kind of bursting into some monumental building; I'd make the tail a bit longer and make the sky better than it is now; I'd make the clouds denser and correct the overall look of the sky. I'll probably do these things in my next personal piece, which I think will be as moody as this was, and perhaps I'll write about it again!

## ARTIST PORTFOLIO

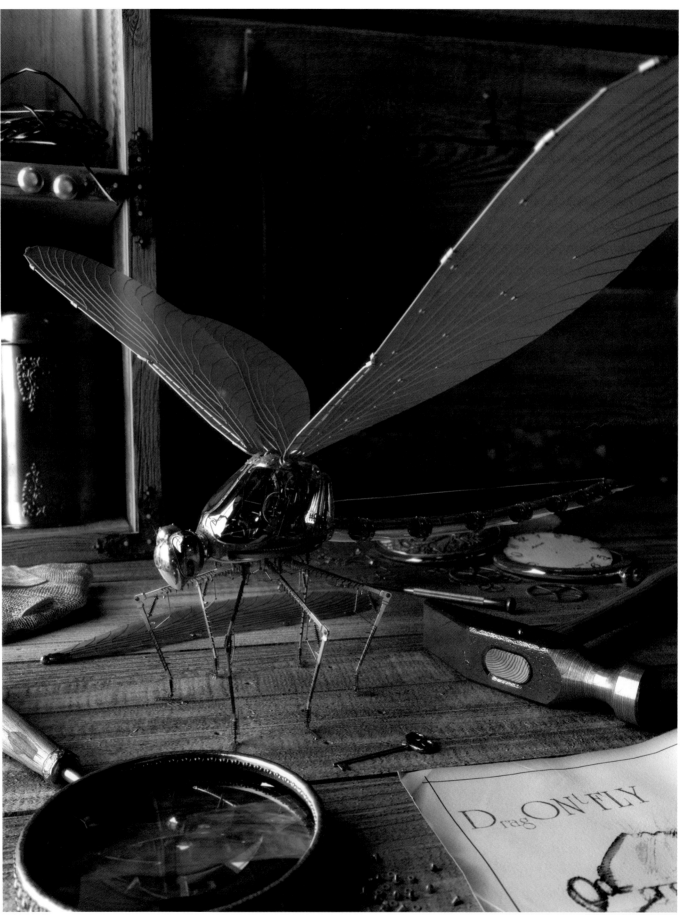

# DragONtFLY
## By Denis Tolkishevsky

### Introduction

I created the first version of this work in 2006. At that time, a website was holding a contest for the best "mechanical toy" and I decided to show that it was possible to create graceful things using rough tools. One of the conditions of the contest was the presence of clockwork. I decided to create a mechanical dragonfly and tried to get a feeling of olden times. I didn't have enough experience in the adjustment of materials and lighting, so the final image wasn't of a high quality. After a year, however, I decided to return to the piece and finish it. I didn't change the model of the dragonfly, but all the other models, materials and light were changed. I added many details which were not in the initial image and I carried on with this work for about a month in total (only in my free time). I'd like to share my experiences with you.

### Modeling

I used poly modeling to model almost all the details of the scene. I usually start by creating primitives (boxes, cylinders, planes and so on). I then applied an Edit Poly modifier and achieved the necessary forms and specifications with the use of poly modeling tools (extrusions, bevels, chamfers, cutting and so on) and modifiers (Symmetry, Bend, Shell, Twist, Noise, Displace, Turbo Smooth and so on) (**Fig.01**).

I decided to use Displacement to create stamping on the rim of the magnifier and on the metal container (to gain extra experience in this area). I required a displacement

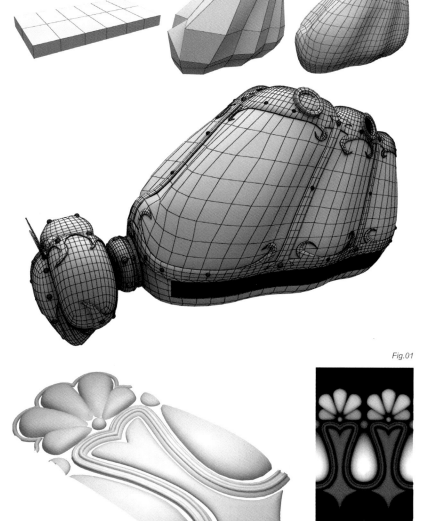

Fig.01

Fig.02

Fig.03

map and so created it by modeling a repeatable section of geometry and rendering a Zdepth map (**Fig.02**). I then used a Cloth modifier to create a rag with the subsequent manual editing of the vertices.

## MATERIALS AND TEXTURING

I spent about half of my time on the creation of materials, as I consider bad materials spoil any model – even the best ones! Therefore, I gave greater consideration to the creation of materials. All the textures used in this work came from my private library. Some were photographed especially for this project, for example the wood texture for the table, the fabric texture and so on (**Fig.03**). I created some textures in Photoshop, for example the paper with inscriptions and a figure on it, as well as a texture for the scratches on the hammer and so on.

For this work, I didn't use Unwrap UVW as I don't like to do it and always try to avoid it if possible. I confined

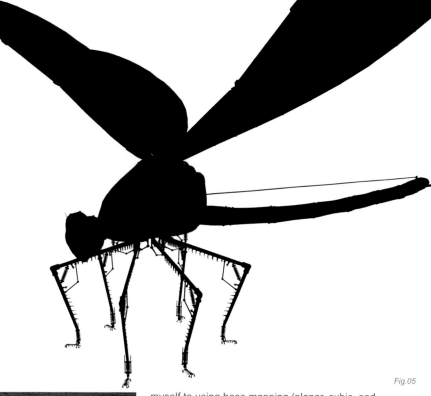

Fig.05

myself to using base mapping (planar, cubic, and cylindrical) and Multi/Sub-Object materials.

I spent a lot of time creating the realistic materials of the glass lens and the metal hammer, because using the parameters of these materials close to their physical characteristics didn't give the desirable results, and instead I had to do it by guesswork.

## LIGHTING AND RENDERING

I used a planar V-RayLight for the basic light source (light from a window) in the scene. So that the light source looked like a window, I positioned two crossed boxes to simulate a window. For the environmental light and reflections I used an HDRI map.

The base image, with a resolution of 2700 by 3672 pixels, was rendered in about four hours on my computer (Pentium IV-3000 with 2GB of memory). I used V-RaySincFilter for an antialiasing filter, Irradiance map for the Primary GI engine, and Light Cache for the Secondary GI engine.

## POST PRODUCTION

I decided to highlight the dragonfly because there wasn't enough contrast when the final render was ready (**Fig.04**). I needed a mask to repeat the contours of the dragonfly and to separate it from the other image. I made all the objects invisible, except the dragonfly, in 3ds Max, and assigned a black material to it. I then disabled all light sources and made a white background, and rendered the image with a mask to separate the dragonfly from the background (**Fig.05**).

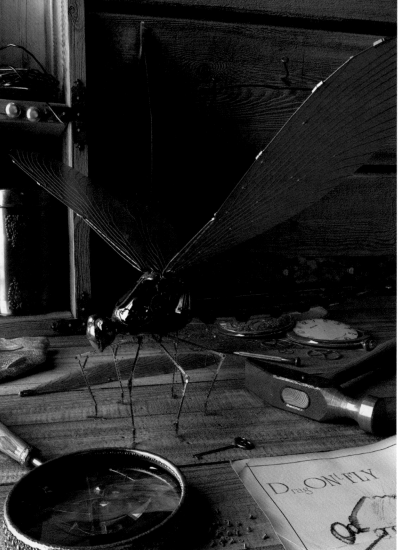

Fig.04

SCI-FI

I made the dragonfly lighter and the background darker by using a mask in Photoshop and then increased the contrast of the image. I decided to create the depth of field in post production to save rendering time, for which I used Zdepth. Two maps were rendered. I took, as a minimum parameter, the distance from the camera to the nearest visible object, and as a maximum parameter I took the distance from the camera to the center of the dragonfly for the first card. For the second one I took, as a minimum parameter, the distance from the camera to the center of the dragonfly, and as a maximum the distance from the camera to the furthest visible object. I then combined them into one by way of mixing the layers using the "Screen" blending mode (**Fig.06**), and then used this image as a mask for applying Lens blur. I understand this method is not correct from a physical point of view, but the final result suited me fine. I applied Volume Light and Dust in Photoshop as a separate layer using Screen mode. Previously, a layer (**Fig.07**) was created in 3ds Max and the additional source of light with Volume Light. I applied a black material to all the objects of the scene and rendered the image.

## CONCLUSION

I have come to understand many things during this work which could be made in alternative, better ways, but I'm not limited to any terms in my personal work. I always try to use unusual ways of working to get additional experience in 3D, and I also try to find ways to speed up achieving the final image! I hope after reading this you will understand some of my methods of working, and perhaps you will find something useful for yourself!

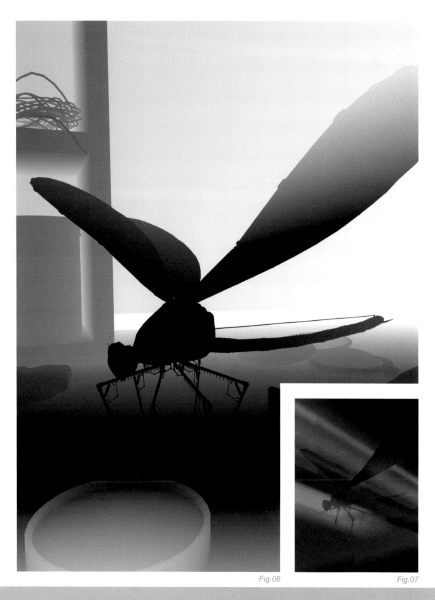

*Fig.06*

*Fig.07*

# ARTIST PORTFOLIO

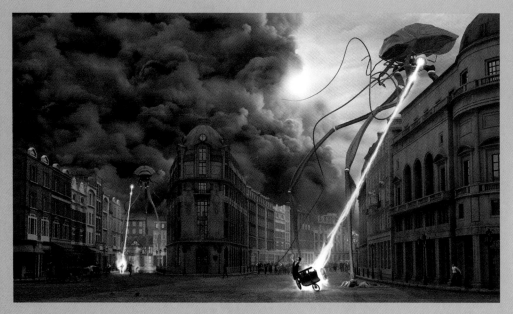

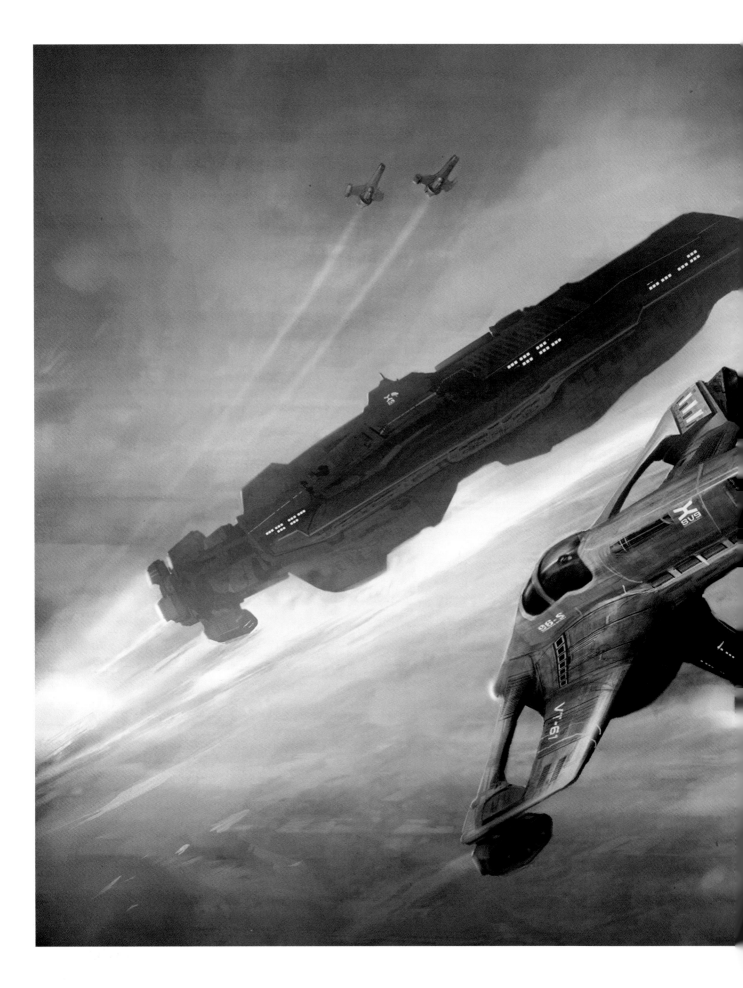

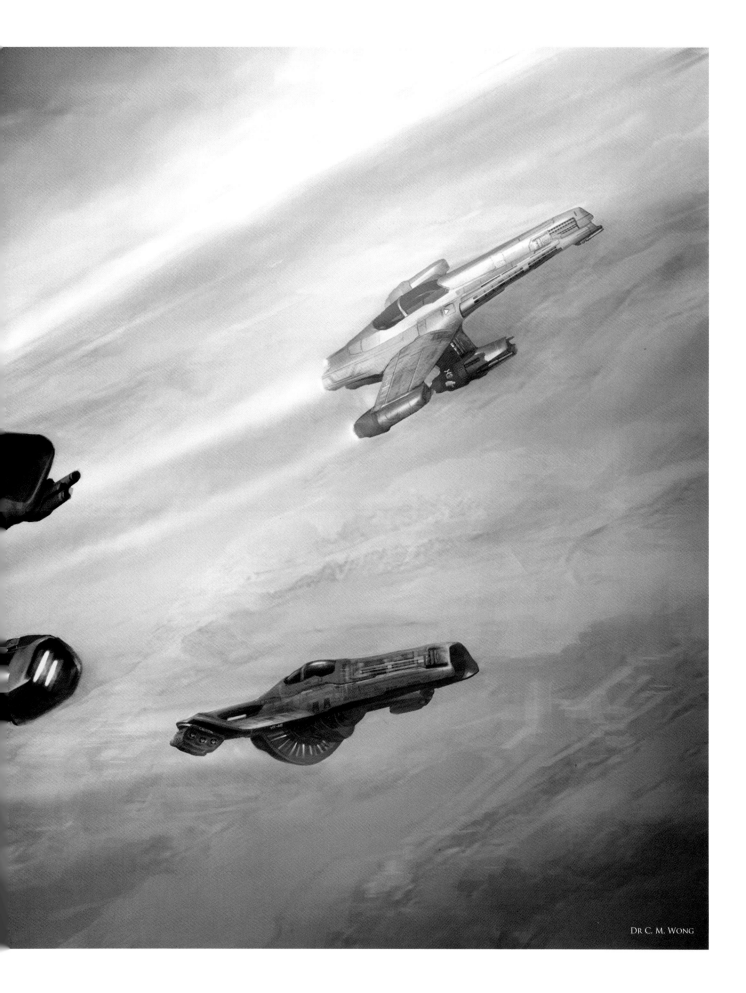

DR C. M. WONG

# Flight of Silverbows

## By Dr Chee Ming Wong

### Introduction

In producing conceptual art and illustration for the entertainment industry, there is often a great deal of an iterative process that goes into the design; this includes the thoughts, philosophy and technical requirements that often accompany an art brief, which ultimately help towards making a non-existent scene believable.

### Producing a Game Asset

In 2005, I signed up with Flavien Brebion (a talented VR programmer) to help produce core conceptual art and illustrations for "Infinity: The Quest For Earth". Infinity is a space-based massively multiplayer online game in the vein of Elite/Frontier (a classic sci-fi game from the 1990s) produced by an independent group of developers. Set many thousand years in the future, it involves a complete galaxy that players can explore, colonize or fight resources for.

Most of the game uses procedural algorithms to create the universe and planets, but requires a database of artist-generated content, such as spaceships and buildings.

The first step to creating a usable in-game 3D model is to make a concept or sketch of the model. It is used as direct reference or to provide inspiration to the modeler (usually a different person than the concept artist), who subsequently produces a low-to-medium poly count 3D model. This 3D model eventually gets UV mapped and textured before it is integrated into the game.

### Concept to Illustration

First, there are no hard and fast rules of how to produce a good, effective design, and evolve into the design phase and the illustrative phase.

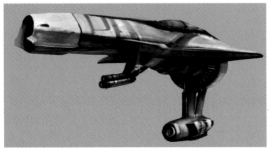

Fig.02

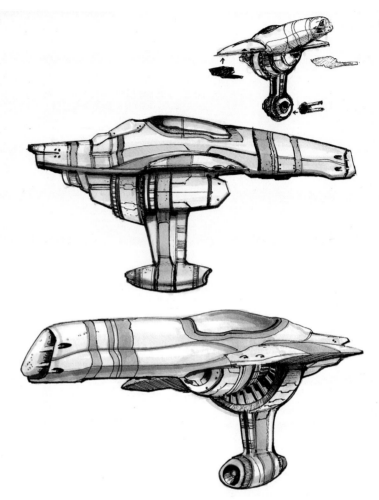

Fig.01

Within the design phase, I prefer traditional media to loosely work out the structure, form, function and aesthetic of a transport – more specifically, I enjoy sketching freehand in perspective with a Pilot Hi-Tec 0.4 pen and a thicker-nibbed G-2 0.7 pen on any paper medium.

Alternatively, exploration via digital media involves producing a variety of solid shapes, which can be used to generate a variety of segments; engine parts, gun emplacements, cowling, and various ship design shapes. This method allows for a modular approach towards building a vehicle that can have parts that integrate and swap seamlessly.

The illustrative phase is more of a methodical process, involving formal layout of composition, and represents a visual description of the concept.

### Design Aspect

Inspiration can come from any source and in many forms. In this regard, the concept originated from a cross between a hairdryer shape and WW1 fighter planes. This started the concept, by building it with a central engine with a smaller ventral type fin and external thruster.

**Initial transport design:** In this design, I postulated that by affixing an external engine ventrally, this allowed for advantageous high-G maneuvers. As such, I explored various options and views in my sketchbook and even explored the option of mounting modular weapon placements (**Fig.01**).

**Refinement of concept:** From the initial sketch, I started afresh within Photoshop and produced a rapid grayscale 3/4 perspective study. This allowed for various strong shapes to be explored. If it reads as a silhouette, it has a strong initial design (**Fig.02**)!

## ILLUSTRATION

In considering an illustration layout, there were various things to consider. In the main, I wanted to show the Silverbow fighters in the role of an escort, and also try to illustrate the squadron in its various modular modes.

**Initial layout:** The initial layout shows a main hero "fighter" – this I placed as No. 2, escorting the main ship. To complicate issues further, I decided that each fighter would have its own vanishing point (to highlight the fighter's high maneuverability) (**Fig.03**).

**Blocking in:** To build up an initial scene fast, one can duplicate the base underlying sketch (onto a new layer) and set it to Multiply. Rough values (approximating light falling on a cylinder) can be used to approximately produce a metallic sheen on each fighter shape. Each

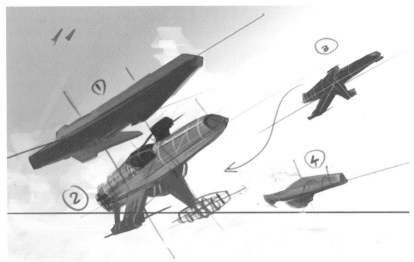

Fig.03

Fig.04

VP1

Fig.05

shape can subsequently be selected and saved as an alpha channel for ease of selection in the future (**Fig.04**).

**Perspective grid**: The overall composition is mainly a multi-perspective illustration. The main vanishing point (VP1) is plotted on the far left. However, there are two other hidden vanishing points (with VP2 outside the canvas at one o'clock and the other VP3 at five o'clock from the center of the canvas). In addition, each fighter and transport has its own VPs (**Fig.05**).

**General lighting and ambience**: For the ease of illustration, each fighter has its own layer with the cloud layer separated onto the canvas. To improve the overall ambience, I separate the objects into a hierarchy of foreground, middle ground and background value (**Fig.06**).

**Additional lighting**: Once the basic shapes and forms are "blocked in" sufficiently and conform to the ambient lighting, the next aim is to add direct lighting, basic detailing, and diffuse color (e.g. sky blue) (**Fig.07**).

**In-game asset**: Here is the end result of the conceptual stage in 3D model form, where the landing gear and ventral fin stow away to the side to present a believable design and use in-game (**Fig.08**).

**Final touches**: The key remaining factors are to add tighter contrast, rim lights (to enhance edge believability),

Fig.06

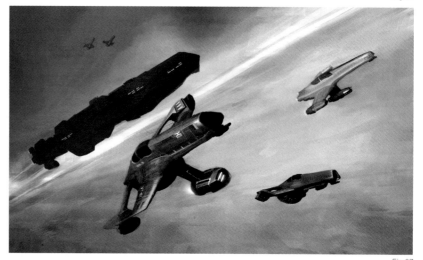

Fig.07

Fig.08

decals and signs (to simulate the feel of a working futuristic fighter. In this regard, Photoshop's transform tools came in very handy, allowing for deformation and subtle adjustment of fonts and text onto the right plane of perspective) and most importantly the fine details such as textures that enhance and confirm the believability (**Fig.09**).

And with a few final touches, the illustration is deemed to be finished at this stage.

## CONCLUSION

Throughout my core process of conceptualization and illustrating for Infinity, I have come to teach myself a wealth of conceptual design and better appreciate the basics of industrial and transport design. With every painting, it does feel as if there is never enough done to call it finished, and the same applies towards this illustration. There are various niggles and approaches I would have liked to explore, but suffice to say this piece represents a small hallmark in my continued growth as a lifelong conceptual artist.

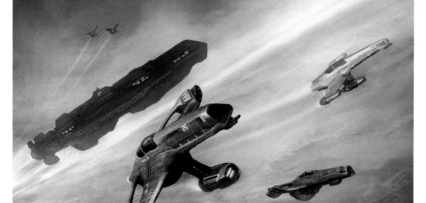

Fig.09

SCI-FI

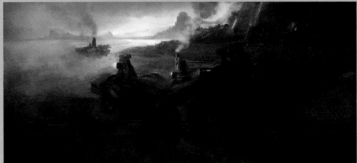

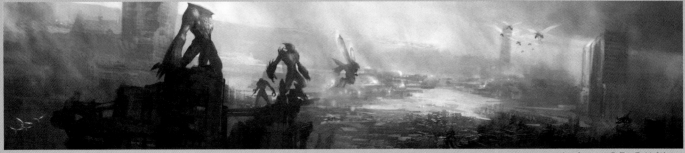

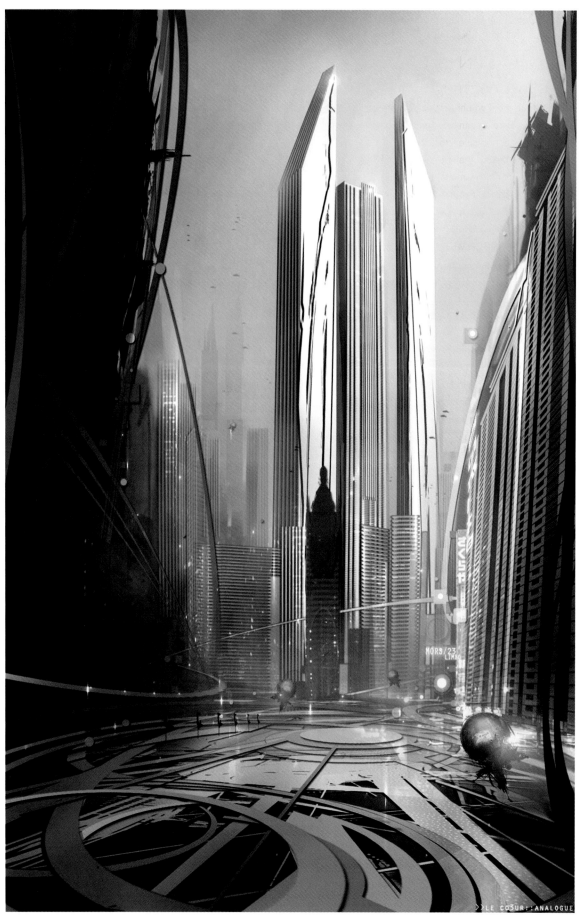

# LIMBO CITY

## BY EDUARDO PEÑA

### INTRODUCTION

This type of graphic project makes people like me, an artist and a designer, able to explore the possibilities so that the software, as a tool, can allow me to commence an artistic and experimental search to achieve work objectives in this great discipline of conceptual art. Furthermore, I include a personal whim by being able to risk creating an image with a well-marked visual force.

The image that I am going to explain in this "making of" forms part of some conceptual art for the development of a scenario for a videogame called "Cell Factor", developed by Immersion Games. This piece shows a particular projection of a building view which characterizes and describes history in this futuristic context. The idea was to create a sort of atmosphere that would show the technological evolution of a distant civilization. The three towers shining on the horizon impose their technological imperialism.

For the development of this artwork, I searched for several visual references that would allow me to have some conceptual clarity of the type of environment I

Fig,02

Fig.01

should develop. I started by searching for photos of large cities, such as New York City, Shanghai, Hong Kong, Tokyo, and so on. Once establishing my references, I started building a mental image of what the city of Limbo would be like. Moreover, part of the inspiration for this art comes from the great artist Stephan Martiniere, who has had a great influence on my education as an artist and designer in this discipline.

Some of the characteristics of this city are perfection, order, and technological power. Obviously, the foregoing leads to creating a visual language describing these characteristics, which will noticeably have to be reflected visually on the final art to better describe the nature of the game's history.

With all the necessary material in order to build the artwork, I started my composition. Nevertheless, there was something which was very important for me, namely setting my working atmosphere. I played some ambient music, which gets me more involved with what I do. My philosophy is such that the main character of my work is a result of getting involved in a similar fashion to the way "actors" immerse themselves in a character role.

### WORKING PROCESS

Before starting, I created a new document, then commenced with the task. I started working on a customized canvas in Corel Painter. The artwork had a neutral base color, in this case white which is what I would begin with on canvas. I started with

a composition by using quick strokes, which rapidly oriented the perspective and location of elements in the proposed space (**Fig.01**), thus facilitating composite hierarchies in the general visualization of the art. I then undertook the search for a little more consistent graphic protagonism for the ideation of the most sublime shot of the most important structure in the city, namely Limbo Corporation Building, which consists of three tall metal towers shining on the horizon. Till the end, I kept searching for certain order within the structures, which I identified little by little during the course of the work with random strokes (**Fig.02–04**). From experience, this process allowed me to play much more with the composited elements without enclosing or standardizing them. Obviously, the point of view was very relative and circumstantial in as much as I only had to create a

*Fig,03*

*Fig,04*

*Fig,05*

*Fig,06*

general visualization in this work, without specifying or focusing on unique shapes.

Upon defining the general composition of the image, I started to give consistency to the city structures by using orthogonal lines – as well as organic shapes – to give a somewhat fictitious and plausible air to my work, and an urbanistic order, so to speak, since it was to be something fictitious, but it also needed to have a certain analogy with our current environment and a descriptive coherence. Simultaneously, I worked with my custom brushes in Photoshop to be able to make

the editing process easier, thus allowing me to work and experiment with shapes and elements that made the technical work easier for me, and even yielded results that complement the final artwork (**Fig.05–06**).

## TONE AND COLOR

I then started working on the color palette by creating another layer, in Overlay mode, to work on my black and white base. I defined my chromatic palette involving metal blue and white colors, which were to reveal a certain psychological air in the context I was proposing (**Fig.07**).

Little by little, I acquired the desired visual consistency and impact I wanted to convey in the image, playing a little with the light and brightness of elements, in as much as, at this stage, they were more of a technical and composite execution.

I wanted to create a perfect environment, with stable meteorological conditions. Never does it get dark in this city since it is at the tip of the sky. I decided to give it a subtle ambient light, which becomes stronger due to the metal frame of these structures in the city.

## CONCLUSION

In short, with conceptual art, I technically reached a very good unexpected result due to the experimentation of techniques themselves, which subsequently worked as a visual guide and a new aesthetical criterion for my own style, which I explore, develop, and execute for the specific demands of each project. I hope these images displayed have been to your liking and have had a good effect on you. Thank you.

Fig,07

# ARTIST PORTFOLIO

ALL IMAGES © LE (CO3UR-ANALOGUE)

# CU-02 in Love

## By Goro Fujita

### Introduction

"CU-02 in Love" was created for the "Strange Behavior Challenge" on CGSociety.org. I felt comfortable with the Challenge topic because I often paint strange scenes when I'm doing sketches of my own. I decided to create a scene with a robot, since I have a passion for them. This illustration took me about two months of my free time to complete.

### Idea

I started out sketching ideas (**Fig.01a–f**), looking for a nice story. I had some ideas that could have worked pretty well as a "Strange Behavior" illustration, but I also wanted to create a profound background story for the painting. Of all the ideas I had in mind, I decided to work on the concept with a cooking robot falling in love with

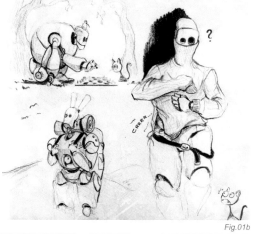

Fig.01a

Fig.01b

Fig.01d

Fig.01e

Fig.01f

a cat. The basic idea was that a cooking robot gets attracted by a beautiful cat and he starts giving her fish to get her attention. The robot tries to mimic her appearance by using old Cola cans as ears and a rope as a tail (**Fig.02**).

### Process

After doing the first sketches and paintings, I soon realized that I had to make clear that the robot was attracted by the cat and not baiting it. So I started doing more thumbnail

Fig.01c

sketches to figure out a good composition to tell the story. I worked on logo designs for the robot manufacturer "Cooking Unit Inc." simultaneously (**Fig.03**).

After working on different compositions, I thought that the story would work best if I got rid of the Cola can ears, the rope tail, and exchange the fish with a flower to emphasize the fact that the robot (CU-02) is in love with the cat. I chose a plain perspective to be able to play around with the silhouettes of the two characters in front of the moon, then made a first color sketch to capture the mood I was aiming for (**Fig.04**).

I was pretty satisfied with how the colors worked together, but I needed to work more on the composition and the

Fig.02

Fig.03

Fig.06a

Fig.06b

Fig.06c

Fig.04

Fig.05

size relations. My goal was to create an invisible storyline which would lead the eye of the viewer, starting with the cat and ending in the kitchen where the meal is boiling over (**Fig.05**).

When I was satisfied with the basic composition I started detailing the environment. I painted a seamless brick texture using photo references for the wall (**Fig.06a**). You can easily paint over the seams by using the offset filter in Photoshop. After finishing the texture I defined a new pattern from it, filled a blank layer with the pattern and transformed it with the transform tool in Photoshop to get the bricks to match the right perspective. I used the Overlay layer mode to blend the texture in the painting and adjusted the colors and the light and shadowed areas afterwards (**Fig.06b–c**).

The posters that you can see on the wall were painted separately. That way I could easily scale, rotate and erase them without worrying that I couldn't go back to the initial state, in case I wanted to make changes on the posters at a later point (**Fig.07a–c**).

## THE CAT

The cat had to be beautiful, arrogant and elegant at the same time (**Fig.08**). It took some time to find the right attitude for the cat. At first I had a simple black cat facing away from CU-02. I liked the simplicity, but her attitude wasn't strong enough yet. As I darkened the sky to pull the focus more on the characters, I needed to improve the contrast and decided to change the cat into a white cat. White fur made her appear more feminine and elegant. Still not satisfied with her attitude though, I tried out different poses. I painted a version where she was looking coquettish at CU-02, but it didn't fit well with the story. She needed to be an arrogant character who is too proud to show any emotions. So, I went back to the idea where she was facing away from CU-02. In the end, I decided to give her a realistic touch and made her fur glow in the moonlight, which emphasizes her elegance.

## FISH, FLOWER, RAT, DINNER PLATE…

It was tough to decide which gift would work best for the story (**Fig.09**). The flower was very charming and it would have been obvious that CU-02 was in love with the

*Fig.07a*

*Fig.07b*

*Fig.07c*

*Fig.08*

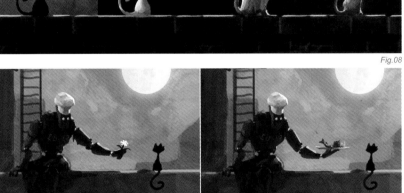

*Fig.09*

cat. Then again, there would have been no connection to his occupation, which was cooking. The plate worked pretty well because it would have shown his effort toward pleasing the cat, but the love part would have been a bit weaker. The rat and the fish both worked pretty well as a silhouette, but it might have been confusing again whether he was baiting or feeding the cat. The arm and hand pose was more suitable for expressing disgust, while the arm pose where he holds the flower or the plate expressed generousness and honesty. After asking many people about this, I decided to combine the flower and the plate (**Fig.10**). I guess this was the best option of all!

## FINAL DETAILING

Detailing a painting is the part that I like the least; it's less intuitive, it takes a lot of time and you have to be very exact – it feels a bit like cleaning up your apartment after a big party! However, I put a lot of time and effort in the detailing process. The wall I mentioned earlier was a plain texture without any light and shadows. I painted the shadowed and light areas depending on the environmental light on the bricks. The shadow of the ladder also follows the structure of the wall (**Fig.11**). I also added little insects and dust particles around the light above the entrance, and a little bit of steam coming out of the kitchen which emphasizes the depth of the painting (**Fig.12a–b**).

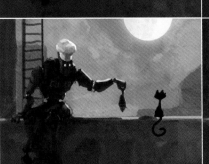
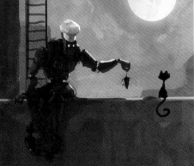

*Fig.10*

## CONCLUSION

I also wrote a background story for this image, which was a first for me as I had never done this before for a single painting, but it was great to see the illustration growing along with it!

I set the story in the year 2056 in which kitchens and restaurants are equipped with "cooking units" (CUs). The CU in this story, however, has malfunctioned, and meets a white cat in the backyard of the restaurant who he tries to woo, night after night, with delicious cooked treats. The cat proves herself to be too proud to get excited over his affection, even though she too has feelings for the robot, and continues to sit high up on her wall casually waiting for her dinner each night, making CU-02 climb up the wall to feed her… If I hadn't put my focus on the story in this way, the painting would work only half as good as it does now. It also helped me in the decision-making, as every element in the painting is there for a reason. The most exciting part was to figure out a way of telling the whole story in just one image!

I didn't win anything in the challenge in the end, but the experience I gained throughout the whole painting process was more valuable to me than anything else!

*Fig.12a*

*Fig.11*

*Fig.12b*

SCI-FI

# Artist Portfolio

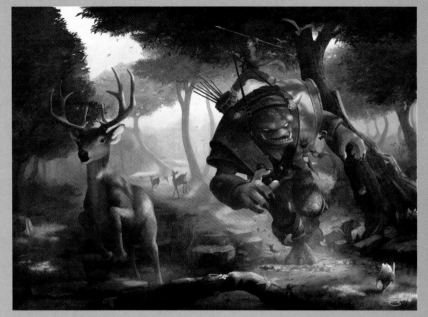

All Images © Goro Fujita

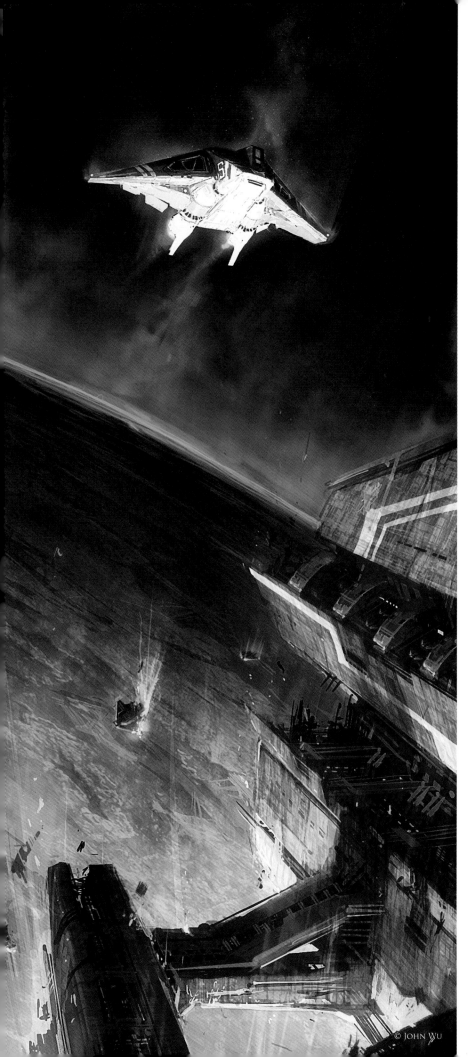

# BREAK AWAY!
## BY JOHN WU

### INTRODUCTION

The purpose of this painting, "Break Away!" was originally produced as a gallery piece for an event at Gallery Nucleus, an art store near my neighborhood. "Imaginary Spaces" was their theme, so they were pretty much open to anything that didn't feature characters as the main subject matter. Being a hardcore fan of the science fiction genre, I knew I wanted to paint something along those lines. However, it was after watching the second season of *Battlestar Galactica* that completely reinforced my decision to go down that route!

Ever since I was a kid, I have always been fascinated by the topic of space travel. I wanted to create a piece that is beautiful, yet still manages to capture the horrific dangers that it presents. There are many variables that are stacked against the idea of space travel, and things eventually do go wrong. So, the scenario I chose for this piece was about a mother ship that has gone too close to a planetary gravitational pull. Luckily, one small vessel manages to break free from the mother ship, only to live another day. Numerous questions popped into my head while brainstorming this scenario. Would this ship be able to propel itself out of the planet's gravitational pull? Would it survive the atmospheric reentry? Or, could the atmosphere even support humans, for that matter?

The painting I wanted to create needed to feel refreshing and exciting. As a result, I avoided the monochromatic approach that most of us are used to seeing. Instead, I referred to the art created by John Berkey for inspiration. My goal was simple: I wanted to keep the composition clean and colorful!

## PROCESS

I always start off my paintings by loosely sculpting the composition with broad strokes of solid grays, because I find it easier to work with fewer values. By keeping it simple, it also allows the shapes to develop quicker (**Fig.01**).

My next step, after I'd somewhat completed the composition, was to figure out the light source. Because the ship was being fired from below, the light source needed to come from underneath (**Fig.02**). This also made the scene more dramatic! To do this, I duplicated the original layer and then brightened it. I then erased the parts that weren't affected by the light, and then flattened the image. This process was repeated several times until I achieved the results I needed.

Then comes the boring part – well, at least to some. With the composition and lighting already established, it was time to make technical corrections. To accomplish this, I created a perspective grid on an Overlay layer and gradually fixed the perspective and scale issues (**Fig.03**). Being technically correct is important, but it is also important not to disrupt the composition too much. For situations like these, I feel it's all right to use a bit of artistic license.

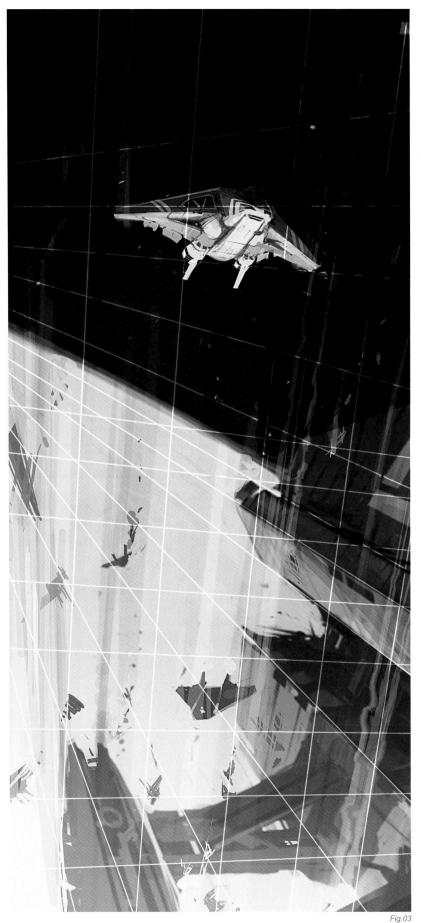

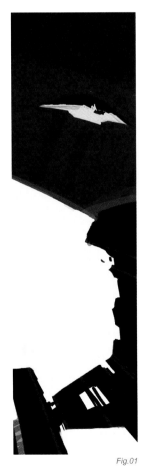
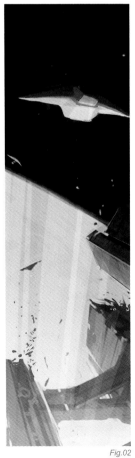

Fig.01                    Fig.02                                                                                                Fig.03

Before I went overboard with the details, I needed to lay down some colors and textures to get a sense of the mood and scale. I used a combination of Multiply and Opacity layers to glaze in some of the colors, and then flattened the image once more. This allowed me to create a color swatch based on the colors in the scene (**Fig.04**). The next step was to add some textures so that it anchored the scale. I did this by painting a sci-fi metal panel texture along with a rocky surface for the planet. The metal panels were created on a new Overlay layer with a series of horizontal and vertical streaks, and then distorted to fit the perspective of the ship. The planet texture was created by using the Difference Cloud filter in the Quick Mask Mode, and then applying a Sharpen filter to it. Once I got the results I needed, I distorted the perspective, quit the Quick Mask Mode, and painted softly over it to get that subtle planet texture. I continued working this process until the image was nearly polished (**Fig.05a–b**).

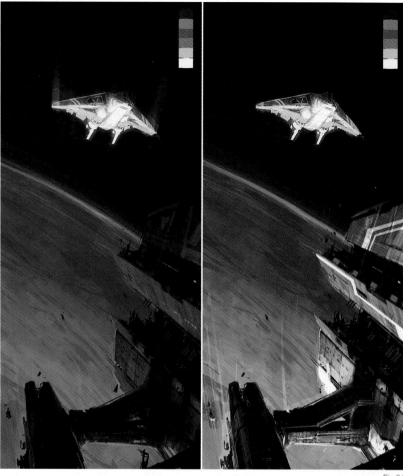

Fig.04

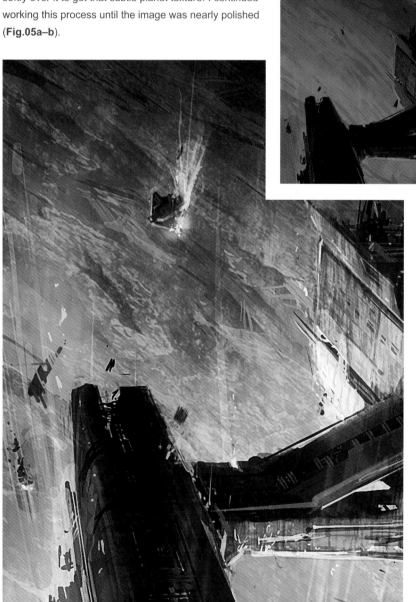

Fig.05b

Fig.05a

Adding special effects is the final step of my work process. For this particular painting, I added glowing debris, speed lines, subtle smoke trails and so on. I found that, by adding these effects, it gave life and excitement to the overall feel (**Fig.06**). And finally, after much jumping back and forth, I was nearly done! For my last step, I adjusted the Color Balance, Brightness and Contrast, and then wrapped it up by flattening the image.

## CONCLUSION

Many of the paintings I create start off as adventures in my head. Being a full-time artist, I seldom have the time to work on personal projects. But as soon as an idea presents itself, I find it necessary to channel my thoughts into a visual format. I'm sure many of us creative types are alike and it is through the process of creating art that we venture into our own imaginations. Think of it as watching a film in your head. By putting all my thoughts into a painting, and going through the experience of executing it, I pick up on a lot of new tricks and techniques along the way. I also update myself on the dos and don'ts. Essentially, every painting becomes a journey, and it only gets better the next time around!

*Fig.06*

# ARTIST PORTFOLIO

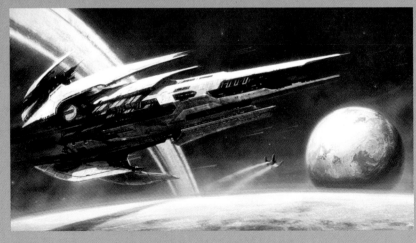

SCI-FI

© Neil Blevins

# Mouths To Feed III

## By Neil Blevins

### Introduction

Mouths To Feed III came about due to my dissatisfaction with the original "Mouths To Feed" image, made back in 2003. It had many things going for it, but there were other parts I was really unhappy with, such as the simplicity of the mouths. So I decided to start with my first image and refine it further to create a brand new image. Therefore, to discuss the making of Mouths To Feed III, we really need to discuss the making of the first image as well.

### Inspiration

Let's go back to the year 2003. As with many of my images, my primary inspiration was nature. I was on a walk when I happened to pick up an immature pinecone. I thought the shapes were really interesting; more specifically, the pinecone was laid out in a hexagonal grid (like a honeycomb: six-sided pods and each row was offset from the previous), and the tip of each had this little bump, which I thought looked a lot like a set of lips. I went home and took a few snapshots (**Fig.01a–b**). Because the object was so small, the photos had really shallow depth of field (i.e. lots of blur), and those three elements became the inspiration for the image: the hexagonal pattern, mouths at the end of each pod, and strong depth of field. Other details, like the brown color, came from the pinecone as well, although I decided to make a complex pipe pattern between each individual pod rather than leaving it completely smooth.

### Modeling

I had to model two elements: a pod and the wires. Thankfully, once I had a single pod constructed I could replicate it again and again. Here's the original pod I modeled

Fig.01a

Fig.01b

in 3dstudio Max using everyday polygonal modeling (**Fig.02**). I also decided to make the pipes modular, since it was far easier to make one set of pipes and then copy it than make unique pipes everywhere. I would then add a few extra pipes in a top layer to give the surface some variation; I didn't want the image to be too repetitive.

I used two main techniques for modeling the pipes. First, I did specific pipes, which were hand modeled either as cylinders or as renderable splines. I also needed to build some more generic pipes, and used the lattice technique. The technique was as follows: I'd create a plane with many segments then delete a number of the faces to make interesting shapes. I'd then use Max's solidify

Fig.02

modifier (which has been replaced by the Shell modifier in later versions of Max) to give thickness to the surface. Then I'd apply a lattice modifier, which turns the edges of a mesh into cylinders and the vertices into spheres. I'd then apply an editmesh on top and adjust the pipes a bit to make them look a little more organic, removing some of those square ends (**Fig.03**).

Then I assembled the generic pipes, placed the more specific pipes on top, added the pods and a few extra greebles for extra flavor (**Fig.04**). You might ask how I avoided pipe intersections, and the answer is: I didn't! There were intersections going on all over the place – I just did a visual sweep of the image and anything that was obviously intersecting I edited by hand.

## LIGHTING AND RENDERING

I decided to do all the texturing in the comp rather than do any 3D texturing, so I applied a dull gray material to all the surfaces. The image was rendered in Brazil; I set up real raytraced depth of field which gave the image a nice microscopic feel (like the original photo). Lighting was pretty simple: a skylight for adding fill light (and those nice ambient occlusion style shadows), and a key area light to add some drama. Here's the rendered result (**Fig.05**).

Fig.06

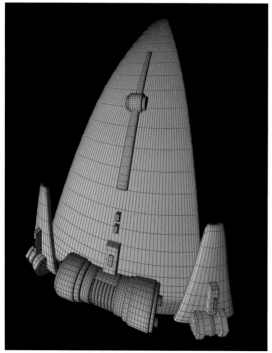

Fig.07

Fig.03

Fig.04

Fig.05

## COMPOSITING

To add texture to the piece I used a layering technique. I am in the habit of taking photos and scans of dirt elements – everything from photos of real dirt to acrylic paint that I smear on canvas, to markers or oil sticks… sometimes I even drag a piece of paper through the mud and scan the results or take a scratchboard and rub it with sandpaper – anything to get interesting dirt patterns! I then began layering them on top of my original image. I used a number of transfer modes, like Overlay, Hard light, Multiply and so on. There were no rules at this stage. I understood the sort of vibe I wanted the final piece to have, and so I was just having fun experimenting with layers, seeing what worked and what didn't. Sometimes I used custom Photoshop brushes to add specific dirt patterns, or I transformed and edited the scanned dirt to more closely match the image I had in my head (**Fig.06**).

## VERSION III

So the image was finished for a number of years. I did a speed painting on a similar subject that became Mouths To Feed II, but then I started looking at the original image and I felt as though it didn't quite live up to my expectations. I liked the wires, but I felt the mouths were far too simple. Also, I liked the vertical aspect of the original pinecone reference photos (see **Fig.01a–b**). The landscape look of the original piece was the right decision at the time, but I felt I could breathe some new life into the image by making it vertical like the photo.

My first step was to make a new mouth. My modeling skills have certainly improved over the last four years, and my computer's much faster now, so I could handle larger

SCI-FI

polygon counts. Here's one segment of the mouth (**Fig.07**) – notice how the panel lines are actually a bump map rather than geometry! I then made an array of eight to form the whole mouth, and added some extra parts (**Fig.08**). I then did a few minor tweaks to the pipes, adding some new pipes, removing some old pipes, trying to get a more organic and chaotic feel.

After a re-render, I flipped the image vertically and then played with darks and lights inside Photoshop to help draw the eye a little more effectively to the hero mouth. The color differences are subtle, but I think they help keep you focused on the point of interest, rather than leading the eye out of the picture.

## CONCLUSION

An image four years in the making; I really like how the final piece came about. I am proud of what I was able to accomplish four years ago, and the original image will always be a valuable part of my personal growth as an artist, but this "remix" of the original is now my new favourite... at least until Mouths To Feed IV comes around!

*Fig.08*

# ARTIST PORTFOLIO

ALL IMAGES © NEIL BLEVINS

# FUTURE STATION

## BY NEIL MACCORMACK

### CONCEPT

For a while now I have been thinking about creating an image of a futuristic environment on a large scale. I knew I wanted to base the image on either a city, station or terminal; a place where people would interact with industry or buildings. I knew I wanted to have a traveling theme with futuristic ships and designs incorporated in the image. So, with this in mind, I made some basic sketches and downloaded some reference material of designs and environments that would give me a starting block (**Fig.01**).

### MODELING

I started the modeling of the main landing platforms based on the research I had already done, and with a clear picture in my mind of what I wanted them to look like. I wanted to have a mesh that was

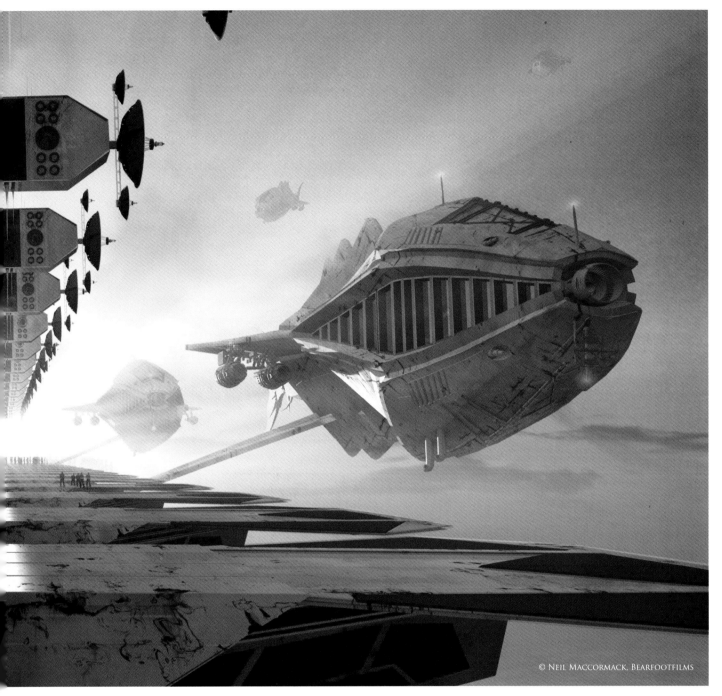

© Neil Maccormack, Bearfootfilms

not too complicated and that I didn't have to spend too much time on, because I wanted to portray the mood and feeling in the picture rather than get bogged down modeling a very technical object.

I used primitive shapes in LightWave's Modeler to begin with, and then defined them more and more to display paneling and industrial details, such as the radars, fans, vents and so on (**Fig.02**).

The ships were also modeled using the same method. This time I used a design I had previously sketched

Fig.01

out for a different project but never used. I didn't mind reusing the design as the ships were not the focal point of this image. If the ships were not there, you would still be able to see the story behind the image. I wanted them to have large viewing bays on each side, and I beveled the windows in (**Fig.03**).

## TEXTURING

The texturing was very simple. The ships really only have base colors applied, because I knew that the lighting in the final scene and their position would mask a lot of the texturing. For the station platforms it was slightly more complicated: I used some base metal texture maps for the platforms, which were applied in a planar format rather than UV as I knew the camera would only ever be stationary and not animated.

**Fig.04** shows the model with the textures applied. As you can see, there is some stretching, but again in the final render this wouldn't matter and I wanted to focus on lighting more than anything else.

*Fig.02*                    *Fig.03*

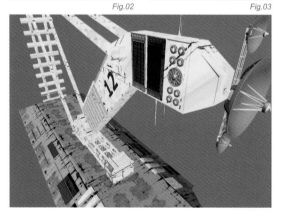

*Fig.04*

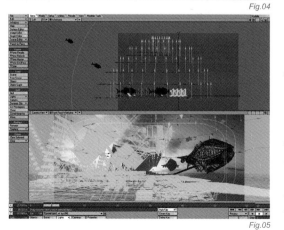

*Fig.05*

*Fig.06*

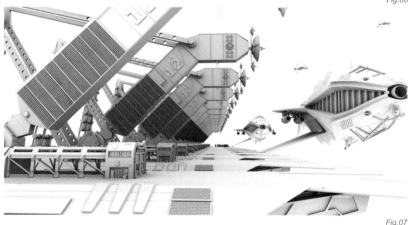

*Fig.07*

## LIGHTING

**Fig.05** is the result after finalizing the sky map. I then had to match my CG lighting with the map in order to produce a photoreal render. The first thing I did was to create a sky dome to produce some soft shadows. The dome consisted of around 140 Point lights, all set to a very low value and light blue/white in color. I matched the position of the sun on the sky map with an Area light and matched the color value also to produce the powerful reflections and specular highlights that create the depth in the final render.

**Fig.06** shows the shaded Layout camera view from LightWave, demonstrating the lighting and compositing with the sky map. Finally, I added some 30% backdrop radiosity to color the objects slightly, and added some bounce light to the image. I used the sky map as the Lightprobe for this.

## RENDERING

I always try to minimize complications at render time, so for this image I rendered out two passes: the normal RGB render first of all, and then an Occlusion render which I could use in post production to add shading in areas of the render where it needed it (**Fig.07**). As you can see from this render, I didn't bother changing the numbering of the platforms. For this pass, it wasn't necessary to do that. I rendered out separate Volumetric lighting passes for the sun rays that I would later use in Photoshop (**Fig.08**).

*Fig.08*

## POST PRODUCTION

As this was never intended to be an animation, it gave me slightly more freedom to use Photoshop to composite the render passes together. I started out with the RGB render and Occlusion pass to form my base layers. I then added a metal texture over the image set to Multiply to warm the colors slightly and to give an extra layer of texture. **Fig.09** shows the layer set in "normal" mode.

I then added the Volumetric lighting and painted in some very simple people in the distance using a Photoshop brush to give the final render. **Fig.10** shows the final render and the various Photoshop layers.

## CONCLUSION

What I did notice in the final render, after the post production was complete, was the repetition of textures on the station platforms. This was due to the cloning of the platforms in the 3D layout. In retrospect, another day or two spent texturing them at an earlier stage would have prevented the repetition in the final render! On the whole, however, I was very satisfied with the image; it really portrays the mood and feel of the environment that I was trying to establish.

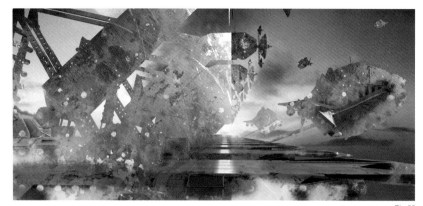

*Fig.09*

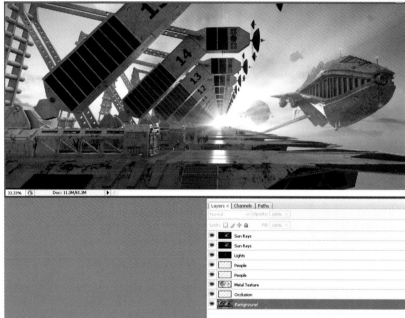

*Fig.10*

# ARTIST PORTFOLIO

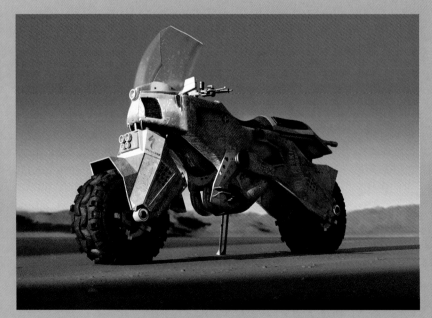

© Richard Anderson

# SPACESUIT

## BY RICHARD ANDERSON

### CONCEPT

This whole idea of a NASA suit came from a competition held on an art forum that I'm part of. The way it works is that you're given a subject to base your concept on, which in this case was "industrial". So, with that, I played with a few ideas… I've always been fond of astronauts and space programs and thought it would be cool if I ran with that. I first started out with a few thumbnails, just for composition ideas and so on (**Fig.01**). After doing a few super random thumbnails, I started painting random aircrafts, robots, ground machinery and so on (**Fig.02**). Once I was happy with a couple of illustrations, I wanted to do a third one with an astronaut that would control the vehicles…

### PROCESS

When painting or drawing in Photoshop, I hardly ever do a line drawing. I always end up blobbing shapes down and erasing away, or using different values to bring things forwards or to push them back. Since I had a color palette already established, and some ideas nailed down, I decided to take those two images and lay them over each other (**Fig.03**).

Once I overlayed them, I used the Transform tool and Distort tool to blow shapes up and flip them. Copying, pasting and changing the opacity on the different images caused it to start revealing textures and shapes I would have not originally thought of. This always helps me when sketching because I really have a hard time just thinking while I draw. It's a lot easier for me to see shapes and ideas when they're in front of me, rather than starting totally anew with a white canvas.

Fig.01

Fig.02

After working with the two images, flipping, turning, making opacity changes and so on, I started to see stuff that I wanted, keeping my thumbnail in mind. From there I started to block in more of the basic shapes; beginning with the darkness from inside the door and bringing the figure further forwards, as you can see in **Fig.04**. I tried not to get caught up with the little details too soon, but it does tend to happen in spots. Plus, having some things already textured out from the previous illustrations, it was easy to get a feel for what the surfaces were like. This was where I started to judge how hot the light would be, and tried to find cool design stuff for the actual suit. For example, whether I wanted his leggings to be white, or maybe his gloves, or the wires wrapped around his arm – things like that.

With an image that I was starting to enjoy, I wanted to concentrate on the stuff I liked about it, as you can see from **Fig.05**. This was where, from messing around with two previous drawings, I made a happy accident that I

Fig.03

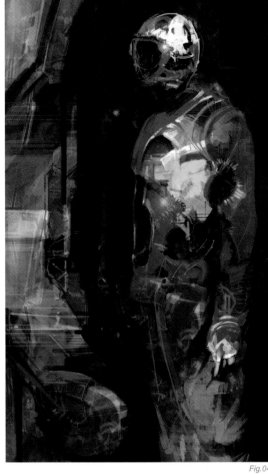

Fig.04

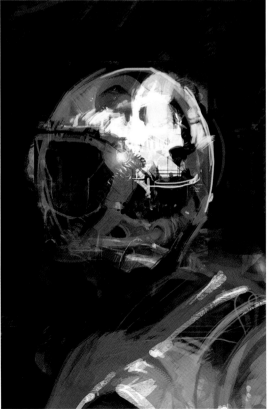

Fig.05

wouldn't have thought of before. I really liked the sharp, almost chipped paint look on the helmet of the astronaut a lot. So, I wanted to incorporate that in some other parts of the suit. I tried to pull that effect off in the chest area and on the hands as well, which you can see in **Fig.06**. I also sharpened the detail since that part of the image was closer to the viewer. Another detail I wanted to work on was the door, since it was so similar to the door in my other illustration. There I was trying to come up with a cool shape to block-in the "spacesuit dude", whilst keeping that same heavy construction spaceship feel.

In the final Spacesuit image (**Fig.07**), I wanted to really make things "pop out" from one another. As you can see, I decided that the door I had at the beginning was much cooler than the one I was trying to make, so I decided to keep it. Throwing more detail into the door and some highlights made it "pop" out of the darkness from within the door nicely. Overall, I felt like I needed the painting to have more contrast, so I started to just push things back with darker values and made the spacesuit "pop" a little more. I then felt good with the position and everything else, and I wanted to start putting in all those fun little details. I wanted to sharpen up some of the shapes on the suit and add some sketchy lines for the texture on the sleeves. Then, at the end, I found a nice picture of an American flag and threw that down on there and erased away a little here and there to make it look like it was a used suit and a bit damaged. That's when I called it done!

## CONCLUSION

Towards the end of this painting I was really pumped, I felt like I totally learned some new things from working on this project. I felt like I accomplished what I wanted to and some happy accidents actually made it cooler than I thought it would be, which is always a good thing. There are a few things I would love to change about this image;

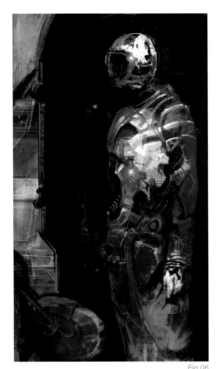

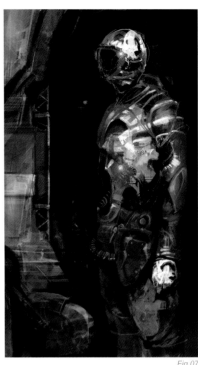

*Fig.06*                                                    *Fig.07*

I feel that more detail in the suit itself, with some cool brush strokes, would make it a much stronger piece. A little more patience altogether is something I really need to learn and I feel that this piece helped with teaching me that, and hopefully in the future I'll have that ingrained in my head!

# ARTIST PORTFOLIO

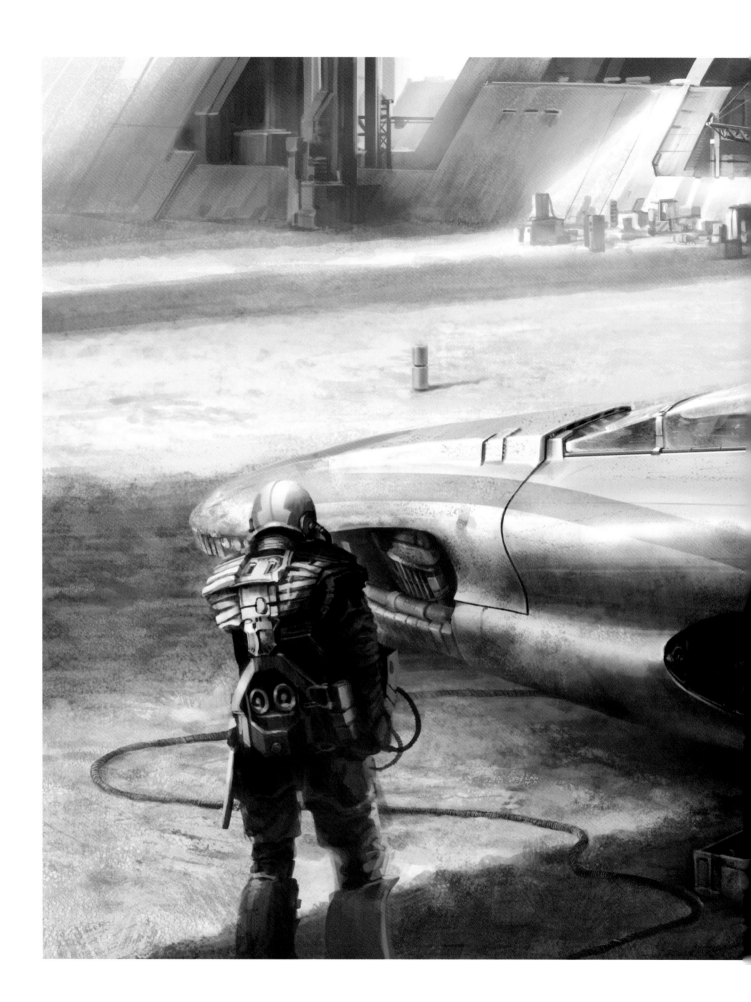

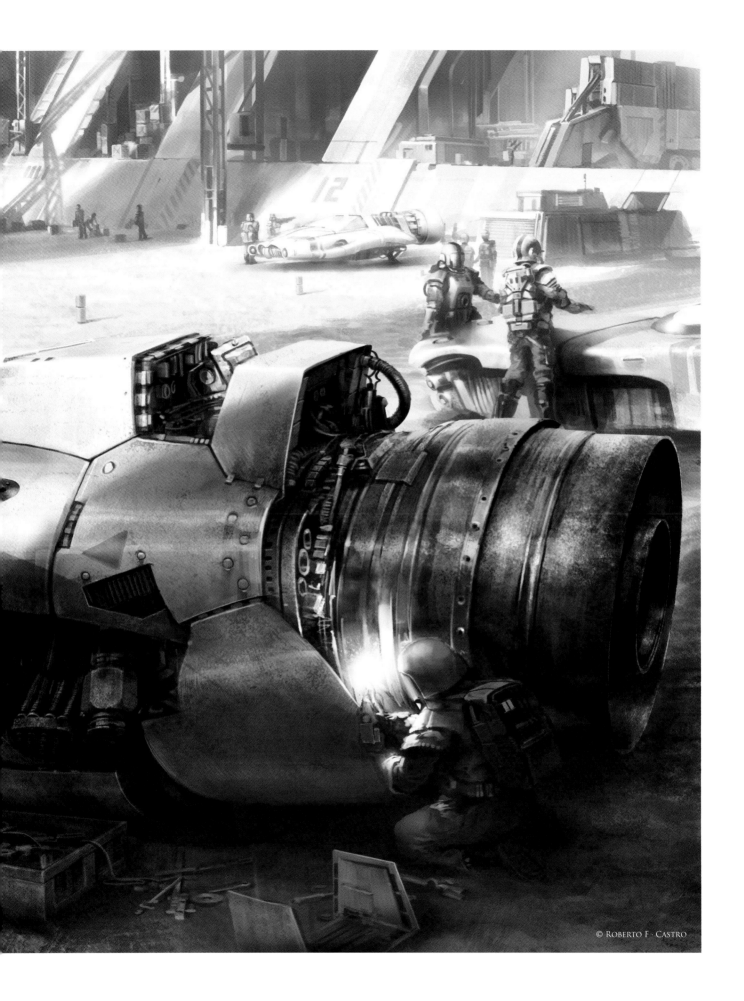

© ROBERTO F · CASTRO

# ENGINE

## BY ROBERTO F · CASTRO

### INTRODUCTION

The inspiration behind this piece is difficult to define. I had some ideas about creating a flying racing car and gathered some sketches of ships and vehicles that I did some time ago (**Fig.01**). I wanted to create a scene where the machine takes prominence over the human, as well as to design a powerful vehicle based on great propulsion machinery. I tried to avoid the typical image of a vehicle flying in a race, steam trailing behind its powerful engine. I had a more static idea, and my intention was to show the vehicle from a different perspective. The idea was to represent a race vehicle surrounded by a real environment and situation. I wanted to create a concrete moment in the same way I can take a photograph of a scene. I tried to evoke a "real fiction", where you can perceive a future decadent age and the hard relationship between humankind and the machine.

### COMPOSITION

I started without any previous sketches. I had the idea of "constructing" the vehicle over a real technological element. I took an engine photograph (**Fig.02**) and used its huge exhaust nozzle as the starting point of my painting. This powerful machine is the main element of the piece and I thought creating a whole painting based on a real object would be an interesting artistic exercise. The rest was created in Photoshop CS using a graphic tablet. I didn't use any other elements in this work like 3D models or previously rendered images.

I opened a pale yellow canvas in Photoshop (approximately 2:1 format). I started my drawings with a medium-sized document (1500 pixels in length) that I increased as the image progressed. I inserted

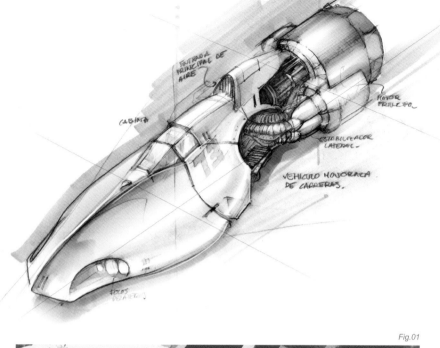

Fig.01

Fig.02

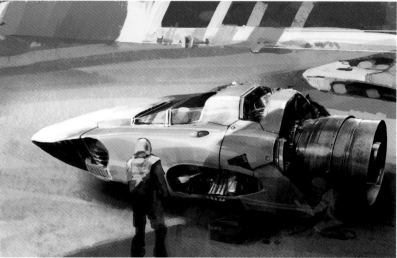

Fig.03a

Fig.03b

232

SCI-FI

the photograph and began with rough brush strokes, covering the engine to create a white metallic shell that provides a streamlined form to the vehicle. In terms of workflow, I try not to focus on only one area of the piece but instead work on maintaining the same amount of detail throughout. I put down loose forms of color which I gradually add detail to as I advance through the painting. I have selected six images from the working process (**Fig.03a–f**).

The idea of the contrast between the brightness of the shell and the dark internal machinery was an important key to conceiving the vehicle's design during the creative process. I decided to show the engine partially dismantled and began to draw a group of technicians around the vehicle, working on maintenance and repairing tasks.

I needed to play down the importance of the background and I added "non-visible" elements that provided a more conceptual depth to the scene. First, I drew the basement of large loading docks. In addition to this, long shadows spread out on the ground created a shadowed ambience of indirect light over the right part of the scene. I think the huge structure surrounding the observer

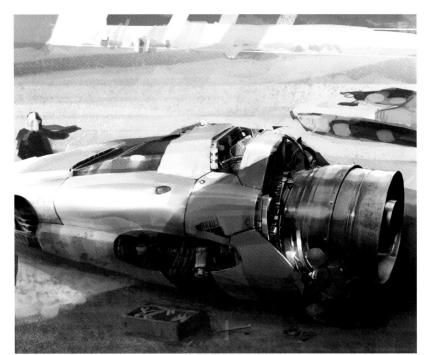

Fig.03c

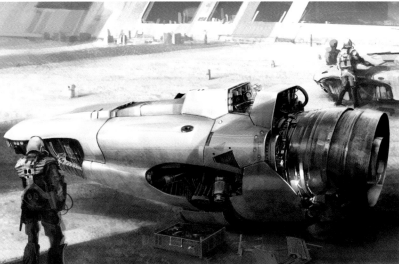

Fig.03d

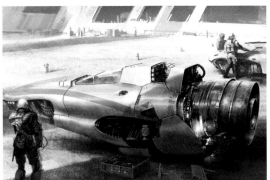

Fig.03e

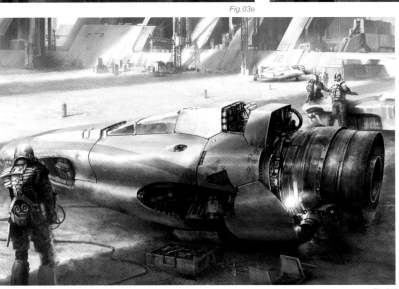

Fig.03f

creates an intriguing atmosphere and lends realism to the composition of the painting. I use a helpful technique for composition, which is making a horizontal canvas flip (mirror effect) to note perspective and lighting mistakes.

## PAINTING METHOD

Regarding my painting technique, I have created around 20 brushes that I use in my work. The tool I use most of time is a simple brush with pressure effects and a light irregular texture that avoids a sharp artificial finish (**Fig.04**). In this way, I prefer vertical flattened shapes to simulate a perspective effect. Moreover, I usually work without too many Photoshop layers. In this picture I created three main layers: the background, the vehicle and the pilot (**Fig.05**). I think too many Photoshop layers make the drawing process difficult, giving an artificial

appearance to the painting. It's useful to include other layers and brushes with different mix types as "overlay" or "multiply", which in turn provide good lighting/shading effects. This image has hard light conditions and the use of overlay brushes is a good option to show a credible effect.

## LIGHTING AND DETAILS

I consider light to be one of the most important elements in my artwork. My career as an architect has allowed me to include a formal and constructive perspective to my work and has also given me an understanding of light and shade. I like to show material properties such as brightness, light reflection and texture. The metal plates that cover the chassis are worn out by time and used race by race (**Fig.06**). These details are very important in making the scene more credible and realistic. The upper part of the vehicle is a good example of this. One can see that the cockpit is protected by a thick glass structure. I distorted the objects behind the glass to create a refraction effect and created a light, irregular yellow veiling to simulate the dust on the surface.

I added a dark layer over the photograph and retouched the nozzle giving a dirty, worn look to the vehicle's engine. In a detailed view, the difference between the original photograph and the final result can be noted (**Fig.07a–b**).

The drawing doesn't have the same level of detail everywhere. The close-up pilot (**Fig.08**) is a good example of a variable detail level. The painting is more defined in the areas I consider more important (the helmet and left shoulder illuminated by the sun). The right part of the body and the legs against the light are darker and roughly painted.

Fig.04

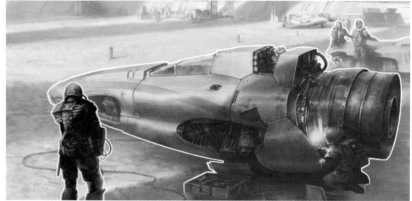

Fig.05

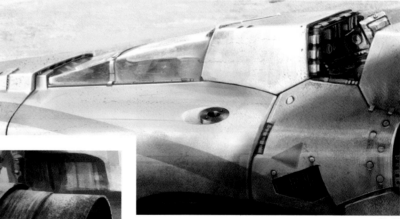

Fig.06

Naturally, background objects do not have the same amount of detail as foreground elements; however, one can notice the importance of using light and shade to give depth and realism to the scene. The use of less intense, more uniform colors ensures that the principal elements of the painting are not muted, and also creates a sense of distance between objects that is believable (**Fig.09**).

## CONCLUSION

This is one of the first pictures made with a graphic tablet. In my personal experience, digital painting has provided

Fig.07a

Fig.07b

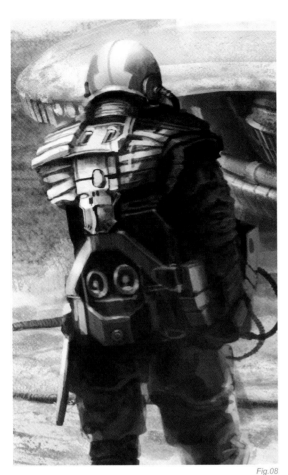

me with a wide range of tools and work methods that have allowed me to represent, in the easiest way, the concepts that I have in my mind.

In relation to this picture, I don't want to transmit any philosophical or special intention. I painted this scene to create a specific atmosphere and a real environment based on some of the ideas I exposed above. I think I was successful in this picture and I'm satisfied with the vehicle's design. From my point of view, this image is a shot from a possible universe based in real and physical parameters, where it can be perceived in the material textures, the brightness of the burnt steel of the engine nozzle, and the difficult repairing work of the technicians under a hard sunlight. I give more importance to the concepts over the picture itself. When I take a look at the painting, I think, "I would really like to drive one of these machines!"

*Fig.08*

*Fig.09*

# ARTIST PORTFOLIO

ALL IMAGES © ROBERTO F · CASTRO

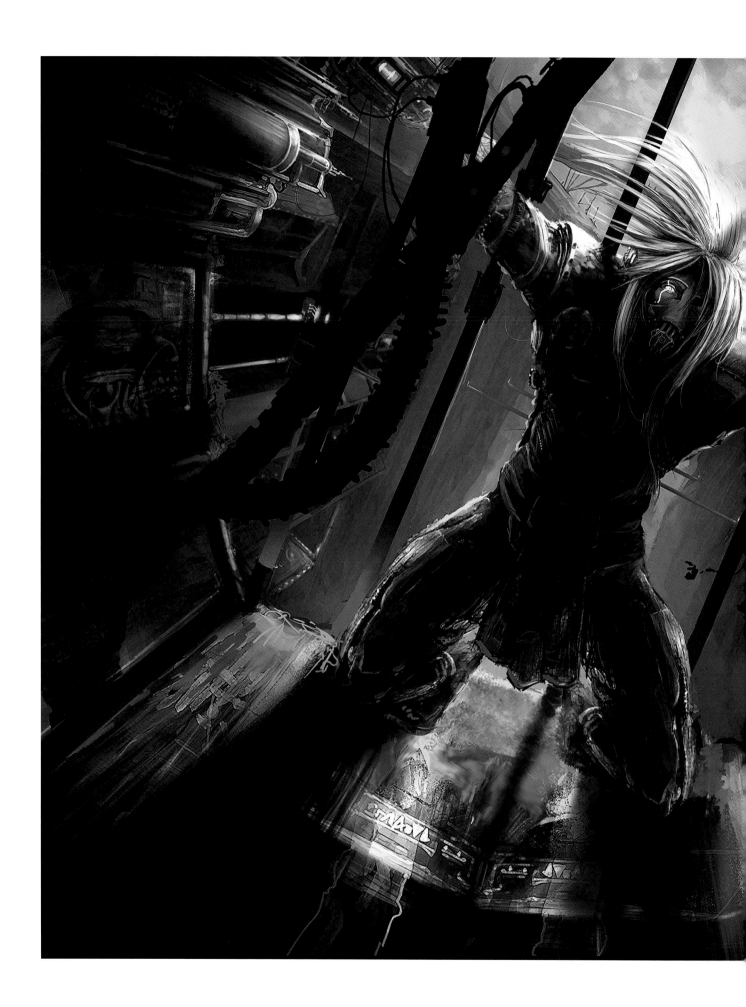

# COME CLARITY

## BY ROBIN OLAUSSON

### INTRODUCTION

When I started creating this piece I didn't have much of an idea in mind; I speed painted some vertical strokes with a large brush (low opacity) to get a feel of depth in the image. Later on I started to see shapes in my strokes and an idea of a cliff with bridges was born. I'm quite a storyteller, so I kept wondering about what this image was about, what I wanted to do with it, and whether it was more than just a fancy environment. I started sketching a figure that seemed to be trapped or imprisoned, which I kind of liked so I decided to go with it.

### STEP 1

I started out with big shapes and a loose composition. At this early stage I tried to find new and interesting shapes and silhouettes, keeping it as highly contrasted as possible and remembering to keep it loose. I tried not to get caught up in the small details at this early stage; the most important thing is the form, lighting, perspective and composition (**Fig.01**).

### STEP 2

I felt that the pose was pretty stiff so I changed it a little, along with the overall mood of the image. I didn't know exactly where I wanted to go with the picture so I played around with different ideas. I added some minor details to the front of the image (where I wanted most of the attention to be). Since I started painting this image in color, I often turned it into a black/white image from time to time, just to check my values (**Fig.02**).

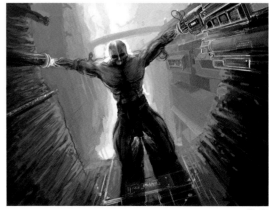

*Fig.01*

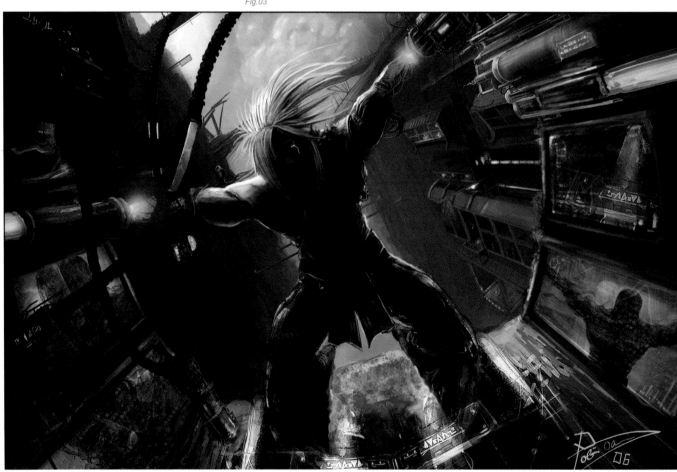

Fig.02

Fig.03

## STEP 3

It's important to keep your mind fresh and open for new ideas, so I kept experimenting with the piece and tried out many new things, just to see what would work. I wanted the prisoner to look high-tech and pretty menacing, so I added more to his face and started to define his body with armor. I kept painting lots of details and added new elements to the image, such as the cables and panels. Try to flip your canvas horizontally to get a fresh view of it; you will be surprised to see how different it will look when you can see it with fresh eyes! With all the cables, instruments and monitors going on, I got the idea that perhaps he was not only a prisoner of war, but that there was something else going on there. What if these guys were using their prisoners as an energy source, for keeping their high-tech city supplied with energy (**Fig.03**)?

## STEP 4

When painting details, I usually just play around with different shapes and silhouettes and don't worry too much about the content or if it has any function. If the design is strong and the form reads well you could always come up with a story and a function for it later on. Actually, in this piece, I ended up painting over a lot of the details, but you can always save the details and use it for future work as I have done. For example, the main character's armor piece has been used in one of my other works, called "Losing desire to breathe" (**Fig.04**).

## STEP 5

Some months later, after doing some more study of light and form, I came back and revisited this image. I thought it had lots of potential, so I used my new found knowledge and "beefed" it up a bit! There wasn't a good focal point so I decided to change the

Fig.04

overall lighting of the image. Since most of the light is coming from far behind, the main character should be pretty dark with a silhouette of light surrounding him. I kept darkening things to push the image closer towards the "camera". Many of the details were lost, but the overall image started to take shape more (**Fig.05a–b**).

## STEP 6
More darks were added close to the "camera" to make more depth in the image. I tweaked the color levels, added more details and refined shapes to achieve an image that was easily read. I painted shadows and added more light in the foreground to enhance the silhouettes within the image, and to make the contrast even stronger.

Fig.05b

Fig.06

Since the refining part of the process is pretty time consuming, I moved my canvas around plenty of times and finally decided to have the piece flipped, because I was getting bored with the same old image (**Fig.06**).

## CONCLUSION
I learned a lot when creating this image and I had so much fun at the same time. I realized that the most important thing is to get an overall reading of the image as early on as possible; leave the details out until you achieve a strong composition with a good value range and contrast. Keep your image zoomed out, that way it's much easier to get a view of the overall mood and composition. If you start detailing too soon, which I did, then you might end up with a dull and flat image. Essentially, when I get the overall mood and composition with lighting established, I start making out strong silhouettes and always try to keep pushing the contrast as much as possible. Hold your highlights and darkest darks until the very end – that way you can really push the contrast and help the eye to get good focal points!

# ARTIST PORTFOLIO

# Bigun
## By Taehoon Oh

### Introduction and Concept

I've always been eager to know where my skills lie, from the rest of the world. For this reason, I entered my work into Dominance War II, a worldwide game art competition. It was a great opportunity to share my experience and passion with other game artists. At the beginning of this project, I had the opportunity to use the concept drawings of Bigun, drawn by my friends James Chung (**Fig.01**) and Karl Östlund (**Fig.02**). Both are very talented concept designers! I was therefore able to use my strong modeling and texturing skills for their concept. After seven weeks of dedication to this project, I finally won the Grand Champion award from Dominance War II!

Fig.01

Fig.02

Fig.05

Fig.03

Fig.04

### Modeling

There was a limit of 7000 triangles on the character and unlimited poly count on the pedestal model. First of all, I built up a low-polygon model of about 8500 triangles. When I finished the final modeling and texturing, I cut this number down to 7000 again (**Fig.03**). It's a very symmetrical character, so I could save on the UV space by around half. That was a good thing in order to save time and UV space; however, Bigun had a lot of detail around his body, and it was not enough to show all this detail through geometry. To solve this problem, I decided to make all the complicated details using a normal map, and I started to make a high-poly model.

Fig.06

Fig.07

Fig.08

Fig.09

The first thing I did was try to sculpt the high-poly model in ZBrush or Mudbox using a low-poly model, but unfortunately a hard surface model didn't work too well in those sculpting programs. So, I decided to go with a classical approach and made it by using the Smooth Proxy tool in Maya. It took a long time this way but it worked well. After I had made the low (**Fig.04**) and high detail (**Fig.05**) models, I baked the normal and occlusion maps using the Xnormal tool (www.xnormal.net). This tool is very handy and powerful; just by selecting the low and high poly geometry, I could easily bake a quality normal and occlusion map!

## TEXTURING

After I created the occlusion map using the Xnormal tool, I placed it as the top layer in Photoshop, with the blending mode set to Softlight. This essentially added more depth to the color map. The main color scheme of this character was monochromatic, so I tried to make it more interesting by adding metal sheens to the surface. I highlighted every edge on the surface then added scratches and oxidations as details in the color map (**Fig.06**). The normal map created from the Xnormal also

brought extra geometry details to Bigun (**Fig.07**). In addition, I made a specular map using a white line on every edge, and added a blue tone to give it a feeling of being under a night light (**Fig.08**). Lastly, the cosine power map created more metallic highlights on the material (**Fig.09**).

## POSING AND COMPOSITION

Posing Bigun was one of the most difficult parts for me. I wanted to make him look brave and confident. It took a lot of trial and error to find a satisfactory pose – four days – before I finally found a good pose. The composition was the more enjoyable part for me, and I'm pleased to be able to share the following tips.

First of all, we need seven different layers: diffuse (color), reflection, specular, shadow, depth, occlusion, and SSS (Subsurface Scattering) maps. Once you have them, you can render this functional image using the "Render layer" option in Maya. The Diffuse map is the map that only shows the color without any specular and shadow (**Fig.10**). You can get the reflection map by changing the amount of material mute

Fig.10

Fig.11

Fig.12

Fig.13

Fig.14

Fig.15

Fig.16

SCI-FI

and reflection to 0.50, and also by ticking the ray-tracing option in the Render globals setting box, and using the HDRI image for the reflection texture (**Fig.11**). But, before rendering the specular (**Fig.12**) and shadow map (**Fig.13**), you need to set up at least a three light rig to get a dramatic feel. Then, later, you can render both maps in the "Render layer". The depth map is a simple black and white image which shows depth. The brighter part means it is closer to the camera, and the darker part means it's further from the camera (**Fig.14**). You can use this map as a depth of field effect, if you desire. The occlusion map from "Render layer" is different from the shadow map, but it's very useful for extra shadows cast across the mesh (**Fig.15**). The Subsurface Scattering (SSS) from "Render layer" brings an extra shiny metal feeling; you can assign it a "miss_fast_skin_maya" material which produces a really nice outcome, especially with an organic model like Bigun (**Fig.16**). After rendering the separate layers, it's then time to composite, so here is a simple layer history; the layer name has a layer type and opacity value, so you will be able to follow this method to get an idea of how this works (**Fig.17**). And here is the final result (**Fig.18**)!

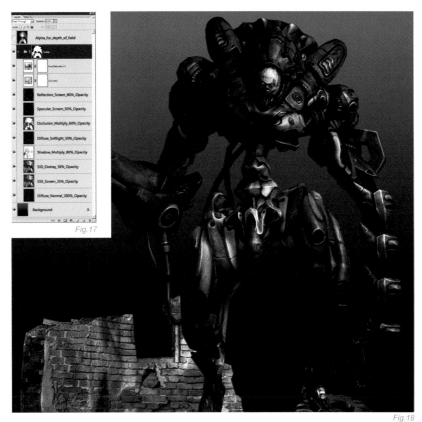

Fig.17

Fig.18

## CONCLUSION

There were exciting moments for me during this competition. This was my first character created as a game model. I have always dealt with hard-surface modeling, but never a character. So it was a really big challenge for me, but I was really satisfied with the results and gained many skills from the experience. From this project, I learned a lot of modeling skills, a more convenient way of texturing, and a way of creating an effective composition. I think Dominance War is one of the best places for video game artists to exchange their ideas and information, as well as getting great feedback and criticism. If you are a game artist or want to be, then I strongly recommend challenging your skills in Dominance War. It will be a rewarding experience for game artists to gain knowledge and skills.

## ARTIST PORTFOLIO

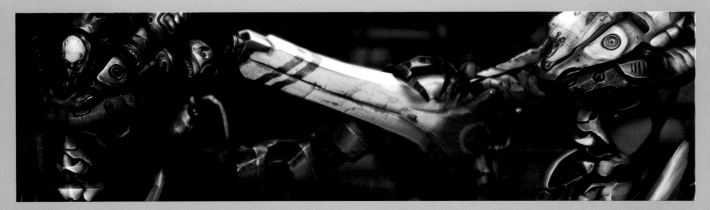

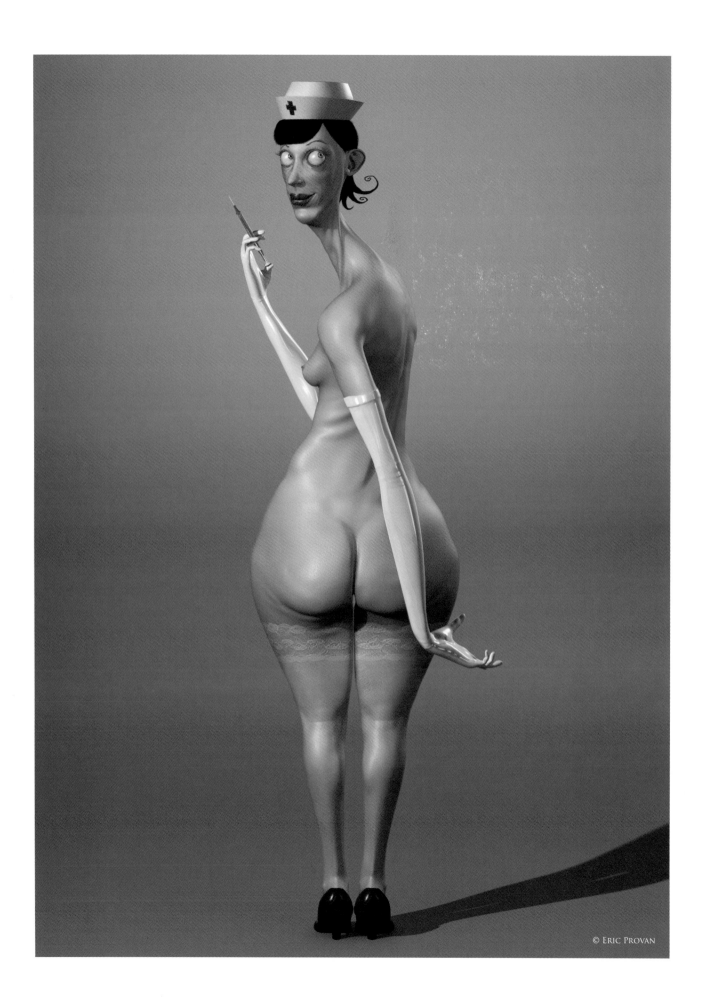

# FLU SHOT ANYONE?

## BY ERIC PROVAN

## CONCEPT

Like most of my personal projects, this one started out as a very rough sketch (**Fig.01**). I enjoyed the sketch so much that I decided to add another dimension. After the initial sketch, I jotted down some notes and made a few more quick sketches focusing on the body type and the face. When I'm working on my own stuff, I don't get too bogged down at this stage; I let my mind run free throughout the entire process. Often, the final result looks much different to the original sketch. The main goal of this image, right from the start, was to make people either laugh or say, "What the heck?!"

## MODELING

I did all of the low poly modeling using Maya 8 (**Fig.02a–b**). I almost always start with a simple polygon cube and box model from there. As with any organic model, my main focus from the very beginning was to make sure that the edge loops were laid out nicely, so that the character deformed well when rigged. I knew this character wouldn't be animated, but I still wanted a nice edge loop layout so that I could get the pose I wanted without much effort. I used Maya's Smooth Proxy tool to get an idea of what the model would look like at higher subdivisions (**Fig.03**). Basically, this tool mirrors your low poly mesh as a high poly mesh. Any changes you make to the low poly object can be seen in real time on the high-res version.

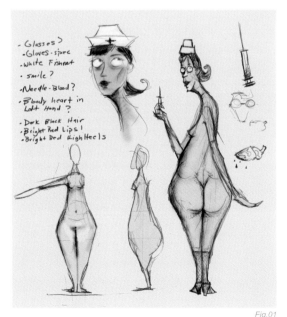

*Fig.01*

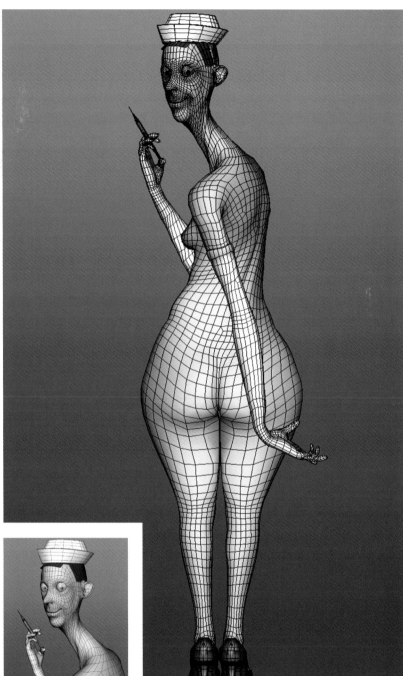

*Fig.02b*

*Fig.02a*

Once I had a nice base mesh, I exported the meshes as .objs and took them into Headus's UVLayout program. I can't recommend this program enough – it's a UV unfolding program that speeds up the UV-ing process tremendously (**Fig.04**)!

Once everything was UV-ed, it was time to put more detail into the model. I exported the .objs from Maya and imported them into ZBrush. This is always my favorite step: I can sculpt for days and days! Anyway, I started at a low subdivision level and slowly worked my way up in detail. This project didn't call for much detail, but I was able to

sculpt in a few muscles and skin folds. Next time, I'll have
to make a sexy dinosaur nurse so I can sculpt for longer!
I have a pretty basic work flow when it comes to sculpting
in programs like ZBrush and Mudbox: Push, Pull, and
Smooth. Once I was happy with the sculpt I created a 32-
bit Displacement using ZBrush's Multi Displacement tool.

## RIGGING

To get the pose I wanted, I had to put a rig on the nurse
(**Fig.05**). I've been using a very cool little Maya plug-in
called "The Set up Machine", which just takes a lot of the
headache out of the rigging process. I highly recommend
it for modelers looking for a quick and easy rigging
solution! In just 30 minutes, I had a nicely weighted rig.

## TEXTURING

With the UVs laid out, it was time to move on to the
texturing process (**Fig.06**). I normally use a very cool
ZBrush tool called "Zapplink", which is a projection tool
that lets you switch back and forth from ZBrush to a
program like Photoshop. But, giving that I wouldn't be
using many texture references for this project, I did all of
the texturing in Photoshop. I laid down a base skin color,
and then filled it with a repeating pore map. After that, I
whitened (dodged) the parts of her body that wouldn't get
much sun. For the stockings, I laid a stocking texture over
the skin and then used its opacity to find a nice mix.

## RENDERING

For the lighting, I used a very simple three spot light
set up: key, fill, and back light. I created an Occlusion
map using Maya's render layers (**Fig.07**). The set up
was extremely simple, given that occlusion is already a
preset. Occlusion maps are a tremendous help during the
compositing stage. I used Mental Ray's misss_fast_skin
shader for her skin – it takes a little tweaking, but the end
result can be amazing! A good tip when working with the
SSS shader is to set all but one of the scatter weights to
0. That way, you can work on one at a time and see the
results much easier.

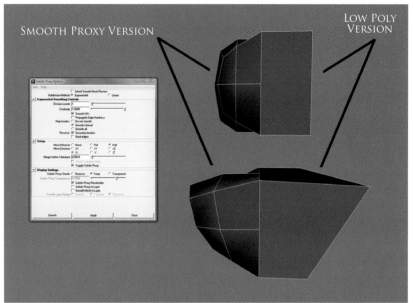

Fig.03

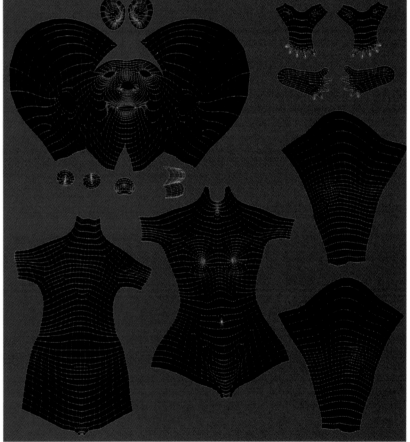

Fig.04

Once I had everything ready, I set Mental Ray's preset to "production", which uses
final gather, and rendered out a nice high-res image. From there, I took the render into
Photoshop. I added the occlusion map as an Overlay layer and tweaked it to give some
nice contrast in the final image. I made a few more small tweaks with Photoshop's tools
and the image was complete!

Fig.05

CARTOON

Fig.06

## CONCLUSION

I really enjoyed putting this little project together. The main goal was to make people giggle, and I think it worked. Who would want her to give you flu shot? This is my basic workflow for personal projects. While this "making of" isn't terribly detailed, I hope that you have gained something from reading it. Please feel free to contact me at **eric_provan@yahoo.com** if you have any questions or need further explanation. Lastly, I really want to thank the gang over at 3DTotal for this amazing opportunity!

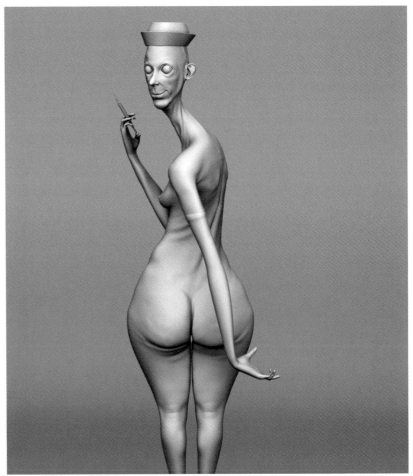
Fig.07

# ARTIST PORTFOLIO

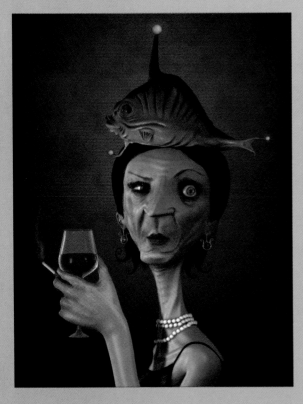

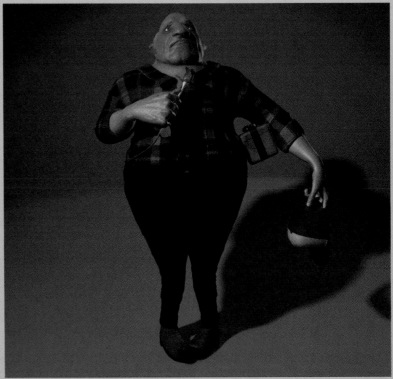

ALL IMAGES © ERIC PROVAN

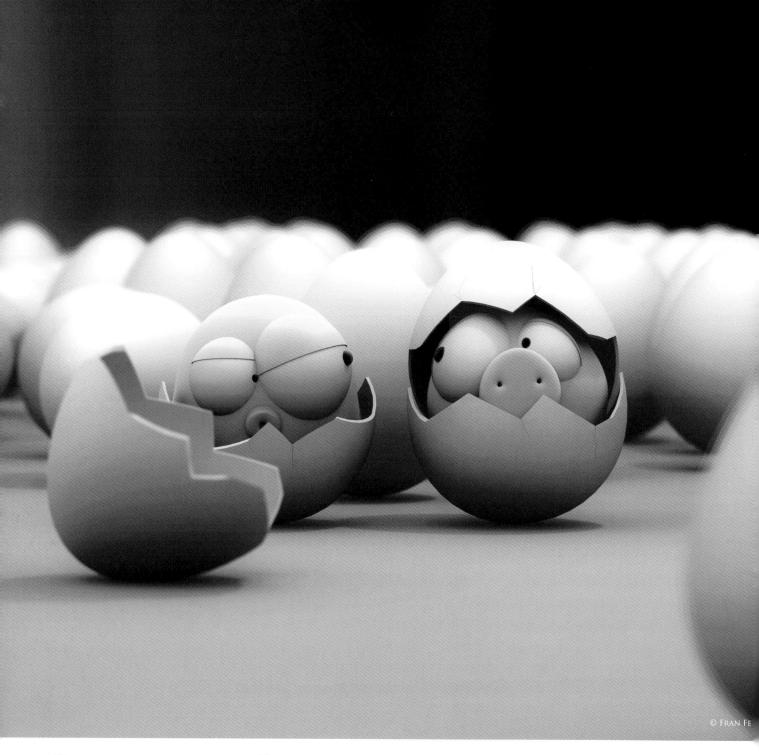
© FRAN FE

# BROTHERS?
## BY FRAN FERRIZ

### CONCEPT
This image was born from the idea of a joke with a single image – no animation or text explaining anything. I wanted the characters to say everything with their eyes only. I found an amusing idea to be one of two

*Fig.01*

CARTOON

Fig.02

eggs that hatch, with one of them being as expected, a chick, but the other a pig! The chick looks at the pig with an angry expression, but the pig looks back and is thinking, "Hey, I don't know what's happened?!" After making several sketches on the idea (**Fig.01**) I chose to make the characters as simple as possible, concentrating solely on their eyes and their expressions.

## Design and Modeling

The steps taken in making the design were a pencil sketch, followed by a detailed drawing in the software Freehand (**Fig.02**), then the last stages were modeling and texturing.

The program used to create the image as a whole was 3ds Max 9. I've used this program since the first version for MS-DOS, and I'm very comfortable with it. First came the modeling of the chicken and the pig. They were modeled from a sphere, as were their eyes. There are

Fig.03

areas of their bodies that are not detailed, because, once placed inside the eggshells, they would be invisible. With the design clear, thanks to the first sketches, the modeling was extremely simple (**Fig.03**).

The eggshells were also modeled from spheres, as well as the broken eggshells (**Fig.04**). Really, eggshells are very easy to model! All elements of the scene were modeled with Editable polys, which is undoubtedly a very good tool.

Most importantly, for me, was the need to emphasize the eyes and expressions of my characters. This work was undertaken in order to get a good expressiveness with simple characters, to "tell a story" through just their looks alone.

Fig.04

Before creating the final expressions for the characters, I made different tests of expressions with the eyes of a chicken character (**Fig.05a–f**). I thought this was a good exercise to prove that, with just a subtle movement or an inclination of eyelids, I could achieve very different results! My goal has always been to show that a simple character can show complex emotions.

## COMPOSITION AND LIGHTING

In the scene, I wanted to show that the characters were in a kind of incubator, therefore the lighting had to be warm and welcoming. The scene was rendered using the Lightracer engine in 3ds Max 9. I used a Skylight and two Omnis. I stressed that the lights had a reddish color, with hues of yellow, and the shadows also adopted this aspect. In the composition, I wanted the characters to be the focul point, making their eyes the most important elements in the entire scene. This is why the view is completely central, and the camera is looking directly at their eyes and their expressions (**Fig.06**). In the image, the characters are also surrounded by more eggs, to give the impression of being within an incubator in a chick farm, but at the same time all of these additional eggs, and also the one in the foreground, had to go unnoticed. I think I achieved my aim and the result was a success: the main characters are the hatching pig and chick, their eyes and their little story.

*Fig.05a*

*Fig.05b*

*Fig.05c*

## COLOR

Color, for me, is probably the most important element in my work. In this case, the warm colors (as explained in the Composition and Lighting section), were kept basic in order to display an atmosphere in which eggs were being incubated. In addition to the shades of color, it was also important that, at all times, the image was very happy, very sweet and conveyed that feeling to the observer.

The materials were also very basic; for example, falloff, which gave a "spongy" touch to the characters. I usually try to approximate the color directly in 3dstudio, but I always finish up using Photoshop for color correction work, and for making adjustments to the levels and saturation and so on, in order to achieve the desired results. In **Fig.07a** you can see the image which came from 3ds Max; in **Fig.07b** you can see how it was changed in Photoshop. The truth is that this is one of the

*Fig.05d*

*Fig.05e*

*Fig.05f*

CARTOON

Fig.06

images that has been the most problematic in finding the right tone and color for what I wanted. The white gave me problems, but eventually it worked out fine.

## CONCLUSION

Technically, the image can be improved. You can always work more on a particular aspect: modeling, lighting or texturing. However, I think my main goal was met. I wanted make a image with a story about feelings and convey a sense of humor, through only the eyes of two very simple characters. I think that's what I have achieved and I am pleased with the final outcome. I hope that when people first see the image they think, "That's funny!", and perhaps the image also produces a smile on their faces as well. That, to me, is the best part of my job!

ORIGINAL COLOR

Fig.07a

FINAL COLOR

Fig.07b

# ARTIST PORTFOLIO

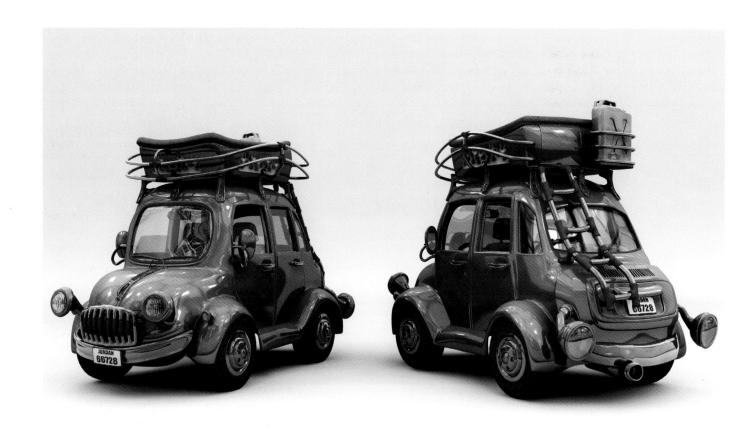

# MY FUNNY CAR
## BY HAMED YOUSEF

### INTRODUCTION

I always do a lot of sketches and drawings – they are the starting point of all my works, so my free time is good for sketching what is rolling around in my mind. This fact brought me to start drawing lines for a car. I like drawing characters with different poses and expressions because I like to feel them come alive, but how could I put life into a car in just a still image? This question drove me to think about a different car style, one with a personality in its shape… By avoiding traditional car concepts, my lines started to shape old curvy lines which would give a cartoony look, but it wasn't enough to be a cartoon car so I continued to enhance it by exaggerating some parts of the car, such as the headlights and taillights. I also started adding parts that might achieve a "funny" appearance, so I added extra parts, such as a back ladder and upper carriage, and eventually ended up with the 2D concept as seen in **Fig.01**.

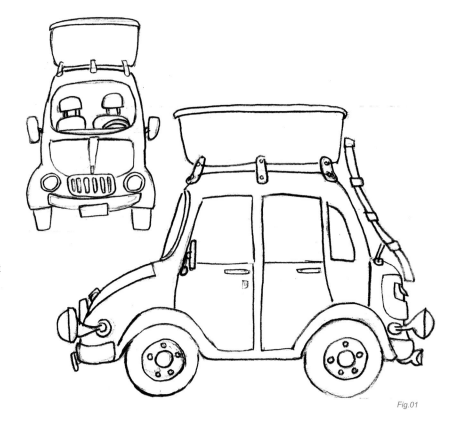

*Fig.01*

CARTOON

## MODELING

Modeling is the most interesting stage in production, and I enjoy it because it's the stage that converts 2D lines into 3D objects in space, and where you can freely view your model as one unit from different angles. I started my modeling process with a single box with the Split Polygon Tool to define proper edges, and then moved vertices in the space to match the blueprint lines. The result was a half rough model for the main body

Fig.02

(**Fig.02**). Then came time to split the main body into more pieces; this would give more detail to the main body and was also a good way to prepare for the UVs later on. This process required more tools, such as Extrude Face, Split Edge, Ring Tool, Duplicate Faces, Separate, Bevel etc. – these tools are common in 3D packages but have different names. After the main body had been extracted into rough elements, such as doors, windows, hood, trunk and fenders, I started adding details for each element, and then added more parts, such as outside mirrors, door handles, door locks, headlights, taillights, bumpers and wheels (**Fig.03a–b**). The more details you can add to your model, the better it will appear in the final image! Sometimes it's good to modify the style directly with more touches, so I added more detail on the upper carriage that had not been drawn in the concept, such as the luggage rack.

For interiors, I usually do medium-detailed stuff as these parts do not often show in the final image; however, it's still required in order to give more accuracy for the purposes of the light during the rendering stage. I modeled the interior without using blueprints (**Fig.04a–b**).

Fig.03a

For the modeling process of this scene, I used polygonal modeling and some nurbs curves for the basic curvy objects, which were later converted into polygons. After finishing the whole model, I started to create the UVs – this stage was time consuming but it was quite simple because most of parts were mapped directly by Planar, Cylinder, Spherical or Automatic Mapping.

## TEXTURING AND SHADING

Texturing and shading are essential parts in the process; for me, it's a chance to deal with both paint and physical properties for the elements. The key for a successful shader is to understand the real physical properties of the materials. Mental Ray shaders have more physical enhancements, rather than the standard shaders. I like to work with these scientific parameters where you have your own "lab" to create the shaders. For the main body I used a (mi_car_paint_phen) shader from the Mental Ray nodes – you can also improve this shader

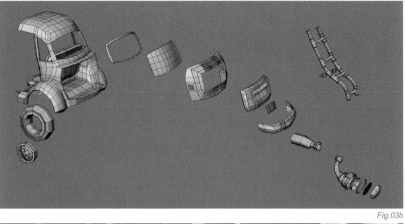

Fig.03b

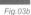

Fig.04a

in a network shading with a Maya standard shader as well. For example, I used the car paint as a node in a layered shader network with a decal texture which had been assigned to the upper carriage as one shader. I like to do real physical shaders to obtain the best light reactions, such as the headlight shader, so I modeled every part with a proper shader; glass with a bump map and Sampler Info (General Maya Utilities), plus a 2D ramp texture, and the reflector with a chrome shader

Fig.04b

Fig.05a

Fig.05b

(**Fig.05a–b**). It then looked better and I had more control than if it were just textured. I used some textures from 3DTotal's texture collections, such as the decals and interior textures.

## LIGHTING AND RENDERING

For the lighting I used a dome as a source of light which had an HDRi (High Dynamic Range image) map. The good thing about an HDRi map is that it makes life a lot easier; it stores both light information and the environment to reflect as well. So, I chose a fully lit interior image to give the scene an exhibition hall feel. Of course, an HDRi map works with Mental Ray when the Final Gather option is activated and the default light system is deactivated – you can find these options in the Render Setting/Mental Ray and Common tabs.

It was then time to apply the initial render settings, just to see the HDRi map effect. I used to make lighting tests with no shaders assigned to the scene, just a Lambert gray shader, so I started with a low Number of Samples and low Final Gather Rays. Since this stage was just to test the HDRi map effect, it was not going to be a time-consuming render, but a low quality image. Once I was satisfied with the initial settings, it was time to push for

Fig.06a

CARTOON

quality by increasing the Number of Samples and Final Gather Rays, and by playing around with the Min and Max Radius. For Multi-pixel Filtering I used the Mitchell filter to make it a bit sharper (**Fig.06a–b**). I rendered the scene with full shaders and textures, with a bit of tweaking given to the Rendering Settings. Finally, I used Photoshop just for color correction, since I did not make any render passes to be composited.

## Conclusion

For me, the most important thing about 3D graphics is the ability it gives me to express myself through the images that I create. The varying styles that an artist can create are limitless, because there are no limits to the imagination – it's the artists and their capabilities that achieve their visions on a computer; this gives 3D an edge over other CG media and it makes creating digital art a very exciting process!

*Fig.06b*

# Artist Portfolio

# ANTON
## BY JONATHAN SIMARD

### INTRODUCTION

Anton was the result of an experiment to change the workflow I'm used to. I didn't have a concept for this character, because the first idea was just to model a realistic character. I always model more cartoon characters, so I decided to do something else this time. The problem was, I got bored at the start doing something realistic so I switched to something more interesting for me. For this character, I was inpired by Anton, the psychotic character in the movie *No Country for Old Men*, and by all the bad ass character designs I could find! The goal was to try to push the design further, more than my previous characters, and also to overstylize it.

### WORKFLOW

Normally, I work the modeling in 3dstudio Max, because I've been a Max user since the beginning, but I decided to change my workflow a little. The basic shape of the character was done in ZBrush from a basic head which I created in Max. As I said, in the initial concept I was hoping to do was something realistic, so I started modeling a basic male head in Max (**Fig.01**) – something really simple. With this done, I exported it into ZBrush and I tried, for the first time, to remodel it with this software. I was used to adding little details in ZBrush, but not to working on the whole shape. The result (**Fig.02**) was more of a realistic approach, like I wanted, but I wasn't really happy because I like exploring extreme shapes in a character and trying different things. So, with

Fig.01

Fig.02

Fig.03

this same head, after a lot of manipulation in ZBrush, I ended up with something more intresting (**Fig.03**)!

I really liked the result, but I wanted something more like the characters I normally make, so I exported the model into Max (with two subdivision collapses!). I had to deal with too many polys, so by hand I deleted all the lines I didn't want, and then deleted half of it to find the symmetrical division (**Fig.04**). I then had a clean mesh to work with, and so came the time to remodel it and add more detail.

Fig.04

Fig.05

I always model faces in the same way. I find it easier to have a basic shape with fewer polys, in order to achieve the correct proportion. Afterwards I added all the detail I needed. From **Fig.04** to **Fig.05**, you can see the basic clean-up of the face, the latter showing more detail. It's easy to get lost when you have lots of polys on the head, and the last thing I wanted was to correct the proportion with too many polygons. It's also easy, when the proportions are good, to delete small parts of the model and redo it – it's like a mix between box modeling and edge extrusion!

You can see from **Fig.05** that I scaled down the eyes, nose and mouth and put them more in the center of the face. To do this, I selected the vertex on the face in Soft Selection mode and added an FFD box modifier and scaled down the control point in the middle (**Fig.06**).

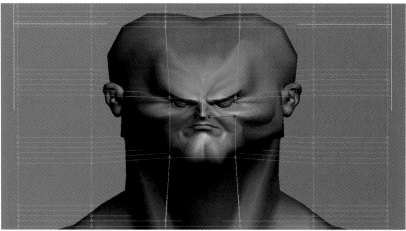
*Fig.06*

*Fig.07*

*Fig.08*

Sometimes I'll use the Soft Selection in Max, but this time I used the FFD box modifier. It helped me a lot to reshape the face, but also, if you make a mistake, you just have the delete the modifier and don't have to worry about the lack of "undos"!

The rest of the objects (**Fig.07–08**) employed simple modeling techniques, nothing exceptional. I knew I wanted some depth of field in the final picture, so I didn't spend too much time on modeling these. I just took care to achieve as a clean mesh as possible as it's important for me and you never know whether you'll need it in the future!

The texturing aspects were a real pain for me. I hated it, and I have even considered stopping texturing my characters in the future! I won't explain how I acheived it, because I don't want to talk about something I'm not really good at. The only major thing was the tattoo, but that was really easy. My girlfriend has a really nice, big tattoo which starts from her back and goes onto her chest. I had some photos of it so I tried to "melt" it onto the texture.

I always composite my final renders in Photoshop, because they never look good directly from Max (**Fig.09**). I have to make some adjustments, so basically, I render different passes in Max and then assemble them in Photoshop. I had the final render pass, the Ambient

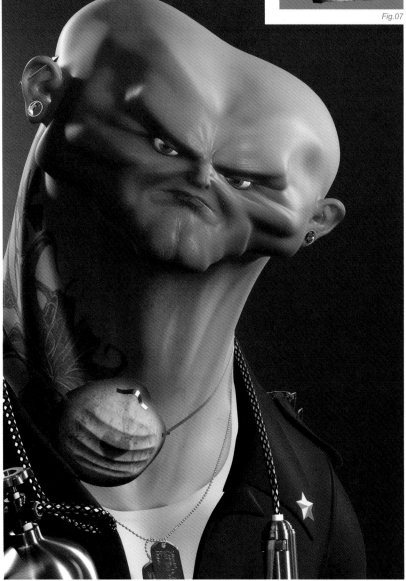
*Fig.09*

Occlusion pass, selection pass (note that I have maybe six renders of different selections; you can also have one pass with a different color on every object with self illumination at 100!) and a lighting pass (**Fig.10**). The first thing I did was to adjust the brightness and contrast and the saturation of the final render. Afterwards I was able to form the picture using the different passes. When the final image was complete, I saved it, and as a different file, tried more color corrections and some minor adjustments. It's never the same – I just experiment and try different things!

## CONCLUSION

I'm never happy in the end, as with everything I do, because I know I could always work more on some areas. Something I've learnt from doing this was that I think I will stop creating textures, or will at least only make basic textures. I'm not a texturer and it's consistently the part I really hate to spend time on. On the other hand, I really like the design I achieved with this character; the way I've pushed it to the extreme with the neck being as wide as the head, and the way the mouth, nose and eyes are all small in the center.

Well, it's time to work on something new now!

*Fig.10*

# ARTIST PORTFOLIO

# ONE DAY FLOWER

## BY BY KRZYSZTOF NOWAK

### INTRODUCTION

My illustration, "One Day Flower", was made for a 3D competition on a Polish CG portal, Max3d.pl. The subject title was "Small is beautiful". I sought to create an image which would open the viewer's imagination and allow them to return to the wonder years of childhood.

### REFERENCES AND RESEARCH

I started with a list of objects I knew I would need, and for this I turned to Google. I looked for imagery of specific objects to get an idea of how they were built and what kind of materials I would need. I found this stage critical as it saved a great deal of time later on!

### MODELING CHARACTERS

The Tim Burton movie, *Corpse Bride* was my main inspiration for the character design. I chose this particular style because I

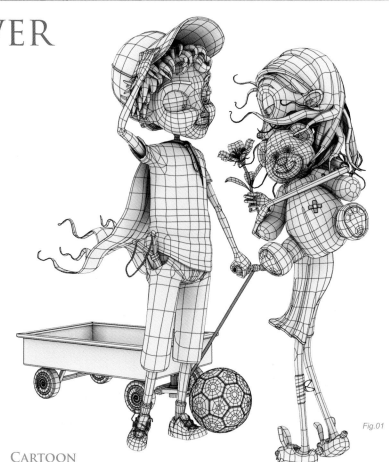

Fig.01

CARTOON

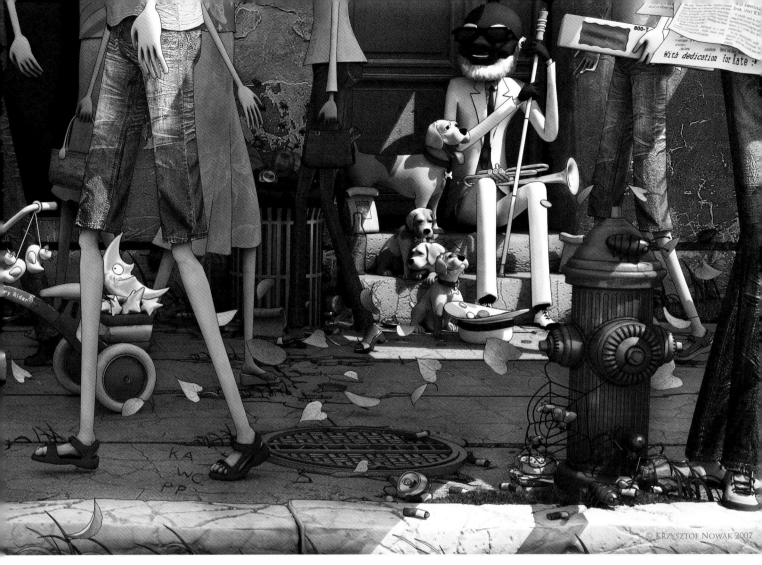

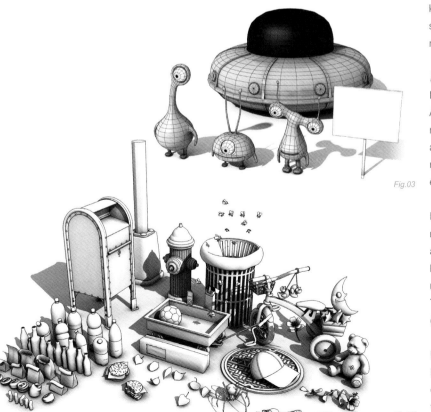

*Fig.02*

*Fig.03*

knew I wanted to make the scene very crowded, and this style enabled me put a lot of figures in the scene whilst not overcomplicating the image (**Fig.01**).

## MODELING OBJECTS

I chose to give the street a very "American" feel, because American street "furniture" and architecture are instantly recognizable to anyone. Most of us grew up with some aspect of American culture in our lives, and I felt it would make the image more universal and understandable for everyone.

I took great care on some of the eye-catching recognizable props, such as the fire hydrant and mailbox, and to save time on the less important props, such as the leaves or cans, I simply instanced them and then used modifiers, such as "Bend" and "Twist", to add uniqueness. This helped create the large number of props I needed (**Fig.02**).

For the small aliens in the trolley, I was inspired by the Moby video, *In This World* and I put them in the image of One Day Flower to symbolize the message from the video clip (**Fig.03**).

To make the curb edge, I utilized ZBrush. I modified a concrete photo into an alpha texture (**Fig.04**) which I then used in ZBrush as an alpha brush for painting cracks. I covered the model with this texture, and then, to break up the repeating uniformity, added details such as hollows and smoothness on a second layer (**Fig.05**).

From this I created a displacement map in ZBrush. Using this as a base image in Photoshop I adjusted the levels so I could add extra shading and a sandy color to the cracks. As a finishing touch, I took another image into Photoshop and on top of this added concrete layers with some transparency and Multiply blending modes (**Fig.06**).

## LIGHTING AND COMPOSITION

The lighting and composition was the most critical stage of the whole process. To help me achieve the result I wanted I used basic "stand in" models to create a simplified 3D sketch of the final image. This helped me to concentrate on the lighting and composition in a way I couldn't with the final models.

It was always my intention to set the composition at a "child's eye" level; I felt this kind of composition would also help to draw the viewer into the image and it also saved me a great deal of time as I didn't have to model the faces or heads of the adults – I had only to play a bit with the clothing and fabrics to add variety to the adult characters. It also helped me to convey the message that children exist in a different world to their "boring" adult counterparts.

As a temporary measure for the adults, I simply rescaled kids and made a few simple modifications. At his stage, it all looked very raw, but this helped me focus on the lighting and compositional aspects of the image (**Fig.07**).

Fig.04

Fig.05

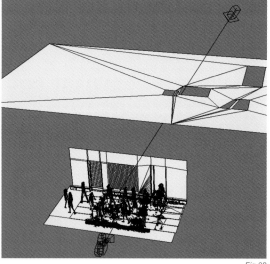
Fig.08

Fig.06

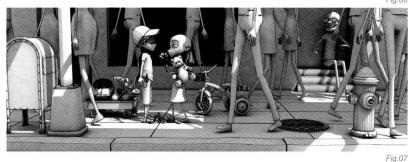
Fig.07

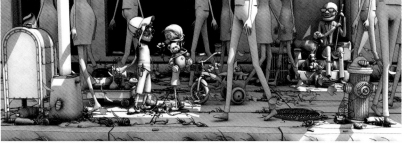
Fig.09

I went for a simple lighting set up; I used one directional light for the bright contrast areas to simulate the sun and also used a sky light as my fill light. To highlight the points of interest in the scene I carefully postioned a simple plane containing holes to act as a "gobo". This helped me to direct the light to where I wanted it. Then, by a process of trial and error, I adjusted the holes to give my image bright light in the key areas of focus (**Fig.08**).

Then, when I was satisfied with the lighting and composition, I started replacing the raw models with the more finished versions (**Fig.09**).

The last stage was adding finishing touches to the adult models and placing a few small objects. The grass and leaves were added to create movement and add life to the image (**Fig.10**).

       CARTOON

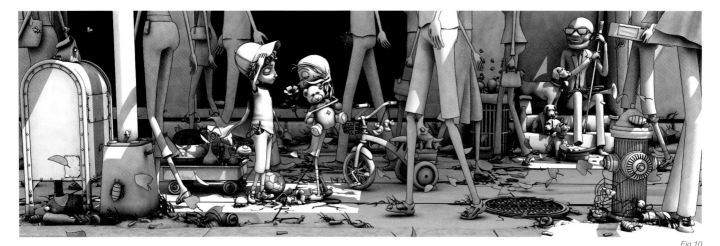

Fig.10

## TEXTURES

For the creation of textures I used Photoshop, supported by ZBrush. For this stage I also have my own library of images. These are often used as a base for most of my textures. Most of my textures were created in four steps (**Fig.11**). In this example, I was creating a metal texture.

1. **Base layer** – a basic fill texture to use as the main basic surface – clean metal
2. **Details for base layer** – a rust texture with mask
3. **Second layer** – a paint layer; for this I use my own custom brushes
4. **Details for second layer** – a final pass of dirt and rust

A few of the textures were simply photos with minor modifications, e.g. door and wall texture (**Fig.12**).

## RENDERING

To render the final image I used V-Ray. This was for two reasons: its speed/quality ratio and because I understand this system well. I wasn't overly concerned with photorealism so I used very low settings for the global illumination, just enough to get the effect I wanted. The outline cell shaded effect was achieved with the V-Ray Toon atmosphere effect.

Fig.11

Fig.12

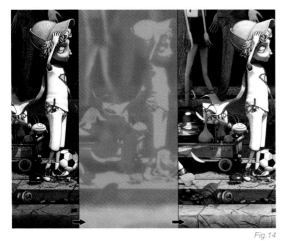

Fig.14

## POST PRODUCTION

I already had a good idea of the "tone" I wanted for the final image, so most of my post production in Photoshop was spent on color correction (Variations + yellow + red) (**Fig.13**) to bring warmth to the color. I also wanted to soften the light so I used a few variations of light layers with soft light mixing (**Fig.14**).

## CONCLUSION

I was very satisfied with the final result, and despite the enormous amount of time I spent on the image, I felt the result was very successful. The support of others also kept me motivated and inspired throughout the process. I learnt a great many things from the process and, although there are many things I might do differently the next time, every image is a learning process. Next time, I might explore different lighting and rendering techniques, but I'll keep that for my subsequent projects.

Fig.13

# GrosNap

## By Laurent Pierlot

### Introduction

The ideas and inspiration for this picture came to me very naturally. I've always had great admiration for the costumes and paintings from the Napoleonic period, with the rich materials they were using, the intricate details of their costumes and accessories, and the obsession to reproduce natural lighting in their portraits. Art history has been an important part of my school background and is always a major source of reference in my work.

Before starting, I did a little book and Internet research for paintings and portraits from painters such as Goya, David or Delacroix. Movies also provide a major source of inspiration; in this case I looked at pictures from *Barry Lyndon*, in which Stanley Kubrick used natural lighting from sunlight or candles, and *Amadeus Mozart*, from Director Milos Forman. From those movies I also noticed how the makeup played a very important part, and as I wanted to have a touch of humour in my picture too, I decided to make him fat and wearing heavy makeup.

It was also a good reason to have fun in ZBrush with a lot of skin folds and wrinkles, with refined facial features in the center of the face. The posing and general attitude

Fig.02

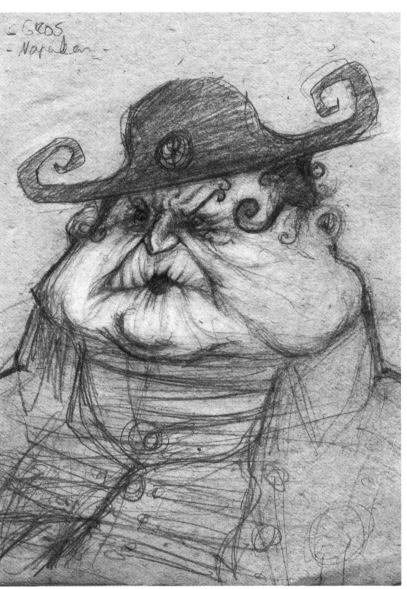

Fig.01

was also important in order to bring some life and personality to the character. The attention to the fine details was, for me, the most enjoyable part of the process. I've spent a lot of my free time doing stills like this one, working step by step until the final result.

### Sketching

The best way to start a picture is to do one or more sketches to define the idea exactly as you have it in mind. You don't really need color at this point, but it's important to work on the general style and composition (**Fig.01**).

### Scene Layout and Modeling

For the modeling part, I always start by building a layout of the scene using very simple geometry and shapes – no detail whatsoever at this point. This gives me great freedom for the most critical phase of the modeling process: the composition of the picture.

When building the layout, I look for the relationship and balance between volumes and space, for example how the shapes relate to each other, and I make sure my general proportions are correct by blocking out the base models. I also define the center of interest and try to find a harmonious flow for the eye to look at by doing a quick paintover with the main axes and directions (**Fig.02**).

At this point, the camera needed to be locked to allow me to prepare for some of the UVs and camera projections for the mapping. A low-res scene was critical for this part of the process, and once everything was in place I knew exactly where I needed to work on specific details.

For the detailing part, most of it was done using ZBrush, and by importing the full-res mesh from ZBrush into Max. I know this makes it an expensive process, but it enabled me to have exactly the same quality in ZBrush and in Max. When I imported the mesh I used the OBJ format

Fig.03a     Fig.03b     Fig.03c

Fig.03d

Fig.03e     Fig.03f

and made sure I kept the UVs I did previously on the low-res mesh. I also imported a medium resolution mesh that I kept on a different layer in Max to perform lighting test renders.

When using ZBrush, I try to stay away from the classical 3D modeling quality and go for a more traditional clay-sculpted feel. To do this, I subdivide the low-res mesh as much as I can from the beginning, and start sculpting it with the clay tool as if it was a rough piece of clay (**Fig.03a–f**). I mainly use the rake tool with broad and large strokes to block out the main features, slowly reducing the size of the tool as I refine the shapes and smooth out the bumps. During the process it was important for me to forget about the basic 3D topology created in Max that lay beneath all those subdivisions.

It's important to have a solid base of bigger folds and volumes before you start working on particular details, as this will help you to find the unique characteristics and proportions of your model. I also never hesitate to stop what I'm doing and start over the sculpting process from scratch several times, rather than spending too much time fixing something I don't like.

For the embroidery details, I masked some parts of the object in ZBrush using alpha maps and then extracted those masked areas using the extract tools in ZBrush. Then I just had to refine those newly created subtools.

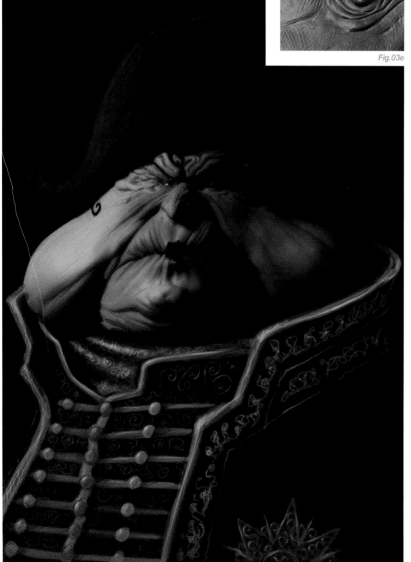

Fig.04

For this particular artwork, I didn't have a very precise idea of the colors and style for the clothing and accessories. To make it easy for me to decide, I usually take some time to do several "paintovers" using the models I have so far (the head in this case) (**Fig.04**). This step was critical and very efficient; it's a quick way of "finding" the style, colors and details before starting to sculpt. It was also a good way to define the general mood and prepare for the rendering\lighting process!

## TEXTURING, LIGHTING AND POST PRODUCTION

For the lighting it was quite simple: I used Mental Ray's Daylight system and final gathering for the render, and an HDRI map on a sphere for the environmental lighting and reflections. I created a very diffused lighting with soft shadows and added a Spot light on the right side, behind the character, to give him a rim light and to get some subsurface on his ear.

When working with the Brazil renderer, I always feel the need to render separate passes for the reflections, key light, rim light and ambient lighting, and then composite everything in Fusion. This technique can give you more control, but with Mental Ray I just render one pass with everything together, which I find is the best way to take full advantage of the Final Gathering option, and it will also save you a lot of time!

It will always take some time to fine-tune your materials and get them to look realistic; the most efficient way I've found is to set up my lighting with one basic material before adding colors and textures (**Fig.05**). This way you can be sure that your lighting is correct before adjusting the materials, usually starting with the bump and specular first.

For the materials and maps I used the Arch Design preset materials that come with Mental Ray. These

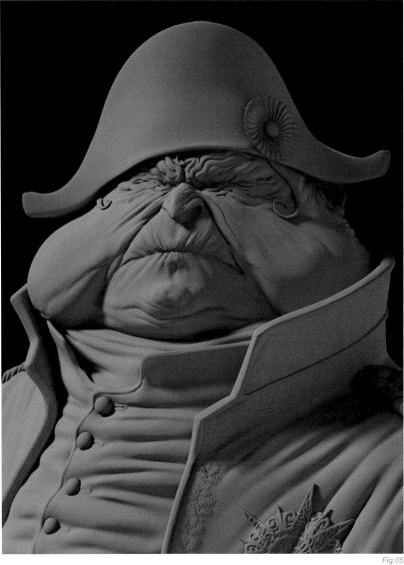

Fig.05

materials are really well made and work perfectly with the daylight system. With just a few textures and some adjustments you'll get some good results, fast!

For the embroidery on his chest (**Fig.06**) I used the basic copper material with only a bump and a specular map. I also like to blend materials together using the blend material in Max with a mask (**Fig.07**). This technique allows me to control the two

SPECULAR                                                                BUMP

Fig.06

materials independently and therefore emphasized the contrast and richly detailed aspect of his clothing. I used the FastSkin material for his face and painted the maps in Photoshop using a camera-mapping projection (**Fig.08a–c**).

I'm never completely satisfied with the results I get from 3D renders, and when I'm doing my own artwork I don't want to spend too much time doing maps and render tests, so I usually do a lot of detailing and adjustments in Photoshop. I will, for example, fix all the UV mapping problems that I get when using tileable textures, or I'll add some specular touches and details on the golden parts. In this case, some extra facial features, such as lipstick and eyebrows, were added. I also used Photoshop to refine the lighting, accentuating the contrast and focus of the picture by darkening the sides of the image, recentering the attention.

For the last step, I took the image into Fusion for a final compositing and tuning process. In this case, I added a bit of atmosphere, some depth of field, and a few filters, such as Glow, Unsharp Mask and color correctors.

## CONCLUSION

For me, the main purpose of doing my own artwork is always to learn and improve new techniques, but it is also to work on personal subjects without the time and art direction constraints that you get in classical production work. I used to do a lot of drawing and sculpting before I started working with ZBrush and 3D in general. Those, along with art history, are bases that any artist will need to develop experience and sensibilities in.

ZBrush gave me the opportunity to transpose my 2D art into 3D without losing the character and particularity of my style. I like to explore the possibility of mixing 2D and

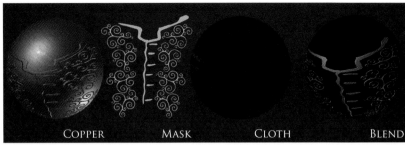

COPPER    MASK    CLOTH    BLEND

*Fig.07*

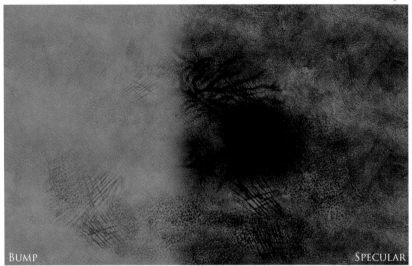

BUMP    SPECULAR

*Fig.08a*

EPIDERMAL

*Fig.08b*

SUBDERMAL

*Fig.08c*

3D media in my work, to try to avoid spending too much time doing hardcore 3D modeling that must work from every angle. The goal is to have fun doing something that is creative and unique, using all the tools and techniques available!

It's difficult to share in just a few lines what you have learned through years of training, and the sensitivity that you have developed from studying and creating art, but I hope this "making of" will help you in your quest to becoming a better artist.

CARTOON

CARTOON

# Jack Stern
## By Patrick Beaulieu

### Introduction

Welcome to the making of Jack Stern. I am going to show you how I created this character, from the design, modeling and texturing through to the passes and rendering. I created this cowboy using 3dstudio Max 9, Photoshop and Hair and Fur. For the creation of Jack, my only goal was to create something different to anything I'd made before (no fur, no cutesy look). I visited a lot of websites for inspiration, looking for Western footage, references to Clint Eastwood, Smith & Wesson guns, and sifted through a lot of Western material. I'm not familiar with this type of character so inspiration was necessary in order to build a complete idea of Jack Stern. I'm happy with the final result and I hope you will enjoy this character, too!

### Design

At the beginning of the creative process, my idea was perfectly clear about the general look of this character. My objective was to create a bad guy with a long face and a stylized look, with a great silhouette.

I created a different type of shape for the head on paper, to better define the proportion of Jack. After some drawing, I decided to give a caricatural look, with a line of action for the whole body. The most important element on my design was the silhouette, which was important in order to recognize the character with the outline (**Fig.01**). Another important element of my design was the "line of action"; all elements on my character, like the cap, the hat and so on, give a "line of action". There was only one direction for the whole body (**Fig.02**). I put the gun on the right side to make a better composition and contrast for the action line. With the sketches done, the general idea of Jack was clear in my head about what the character should look like. Then it was time to start the character in 3D!

### Modeling

As usual, for the modeling, I worked with the same method; I used the "Cage" method (**Fig.03**). This method consists of creating all edge loops in quads around all principal lines that define the model. Working this way can give a great and clean modeling really quickly with a

SILHOUETTE

*Fig.01*

*Fig.02*

great topology. Before using this method, I used to work by extruding edges without defining the cage for the entire model. However, working this way is more complicated: it's difficult to see your principal forms; you always try to tailor your mesh to comprise quads, which does in fact work; however, for me, it was not the best way of doing things. So, by using the cage method, I started creating my models faster and cleaner. Using a cage is like creating a "rough sketch"; when everything looks good I can finish it by filling in all the gaps and closing the mesh!

I started with the shape of the head, added eye edge loops and all principal lines for the face. I then made all the principal edges or contours that defined the form of the character as a whole. I worked on the proportion with the cage mesh, to achieve the same look as the sketches. I used the FFD (Free Form Deformation) modifier to make the character asymmetrical. So, when all the key contours were right, I created polygons in between these edges to close the cage and complete the mesh (**Fig.04–05**).

So, with the modeling now close to being finished I reviewed my "sketch" which still appeared really basic. As a result I made a render in order to see what needed to be added. I stylized the character and added some edgy elements, like the nose and lips (**Fig.06**).

*Fig.03*

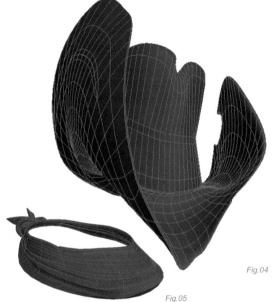

*Fig.04*

*Fig.05*

*Fig.06*

## TEXTURING, LIGHTING, FUR, PASSES AND RENDERING

For the texturing, I started with a general variation of palettes. I simply rendered an Ambient Occlusion map of Jack, opened this in Photoshop and tried different color schemes for each part of the character. This is my way of finding the color, contrast and seeing a preview of what the final image should look like in 3D. It was just a test though, so I didn't put too much effort into it. I find it faster to test in 2D than to try to change colors in 3D by way of altering multiple texture in order to find the "perfect" color. I selected each part of the character separately in Photoshop and used an alpha channel with each separate piece using a different channel – it's easier to isolate and select different parts this way.

For the Unwrap, I used the Pelt mapping in the Unwrap modifier. I didn't have too many pieces, so creating the UVs with pelt mapping was a faster method!

For texturing, I used a number of render passes (**Fig.07a–b**). I think this is a better way to work fast and

have control over your images. You can render five or six passes in a large size, combine everything in Photoshop and have the control over the opacity, color, brightness and contrast etc. which is an efficient way of working quickly! It's better than making a 3D render, changing a parameter, then starting another render… and waiting – it takes too long! That's why I prefer using different render passes.

For the character of Jack, I started with Ambient Occlusion passes which were the first renders I did. After these passes, I worked with texture and color. I rendered all texture and color passes without light or shadow, with the ambient mode. I added all color passes in Multiply mode. Normally, I work with Multiply, Soft light or Overlay. However, I also like to try other modes to see other results – sometimes it works, sometimes it doesn't… but it's a cool thing to try.

The majority of the texture maps were done in Photoshop. Other textures were done in 3ds Max with procedural texturing. I like to use some types of shader and procedural texturing, like Falloff, Noise, Smoke, Stucco, Splat, Gradients and so on – it's simple to create these maps. I didn't use these passes with a high intensity, but added noise passes on the character with 10% opacity, plus a small falloff around the character to create a contrast with the background. I like to use these passes to add more detail to the character as these procedural textures are very useful.

Lighting is the most difficult part of my process and so I devote a lot of time to it, using passes to render Occlusion, plus three principal light passes. I combined all three light passes to create the final lighting conditions, did some touch-ups by hand on the

OCCLUSION  BACKLIGHT  LIGHT 1

Fig.07a

LIGHT 2  FINAL

Fig.07b  Fig.08

final images and composited all the passes in Photoshop. After all the passes were cemented together, I made some tweaks to the final image, added a background, tried to remove the 3D effects, and added some details to the character to portray an image that more closely resembled a 2D drawing (**Fig.08**). I used the lighting effects in Photoshop on the final images to make small adjustments. I always use this tool on every image because it does a good job of boosting colors, intensity and marrying the foreground and background.

## CONCLUSION

Well, I hope you have appreciated the making of Jack Stern. It has been a great experience creating this cowboy, and I've learned numerous things which have helped me greatly in further evolving the way in which I work.

# ARTIST PORTFOLIO

# Not So Alone

## By Vincent Guibert

### Introduction

First, there was a story about a round-shouldered man. He considered this posture to be a disease or malediction, so he was looking for people to help him. In this picture, he is trying to find a witch's house, lost in a dark and dangerous forest... This character was created a long time before the environment, using a quick sketch (**Fig.01**). I rendered him (**Fig.02**) and animated him a little, but didn't create any really finished illustration, even though I thought he deserved a

*Fig.01*

CARTOON

© Vincent Guibert

good one! A little later on, I had the desire to make a great environment. I often create characters with simple backgrounds, and so I wanted to go further with this one. I decided a forest would be a fun way to introduce this character.

There was an artistic challenge about achieving a great mood. Moreover, the idea was to do a night and a day version (see **Fig.03**), using the same scene but changing only the lighting and compositing. The night version was the most difficult! You have to keep it very dark to be believable, which is something that can be very hard for such a stylized and colored illustration!

*Fig.02*

CARTOON

Technically, I try to learn new things with every new image creation. For this one, I used ZBrush as the modeler for the tree (**Fig.04**), and V-Ray.

In my opinion, the main interest of this picture is in his mood and how I have used lighting and compositing to achieve it. So, I will focus essentially on these elements in this "making of".

## SETTING UP THE LIGHTING

First of all, I made a quick render using Global Illumination to get an idea about the volume of the scene and to adjust the point of view and the displacement (**Fig.05a–b**). I then worked on the lights, one by one, before mixing them.

The first light created was of course the main light. Coming from the top left, it symbolized the light of the moon (**Fig.06**). To create the shadows of the leaves on the ground (which everybody expects to see in a forest illustration), I used some projected noise in my moon light. This was easier than having too many trees in the scene. Moreover, I wanted something particular – more a patch of light, a clearing, rather than something too speckled!

The illustration has three hills that delineate the foreground, middle ground and background, meaning that there are three parts on the road, creating three different depths. Once the main light was in place, I used different lights to keep a noticeable difference between the three sections, by orienting the light to influence only the foreground, or foreground and middle ground, or background only.

The second light I added was the one just in front of us. At the end you'll see from the compositing that I rendered the picture twice, with two different intensities of this light

*Fig.10a*

*Fig.10b*

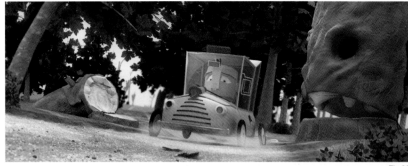

*Fig.03*

*Fig.04*

*Fig.05a*     *Fig.05b*

*Fig.06*     *Fig.07*

*Fig.08*     *Fig.09*

(**Fig.07**). The aim was to make the foreground readable and to simulate a possible car off-screen. With its falloff, it creates a demarcation with the rest of the picture. It is the light that reveals the most detail of the road and trees. Finally, I changed its purpose to simulate the light of the character's torch.

I then added a fill light on the right side. I made some different tests before finding the best way to adjust it, and I chose, finally, the opposite of the car light to reveal the contour of the other objects (**Fig.08**). This added some blue color – very interesting for the atmosphere! This light was effective for the foreground and middle ground only. For the background, I wanted something slightly different. It had to be really dark, but also needed to simulate other life there (**Fig.09**), so I used a very strong intensity to create a thin line of light on black trees. At this point, the picture depicted quite the atmosphere I needed. The rest was more adding details to some parts, specifically to the main tree which was to be considered as the other "character" in the scene. So I created two lights for him (**Fig.10a–b**): one purple light to fill it a little, and above the whole scene I placed a sort of specular light which revealed all the ZBrush details.

The character was lit once the background was finished. I tried to use the same light set up as for the environment and, much to my surprise, it was a success! That was, for me, the last sign to suggest that this light set up was right, even if it did look like a confusing mess in the software (**Fig.11**)!

## COMPOSITING AND HOW TO INCREASE COLORS, DEPTH AND FOCUS

First of all, I created all the passes I needed. I had my two environment renders, one with the main light really strong, and one without. I also rendered a Zdepth pass, the character alone, its dirt map (for details), and, finally, some masks for the lamp or the foliage (**Fig.12**). Here's what the picture would look like if I had just placed the layers one over the over. As you can see, we are very far from a finished result (**Fig.13**)!

In Digital Fusion, I started by setting up the ambience using some subtle color correction, adding some blue and creating the background with a gradient. I mixed the two renders I'd made to achieve the good feeling. To add details, I made some camera blur to create more depth. I also used the Zdepth pass to fade the alpha of my picture to mix it with the background. Finally, I added the character and the final details to the picture (**Fig.14**). By adding some more masks with color correction, I tried to really focus the picture on the character and the tree. One of the last things to do was to create the lamp effect, and then I went into Photoshop to create the sort of dust that you can see behind the light beam!

## CONCLUSION

Reading this, you could think that I have always known what I wanted to create and how to do it. But, the truth is that it wasn't so easy! This was a very long creation (as the rendering was a little heavy for my tiny computer) and I made many attempts and adjustments before having something that suited me. At one point, I was so lost on my lighting that I started again (adjusting the lights, one by one)! In this way, I finally found my way through this dark and dangerous forest!

Fig.11

Fig.13

Fig.14

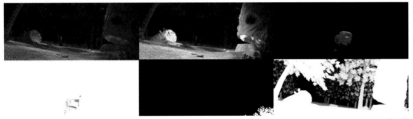

Fig.12

## ARTIST PORTFOLIO

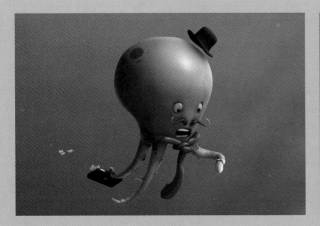

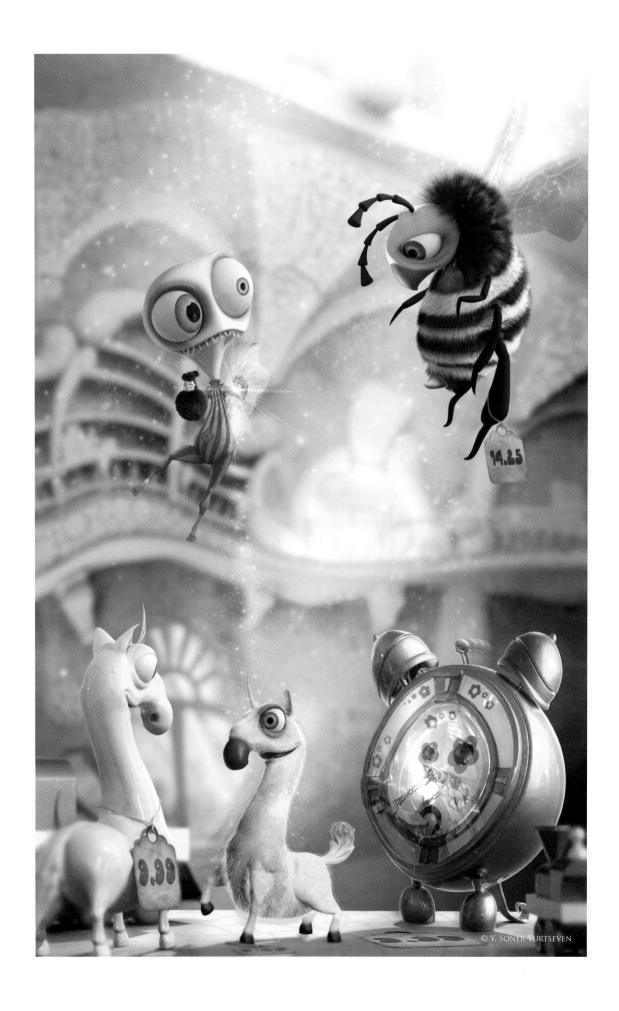

# PRICELESS FRIENDS

## BY Y. SONER YURTSEVEN

### CONCEPT

This image was my entry for the CGSociety Challenge, "Strange Behavior". In the beginning, a story was needed in order to work on it. So my dear fiancée, Melek, and I started thinking about a story to create creatures for...

We composed a story about an unusual, lonely fairy who was trying to find friends in an ancient, forgotten, "knick-knack" store, and how he used his ability to create

Fig.01

his own friends from the bibelots in the store. But, by mistake, he accidentally brought a bee to life, which was the scariest of all creatures for the fairy!

After the story was written, everything was ready for designing the characters and the environment. In the design process, the main points that I focused on were having both visual totality and individual differences in every design. The environment also had to be unique, because I thought it would be the best way of describing this imaginary world. I made various sketches of characters to transfer them from 2D to 3D in the best way possible (**Fig.01–02**).

### THE STORY

In this ancient, forgotten, knick-knack store, there were "twangs", "clinks" and "clacks" which started after many long, silent years. A weird and unexpected visitor was there, too. The unexpected visitor was an unusual fairy which looked like he was just trying to find something he had lost. The fairy was trying to find friends whom he had neither lost nor found. But, wherever he looked, he couldn't find any living thing in this place! The place was just full of bibelots and knick-knacks with price tags on them. However, he wanted to have friends more than anything else, so he decided to use his ability, an ability enabling him to do whatever he wishes with his magic dust... So, he started

Fig.02

Fig.03

hanging around, looking around and kicking around, choosing the bibelots that he liked the most in all those found around the store. Just at that moment, all the twangs, clinks and clacks started! After their lifeless years, all the bibelots that the fairy had chosen began to come alive, gradually, under a magical, dusty rain. The bibelots were all confused about what was happening to them when they came to life. The weird fairy was also confused because one bibelot which had come to life had done so by accident! It was the bee, one of the scariest creatures for the fairy. But, maybe this time he could be a friend of a bee...

## MODELING AND RIGGING

Everything – the characters, environment and other objects – was modeled in Maya. While I was modeling the characters and the environment, I got references from their concept sketches (**Fig.03**). I tried to maintain the "toon" style of the sketches as much as possible during the modeling process. The sketching milestone is one of the most important points of the work in progress. With a well-designed sketch, modeling the design will be more successful! The necessity for a sketch is unavoidable for the modeling stage (**Fig.04**). A part of the success of the modeling belongs to well-made sketches.

At first, I thought about showing the bibelots in the scene as if they'd been broken, with the creatures – the bibelots themselves – coming to life from inside each of the broken pieces…  But then I decided not to have broken pieces, just the bibelots coming to life, along with just one lifeless bibelot, for which the dog/horse seemed convenient.

As seen from the sketches, there are no horns on the dog/horse. But, while I was modeling it, I made a horn for it so that it became a weird and funny unicorn. Also, in the sketch of the dog it has a collar, too, and so I added a collar to the model while making it. In the sketches, the bee has only two legs, but the others simply weren't drawn. On

*Fig.04*

*Fig.06*

*Fig.07*                    *Fig.08*

the model, though, it has six. With the other attached legs, the character looks more complete! Also, the fur on the 3D model's neck is more "bunchy" than in the sketches.

For the fur I used Maya fur. A correct UV map was needed, and for the color differences I made partitions in some areas on the map and the model. By using the fur options, such as "Density_length_scraggle", and so on, good results can be achieved!

The environment consisted of amorphous forms, so it wasn't possible to construct it just from the frontal elevation. I therefore needed to work on it in a plan format and only then, in the 3D process, add further detail (**Fig.05**).

*Fig.05*

CARTOON

Finally, the rigging process was done to get the characters ready for making an animation for a future project (**Fig.06**). By the way, rigging is one of the most important milestones for animation!

## TEXTURING AND SHADING

While working on the textures for the bibelots, I tried not to exaggerate the wear and tear on them too much, even though they were old and decrepit from having been used extensively and then left unwanted. The price tags from paper which were added onto the characters were the most timeworn aspects (**Fig.07–08**).

Most of the materials were from the Mental Ray materials. For the character skin shaders I used Mental Ray's "SSS" (Subsurface Scattering).

## RENDERING AND COMPOSITING

The scene was rendered with Mental Ray using more than one render pass (Color, Alpha, Shadow, Reflection, Background and Foreground). Before the final scene I made some test renders to help make a decision about the background and foreground (**Fig.09–13**).

The concept was clear in my mind but I didn't work on a detailed sketch of the scene because working in 3D gives you the chance of changing the camera angle.

The magic dust that's falling out from the hand of the fairy, the dust particles in the air, and the exterior trees were all done in Photoshop. To achieve the special effects on the characters, I blurred the background evenly, and therefore made the detailing less apparent. Consequently, the characters appear more in focus which was the intention. For the final scene, I preferred a yellow light to convey the magical atmosphere.

Fig.09

Fig.10

Fig.11

Fig.12

Fig.13

All these stages were composited in Photoshop, and with a little more work the scene arrived at the final version.

## CONCLUSION

During the work in progress period I wanted to finish the concept in the way that I had been preparing for all along; with all the characters' rigging phases complete so that they were ready for the animation process, and I achieved exactly what I set out to do. I didn't change the way I worked, or do anything differently, but as I was producing the piece for a challenge, I got the chance to communicate with people from all around the world. Talking to them about different ideas and sharing my thoughts in forums was great and probably helped to shape my finished piece. Taking part in challenges is a one of the best ways to share experiences, and it also encourages you to work on something personal, rather than just the projects you have to work on for your job.

# ARTIST PORTFOLIO

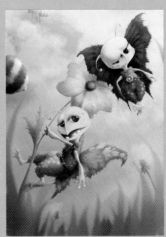

# THE DIGITAL ART MASTERS

### ALON
### CHOU
along1120@yahoo.com.tw

http://www.alon.tw

### ANDRÉ
### CANTAREL
andre@cantarel.de

http://www.cantarel.de

### DR CHEE MING
### WONG
Chee@opusartz.com

http://koshime.com

### CHEN
### WEI
lorlandchen@hotmail.com

http://flowercity.ppzz.net

### DAMIEN
### CANDERLÉ
canderled@hotmail.com

http://www.maddamart.com

### DAVID
### EDWARDS
david@capturefx.co.uk

http://www.capturefx.co.uk

### DENIS
### TOLKISHEVSKY
mail@to3d.ru

www.to3d.ru

### DRAZENKA
### KIMPEL
picky@creativedust.com

http://www.creativedust.com

### EDUARDO
### PEÑA
caareka20@hotmail.com

http://leco3ur.deviantart.com

### ELI
### EFFENBERGER
marmite_sue@hotmail.com

http://www.marmite-sue.co.cc

### ERIC
### PROVAN
eric_provan@yahoo.com

http://www.ericprovan.com

### FRAN
### FERRIZ
fran@frriz.com

http://www.franferriz.com

### FREDERIC
### ST-ARNAUD
http://www.starno.net

### GERHARD
### MOZSI
contact@gerhardmozsi.com

http://www.mozsi.com

### GORO
### FUJITA
gfujita@web.de

http://www.area-56.de

### GREGORY
### CALLAHAN
sasquatchpoacher@gmail.com

http://callahanarts.googlepages.com

### GUILLAUME
### MENUEL
guigui_oni@hotmail.com

http://gmgallery.blogspot.com

### HAMED
### YOUSEF
hamed3ds@yahoo.com

### HAO
### AI QIANG
Metalcraer@hotmail.com

http://www.sleep-m.com/SilentArt

### HENNA
### UOTI
henna.uoti@gmail.com

http://www.hennauoti.com/

### JAMES
### PAICK
jpaick@yahoo.com

http://www.jamespaick.com

### JOHN
### WU
therealjohnwu@hotmail.com

http://www.therealjohnwu.com

### JONATHAN
### SIMARD
capitaine_star@hotmail.com

http://pikmin.cgsociety.org/gallery/

### JONATHAN
### THIRY
greendjohn@hotmail.com

http://greendjohn.over-blog.com

### JURE
### ZAGORICNIK
info@3dg.si

http://www.3dg.si

### KRZYSZTOF
### NOWAK
christof.nowak@googlemail.com

http://black-eye.cgsociety.org/

### LAUREN
### K. CANNON
lkcannon@comcast.net

http://navate.com

### LAURENT
### PIERLOT
laurent@blur.com

http://sato.cgsociety.org/gallery/

### LEVENTE
### PETERFFY
lp@leventep.com

http://www.leventep.com

### LOÏC E338
### ZIMMERMANN
info@e338.com

http://www.e338.com

### MARC
### BRUNET
finalxii@msn.com

http://www.bluefley.cgsociety.org

### MARCELO
### EDER CUNHA
mecmancg@hotmail.com

http://www.mecmancg.com

### MARCO
### EDEL ROLANDI
public@marcorolandi.com

http://www.marcorolandi.com

# THE DIGITAL ART MASTERS

### MAREK
### DENKO
marek.denko@gmail.com

http://www.marekdenko.net

### MATHIEU
### AERNI
Mathieu.aerni@yahoo.ca

http://www.mathieuaerni.com/

### MATT
### DIXON
mail@mattdixon.co.uk

http://www.mattdixon.co.uk

### MORGAN
### YON
morgan.yon@gmail.com

http://www.morgan-yon.com

### NATHANIEL
### WEST
nathaniel@nathanielwest.net

http://www.nathanielwest.net

### NEIL
### BLEVINS
neil@soulburn3d.com

http://www.neilblevins.com

### NEIL
### MACCORMACK
neil@bearfootfilms.com

http://www.bearfootfilms.com

### NYKOLAI
### ALEKSANDER
x@admemento.com

http://www.admemento.com

### PATRICK
### BEAULIEU
squeezestudio@hotmail.com

http://www.squeezestudio.com

### PAWEŁ
### HYNEK
hynol@op.pl

http://hynol.cgsociety.org

### RICHARD
### ANDERSON
flaptraps@flaptrapsart.com

http://www.flaptrapsart.com

### ROBERTO
### F · CASTRO
contact@robertofc.com

http://www.robertofc.com

### ROBIN
### OLAUSSON
armetage@hotmail.com

http:// www.robin.reign.se/gallery

### RODRIGO
### LLORET CRESPO
Rodrigo.Lloret@gmail.com

http://www.rlloret.com/

### SANDARA
### TANG SIN YUN
Sandara3@gmail.com

http://www.sandara.net

### SANJAY
### CHAND
chand.3d@gmail.com

http://www.sanjaychand.com

### STEVE
### JUBINVILLE
stevejubz1@hotmail.com

http://www.stevejubinville.com

### TAEHOON
### OH
5taehoon@gmail.com

http://www.taehoonoh.com

### TEY
### CHENGCHAN
tchengchan@yahoo.com

### TIBERIUS
### VIRIS
suirebit@gmail.com

http://www.suirebit.net

### TOMASZ
### MARONSKI
maronscy@interia.pl

http://www.maronski.art.pl

### TONI
### BRATINCEVIC
toni@interstation3d.com

http://www.interstation3d.com

### VINCENT
### GUIBERT
guibertv@free.fr

http://www.vincentguibert.fr/

### WEI-CHE
### (JASON) JUAN
jasonjuan05@gmail.com

http://www.jasonjart.com

### YANICK
### GAUDREAU
yanickg@hybride.com

http://www.yanickgaudreau.com

### Y. SONER
### YURTSEVEN
ysoneryurtseven@gmail.com

http://ashiataka.cgsociety.org

### YIDONG
### LI
lyd17@sina.com

### ZOLTÁN
### KORCSOK
bea.zoli@t-online.hu

http://trurl.cgsociety.org

# INDEX

2D design:
creatures, 123
*Gros Nap, 268*
*It Was You, 68*
*Jack Stern, 272*
*Priceless Friends, 279*
tattoos 120
3D design:
cowgirls, 101
creature characters, 123
*Gros Nap,* 266, 268
helicopters, 13
*Jack Stern,* 272
locomotives, 42
*My Funny Car,* 255
*Priceless Friends,* 279
tattoos, 118, 120
*The Eyewitness* fantasy, 158
*3D Studio Max* software:
*Anton,* 257
creatures, 123
*Gros Nap,* 266
helicopters, 13
interiors, 69
*It Was You,* 66
*Jack Stern,* 257, 271

Adjustment Layers, 18-19, 188
*Adobe Photoshop see Photoshop*
Aerni, Mathieu, 122-5
Aeroplanes, 56-9, 200-2
*After Effects* software, 79
Ai Qiang, Hao, 20-3
Aleksander, Nikolai, 126-30
Alpha Vision (company), 148
*Amadeus Mozart* (film), 265
Ambient occlusion, 136, 273
Anderson, Richard, 226-39
*Anton* (Simard), 256-9

*Bacab* (god of earth), 184
Baldasseroni, Alexandro, 76-7
*Barry Lyndon* (film), 265
*Battlestar Galactica,* 214
Beaulieu, Patrick, 270-3
*Before they are Hanged* (Peterffy), 32-5
*Bigun* (Oh), 240-3
*Black Cat White Cat* (Effenberger), 96-9
*Black Hawk Down* (film), 12
Blevins (Neil), 218-21
*Bone Hill* (Maronski), 190-3
Bratincevic, Toni, 64-9
*Brazil* software, 267-8
*Break Away!* (Wu), 214-17
Brebion, Flavien, 198-203
*Brothers?* (Ferriz), 248-51
Brunet, Marc, 156-9
Brushes, 34, 139, 142
*Buckle Bunny* (Callahan), 100-3
Building scenes, 36-9, 45
Butterflies, 110

"Cage method" for modeling, 271-2
Callahan, Gregory, 100-3
Campbell, Scott, 102
Canderlé, Damien, 88-91
Canon, Lauren K., 112-15
Cantarel, André, 10-15
Car scenes, 52-5
Cartoon:
*Anton,* 256-9
*Brothers?,* 248-51
*Flu Shot Anyone?,* 244-7
*Gros Nap,* 264-9
*Jack Stern,* 270-3
*My Funny Car,* 252-5
*Not So Alone,* 274-7
*One Day Flower,* 260-3
*Priceless Friends,* 278-81
Castro, Roberto F, 230-5
Cats, 96-9, 209-12
*Cell Factor* (game), 205
*Chaac* (god of rain), 184
Chand, Sanjay, 132-7
Characters:
cats, 96-9
cowgirls, 101-3
creatures, 123-5
Crusades, 84-7
female figures, 93-5, 106-7
girls, 109-11
gnomes, 89-91
heavenly, 113-15
*Jack Stern,* 271, 273
Lucifer type, 127-30
monsters, 134-7
*Not So Alone,* 274-5
*Photoshop,* 97-9
*Priceless Friends,* 280-1
SCI-FI, 241-3
tattooed, 118-21
Chengchan, Tey, 60-3
*Chinatown* (Mozsi), 16-19
Chou, Alon, 84-7
Chung, James, 241
Cities, 149–51, 205-7
Colors:
aeroplanes, 57
*Brothers?* cartoon, 250-1
cities, 207
combination, 34-5
Crusade characters, 86
female figures, 95
hanging, 34
*Heavenly Slain,* 113
*Lucifer,* 128-9
*Not So Alone,* 277
*Queen of Ultima,* 141
*Combustion* software, 91
*Come Clarity* (Olausson), 236-9
Composition:
aeroplanes, 57-8
*Brothers?* cartoon, 250
cities, 206-7

*Come Clarity,* 237
cooking robots, 210
Crusade characters, 85-6
engines, 232-3
environment, 187
*Fallen Beauty,* 146-7, 150-1
female figures, 106-7
fish skeletons, 191-2
girls, 109-11
machines, 167-9
military trucks, 79
new/old objects, 62
*Not So Alone,* 277
*One Day Flower,* 262
palaces, 153-4
*Photoshop,* 187
pinecones, 220
*Priceless Friends,* 281
*Queen of Ultima,* 139-41
railways, 164
SCI-FI characters, 241-2
software, 22
space travel, 215-16
spiders, 83
street scene, 17-18
tattoos, 119-20
temples, 185-6, 188
*V-ray* software, 22
Control rooms, fantasy, 172-5
*Convivium* (novel), 127
Cooking robots, 209-12
Cooking units (CUs), 212
*Corel Photopaint* software, 192
*Corpse Bride* (film), 260
Creature characters, 123-5
*Creature Concept* (Aerni), 122-5
Crusade characters, 84-7
*CU-02 in Love* (Fujita), 208-13
Cunha, Marcelo Eder, 36-9
CUs *see* cooking units
Custom brushes, 34

*Darkness Monster* (Jubinville & Gaudreau), 180-3
Denko, Marek, 40-5
Depth in nature, 186
Desnoyers, Martin, 148-51
*Desnoyers-Ville* (Arnaud & Desnoyers), 148-51
*Devil's Beauty* (Yon), 46-9
*Digital Fusion* software, 277
Dixon, Matt, 166-9
*Dragonfly* (Tolkishevsky), 194-7
*Dream Avenue,* (Thiry), 24-7
Dream scenes, 24-7

Effenberger, Eli, 96-9
*Engine,* (Castro), 230-5
*Engine Warmup* (Cantarel), 10-15
Engines (SCI-FI), 232-5
Environment, composition, 187

*Fall into Oblivion* (ai Qiang), 20-3

*Fallen Beauty* (Edwards), 144-7
Fantasy:
cities, 149-51
control rooms, 172-5
*Fallen Beauty,* 144-7
fish skeletons, 190-3
lost world, 184-9
machines, 167-9
monsters, 180-3
palaces, 152-5
queens, 139-43
railways, 160-5
*The Eyewitness,* 156-9
underwater creatures, 177-9
*Fearless* (Chou), 84-7
Female figure characters, 106-7
Ferriz, Fran, 248-51
FFD *see* Free Form Deformation
Fighter aeroplanes, 200-2
Filters in *Photoshop,* 103
Fish skeletons, 190-1
*Flight of Silverbows* (Wong), 198-203
*Flu Shot Anyone?,* (Provan), 244-7
Forman, Milos, 265
Free Form Deformation (FFD), 272
Fujita, Goro, 208-13
Fur:
*Jack Stern* cartoon, 272-3
*Priceless Friends* cartoon, 280
spiders, 83
tattooed characters, 119
*Fusion* software, 136, 268
*Future Station* (Maccormack), 222-5

Gallery Nucleus (art store), 214
Gaudreau, Janick, 180-3
Girl characters, 109-11
Global approach for image integration, 18
Gnome characters, 89-91
Grass modeling, 43
*Gros Nap* (Pierlot), 264-9
Guibert, Vincent, 274-7

Hanging scenes, 32-5
*Heaven Slain* (Canon), 112-15
Heavenly characters, 113-15
*Hektor* (Denko), 40-5
Helicopters, 10-15
*Hellfire Widow* (Korcsok), 80-3
*Homage to Sidonio Porto* (Cunha), 36-9
Hynek, Pawel, 52-5

*Illustrator* software, 174
Imaginary Spaces theme, 214
*In the Sky* (Crespo), 56-9
*Infinity: The Quest for Earth* (game), 200

Interior scenes, 66-9
*It Was You* (Bratincevic), 65-9

*Jack Stern* (Beaulieu), 270-3
Japanese culture, 119-20
Juan, Wei-Che, 70-3
Jubinville, Steve, 180-3

Kimpel, Drazenka, 92-5
Koi fish, 120
Korcsok, Zoltan, 80-3
Kubrick, Stanley, 265

*Lady Sylphine* (Tang Sin Yun), 176-9
*Laughing Out Loud* (Chand), 132-7
Li, Yidong, 74-9
Lighting:
   aeroplanes, 202
   *Anton* cartoon, 259
   *Brothers?* cartoon, 250
   buildings, 38
   cars, 54-5
   *Come Clarity*, 238-9
   control rooms, 173
   cowgirls, 103
   creatures, 124-5
   dragonfly, 196
   effects, 21-2
   engines, 234
   *Fall into Oblivion*, 21
   *Fallen Beauty*, 146
   fish skeletons, 191
   gnomes, 90-1
   *Gros Nap*, 267
   interiors, 68
   *Jack Stern*, 272-3
   locomotives, 44
   military trucks, 78
   monsters, 135-6, 182-3
   *My Funny Car*, 254-5
   new/old objects, 62
   *Not So Alone*, 276
   *One Day Flower*, 262
   palaces, 154
   pinecones, 220
   scooters, 31
   space stations, 224
   space travel, 215
   *The Eyewitness*, 158
   *V-ray* light, 26
*Limbo City* (Pena), 204-7
Locomotives, 40-4, 162-3
*Longmen's Fall, Revisited* (Zimmermann), 116-21
*Longmen's Fall* (story), 120
*Lost World: Temple of Nature* (Viris), 184-9
*Lucifer* (Aleksander), 126-30

Maccormack, Neil, 222-5
Machine fantasy, 166-9
*Macromedia flash* software, 31

Maronski, Tomasz, 190-3
Materials:
   cars, 53-4
   interiors, 67-8
Matte painting, 186
Maugham, Andrew E., 127
*Max* software, 25, 258
   see also 3D Studio Max software
*Maxwell* software, 68-9
Maya civilization, 184
*Maya* software, 120
*Mental Ray* software, 66, 267, 281
Menuel, Guillaume, 104-7
*Mercedes-Benz 720SSKL* (Hynek), 50-5
Meshpainting fur on spiders, 83
Metal shading for railways, 163-4
*Metropolis* (film), 160
*Miami* (Menuel), 104-7
Military truck scenes, 74-9
Modeling:
   AF loft function, 21
   *Brothers?*, 249-50
   buildings, 38
   cars, 52-3
   cowgirls, 102
   creatures, 123-4
   *Dragonfly*, 195-6
   *Fall into Oblivion*, 21
   *Flu Shot Anyone?*, 245-6
   gnomes, 89-90
   grass, 43
   *Gros Nap*, 265-7
   helicopters, 12-13
   interiors, 67
   *Jack Stern*, 271-2
   locomotives, 42
   military trucks, 76-9
   monsters, 134-5, 181-2
   *My Funny Car*, 253
   new/old objects, 62
   objects, 25
   *One Day Flower*, 260-2
   pinecones, 219-20
   pipes, 220
   plants/bushes, 43
   polygons, 21
   *Priceless Friends*, 280-1
   SCI-FI characters, 241-2
   scooters, 29-30
   space stations, 222-3
   spiders, 81
modeling "Cage" method, 271-2
*MODO* software, 82-3
Monster:
   characters, 134-7
   fantasy, 180-3
Motion of Crusade characters, 85-6

*Mouths to Feed III* (Blevins), 218-21
Mozsi, Gerhard, 16-19
*Mudbox* software, 101
*My Funny Car* (Yousef), 252-5

Napoleonic period, 265
Natural History Museum, 146
New/old objects scenes, 60-3
*Not So Alone* (Guibert), 274-7
Nowak, Krzysztof, 260-3

Object scenes, 20-3
Oh, Taehoon, 240-3
Olausson, Robin, 236-9
*One Day Flower* (Nowak), 260-3
Overlays, *Photoshop*, 70-2

Paick, James, 152-5
Painting:
   consistency, 35
   engines, 233-4
*Palace Entrance* (Paick), 152-5
Palace lighting, 154
Parisian Art Nouveau design, 172
*Pauahtun* (god of wind), 184
*Pave Hawk* (Cantarel), 14
Pena, Eduardo, 204-7
*Philosopher* (Chengchan), 60-3
*Photoshop*:
   aeroplanes, 59
   *Anton*, 258-9
   brushes, 139, 142
   characters, 97-9
   creatures, 125
   *Dream Avenue*, 26-7
   engines, 232-3
   filters, 103
   framing, 17, 47
   *Gros Nap*, 268
   heavenly characters, 113
   helicopters, 14
   Illustrator software, 174
   initial sketching, 177
   interiors, 69
   *Jack Stern*, 272-3
   locomotives, 44
   *Not So Alone*, 277
   overlays, 70-2
   pinecones, 221
   rendering, 31
   sky, 187
   space stations, 224, 225
   spacesuits, 227
   spiders, 83
   sun rays, 224
   tattoo design, 120
   texturing, 68
   trees, 281
Pierlot, Laurent, 264-9
Pinecones, 219-21
pipes, 220
Planes see aeroplanes
Plants/bushes, modeling, 43

Plate cleaning, *Fallen Beauty*, 146
polygons, 21
Posing:
   *Come Clarity*, 237
   SCI-FI characters, 241-2
   spiders, 82-3
Post production:
   aeroplanes, 58-9
   buildings, 38
   dragonfly, 196
   *Dream Avenue*, 26-7
   gnomes, 91
   *Gros Nap*, 267
   helicopters, 14
   *It Was You*, 69
   locomotives, 44
   monsters, 137, 183
   *One Day Flower*, 263
   scooters, 31
   spaces stations, 225
*Priceless Friends* (Yurtseven), 278-81
Provan, Eric, 244-7
*Purple Orchid* (Kimpel), 92-5

Qual, Ziv, 27
Quantic Dream (company), 118
*Queen of Ultima* (Wei), 138-43

*Rail Haven* (Rolandi), 160-5
Railway fantasy, 160-5
References:
   architecture, 37
   *Desnoyers-Ville*, 149-50
   heavenly characters, 113
   *It Was You*, 66
   locomotives, 41-2
   military models, 76
   military trucks, 77
   *Palace Entrance*, 154
*Relics* (Li), 74-9
Rendering:
   *Anton* cartoon, 258-9
   buildings, 38
   cowgirls, 103
   creatures, 124
   dragonfly, 196
   *Dream Avenue*, 26
   *Fall into Oblivion*, 21-2
   *Flu Shot Anyone?*, 246
   gnomes, 90-1
   *Gros Nap*, 267
   helicopters, 14
   *Jack Stern*, 272-3
   locomotives, 44
   machines, 168
   monsters, 182-3
   *My Funny Car*, 254-5
   *Not So Alone*, 277
   *One Day Flower*, 263
   pinecones, 220
   post production, 38

SCI-FI characters, 243
scooters, 31
space stations, 224-5
spiders, 82-3
Research:
    *Fallen Beauty*, 145
    monsters, 181
Rigging:
    *Flu Shot Anyone?*, 246
    *Priceless Friends*, 280
Robots, cooking, 209-12
Rolandi, Marco Edel, 160-5

Scenes:
    aeroplanes, 56-9
    buildings, 36-9, 45
    cars, 52-5
    dreams, 24-7
    hanging, 32-5
    helicopters, 12-15
    interiors, 66-9
    locomotives, 40-2, 44
    military trucks, 74-9
    new/old objects, 60-3
    objects, 20-3
    scooters, 30-1
    spiders, 80-3
    streets, 17-19
    temples, 70-2
    war, 46-9
SCI-FI:
    aeroplanes, 200-3
    cats, 209-12
    characters, 241-3
    cities, 205-7
    *Come Clarity*, 238-9
    cooking robots, 209-12
    dragonfly, 195-7
    pinecones, 219-21
    space stations, 222-5
    space travel, 215-17
Scooters, 28-31
Shading:
    *My Funny Car*, 253-4
    *Priceless Friends*, 281
    scooters, 30-1
    trucks, 76-7
    *see also* texturing
Simard, Jonathan, 256-9
Skeletons, fish, 190-1
Skies, 114
Space:
    ships, 223-4
    stations, 222-5
    travel, 214-17
*Spacesuit* (Anderson), 226-39
"Spacesuit dude", 228
Spacesuits, 227-9
Specular accuracy, 158
Spider scenes, 80-3
St-Arnaud, Frederic, 148-51
Stones, 43
"Strange Behaviour" challenge,
    209, 279

Street scenes, 17-19

T-Rex dinosaurs, 181
Tang Sin Yun, Sandara, 176-9
Tattooed characters, 118-21
Temple fantasy, 184-9
*Temple Festival* (Juan), 70-3
Texturing:
    antiques, 62
    *Anton* cartoon, 258
    buildings, 38
    creatures, 125
    dragonfly, 196
    female figures, 95
    *Flu Shot Anyone?*, 246
    gnomes, 90
    *Gros Nap*, 267
    helicopters, 13
    interiors, 67-8
    irregular objects, 38
    *Jack Stern*, 272-3
    locomotives, 43
    *Macromedia Flash*, 30-1
    monsters, 135, 182
    *My Funny Car*, 253-4
    *One Day Flower*, 263
    palaces, 154
    pinecones, 220
    *Priceless Friends*, 281
    railways, 162
    SCI-FI characters, 242
    scooters, 30-1
    space stations, 224
    space travel, 126
    spiders, 82-3
    UV template, 13
    *V-ray* materials, 25-6
*The Control Room* (West), 170-5
*The Eyewitness* (Brunet), 156-9
*The Gnom* (Canderlé), 88-91
*The Machine* (Dixon), 166-9
Thiry, Jonathan, 24-7
Tolkishevsky, Denis, 194-7
Tone *see* color
*Torturement* (Uoti), 108-11
Trucks, military, 74-9
tires, 30

Underwater creatures fantasy,
    177-9
Unfold 3D software, 182
Unwrapping, editor, 12-13
Uoti, Henna, 108-11
UV mapping, 62, 181-2

*V-Ray*:
    light, 26
    scenes, 24
    software, 22
*Vespa 150GL* (Zagoricnik), 28-31
Viris, Tiberius, 184-9
*Vue* software, 187

Wacom tablet, 139
War scenes, 46-9
Water design, 174
Wei, Chen, 138-43
West, Nathaniel, 170-5
Wong, Dr Chee Ming, 198-203
Workflow:
    cowgirls, 101-2
    machines, 167-8
Wu, John, 214-17

Yon, Morgan, 46-9
Yousef, Hamed, 252-5
Yurtseven, Soner, 278-81

Zagoricnik, Jure, 28-31
*ZBrush* software:
    *Anton*, 257
    creatures, 123-5
    *Gros Nap*, 266, 268
    monsters, 134, 181-2
    *Not So Alone*, 276
    *One Day Flower*, 262
    posing, 119
    spiders, 81-2
Zimmermann, E338 Loïc, 116-21

# DIGITAL ART MASTERS

## VOLUME 1

THE FIRST BOOK IN THE "DIGITAL ART MASTERS"
SERIES FEATURES 48 OF THE FINEST 2D AND 3D
ARTIST FROM THE LIKES OF:

ANDRÉ HOLZMEISTER, DANIELE MONTELLA,
DRAZENKA KIMPE, ERIC WILKERSON, FRANCISCO
FERRIZ, FRED BASTIDE, JESSE SANDIFER,
KHALID ABDULLA AL-MUHARRAQI, LAURENT
MÉNABÉ, LINDA TSO, MARCEL BAUMANN, MENY
HILSENRAD, NATASCHA ROEOESLI, NICOLAS
RICHELET, PATRICK BEAULIEU, PHILIP STRAUB,
PISONG, RICHARD TILBURY, ROBERT CHANG,
ROMAIN CÔTE, RUDOLF HERCZOG, RYAN LIM,
SIKU AND THIERRY CANON.

## VOLUME 2

THE SECOND BOOK IN THE "DIGITAL ART
MASTERS" SERIES FEATURES 58 OF THE FINEST 2D
AND 3D ARTIST FROM THE LIKES OF:

ANDREA BERTACCINI, BENITA WINCKLER, BRIAN
RECKTENWALD, CYRIL ROLANDO, DAARKEN,
DANIEL MORENO, DANIELA UHLIG, EMRAH
ELMASLI, FRED BASTIDE, GERHARD MOZSI, GLEN
ANGUS, HYUNG JUN KIM, JAMES BUSBY, JIAN
GUO, JONATHAN SIMARD, JONNY DUDDLE,
KORNÉL RAVADITS, MAREK DENKO, MASSIMO
RIGHI, MICHAEL SMITH, MIKKO KINNUNEN, NEIL
MACCORMACK, OLGA ANTONENKO, PATRICK
BEAULIEU, PHILIP STRAUB, WIEK LUIJKEN, VINCENT
GUIBERT, HOANG NGUYEN AND TAE YOUNG CHOI.